RUBENS AND THE POETICS OF LANDSCAPE

RUBENS AND THE POETICS OF LANDSCAPE

LISA VERGARA

YALE UNIVERSITY PRESS NEW HAVEN AND LONDON

Published with the assistance of the F. B. Adams, Jr. Publication Fund.

Designed by Sally Harris
and set in VIP Janson type.
Printed in the United States of America by
Vail-Ballou Press, Binghamton, N.Y.

Library of Congress Cataloging in Publication Data

Vergara, Lisa, 1948–
 Rubens and the poetics of landscape.
 Bibliography: p.
 Includes index.
 1. Rubens, Peter Paul, Sir, 1577–1640.
2. Landscape in art. 3. Ut pictora poesis
(Aesthetics) I. Title.
ND673.R9V37 759.9493 81–11385
ISBN 0–300–02508–4 AACR2

10 9 8 7 6 5 4 3 2 1

CONTENTS

ILLUSTRATIONS

Works are by Rubens unless otherwise indicated; all engravings after Rubens' landscapes are by Schelte à Bolswert.

ABBREVIATIONS

B.-H.	Ludwig Burchard and R. A. d'Hulst, *Rubens' Drawings*
CDR	Charles Ruelens and Max Rooses, eds., *Codex diplomaticus Rubenianus: Correspondance et documents épistolaires*
ckl. no.	Entry in Checklist of Rubens' Paintings Mentioned in the Text (see below, pp. 194–196)
Grondt	Carel van Mander, *Den grondt der edel vrij schilderconst*
Evers (1942)	H. G. Evers, *Peter Paul Rubens*
Evers (1944)	H. G. Evers, *Rubens und sein Werk*
Glück	Gustav Glück, *De landschappen van P. P. Rubens*
Held	Julius S. Held, *Rubens: Selected Drawings*
Magurn	Ruth Saunders Magurn, trans. and ed., *The Letters of Peter Paul Rubens* (Ed. note: in some cases Magurn's Latin translations have been rendered more accurately)
G. Martin	Gregory Martin, *The National Gallery Catalogues: The Flemish School circa 1600–circa 1900*
Miedema	Carel van Mander, *Den grondt der edel vry schilderconst*, vol. 2 (critical commentary), edited and translated by Hessel Miedema
Rowlands	John Rowlands, *Rubens: Drawings and Sketches*

PREFACE

No one, perhaps, has regarded Rubens' landscapes as highly as did the artist himself; of some thirty he produced, at least half remained in his own collection.[1] The English miniaturist Edward Norgate remarked in 1648, nine years after his visit to Rubens' studio, that the artist "was so delighted [with landscape] in his later time [that] he quitted all his other practice in Picture and Story, whereby he got vast estate, to studie this, whereof he hath left the world the best that are to be seene. . . ."[2] And in 1676 the painter's nephew Philip stated that although his uncle's landscapes were few in number, they were among the most esteemed of his works.[3] In the following centuries the artists and writers who paid public tribute to Rubens' landscapes include Watteau, Gainsborough, Goethe, Turner, Constable, Delacroix, Baudelaire, and even Manet—a small but illustrious group.

The diversity of admirers of Rubens' landscapes is but one reflection of the extraordinary thematic, stylistic, and expressive variety found in these works. As early as the late seventeenth century Roger de Piles observed of the landscapes by Rubens in the collection of the duke of Richelieu:

C'est une chose surprenante de voir comme Rubens a réussi dans tous les genres de la peinture. Il ne faut pas que vous vous imaginiez que personne ait jamais mieux fait le paysage que lui. Il y en a cinq tous différens de manières aussi-bien que de situation.[4]

Corresponding to this range of style, subject matter, and "situations" in Rubens' landscape oeuvre is the broad compass of human experience such works convey: perceptions, feelings, and attitudes

1. J. Denucé, *The Antwerp Galleries: Inventories of the Art Collections in Antwerp in the Sixteenth and Seventeenth Centuries* (Antwerp, 1932), nos. 104, 105, 106, 108, 110, 112, 132, 133–34, 135–36, 137, 150, 171–72, 173; the consecutive numbers listed together were presumably pendants. Other paintings by him with peasant subjects were also in the collection. If Schelte à Bolswert executed his engravings after Rubens' landscapes in the 1630s, as the evidence suggests, then these prints may reflect the landscapes Rubens possessed in the last decade of his life—that is, considerably more than appear in the inventory. Rubens owned twenty-nine landscapes by other artists.

2. Edward Norgate, *Miniatura, or the Art of Limning*, ed. Martin Hardie (Oxford, 1919), p. 46.
3. Charles Ruelens, "La vie de Rubens par Roger de Piles," *Rubens-bulletijn* 4 (1890), p. 167. Previously, in 1661, Jacques de Bie had praised Rubens' landscapes (*Het gulden cabinet* (Lier, 1661)).
4. Roger de Piles, *Recueil de divers ouvrages sur la peinture et le coloris*, "Description de quelques tableaux de Rubens, tirés du cabinet de M. le Duc de Richelieu" (Amsterdam and Leipzig, 1767), p. 340.

toward nature as place, process, and property; and toward landscape painting itself as a mirror of thought, reflection of God, and worthy arena of the noblest talents.

This study began as an attempt to explore the meanings of Rubens' landscapes—a task, I soon discovered, that demanded a wider intellectual framework than the older literature offered. There one often encounters the notion that among all of Rubens' paintings, his landscapes are the easiest to understand, or alternatively, that they are so mysterious as to defy analysis.[5] Frequently the figures within the landscapes are discussed as if they were mere vestiges from the older tradition of history painting, while the settings themselves are considered pretexts for a purely artistic exploration of effects of light, the forces of nature, or striking scenery. The difficult question that always remained was how one could approach Rubens' landscapes in a less fragmented way. Here I have turned to the Renaissance notion *ut pictura poesis* and found it still useful and flexible as a critical tool: thus the metaphoric use of the word "poetics" in the title of this book. The term can claim historical validity, for Renaissance and Baroque artists assumed that painting functioned according to many of the same principles as poetry. The pictures themselves suggested that Rubens shared the traditional thematic interests of poets with respect to landscape and that he understood these themes to be of particular relevance to painting; indeed, his landscapes seem to fit into preconceived types found in literature. But "poetics" here connotes more than an occasional kinship of subject and structure between words and images. Rubens created supremely original poetic structures based on his own rules of invention and interpretation. His perception of affinities among phenomena, forms, and ideas and his ability to give meaning and life to literary types and topoi resulted in landscapes that fully reflect the depth and range of his culture.

The striking fact that Rubens kept most of the landscapes for himself suggests that these works had a particularly personal dimension. Jacob Burckhardt understood this when he wrote, "In the grand total of Rubens' work, the landscapes speak a peculiar language, and stand even psychologically in a special relationship with their author."[6] Thus, before exploring the implications of poetics and painting proper, we may begin with a consideration of the artist as his own patron. Ultimately I hope to show that Rubens' landscapes express in a profound and unique way his personal sense of place—at once geographic, historic, social, and artistic.[7]

5. An example of the first attitude has been expressed by Neil MacLaren: ". . . no great artist before Rubens had used landscape . . . without ulterior significance . . . no one had created a great work of art in which landscape alone was the subject" (*Peter Paul Rubens: The Château de Steen* [London, 1946], p. 3); the second assumption has been voiced by, among others, H. G. Evers: ". . . wie die Landschaft für ihn selber eine Offenbarung war, so ist sie auch für uns Nachgeborene geheimnisvoll geblieben. Was schon von jedem Kunstwerk gilt: dass grosse Wahrheiten in ihm enthalten sein mögen, die wir noch nicht sehen, die aber unsere Enkel vielleicht erkennen, das gilt von den Landschaften von Rubens am meisten. Nicht mit Dissertationen werden wir ihnen beikommen, aber am Ende unseres Lebens werden wir uns wieder fragen, was in ihnen steht" (1942, p. 387).

6. "In der grossen Gesamtarbeit des Rubens sprechen seine Landschaften eine ganz besondere Sprache und stehen auch zu ihrem Urheber seelisch in einem ganz besonderen Verhältnis." With this sentence Burckhardt begins the final section of his *Erinnerungen aus Rubens* (Basel, 1898), p. 307.

7. Landscapes have not always been considered amenable to interpretation, and it is not surprising, therefore, that in spite of the appeal of Rubens' paintings, few studies have been devoted to them. Scholars such as Emil Kieser (*Die Rubenslandschaften* [Munich, 1926]), Herbert Herrmann (*Untersuchungen über die Landschaftsmalerei des Rubens* [Berlin, 1936]), Gustav Glück (*De landschappen van P. P. Rubens* [Antwerp, 1940]), and Yvonne Thiéry (*Le paysage flamand au XVII siècle* [Paris, 1953]) have been primarily concerned with questions of documentation, influences, stylistic devel-

opment, and connoisseurship. H. G. Evers's chapter on the landscapes (1942) is exceptional, since it implicitly aims at interpretation. Unlike other art historians who arrange the landscapes in broad stylistic categories, Evers considers a selection of paintings and discusses them with a sense of the interrelationship of style, subject matter, and the artist's life and sensibility. The justness and originality of most of his observations are sometimes offset, however, by a "blood and soil" political bias that leads him largely to ignore—as have other writers for other reasons—the specific historical and intellectual context of the landscapes. But Evers's insight into the importance to Rubens of the land itself must have inspired his fresh visual analyses. His willingness to look closely at the landscapes, and his realization that they are far more than artfully constructed views, have influenced my own approach. At the same time, the research of other students of Rubens' landscapes has provided an indispensable documentary basis for the present study.

I have not made it my task to deal with all the landscapes by or attributed to Rubens; rather, I have selected those—including all the major ones—that I believe reveal his characteristic approach to this branch of painting. Nor have I attempted to discuss in a systematic way the many problems of attribution and chronology that these works still present. A new, complete catalogue of Rubens' landscapes and hunting scenes, compiled by Wolfgang Adler, will be published in the near future as part of the *Corpus Rubenianum Ludwig Burchard*.

ACKNOWLEDGMENTS

For helping my interest in Rubens' landscapes find a place, I give warm thanks, first and foremost, to David Rosand. As dissertation advisor when I initially prepared this study, he gave enthusiastic guidance from the start, offered ideas and practical advice at every stage, and read many drafts with uncommon thoughtfulness and good will. Leo Steinberg, whose arresting comments on a landscape by Rubens gave me an unforgettable introduction to the subject when I was a student at Hunter College, deserves very special thanks. I am deeply grateful to him for sharing his insights into several of the works treated here, and, more generally, for having brought such intelligence and passion to the field of art history, providing through his work truly inspiring models of scholarship and sensibility. J. W. Smit, in the course of many stimulating, wide-ranging conversations, added important dimensions to my understanding of Rubens' landscapes and the culture in which the artist worked. It was my good fortune also to have been advised on this study by John Walsh, whose careful judgments, probing questions, and sound suggestions were crucial. The kind assistance that these scholars extended throughout my later student years was vast and varied, their intellectual support immeasurable; not least important has been their sustained and sustaining friendship.

To Anne Walters Lowenthal, Egbert Haverkamp-Begemann, and Julius S. Held I am greatly obliged for having read the manuscript and generously offering an array of valuable recommendations.

It has been a pleasure as well as an honor to collaborate with Yale University Press; in particular I am grateful to Judy Metro for her longstanding interest and encouragement. Finally, I wish to thank my parents and husband for their manifold and unfailing support.

1. THE LEARNED ARTIST AND THE LAND

The biographers of Rubens have served him well. It is likely that nearly all the surviving documentation regarding his life has been found, recorded, and woven into perhaps the fullest history we have of a seventeenth-century painter. By all accounts, his character, work, and experience correspond in near perfect harmony, and although complex, the picture we have of the artist is all of a piece. Thus even aspects of Rubens' life that may at first seem to have little bearing on his artistic conceptions can add to our understanding of his paintings.[1]

In connection with his landscapes, two main features of Rubens' biography demand our attention. The first we may term his experience and sense of place, characterized by a strong commitment to the Southern Netherlands as well as a definite cosmopolitanism; the second, in many ways related to the first, is his love of classical thought, particularly as expressed in Latin literature.

Rubens traveled as frequently and as far as other members of his profession, yet he was not one of the uprooted artists of the seventeenth century. Always he had Antwerp to come back to, and after his momentous decision to settle there permanently, that city became a true home, a place offering the emotional security of family ties, the company of friends from whose learning he was always quick to benefit, leadership of a collaborative artistic community, and membership in a parish whose church he counted on as a last resting place. Finally, though not least important, Antwerp served as a base for those wide-ranging transactions that made Rubens a very rich man.[2]

It was surely in Cologne, however, that Rubens began the studies and adopted many of the values that would stand him in good stead throughout his life. No documents exist regarding his schooling in Germany, but the instruction of his father, a learned man who had received a doctorate in Rome in 1554, must have counted as a crucial stage in Rubens' education; that, at least, is what the artist's

1. The best modern biographies of Rubens are those by Max Rooses (*Rubens*, 2 vols. [London, 1904]) and Evers (1942). A chronological list of the artist's earliest biographers is given by Horst Gerson and E. H. ter Kuile in *Art and Architecture in Belgium, 1600–1800* (Harmondsworth, Middx., 1960), p. 211.

2. Regarding the admittedly vague but useful term "sense of place," we might note that Rubens himself was conscious of the notion of the "genius" of a certain locale—that is, something which gives a place its essential character. Commenting on the sale to Charles I of the magnificent Gonzaga collection of Renaissance paintings—symbol of the cultural brilliance of Mantua—Rubens wrote to Dupuy: "This sale displeases me so much that I feel like exclaiming, in the person of the genius of that State: *Migremus hinc* [let us depart hence]!" (Rubens to Dupuy, June 15, 1628; *CDR* 4:431; Magurn, p. 268).

nephew Philip Rubens reported in 1676. Roger de Piles, referring to Rubens' formal education, had asked Philip whether it was likely that his uncle could have acquired his understanding of literature at such an early age. "I say," replied Philip, "that he did not cease to apply himself to Latin, in spite of his artistic labors, so that his whole life was but one long course of study; and as his father was extraordinarily versed in letters, he received sound principles and instructions, in addition to the quick and lively wits with which nature had endowed him."[3]

In Antwerp, before his apprenticeship as a painter, Rubens may have had less than two full years of classical education. The school he attended, however, was the finest of its kind in the city, including in its curriculum works by Cicero, Virgil, Terence, and Plutarch, as well as Latin and Greek grammars and theoretical manuals.[4] We do not know the nature of Rubens' reading in the years after he left school or the extent to which his literary interests were influenced by his scholarly brother Philip or his second master, the learned painter Otto van Veen. The number and quality of books available to the artist must have increased while he was in Italy, and although there is again little evidence concerning his reading matter, we can be quite sure that he did not limit his study to works of art and archaeology. Rubens' knowledge of literature was remarked upon by the classical scholar Scioppius in a book published in 1606:

My friend Peter Paul Rubens, in whom I know not what to commend the more—whether his skill in painting, in which, to the eyes of connoisseurs, he seems to have attained perfection, if anyone has attained it in these times; or his knowledge of all that pertains to letters; or that refinement of judgment which he combines with a particular charm of speech and conversation. . . .[5]

Thirty-four years later, just after the artist's death, the scholarly abbot Philippe Chifflet hailed Rubens as "the most learned painter in the world."[6] And Roger de Piles, enlarging on what Philip Rubens had told him, wrote:

Quoy-qu'il fut fort attaché à son Art, il ménageoit neanmoins son tems de maniére, qu'il en donnoit toujours quelque partie à l'estude des belles lettres, c'est à dire de l'Histoire & des Poëtes Latines qu'il possedoit parfaitement, & dont la Langue luy estoit fort familiére aussi bien que l'Italienne, comme on en peut juger par les observations manuscrites qu'il a faites sur la Peinture, où il a rapporté quelques endroits de Virgile & d'autres Poëtes que faisoient à son sujet.[7]

De Piles also speaks specifically of a notebook of Rubens' with observations

3. Charles Ruelens, "La vie de Rubens par Roger de Piles," *Rubens-bulletijn* 2 (1885), p. 164; translated in Rooses, *Rubens* 1:29.

4. Max Rooses, "Petrus Paulus Rubens en Balthasar Moretus," part 1, *Rubens-bulletijn* 1 (1882), p. 212.

5. Charles Ruelens, "Un témoignage rélatif à Peter Paul Rubens en Italie," *Rubens-bulletijn* 4 (1890), p. 150; translated by Magurn, p. 12.

6. Chifflet to Balthasar Moretus, June 6, 1640; *CDR* 6:303. On Chifflet, see Magurn, p. 508.

7. Roger de Piles, *Dissertation sur les ouvrages de plus fameux peintres* (Paris, 1681), p. 32.

des actions tirées de quelques descriptions qu'en ont fait les Poëtes avec des démonstrations à la plume d'après les meilleurs Maistres, & principalement d'après Raphaël, pour faire valoir la Peinture des uns par la Poësie des autres (soit que ces habiles Peintres eussent travaillé par principe, ou seulement par la bonté de leur génie).[8]

The fact that Rubens was a lettered man helped ease his way into circles that might otherwise have been closed to a mere painter, and in 1625 he was able to write to his French correspondent Valavez: "Other things being equal, I regard all the world as my country, and I believe that I should be very welcome everywhere."[9]

The artist's decision to settle in Antwerp after returning from Italy late in 1608 was partly an expression of his faith in the revival of the Southern Netherlands. The ratification of the Twelve Years' Truce, for which final negotiations took place in Antwerp in 1609, had awakened expectation of the peace upon which the welfare of the country depended. In a letter of April 11, 1609 to his friend Johann Faber, a German physician in Rome, Rubens wrote:

> But to come to my own affairs, I have not yet made up my mind whether to remain in my own country or to return forever to Rome, where I am invited on the most favorable terms. Here also they do not fail to make every effort to keep me, by every sort of compliment. The Archduke and the Most Serene Infanta have had letters written urging me to remain in their service. Their offers are very generous, but I have little desire to become a courtier again. Antwerp and its citizens would satisfy me, if I could say farewell to Rome. The peace, or rather, the truce for many years, will without doubt be ratified, and during this period it is believed that our country will flourish again. It is thought that by next week it will be proclaimed through all the provinces.[10]

8. De Piles (1681), p. 36. Earlier, G. P. Bellori (*Le vite de' pittori, scultori, ed architetti moderni . . .* , [Rome, 1672], p. 274) had given a very similar description of the notebook (destroyed), which, however, was in de Piles's possession. For a brief history of the notebook, see Michael Jaffé, *Van Dyck's Antwerp Sketchbook*, vol. 1 (London, 1966), appendix B. According to Jaffé's investigations, Van Dyck's sketchbook reflects, in part, the notebook of Rubens.

To some extent, the depth and extent of Rubens' knowledge of literature and of Latin can be gauged from his letters, where quotations as well as lines of his own invention abound. It would be misleading, however, to claim that he was a Latin scholar like his brother or like many of his friends and correspondents. In a letter of December 29, 1628, to his close friend the Antwerp humanist Jan Caspar Gevaerts (Gevartius), Rubens writes: "My response in the Flemish language will be sufficient to show that I do not deserve the honor which you confer on me with your letters in Latin. My practice and studies in the humanities have fallen so far behind that I should first have to beg permission to commit solecisms. Therefore, please do not put me, at my age, in competition with school-boys." The fact that Gevaerts, who knew the artist so well, wrote to him in Latin is, however, proof—if such be needed—of Rubens' thorough comprehension of the language. In the same letter, moreover, Rubens writes: ". . . I should like to examine that volume of *Inscriptiones Africae* myself, not so much to render you a service (that can be done by others with more accuracy), but to indulge my personal taste" (*CDR* 5:14; Magurn, pp. 293–94). Gevaerts, in fact, later wrote of Rubens: "He has perfect knowledge of literature, and all sciences, and is everywhere respected for his expert knowledge of public affairs" (cf. *Pompa Introitus Ferdinandi*, [Antwerp, 1641], p. 171; cited and translated by Julius Held in "Rubens and Aguilonius: New Points of Contact," *Art Bulletin* 61 [1979], p. 257, n. 3).

9. Rubens to Valavez, January 10, 1625; *CDR* 3:319 ff.; Magurn, pp. 12, 102. Such cosmopolitanism was an essential principle in the political thought of Lipsius and his school (cf. Martin Warnke, *Kommentare zu Rubens* [Berlin, 1965], p. 37).

10. Rubens to Faber, April 10, 1609; *CDR* 6:323; Magurn, pp. 52–53. Frans Baudouin ("Rubens' Social and Cultural Background," in *Stil und Ueberlieferung in der Kunst des Abendlandes. Akten des 21. Internationalen Kongresses für Kunstgeschichte in Bonn, 1964* [Berlin, 1967], pp. 14–16) cites this letter to support his thesis that it was the prospect of getting many good commissions in Antwerp, rather than his appointment as court painter, that weighed most in Rubens' decision to remain in the Southern Netherlands.

Once Rubens made up his mind to say farewell to Rome, he quickly rose to become one of Antwerp's leading citizens. Within a few months of writing to Faber, he was admitted to the society of the Romanists, was appointed court painter to Albert and Isabella—with the stipulation that he be allowed to live in the city, rather than at court—and married into a local patrician family. Rubens' success as an artist was immediate, and it was the Antwerp high bourgeoisie who commissioned many of the works (including some of the most important) that he produced during his first few years back in Antwerp.[11]

Rubens' strong ties to the city, as well as many of his most cherished values, are manifest in his palatial home in Antwerp (figs. 1–3). Shortly after his return from Rome, the artist bought some property that included a house with a traditional Flemish stepped-gable façade; this dwelling he partially rebuilt. He also designed, in a contrasting early Baroque style, the separate studio, the magnificent portico joining the two buildings, and a garden with its own pavilion.[12] Even though located in the center of town, the house imitates a Genoese suburban villa rather than an urban *palazzo* (both types occur in Rubens' publication of 1622, *Palazzi di Genova*).[13]

Characteristically, Rubens arranged and adorned all the elements of the house according to a coherent program displaying his considerable architectural talents as well as his humanistic and civic interests. The niches of the lower level of the ornate studio façade (fig. 2), for example, contained busts of rustic deities— a satyr, a faun, Pan, and Silenus—symbols of fertility and inspiration; over the door at the center was a bust of a philosopher, and above, along the second course, painted grisaille busts of other ancient sages; finally, at the highest level appeared classical gods painted to look like sculptured herms.[14] A frieze, also painted and representing scenes from ancient history and mythology, ran between the second and third stories.[15]

The portico, with its triple arcade, was of a grandeur unusual in the private home of an artist and thus constitutes a statement

11. Baudouin (1967), pp. 13–14.
12. No complete study of Rubens' house has been published, but a dissertation on the subject by Michael Yardley (Columbia University) will soon be available. In order to imagine the appearance of the building in Rubens' lifetime, one must make a synthesis from the information provided by various secondary sources. These include Rooses, *Rubens* 1:145–55; Evers (1942), pp. 150–51, and Frans Baudouin (*Rubens House: A Summary Guide* [Antwerp, 1971]).
Rubens' interest in architecture is attested by his acquisition of standard publications in the field: in 1615 he purchased two different editions of Vitruvius; in 1616 he had Serlio's *Architectura* bound; in 1617 he had the works of Simon de Caus bound, and in the same year he bought *Architecture de Vincentio Scamozzi* and *Architecture de Jacques Francquart* (cf. Max Rooses, "Petrus Paulus Rubens en Balthasar Moretus," part 4, *Rubens-bulletijn* 2 [1885], p. 180).

13. This point was made by Michael Yardley in a paper entitled "The Portico of Rubens' House in Antwerp," presented at the Rubens Symposium, Columbia University, November 12, 1977.
For Rubens' views concerning architecture for the bourgeoisie, see foreword to *I palazzi di Genova*, (Antwerp, 1622; quoted and commented upon in *CDR* 2:422–30); see further John Rowlands, *Rubens: Drawings and Sketches* (London, 1977), p. 110.
14. The bust above the door traditionally has been thought to represent Seneca, but as Wolfram Prinz points out, there is insufficient evidence for this identification ("*The Four Philosophers* by Rubens and the Pseudo-Seneca in Seventeenth Century Painting," *Art Bulletin* 55 [1973], p. 412).
15. Elizabeth McGrath's excellent article on the painted frieze appeared after this study was completed; she shows that the carefully selected scenes were intended as a tribute to the great artists of antiquity ("The Painted Decorations of Rubens's House," *Journal of the Warburg and Courtauld Institutes* 41 [1978], pp. 245–77).

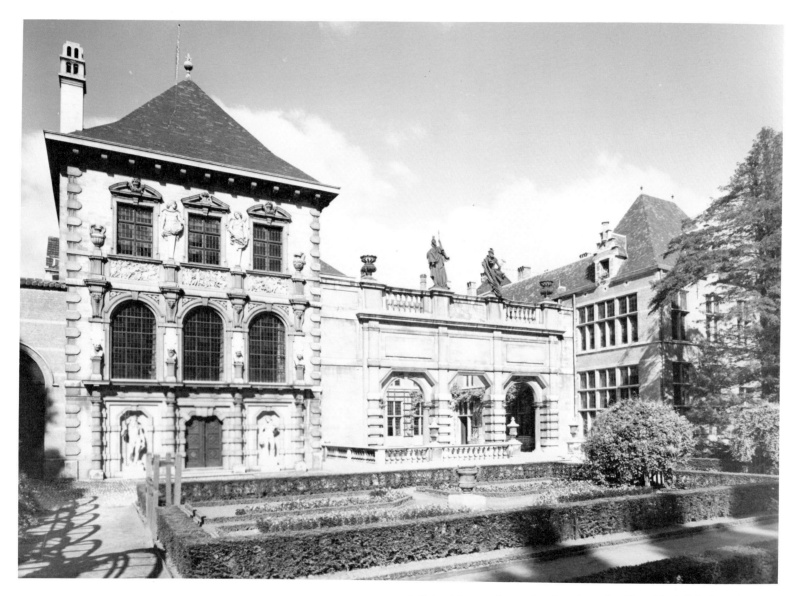

1. Rubens' Antwerp house, view from the garden (Copyright A.C.L.-Brussels)

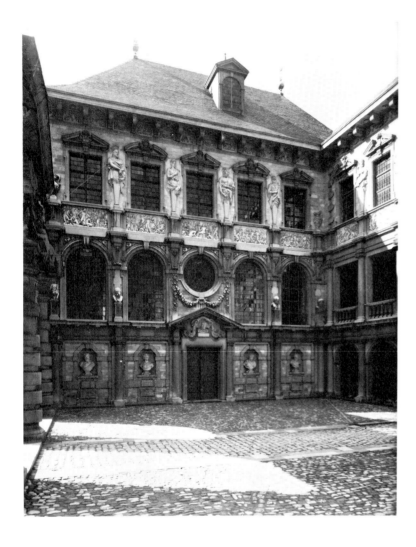

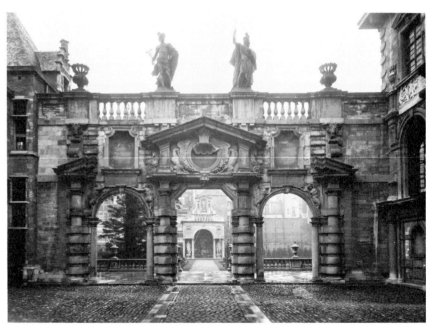

2. Rubens' Antwerp house, studio façade (Copyright A.C.L.-Brussels)

3. Rubens' Antwerp house, garden pavilion viewed through portico (Copyright A.C.L.-Brussels)

by Rubens about his own status and that of his profession.[16] (Later, in 1616, an elaborate exterior stairway leading to the *piano nobile* was built, and this added a further connotation of rank.)[17] The decoration of the portico, like that of the studio façade, embraces mythology and philosophy. There are, for example, satyrs and satyresses, "ancient symbols of the physical prowess of men and women" (in Wolfgang Stechow's words), as well as verses from Juvenal distributed in two cartouches. These read: "Leave it to the gods to give what is fit and useful for us; dearer to them is man than he is to himself. One must pray for a healthy mind in a healthy body, for a courageous soul which is not afraid of death . . . and which is free of wrath and desires nothing" (*Satires* 10:356–60).[18] The portico was topped by a balustrade on which stood two statues of Mercury and Minerva, both patrons of diplomacy and art; the large shells on the frieze may refer to sea trade. Thus the portico

exhibits the imagery of peace and good government and reflects the hopeful attitude nourished by the truce.

In the large garden behind the house, aligned with the central arch of the portico, was a pavilion designed as a rural temple *all'antica* with statues of Ceres, Bacchus, and Hercules, protectors of the land (fig. 3);[19] from the first, it seems, Rubens saw fit to provide his urban dwelling with a token piece of the country, planted around with fruit trees. Another rustic element, situated in a corner of the courtyard, was a spring of water that issued from a grotto containing a seated, piping shepherd with a stag by his side.[20] Inside the house was a large collection of antiquities, paintings, and art objects, as well as what must have been a large library.[21] Thus, considered as a whole—in its expression of domestic, professional, humanistic, and bourgeois values, of traditional and modern styles of architecture, of the artificial and the natural—Rubens' house was the most telling symbol of his identity, reflecting its complexity and essential unity.

The construction of Rubens' house was an event of some importance in a city whose troubles had discouraged any building of significance for some time, and it stood as a sign of civic optimism and returning prosperity.[22] Jan Woverius must have spoken for many of his townsmen when he said of his friends Rubens and the

16. As Evers notes (1942, p. 152), the sixteenth-century artists Quentin Massys and Frans Floris had impressive houses built for themselves in Antwerp. See also McGrath (pp. 248–50, with further references) for a discussion of the houses of other Renaissance artists.

17. Evers (1942), p. 155.

18. Translated by Wolfgang Stechow, *Rubens and the Classical Tradition* (Cambridge, Mass., 1968), pp. 85–86. Juvenal, we may recall, wrote a diatribe against the city in his Third Satire. On the humanist exaltation of country life, as opposed to city life, see below, chapter 6, *passim*.

Placing an inscription—in Greek, Latin, or even Hebrew—over the portal to one's garden had been a custom among humanists at least as early as the sixteenth century; Erasmus mentions this practice in his *Convivium religiosum* of 1522 (cited by P. A. F. van Veen, *De soeticheydt des buyten-levens, vergheselschapt met de boecken . . .* [The Hague., 1960], p. 156).

Over the central arch of Rubens' portico there is also a pair of eagles, probably allusions to secular power; the eagle, symbol of the Holy Roman Empire, figured in the coat of arms of Antwerp. Three episodes of a Roman triumph, moreover, were depicted on the garden façade of the studio (Rooses, *Rubens* 1:148).

19. Baudouin, *Rubens' House*, p. 28. Hercules' association with the Garden of the Hesperides is also relevant in this context.

20. Rooses, *Rubens* 1:147. The grotto is visible in an engraving of 1692 by Jacobus Harrewijn after J. van Croes (illustrated in Evers [1942], fig. 77).

21. For a partial list and description of books owned by Rubens, see Sigrid Macrae, "Rubens' Library" (M.A. thesis, Columbia University, 1971).

22. Cf. Evers (1942), p. 152.

publisher Balthasar Moretus: "How fortunate is our city of Antwerp to have as her two leading citizens Rubens and Moretus. Foreigners will gaze at the houses of both, and tourists will admire them."[23] Woverius wrote these words in 1620; the following year the truce ended, and the condition of Antwerp once again took a downward turn, this time irreversible. The secretary of King Christiaan of Denmark, Abraham Golnitzius, who visited the city in 1624, spoke of the animation that had formerly characterized the stock exchange, and he added: "But of all that, there remains only an immense solitude; the stalls are covered with dust and the pictures with cobwebs. Not a merchant nor a courtier more is to be met with. All has disappeared, all has foundered in the deeps of civil war."[24]

At the time, however, there was still a measure of hope that peace and prosperity might be restored, and it was with this goal in mind that Rubens became involved in a long series of diplomatic activities. The artist was prepared for this new role in part by his early and continuing association with a circle of men who professed the teachings of Justus Lipsius. In Lipsius's "doctrina civilis" the education of the "homo politicus" was put above self-sufficient humanistic scholarship. This philosophy, though Christian, had a largely classical basis, drawing upon Roman history and traditions of Stoicism and using the heroic language of later Roman writers.[25] Rubens' political activity, therefore, functioned for him on one level as another aspect of his devotion to classical ideals, and his own words sometimes express this connection: "I should like the whole world to be in peace," he wrote in 1627, "that we might live in a golden age instead of an age of iron."[26]

The Infanta Isabella, her minister Ambrogio Spinola, and Rubens, all eager to deal seriously and directly with the Dutch, were nevertheless prevented from doing so by the Spanish king, Philip IV. Rubens often felt discouraged by the tactics of the very government he had chosen to serve and came to believe that Spain had little interest in the welfare of the Southern Netherlands. The condition of Antwerp was ever on his mind. In 1627, for example, he wrote to Dupuy:

Public affairs are going along very quietly here, and we find ourselves rather without peace than at war; or, to put it better, we have the inconvenience of war without the advantage of peace. This city, at least, languishes like a consumptive body, declining little by little. Every day sees a decrease in the number of inhabitants, for these unhappy people have no means of supporting themselves either by industrial skill or by trade. One must hope for some remedy for these ills caused by our own imprudence, provided it is not according to the tyrannical maxim, *Pereant amici dum inimici intercidant* [Let friends perish, as long as enemies are destroyed with them]. But even this plan would not succeed, for our own misery far exceeds the little damage we can inflict upon our enemies.[27]

23. Woverius to Moretus, October 1, 1620 (trans. in Rooses, *Rubens* 1:153). Moretus at that time was considering enlarging and beautifying his ancestral house. Woverius urges him to do so, saying, "Forward, my dear Moretus, and continue to exalt the glory of your race, not only by your art and your erudition, but also by the magnificence of your abode."

24. Translated in Rooses, *Rubens* 1:15.

25. Rudolf Pfeiffer, *History of Classical Scholarship from 1300 to 1850* (Oxford, 1976), p. 126, and Warnke, *Kommentare*, pp. 33–38.

26. Rubens to Pierre Dupuy, April 22, 1627; *CDR* 4:243–47; Magurn, p. 178.

27. Rubens to Dupuy, May 28, 1627; *CDR* 4:264–65; Magurn, pp. 184–85.

From September 1628 to March 1630, Rubens, as an official emissary of the Spanish crown, was in Spain and England seeking to negotiate a treaty between the two nations. The events of this year and a half abroad touched Rubens' life in many ways. A letter written from London to Dupuy in 1629 is especially revealing and bears quoting in part:

To see so many varied countries and courts, in so short a time, would have been more fitting and useful to me in my youth than at my present age. My body would have been stronger, to endure the hardships of travel, and my mind would have been able to prepare itself, by experience and familiarity with the most diverse peoples, for greater things in the future. Now, however, I am expending my declining strength, and no time remains to enjoy the fruits of so many labors, *nisi ut, cum hoc resciero doctior moriar* [except insofar as, by discovering this, I may die the wiser].

Nevertheless, I feel consoled and rewarded by the mere pleasure in the fine sights I have seen on my travels. This island, for example, seems to me to be a spectacle worthy of the interest of every gentleman, not only for the beauty of the countryside and the charm of the nation; not only for the splendor of the outward culture, which seems to be extreme, as of a people rich and happy in the lap of peace, but also for the incredible quantity of excellent pictures, statues, and ancient inscriptions which are to be found in this Court. I shall not mention the Arundel marbles, which you first brought to my attention. I confess that I have never seen anything in the world more rare, from the point of view of antiquity, *quam*

foedus ictum inter Smyrnenses et Magnesios cum duobus earundem civitatum decretis et victoriis Publii Citharoedi [than the treaty between the people of Smyrna and those of Magnesia, with the decrees of these two cities and the list of the victories of Publius Citharoedus]. . . .

I expect to remain here for a little while, in spite of my desire to breathe once more the air of my own home.[28]

By 1629, then, Rubens felt himself to be growing old and was worried by a sense that his years were limited. At the same time, however, his natural curiosity about the world and enthusiasm for new experiences and sights—including the beautiful countryside—remained undiminished. (England, "happy in the lap of peace," must have presented a strong contrast to his native Netherlands, "the battlefield and theater of the tragedy," as he once called it.) Of all the treasures in the collection of the Earl of Arundel, Rubens chooses to mention one that had a personal significance for him, an ancient treaty, which in his mind must have been connected with his own recent diplomatic success.[29] Finally, as he does in so many of his letters written while away from Antwerp, Rubens expresses his desire to return home—though as he states elsewhere, it is not without a certain dread that he faces "coming back in such unfavorable circumstances."[30] In spite of the turmoil in which the Southern Netherlands still floundered, however, Rubens was to live out the rest of his days in happiness and prosperity.

28. Rubens to Dupuy, August 8, 1629; *CDR* 5:147; Magurn, pp. 320–21.
29. Stechow notes this connection (*Rubens*, p. 20).
30. Rubens to Jan Caspar Gevaerts, September 15, 1629; not in *CDR*; Magurn, p. 337.

If Rubens was wearied by his efforts at court, there is little sign of declining strength in the last decade of his life—a period, in fact, of personal renewal. Returning home, he wed the young Helena Fourment, and they produced five children. In the 1630s Rubens' artistic activity also increased, and in spite of a large number of important commissions, he found time to paint for himself. Even his style continued to develop during these years, partly as a result of his intense study of Titian's paintings in Spain.

In a famous letter to Peiresc of December 18, 1634, written after their correspondence had been suspended for four years, Rubens brings his friend up-to-date on the recent turns his life had taken:

Now, for three years, by divine grace, I have found peace of mind, having renounced every sort of employment outside of my beloved profession. . . . When I found myself in that labyrinth, beset night and day by a succession of urgent duties; away from my home for nine months, and obliged to be present continually at Court; having reached the height of favor with the Most Serene Infanta (may she rest in glory) and with the first ministers of the King; and having given every satisfaction to the parties abroad, I made the decision to force myself to cut this golden knot of ambition, in order to recover my liberty. Realizing that a retirement of this sort must be made while one is rising and not falling; that one must leave Fortune while she is still favorable, and not wait until she has turned her back, I seized the occasion of a short, secret journey to throw myself at Her Highness' feet and beg, as the sole reward for so many efforts, exemption from such assignments and permission to serve her in my own home. This favor I obtained with more difficulty than any other she ever granted me. Now,

by God's grace, as you have learned from M. Picquery, I am leading a quiet life with my wife and children, and have no pretension in the world other than to live in peace.[31]

With his young wife and growing family, Rubens had a very personal stake in the future of the Southern Netherlands. Antwerp's decline continued, and this became one of the major themes of the decorations he designed for the triumphal entry of the Infante Ferdinand in 1635.[32]

Rubens' purchase of the seignory of Steen, less than a month after Ferdinand was welcomed to Antwerp, was surely connected with the plight of the city. Already ennobled for his diplomatic services by Charles I and Philip IV, the artist was thereby eligible to become a member of the Flemish lower gentry. His application for the title met with no opposition, and the Council of Brabant approved the purchase on May 12, 1635. There was a certain honor attached to the title "Heer van Steen," and it is in fact among the first of Rubens' attributes that Gevaerts mentions on the epitaph he wrote at his friend's death.[33] But one cannot help thinking that

31. Rubens to Peiresc, December 18, 1634; *CDR* 6:81; Magurn, pp. 392–93.
32. On Rubens' designs for the triumphal entry, see J. R. Martin, *The Decorations for the Pompa Introitus Ferdinandi* (New York, 1972).
33. The epitaph, quoted and translated in Rooses, *Rubens* 1:571 reads:

D. O. M. [Deo optimo maximo] Petrus Paulus Rubenius Eques Joannis, hujus urbis senatoris, Filius steini Toparcha: Qui inter caeteras quibus ad miraculum Excelluit doctrinae Historiae priscae, Omniumque bonarum Artium et Elegantiarum dotes Non sui tantum saeculi, Sed et omnis aevi Apelles dici meruit: Atque ad Regum Principumque virorum amicitias Gradum sibi fecit: A Philippo IV. Hispaniarum indiarumque Rege Inter sanctioris Concillii scribas adscitus, Et ad Carolum Magnae Britanniae Regem Anno M. DC. XXIX. delegatus, Pacis inter eosdem Principes mox initae Fundamenta feliciter posuit. Obiit anno sal. MDC. XL. XXX May aetatis LXIV. (To God all good and great. Peter Paul Rubens, knight, son of Jan alderman of the city of Antwerp: Lord of

the gain in social status attending the acquisition of the estate must have seemed desirable to Rubens chiefly for the sake of his family's future. When Helena Fourment remarried in 1644, her new husband was a nobleman; Nicholas acquired a seignoral seat; and the two oldest children of the second marriage wed members of the landed gentry.[34] Rubens' descendants would not have enjoyed such high social standing, had they not been heirs of the Lord of Steen. Furthermore, Rubens lived on the estate only during the summer months, whereas after his death—as he may have foreseen—his wife and younger children spent most of their time in the country. Nine years after Rubens' death, the Antwerp house was rented out, and thereafter it was never again inhabited by members of the artist's family.[35]

Rubens paid a high price for Het Steen, considering that neither the house nor the amount of land was very large.[36] The château presented a striking contrast to the refined Italianate home in Antwerp (fig. 4 shows the remodeled castle as it looks today). When the estate was put up for sale in 1682, it was described as a "manorial residence with a large stone house and other fine buildings in the form of a castle, with garden, orchard, fruit trees and draw-bridge, and a large hillock on the middle of which stands a high square tower, having also a lake and a farm . . ., the whole surrounded by moats."[37] Thought to have been about a century old in 1635, the castle was designed in a simple Flemish Renaissance style fea-

Steen, who, among the other gifts by which he marvellously excelled in the knowledge of ancient history and all other useful and elegant arts, deserved also to be called Apelles, not only of his own age, but of all time, and made himself a pathway to the friendship of kings and princes: by Philip IV, King of Spain and the Indies, he was appointed one of the secretaries of the most venerable council, and sent as an ambassador to Charles, King of Britain in the year 1629, and laid with skill the foundations of the peace that was thereafter soon concluded between those Princes. He died in the year of our salvation 1640, on the 30th May, aged 64 [sic].)

34. Evers (1942), p. 477. The remaining three children either died early or took religious vows. Albert had been appointed secretary to the privy council as early as 1630, though he was not supposed to act in that capacity until his father's retirement or death (Rooses, Rubens 1:154).

35. We do not know how much time Rubens actually spent at the château. A number of letters written by him from Antwerp and dating from the summer months of the years 1636–39 indicate that he went back and forth between Elewijt and the city with some regularity. In a letter of May 9, 1640, Rubens mentions that his wife is departing for Steen; thus his family may have sojourned there even when he was compelled to stay behind in Antwerp.

36. The land immediately surrounding the château measured over eight acres (4 bunderen, 50 roeden) and many other pastures and farmlands in the vicinity belonged to the estate as well (Max Rooses, "De plakbrief der heerlijkheid van Steen,"Rubens-bulletijn 5 (1900), pp. 149 ff.

Rubens paid 93,000 florins for the seignory, and made 7,000 florins worth of improvements and additions (Rooses [1900], p. 149). To gain an idea of what this amount meant, we can compare it with the 84,000 florins Rubens received from the largest sale he ever made—that of his collection of classical statuary and many paintings to the duke of Buckingham (the money he made from this sale, incidentally, was invested in land); the 500 florins he received annually as a painter to the archducal court; or the 1,600 florins he earned painting an altarpiece for the high altar of a church in Afflighem (cf. Evers [1944], p. 87).

Het Steen was not the first rural property Rubens owned. He had inherited farmlands from his mother and had made several purchases on his own; it is thought that most of these properties were investments from which he received annual rents (he also owned a good deal of urban real estate). On Rubens' ownership of land other than Het Steen, see Evers (1942, p. 385) and Max Rooses, "Staet van goederen in het sterfhuis van Isabella Brant," Rubens-bulletijn 4 (1895), pp. 165–72.

37. Rooses, Rubens 2:571, and Max Rooses, "De plakbrief," p. 152. Rooses publishes photographs of the house as it appeared before the restorations and embellishments of the late nineteenth century (Rubens 2:571, 572); apparently the building was originally simpler and rougher in aspect than it is today.

A fuller description of the château in its present form can be found in E. Poumon, Les châteaux du Brabant (Brussels, 1949), nos. 5, 6; in the introductory essay Poumon states that most of the castles in the region were constructed on the foundations of medieval châteaux.

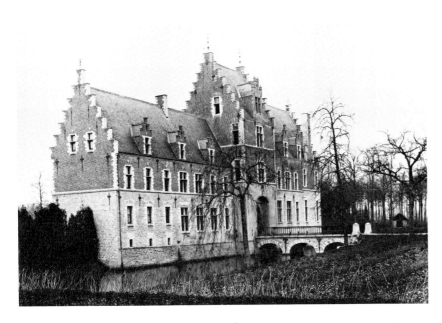

4. Rubens' château, Het Steen, Elewijt, Belgium; recent photograph (Copyright A.C.L.-Brussels)

turing stepped gables, jointed red brick walls with white stone frames around the windows and doors, and a hexagonal turret on the façade facing the park. A long, low building—the stable—was attached to the residence, and there were several farm buildings nearby. The surrounding landscape was as typically Netherlandish as the manor house, and was known then, as now, for its fertile soil, healthy climate, and pleasing aspect.[38]

Unlike Rubens' Antwerp house, where the architecture itself reveals so much about the artist's attitudes and values, the meaning of Het Steen for Rubens can only be inferred. The artist had been suffering from gout as early as 1625, and his health steadily declined during the 1630s. Antwerp was hardly known for its healthy climate, and Rubens had been compelled to leave the city for this reason on at least one occasion.[39] Perhaps the greatest importance his country place had for him, however, was that it offered the leisurely atmosphere and proper surroundings in which he could devote himself seriously to the painting of landscape, a subject he certainly thought about deeply. The connection between Het Steen and Rubens' landscapes was made early, in one of the letters concerning his uncle's biography that Philip Rubens wrote to de Piles:

> The landscapes he painted even surpass in esteem the figure paintings, and are fewer in number. Having bought the seignory of Steen, between Brussels and Malines in the year 1630 [sic], he took great pleasure living there in solitude, in order to paint vividly and *au naturel* the surrounding mountains, plains, valleys, and meadows, at the rising and setting of the sun, up to the horizon.[40]

38. See *Winkler Prins encyclopedie van Vlaanderen*, vol. 2 (Brussels, 1973), pp. 338–40, where the beauty of the landscape around Het Steen is remarked upon. The fertility of the soil and healthy climate are mentioned by Rooses (*Rubens* 1:571).

39. It is generally believed that Rubens' wife Isabella Brant died of the plague.

40. "Les paysages qu'il a peints surpassent encore en estime les figures, aussi sont-ils en moindre nombre. Ayant acheté la seigneurie du Steen entre Bruxelles et Malines, l'an 1630, il y prenoit grand plaisir de vivre dans la solitude, pour tant plus vivement pouvoir dépeindre au naturel les montaignes, plaines, vallées et prairies d'alentour, au lever et au coucher du soleil avec leurs orizons" (Ruelens, "La vie," p. 167).

Rubens himself says little about the estate in his surviving letters, only two of which were written from Het Steen. The first of these is addressed to Peiresc. Apologizing for his "long silence," the artist explains: "To tell the truth, I have been living somewhat in retirement for several months, in my country house which is rather far from the city of Antwerp and off the main roads. This makes it very difficult for me to receive letters and also to send them." After discussing various drawings after ancient objects that the correspondents were exchanging, Rubens continues:

I cannot pass over in silence the fact that in this place are found many ancient medals, mostly of the Antonines, in bronze and silver. And although I am not very superstitious, I confess that it did not seem to me a bad omen to find on the reverse of the first two that came into my possession: SPES and VICTORIA. They are medals of Commodus and his father, Marcus Aurelius.

Further talk of books follows, and at the bottom of the letter Rubens writes—not, we imagine, without a certain pride—"From my Castle Steen, September 4, 1636."[41] Thus we learn that Rubens has spent the summer in the country "somewhat in retirement," although

nothing specific is said about how he is occupying his time. We can be quite sure, however, that he continued to paint as he always had, even when he had been away from Antwerp on diplomatic missions. Rubens' personal reaction to the Roman coins dug up near the estate recalls his enthusiastic response to the inscription on Arundel's ancient treaty.

The second letter, of August 17, 1638, to Lucas Fayd'herbe, who was taking care of the Antwerp studio reads:

My dear and beloved Lucas:
I hope that this will find you still in Antwerp, for I have urgent need of a panel on which there are three heads in life-size, painted by my own hand, namely: one of a furious soldier with a black cap on his head, one of a man crying, and one laughing. You will do me a great favor by sending this panel to me at once, or, if you are ready to come yourself, by bringing it with you. It would be a good plan to cover it with one or two new panels so it may not suffer on the way, or be seen. We think it strange that we hear nothing about the bottles of Ay wine; that we brought with us is all gone.
And so, with best wishes for your health, and for little Caroline and Susanna also, I remain, with all my heart, dear Lucas,

Your devoted friend,
Peter Paul Rubens

Take good care, when you leave, that everything is well locked up, and that no originals remain upstairs in the studio, or any sketches. Also remind William the gardener that he is to send us some Rosile pears as soon as they are ripe, and figs when

Even earlier, around 1630, Constantine Huygens remarked of Rubens, "When an infectious disease that recently reigned in the city forced him to retreat to a country place, he applied himself to the painting of landscapes with the same fruitfulness and proficiency [as he had to other works]" (J. A. Worp, "Constantijn Huygens over de schilders van zijn tijd," *Oud Holland* 8 [1891], p. 119). Many of the landscapes listed in his inventory are characterized as having been painted directly from nature.

41. Letter of September 4, 1636 (*CDR* 6:164; Magurn, pp. 404–06).
The parish of Elewijt had been the site of Roman settlements during the Augustan period, the first century A.D., and at the end of the second and beginning of the third centuries (*Winkler Prins encyclopedie van Vlaanderen*, vol. 2, p. 389).

there are some, or any other delicacy from the garden. Come here as soon as you can, so the house may be closed; for as long as you are there you cannot close it to the others. I hope that you have taken good care of the gold chain, following my orders, so that, God willing, we shall find it again.[42]

Lucas Fayd'herbe, a sculptor from Malines, was forty years younger than Rubens and not only the painter's protégé but also a close friend. From this letter we learn that the Antwerp studio—containing among other treasures Rubens' gold chain, given to him by Charles I—was left in Fayd'herbe's care, and that soon the young sculptor would be visiting Rubens in the country. The mention of Ay wine (a type of champagne), Rosile pears, and figs creates a sense of the pleasures Rubens set store by while spending his summers at Het Steen.

The letter to Fayd'herbe also confirms that Rubens continued to work when he was in the country. The painting depicting three heads was surely a study piece, most likely intended for a painting of peasants and marauding soldiers that is known in several versions.[43] We may also recall the testimony of Philip Rubens, often repeated by later writers, that his uncle painted landscapes at Het Steen. Indeed, the pleasing picture of an aging Baroque artist producing peaceful rural landscapes for his own enjoyment, at a country house signifying his well-earned wealth and status, led to the popular notion that Rubens' landscapes belong only to the later period of his artistic activity.

The association of the landscapes with the country estate does in fact provide an important focus for exploring certain central issues in his art. But the majority of the landscapes were painted before he purchased Het Steen, and the traditional assumptions regarding country life, ownership of land, retirement, and freedom are in the end relevant only to a small number of his works.

Rubens' interest in the world of nature and the world of art arose from many sources and finds the most varied and changing expression in his landscapes. In the following chapters I hope to suggest the breadth and depth of his ideas as well as their basic unity.

42. *CDR* 6:22; Magurn, pp. 410 f.
43. The panel Rubens mentions is lost. Its possible connection with the painting of peasants and marauding soldiers (original lost) was pointed out by Held, no. 68, with further references.

2. READING RUBENS' LANDSCAPES

A concept critical for comprehending the landscapes of Rubens—"the most learned painter in the world"—is *ut pictura poesis*. The phrase was deliberately misread by Renaissance art theorists to mean "as is poetry, so is painting." Ut pictura poesis carried with it the demands that painters, like poets, imitate illustrious models, choose their themes from established sources (especially from the sister art, poetry), treat subject matter with decorum, and seek both to edify and to delight the viewer. One assumption behind these ideas is that the status of painting is enhanced through its association with the liberal art of rhetoric, a species of which is poetry.[1]

Ut pictura poesis applies to landscape insofar as painters traditionally followed poets when the outdoor settings of their stories were deemed important. Pieter Bruegel's *Fall of Icarus* (fig. 5) provides perhaps the best-known example; like Ovid, the painter assumes a panoramic viewpoint, peoples the land with a fisherman, a shepherd, and a plowman, and scatters islands in the sea (*Me-* tamorphoses 8:217-30).[2] Another instance is Titian's *Diana and Actaeon* (Edinburgh, National Gallery of Scotland, loan), in which Ovid's picture of an arched woodland grotto is explicitly recreated (*Metamorphoses* 3:155-62).[3] And Rubens and Jan Brueghel, in their *Feast of Achelous* (New York, Metropolitan Museum of Art), translate into paint Ovid's description of a river god's damp cave of pumice and tufa (*Metamorphoses* 8:547-76).[4]

Among the finest paintings inspired by a text is a late landscape by Rubens himself: *Odysseus on the Island of the Phaiakians* (fig. 6; ckl. no. 8). In this work the artist reveals his understanding of the meaning of the land in a story told by Homer (book 6). The episode in the narrative that Rubens depicts follows the shipwreck of Odysseus, his desperate swim through choppy waters until he finds the mouth of a river, his arrival at an unknown shore, and a night

1. The classic study of this idea with respect to the Renaissance and the seventeenth century is R. W. Lee, *Ut Pictura Poesis: The Humanistic Theory of Painting* (New York, 1967).

2. See G. Glück, "Peter Bruegel the Elder and Classical Antiquity" (*Art Quarterly* 6 [1943], pp. 167 ff.) for the relationship between the *Fall of Icarus* by Bruegel and Ovid's text.

3. On Titian's imaginative reading of Ovid for the setting of the *Diana and Actaeon*, see E. Panofsky, *Problems in Titian, Mostly Iconographic* (New York, 1969), pp. 157 ff.

4. The Rubens-Brueghel Feast of Achelous is discussed by Julius Held ("Achelous' Banquet," *Art Quarterly* 4 [1941], pp. 122 ff.).

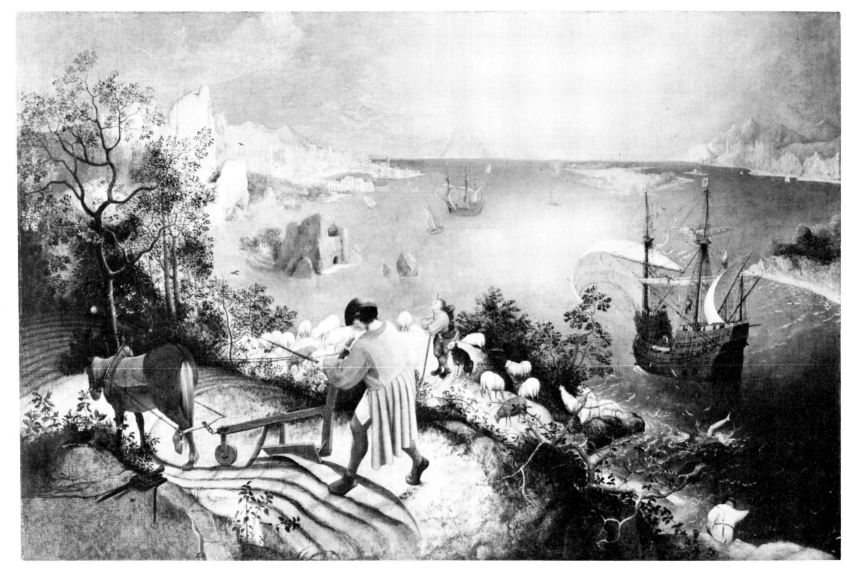

5. Pieter Bruegel, *Fall of Icarus*, Brussels, Musées Royaux des Beaux-Arts (Copyright A.C.L.-Brussels)

spent in a wood up the slope from the river. Homer, always precise about the hero's survival tactics, tells how Odysseus made his bed in layers of fallen leaves beneath two trees, one of thorn, one of olive, and so closely intertwined as to be inpermeable. The next morning Odysseus is awakened by the playful shouts of young women: the court ladies of Nausikaa, daughter of Alkinoös, king of the island of the Phaiakians, and Nausikaa herself. The dutiful princess had come with her friends to a remote stream in order to wash the clothes of her father and brothers. Just as she is preparing to leave, the miserable Odysseus emerges from the bushes, resolved to save himself from cold and starvation. At the sight of him, Nausikaa's companions are frightened away, but the princess herself stands firm and hears the hero out. Thus Rubens presents the dramatic moment when two people cast together by fate confront each other with all their wits. The larger meaning of this story, however, depends on the depiction of the landscape, which shows both the place whence Odysseus came and where he is soon to head.

The composition is dominated by a diagonal separating the great mountain from sky and sea. From the summit of the mountain, which blends with clouds in the upper right corner of the painting, cascades of water pour down to the place where Nausikaa and her companions stand. The location of this washing site, according to the poet and as suggested by the painter, was up the slope from the saving river and near the woods where Odysseus had spent the night. Close by stood the princess's wagon and mules. Homer repeatedly refers to the conveyance, describing it as high, fine, with good wheels, polished, and equipped with a carrying basket. The wagon has importance in the narrative as a sign of the well-kept household of the king and as the vehicle linking the shipwrecked Odysseus to the town—or one part of the story to the next. Rubens gives the motif a certain prominence and shows it already pointing down the road.

Below, in the lower left corner of the picture is a patch of dark sea, referring to Odysseus's adventure of the previous night. Above this—the lowest, darkest, and densest place in the painting— is the highest, loosest, and lightest place: the goddess Athena, Odysseus's protectress, holding council in the clouds with Jove. Moving up the coast the water changes: at the tip of the land is a calm, shining harbor with the capital city of the Phaiakians rising above. Nausikaa promises to escort Odysseus there and explains in advance of the trip exactly what he will see: a towering wall with a handsome harbor on either side of the city, a narrow causeway, and along the road the oarswept ships, each drawn up at its own slip; also, a stone place of assembly built around a precinct of Poseidon where boatmen tend their gear. Rubens translates this description into a miniature city sparkling in the sun with a harbor and blue sea stretching out before it. On the way, Nausikaa continues, they will pass her father's estate; and indeed, the mountain, halfway up, is adorned with a country house and elaborate formal garden, complete with pergola, round temple, and plantings of trees. It is a good land, and the princess is proud of its features: its isolation from the homes of other men, its special favor in the eyes of the gods, its lawful government, and the skill and industry of its people.[5]

5. The king's estate, according to the poet, was "as far from the city as a shout of a man will carry" (trans. Richmond Lattimore [New York, 1965], p. 110). In this respect, Rubens does not follow the text literally; instead, he isolates the estate, setting it up for display at the center of the picture.

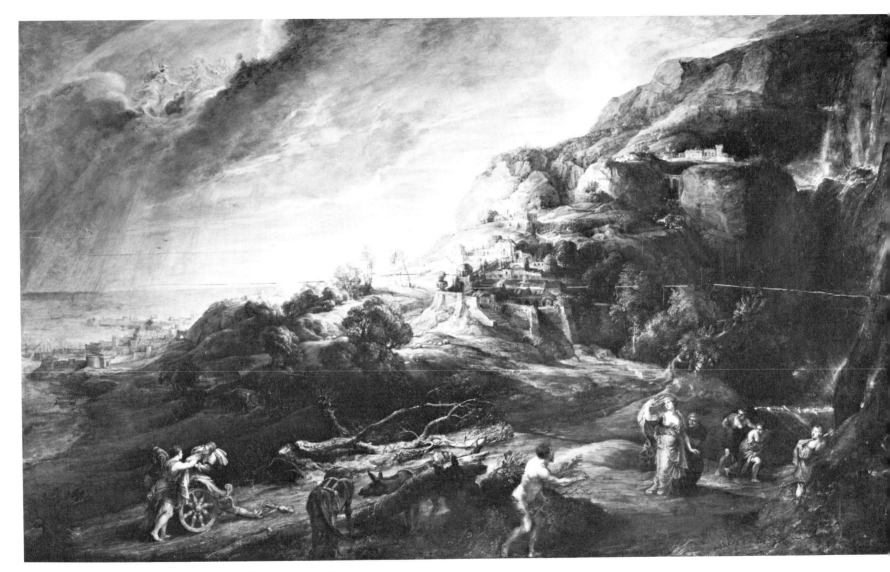

6. *Odysseus on the Island of the Phaiakians*, Florence, Galleria Pitti, Gabinetto Fotografico, Soprintendenza Beni Artistici e Storici di Firenze.

Rubens does not simply tell a story with this picture but also conveys its themes: the mythical narrative has to do with human and divine will, fortune and fate, struggle and salvation, the unpredictability of the sea versus the stability of the land, wandering through the world and coming home to rest. *Odysseus on the Island of the Phaiakians*—a picture in which the artist breaks through with a bold design, plays out a rich chromatic scale, and represents a world in both its minute particulars and its expansive spaces—also reveals the sort of appeal that landscape alone could have for a painter.[6]

Generally it is not possible to plot the relationship between landscapes by Rubens and a specific text, as in the case of the *Odysseus*. Yet the notion ut pictura poesis remains helpful for interpreting his works in this branch of painting. Since the literary dimension of Rubens' landscapes is a major theme of this chapter, we may begin by considering the relationship of landscape painting and poetry as perceived by the most articulate Northern artist of the late sixteenth century, Carel van Mander.

CAREL VAN MANDER: UT PICTURA POESIS AND LANDSCAPE PAINTING

Carel van Mander, author of the *Schilder-boeck* (Amsterdam, 1604), was the chief proponent in the North of ut pictura poesis, a notion repeatedly expressed in his writings. A poet as well as a painter, like his learned teacher Lucas de Heere, he was well qualified to propagate the idea that painting and poetry enjoy a special relationship. Part of the *Schilder-boeck* is a lengthy treatise on painting entitled *Den grondt der edel vrij schilder-const* ("The Foundation of the Noble and Liberal Art of Painting"). *Den grondt* is actually written in rhymed verse, and its section on landscape (chapter 8) contains many purely poetic passages having nothing to do with pictorial technique. In fact, although the treatise synthesizes sixteenth-century Italian theories of art from a Northerner's point of view, it is more a literary work than a true guide to the chief artistic issues of the period.[7] Still, van Mander remains an important art-historical source, since he was an active professional artist and a friend of such men as Hendrick Goltzius and Cornelius Cornelisz. van Haarlem.

As a poet, van Mander was influenced even more by the culture of France than of Italy.[8] French literature, in fact, played a crucial role in the development of Netherlandish literary language in the late sixteenth and the seventeenth centuries. For our purposes it

6. Roger de Piles, in his "Description de quelques tableaux de Rubens tireés du cabinet de M. le Duc de Richelieu" (*Recueil de divers ouvrages sur la peinture et le coloris* [Amsterdam and Leipzig, 1767], pp. 343 f.) gave a detailed description of this landscape. He believed that Rubens first represented an actual site, the town of Cadiz, and then decided to add figures from the Odyssey. It is possible, certainly, that the artist began with the landscape, though not necessarily a topographical view. Burckhardt recognized that the seaport depicted in the painting represents— or, we might say, came to represent—the capital of the Phaiakians, and the palace and garden halfway up the mountain the estate of King Alkinoös (Jacob Burckhardt, *Recollections of Rubens*, trans. Mary Hottinger, ed. H. Gerson [New York, 1950], pp. 156 f.).

7. Hessel Miedema makes this point repeatedly in his edition of *Den grondt*. Among van Mander's Italian sources are Alberti, Dolce, Francesco Lancelotti, Leonardo, and Vasari. Miedema cites evidence of van Mander's use of these and other authors (pp. 629–49; see also E. K. J. Reznicek, "Het leerdicht van Karel van Mander en de acribe van Hessel Miedema," *Oud Holland* 89 [1975], p. 107).

8. Miedema, pp. 630–32, with further references.

is important that the entire range of Renaissance ideas about nature was fully expressed in French poetry of the later sixteenth century and that these ideas were current in the Netherlands (North and South) in Rubens' day. In particular, the works of two poets familiar to van Mander, Pierre de Ronsard and Guillaume de Sallust, Sieur du Bartas, offer a compendium of notions that are useful to keep in mind when studying seventeenth-century landscape. An aspect of Ronsard's poetry enthusiastically imitated in the Low Countries is the lyrical celebration of the countryside as a place of beauty, tranquility, and poetic inspiration and as a setting for love as well as self-revelation. Du Bartas, on the other hand, whom van Mander called "the light of the French language," saw nature as a mirror of infinite, divine love.[9] His *Première sepmaine ou la création du monde* (1578), a total of more than 7,500 rhymed lines divided into seven "days," is an encyclopedic cosmological poem, written from a fervently Christian viewpoint, about the origin and workings of the universe. Du Bartas, moreover, like Ronsard, had retreated to an estate in search of respite from the turmoil of his day, claiming to find in the country solace and inspiration. But he was less interested in the stirrings of the heart than in the divine plan of human history revealed in the Bible. *Première sepmaine*, available in many French editions in Rubens' day and translated into Flemish in 1609, may well have been familiar to the artist.[10]

9. Van Mander's praise is quoted by A. Beekman, *Influence de du Bartas sur la littérature néerlandaise* (Poitiers, 1912), p. 30.

10. The translation of 1609 was by a Fleming, Theodore van Liefvelt, Heer van Opdorp. Opdorp dedicated his translation to the States of Brabant and to the city of Brussels. In these two dedications he characterized his effort as an attempt to purify and enrich the native tongue by translating a celebrated work without recourse to any foreign words. One result of his purifying effort is that his translation,

As a painter, van Mander himself produced a number of landscapes. But when he used the word *landschap* with respect to painting, he did not necessarily mean *a* landscape; rather, he employed the word descriptively to mean outdoor scenery, whether this made up the whole of a picture, a setting, or a background. A landscape painter reading van Mander's chapter on landscape in *Den grondt* would think of landscapes, while a history painter might read it with settings in mind.[11]

literally faithful, is immensely difficult to read, being full of neologisms and Flemish dialect words that never entered into standard usage (cf. Beekman, pp. 73–89).

In F. Haber's words, du Bartas's *Première sepmaine* "was something of an inspirational bestseller in the late sixteenth and early seventeenth centuries." It went through at least fifteen editions before 1584, and the last Paris edition appeared in 1611. Although du Bartas was a Calvinist, and very popular in Protestant countries, there seems to have been "no particular hostility to him on the part of Catholics. The conversion of Henry to Catholicism upon taking the crown was probably of far less importance in explaining his loss of popularity in Paris than the shifting tides of taste" (cf. Guillaume de Salluste, Sieur du Bartas, *Bartas: His Devine Weekes and Works*, trans. Josuah Sylvester [London, 1605]; a facsimile reproduction introduced by F. Haber [Gainesville, Fla., 1965], pp. v–vii). In the standard critical edition of the works of du Bartas no instances are cited of Catholic prejudice toward his writings (cf. Guillaume de Salluste, Sieur du Bartas, *Works*, ed. Urban Tigner Holmes, Jr., John Coriden Lyons, and Robert White Linker, vol. 1 [Chapel Hill, N.C., 1935]). The direct quotations from du Bartas will be found in this edition of his works.

11. Miedema (p. 539) does not believe that van Mander or his contemporaries thought of landscape as an independent genre; this is disputed by E. K. J. Reznicek in "Het leerdicht," pp. 118 f. The terms of their argument seem confused, however. By van Mander's time pictures called landscapes, with figures complementing the setting rather than vice versa, already existed in great numbers. But we should not think of such pictures as "pure landscapes" in the sense that the phrase is frequently used today, suggesting an unimaginably value-free kind of subject (cf. E. H. Gombrich, "The Renaissance Theory of Art and the Rise of Landscape," in his *Norm and Form* [London, 1966]; while Gombrich does not go quite so far, such is often the trend of his discussion of sixteenth-century Northern landscape). Renaissance and Baroque landscapes—like all art—always express a theme, a shared strain of sentiment, or a set of vlaues, no matter how trivial and regardless of whether human figures are depicted or not.

In *Den grondt*, the concept *ut pictura poesis* is manifest with regard to landscape mainly through those poetic descriptions with which van Mander displays his literary skills and through which, at the same time, he wishes to inspire analogous pictorial responses on the part of his professional audience. It is not that he expects artists to illustrate his literary evocations, but rather that he hopes they will convey similar values in their works. In his chapter on landscape, which runs to forty-seven verses, he begins with an exhortation to young painters who have been sitting hunched over, diligently grinding away at their work for so long that they have become muddled, their senses dulled, now to lay aside their yoke, "because rest is also necessary for strong men: the bow cannot always be bent" (*Grondt* 8:1).[12] Van Mander advises these students— since it is summer and the nights are short—to take a light dinner, go early to bed, and rise before dawn. "Come," he says, "let us lighten our spirits and go look at the beauty that is to be seen outdoors, where beaked musicians pipe their songs. There we'll see many views that will serve us in painting a landscape on canvas or on hard oak planks. Come, I think you'll be satisfied with the trip" (*Grondt* 8:3). Then he paints a verse picture of the dawn as it is enacted by Aurora. Such classical allusions abound in the treatise, but like pastoral poets who wish to create a rustic tone, van Mander also uses Dutch words in dialect, which he translates *in margine*. He feels obliged to explain certain poetical figures as well; one marginal note, for example, reads, "Tellus is the earth; her hair is made of plants and grasses be-pearled with dew" (*Grondt*

8:6). Abruptly turning from the mythological conception of dawn, van Mander then exclaims: "Look—the orange-yellow, round ball of the sun has already risen; that happened fast, when we stood looking in the opposite direction. Look—over there, in front of us: hunters with dogs walking through the green, bedewed fields. O look how the dew that's been trod upon shows us, with a greener shade of green, which way they've walked, the track of their footprints" (*Grondt* 8:7). It is only in the following stanza that van Mander begins to offer technical advice on how to paint landscape.

In the first seven stanzas of his chapter on landscape, then, van Mander associates nature with leisure and artistic inspiration; that is, he endows landscape with its most common poetical meaning. Van Mander employs a conceit, fairly traditional in poetry, that he is actually in the landscape, pointing out various sights to young painters. This gives the last passage in particular a feeling of immediacy, epitomized by the observation that the darker shade of green in the grass marks the path trodden by hunters and dogs. The motif of footprints, however, may have been inspired by another literary source. In Sannazaro's *Arcadia* there is a famous descriptive passage in book 1 that reads, in part, as follows:

> . . . we found painted above the entrance [of a temple] some woods and hills very beautiful and rich in leafy trees and a thousand kinds of flowers. A number of herds could be seen walking among them, cropping the grass and straying through the green meadows, with perhaps ten dogs about them standing guard, their tracks most realistically visible in the dust.[13]

12. Unless otherwise indicated, the translations from van Mander are mine, based on Hessel Miedema's modern Dutch translation. The source numbers here and in the text correspond to chapter and stanza.

13. Jacopo Sannazaro, *Arcadia and Piscatorial Eclogues*, trans. R. Nash (Detroit, 1966), pp. 42 f. Subsequent citations are to this edition.

Van Mander draws upon this description again elsewhere in the treatise, "paints" a typical pastoral scene in his chapter on landscape, characterizes the *Arcadia* as being "full of sweet pastoral poetry" (*Grondt* 6:21), and says of Sannazaro that he was a "Neapolitan nobleman, and therefore knew how to write about painting" (*Grondt* 5:62).[14]

The Flemish author refers repeatedly to Ariosto as well. *Den Grondt*'s chapter on reflections, with its many remarks applicable to landscape painting, includes a three-stanza description (7:58–60) paraphrasing a landscape found in Ariosto's *Orlando furioso*. Van Mander's passage concludes with the comment: "Thus, painters should not be completely dissuaded from reading poetry, because that can teach, as well as evoke for them, many things concerning the art of painting" (7:60).[15]

This last idea, needless to say, was a commonplace—Alberti had made the same recommendation—but van Mander explicitly connects it with subject matter in which landscape plays a major role. It is possible that he borrowed all this from Lomazzo, who had used Ariosto in a similar way in his treatise on art.[16]

Van Mander's references to poetry in his chapter on landscape should be seen in the context of contemporary practice. Flemish landscapes were produced in quantity, often as a market commodity and usually decorative in form and function. Such landscapes had come to be considered typically Northern, often in a condescending way—that is, as a kind of painting belonging to Netherlanders by default, since they were deemed unable to paint the human figure. Of course, this "limitation," such as it may be, is only one aspect of Northern landscape production, perhaps a minor one, but van Mander took it seriously. He was proud of the fame his countrymen had won in Italy for their skill in painting landscape, but at the same time he was dissatisfied with the negative aspects of their reputation. Expressing hope that soon the North would equal the South in history painting, he remarked: "They [the Italians] can already see this coming true on canvas, stone, and copper plates. Be alert my young friends, take courage, even though there will be many disappointments, apply yourself, so that we can achieve our goal—namely that they can no longer say (as is their custom): The Flemings cannot paint figures" (*Grondt* 1:72).[17] This criticism leveled at Northern artists must have had a double sting, moreover, because—as van Mander admits—the few Italians who painted landscapes were "excellent and almost without rivals" (*Grondt* 8:24).[18]

17. Translated by Wolfgang Stechow, *Northern Renaissance Art, 1400–1600: Sources and Documents* (Englewood Cliffs, N.J., 1966), p. 58.

18. Earlier, Paolo Pino had praised Titian's landscapes as being better and "molto piu graziosi" than those of the Flemings (*Dialogo di pittura*, [Venice, 1548], p. 29v; cf. Paola Barocchi, ed., *Trattati d'arte del cinquecento, fra manierismo e controriforma*, vol. 1 [Bari, 1960], p. 134). For recent discussions of the attitudes of sixteenth-century Venetian theorists toward landscape, the role of Northern landscape painters in the South, and the praise accorded in Italy to Titian for his work in this "part" of painting, see Marianne Haraszti-Takács, "Einige Probleme der Landschaftsmalerei im Venedig des Cinquecento," in Dresden, Staatliche Kunstsammlungen, Gemäldegalerie, *Europäische Landschaftsmalerei, 1550–1650* (Dresden, 1972), pp. 24 ff.,

14. Van Mander makes other references to the *Arcadia* as well; cf. Miedema, p. 647.

15. In a marginal note van Mander cites as the source of his poetic description Ariosto, *Orlando furioso* 1:35–38. Miedema (p. 533) gives a more precise citation, 1:33, 35, 37, 38.

16. Cf., for example, G. P. Lomazzo, *Trattato della pittura* (Milan, 1584), bk. 6, ch. 39. Ariosto was so popular, however, that van Mander's dependence on Lomazzo need not be insisted upon here.

Van Mander's poem on painting bears witness to his desire to raise the status of Northern art—including the "Northern" genre, landscape—as he felt it deserved. Convincingly natural effects and variety of subject matter were sufficient, perhaps, to satisfy a collector or connoisseur. But in the eyes of a theorist who owed as much to Italy as van Mander did, such values alone would not wholly suffice. That he felt the need for an association between landscape and poetry is suggested not only by *Den grondt* but also by his translation into Flemish of Virgil's *Eclogues* and *Georgics*. The latter is in fact prefaced with a sonnet to Goltzius on the theme of ut pictura poesis:

Let gratitude be shown to the Mantuan for the way he has
Taught Echo to sing in sweet Latin of Amaryllis, and let us
 also
Be thankful for his rules of agriculture, which encourage the
 land
To be more generous—both sung to you now in Flemish.

O Goltzius, indeed the ornament of our age, my
 Great Maecenas: I write this to you because painters,
 especially,

Find poets helpful. On the other hand, it is a constant effort
To make ingenious poetry, resembling a painting.

For the one is mute, while the other can speak:
The one speaks with colors, and the other paints with veiled
Pass-words, and each explains anything you desire.

No one in this respect can be compared with Virgil,
But as far as my effort here is concerned, I guess
That if it is not worth praising, it is at least worthwhile.[19]

Van Mander's efforts were part of a larger movement to elevate Netherlandish culture as a whole, including the language.[20] Thus a certain D. Theodorus Velius, in a short poem written for van

and H. G. Franz, *Niederländische Landschaftsmalerei im Zeitalter des Manierismus*, 2 vols (Graz, 1969).

Gombrich (p. 115) quotes verses of the Fleming Lampsonius (1572) to the effect that Northerners are famous for good landscape painting because they have their brains in their hands, while Italians, who have their brains in their heads, paint histories.

See also A. Richard Turner, *The Vision of Landscape in Renaissance Italy* (Princeton, 1966), pp. 128–132, on the situation and status of landscape in Italy in the sixteenth century.

19. Den Mantuaen hoe hy in soet Latijn
Van Amaryl heeft Echo leeren singhen:
Sijn wetten oock om t'landt tot mildheyt dwingen,
Gesonghen dy in Vlaems, laet danckich zijn.

O Goltzi vry ons eeuwer ciersel, mijn
Mecenas groot: Want Schilders sonderlinghen
Nut scheppen uyt Poeten, ja een ding en
Is constich Dicht, en Schildery int Schijn.

Dan d'een is stom, en d'ander can wel spreken:
D'een verwich wijst, en d'ander met bestreken
By-woorden mhaelt, en duyt al watt Begheert.

Niemand hier in Virgilio was gh'leken,
Maer wat belanght mijn doen te minst, ik reken,
Is lovens niet, soo ist onschuldens weert.

The title page of van Mander's translation of Virgil reads: *P. Vergilius Maro, Bucolica en Georgica, dat is, Ossen-stal en Landt-werck. Nu eerst in rijm-dicht vertaelt, door K. V. Mander, Haarlem (bij Gillis Rooman). 1597.*

20. See C. van den Branden, *Het streven naar verheerijking, zuivering en opbouw van het Nederlands in de 16de eeuw* (Ghent, 1956), and C. G. N. de Vooys, *Geschiedenis van de Nederlandse taal* (Antwerp, 1952), especially ch. 3 and 4.

Mander's translation of Virgil, imagines the Roman poet marveling that now one can speak in the barbarian Batavian tongue (Dutch) as sweetly as in Latin.[21] This wish to elevate the native culture by comparison with classical antiquity or even with the Italian Renaissance was a manifestation of a phenomenon that had occured earlier in Italy and France. In Flemish art, Rubens' works can be seen as representing the culmination of such impulses. That this was recognized in the artist's own time is revealed by a poem of 1621, written to Rubens by the Flemish poet and scholar Antoine Sanders. Sanders's encomium to the painter ends with the words, "Weep, Rome: now Rubens, the Fleming, triumphs over Latium by the skill of his brush."[22]

THE CLASSICAL DESCRIPTION OF LANDSCAPE PAINTING: PHILOSTRATUS'S "A MARSH"

The chief rhetorical device van Mander employs in his chapter on landscape is *ekphrasis*, or elaborate literary description. Ekphrases were generally devoted to people, places, buildings, and works of art. In the Renaissance tradition the most famous compendium of ekphrases of works of art was Philostratus's *Imagines* (ΕΙΚΟΝΕΣ; second century A.D.). That this rhetorical form remained vital in

Rubens' day is attested by Giambattista Marino's *La Galleria* (Venice, 1619), in which one of seventeenth-century Europe's most widely read poets described real and imaginary paintings, mostly Italian, but some by Rubens himself.[23]

Naturally, Philostratus's *Imagines* was used by painters. Rubens is known to have owned the work,[24] and the subjects of his copies of Titian's *Bacchanal of the Andrians* and *Feast of Venus* (Stockholm, Nationalmuseum) are correctly identified in his inventory as deriving from that author.[25]

Several of the paintings that the Greek writer describes are landscapes. One of these depicts a marsh—its waters, the surrounding mountains, the plants, birds, shepherds, and flocks (*Imagines* 1:9). We need quote only an excerpt from the piece to illustrate how detailed Philostratus's descriptions can be:

> The Earth is wet and bears reeds and rushes, which the fertile marsh causes to grow "unsown and untilled" and tamarisk and sedge are depicted; for these are marsh-plants. The place is encompassed by mountains heaven high, not all of one type . . . And springs are breaking forth from the mountain sides; as they flow down and mingle their water below, the plain becomes a marsh; not, however, a disordered marsh or the

21. Dutch and Flemish are the same language. Van Mander had fled as a refugee from his native Flanders to Holland in 1583. "Hollands" was a name for the Dutch spoken in the province of Holland, where van Mander settled (in Haarlem). Velius uses the term "Batavian" as a synonym for "hollands." ("Batavian" did not have a nationalistic connotation at this time; the reference was regional.)

22. Sanders compares Rubens, whom he called "learned" (*doctus*), with Michelangelo (cf. *CDR* 2:288–90).

23. See James Mirollo, *The Poet of the Marvellous: Giambattista Marino* (New York, 1963), pp. 45–51, and Svetlana Alpers, "Ekphrasis and Aesthetic Attitudes in Vasari's *Lives*," *Journal of the Warburg and Courtauld Institutes* 23 (1960), pp. 190 ff.

24. Max Rooses, "Petrus Paulus Rubens en Balthasar Moretus," part 4, *Rubensbulletijn* 2 (1885), p. 189.

25. J. Denucé, *The Antwerp Galleries: Inventories of the Art Collections in Antwerp in the Sixteenth and Seventeenth Centuries* (Antwerp, 1932), p. 60, nos. 81 and 82. Inexplicably, these paintings are not mentioned in the inventory as deriving from original inventions by Titian, as are Rubens' other copies after his works.

kind that is befouled with mud; but the course of its waters . . . winds in many a tortuous meander, abounding in parsley and suited for the voyaging of the water fowl. For you see the ducks, I am sure, how they glide along the watercourse blowing jets of water from their bills Here is the most beautiful water of the marsh, issuing direct from a spring, and it forms a swimming pool of exceeding beauty. In the midst of the pool amaranth flowers are nodding this way and that, sweet clusters that pelt the water with their blossoms Behold, a river also issues from the marsh, a broad rippling stream, and goatherds and shepherds are crossing it on a bridge.[26]

The part of this ekphrasis dealing solely with the landscape and its inhabitants has much in common with many sixteenth- and early seventeenth-century Flemish landscapes. Philostratus adds such mythological ornaments as cupids riding swans and the winged figure of Zephyrus, but these too have their parallels even in topographical Flemish landscapes—for example, Denis van Alsloot's pendants, *Winter: Abbey of Cambre, near Brussels*, with figures of Boreas and Orithya, and *Spring: Groenendael Abbey in the Forest of Soignes in 1612* with figures of Flora and Zephyrus (figs. 7, 8).

A description such as "A Marsh" gave classical sanction to landscape as an inherently interesting subject. Mere imitation of nature, nonetheless, is denigrated by Philostratus. In the same place, he writes:

If we were to praise the painter for his goats because he has painted them skipping about and prone to mischief, or for his

26. Philostratus, *Imagines*, trans. A. Fairbanks (Cambridge, Mass., 1960), p. 41. All subsequent references to Philostratus are from this edition.

7. Denis van Alsloot, *Winter: Abbey of Cambre near Brussels*, Brussels, Musées Royaux des Beaux-Arts (Copyright A.C.L.-Brussels)

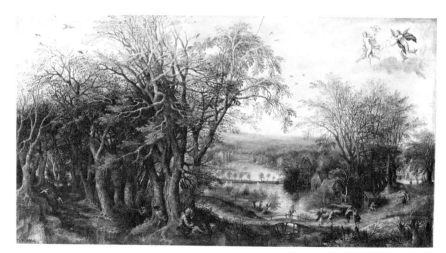

8. Denis van Alsloot, *Spring: Groenendael Abbey in the Forest of Soignes in 1612*, Brussels, Musées Royaux des Beaux-Arts (Copyright A.C.L.-Brussels)

sheep because their gait is leisurely as if their fleeces were a burden, or if we were to dwell on the pipes or on those who play them—the way they blow with puckered lips—we should praise an insignificant feature of the painting and one that has to do solely with imitation; but we should not be praising its cleverness or the sense of fitness it shows, though these, I believe, are the most important elements of art.[27]

Philostratus continues—in answer to his own question, "wherein then, lies its cleverness?"—by pointing out the central idea of the painting to the imaginary young man accompanying him on the tour of the gallery:

> The painter has thrown a bridge of date palms across the river, and there is a very pretty reason for this; for knowing that palms are said to be male and female, and having heard about their marriage, that the male trees take their brides by bending over toward the female trees and embracing them with their branches, he has painted a palm of one sex on the one bank and one of the other sex on the other bank. Thereupon the male tree falls in love and bends over and stretches out over the river; and since it is unable to reach the female tree, which is still at a distance, it lies prone and renders menial service by bridging the water, and it is a safe bridge for men to cross on because of the roughness of its bark.[28]

For Philostratus, then, the painting must not only describe, but also reveal *concetti* that lend themselves to discourse, in this case,

discourse of an anecdotal nature. Another implication of this ekphrasis is that in both making and "reading" landscapes one must possess a degree of learning—for example, one should know about trees. Earlier in "A Marsh," Philostratus had explained that the painter actually suggested various types of soil on each mountain by representing different kinds of trees on them, "for some that are covered with pine trees suggest a light soil, others luxuriant with cypress trees proclaim that their soil is of clay, and yonder fir trees—what else do they mean than that the mountain is storm-swept and rugged?" These particular kinds of conceptual subtleties seem to have been as uncommon in the decorative landscapes of Rubens' day as they may well have been when Philostratus was writing. (In fact, the palm trees seem to be of the author's own invention, perhaps a form of one-upmanship in an epoch when, according to one scholar, "literature and painting vied with each other in the presentation of the same themes.")[29] Generally, even Renaissance writers do not propose quite this sort of ingenuity on the part of the landscape painter. Van Mander, for example, finds it worthy of mention that Frans Pourbus distinguishes three different kinds of trees in a painting, but his criterion for praise seems to be mere variety.[30]

Van Mander, and Renaissance art theorists in general, reveal a fairly limited conception of the meaning of landscape painting. But their ideas were not restrictive and indeed contained hidden potential for the development of the genre into something far greater than they themselves could imagine. Two main and, to be sure, intersecting avenues of expansion are suggested in art theory. One

27. Philostratus, pp. 39, 41.
28. Philostratus, p. 41.

29. Arthur Fairbanks, in his introduction to Philostratus, *Imagines*, p. xvii.
30. Miedema, p. 556.

lay within the realm of faithful imitation of nature; the very "truth" of the depiction gave dignity to the art. The other possible course involved the exploration of highly evocative, poetic themes. In the following discussions of Rubens' landscapes, I hope to show that these two tendencies fuse and culminate in his art.

THE OVIDIAN LENS: THE *POND*

The *Pond* (c. 1610-15; fig. 9; ckl. no. 26), one of Rubens' earliest landscapes, depicts a secluded highland watering place visited by milkmaids and cows and adorned with a wildly mixed crop of trees. The composition—framing trees, a strip of land in the foreground, two curving spatial alleys, and a large central mass—is not unusual for the period (cf. fig. 11). But as scholars have previously observed, no contemporary work is so broadly visualized nor so boldly and imaginatively designed. Eschewing the painstakingly descriptive manner and ethereal blue spaces found in the fashionable landscapes of Jan Brueghel, Rubens instead creates a closed, compact world of nature. He builds up the lower right corner of the picture with a tightly constructed triangle of milkmaids, cows, and an oblique section of tree trunk. And he reverses the usual function of the spatial alleys; instead of dissolving into a distant mist, they are cut short, on the left by a smooth wall of hills, on the right by airy yet impenetrable poplars. The central mass of land, moreover, is made to look organic, almost animal, with its curving "spine" ending in a "reptilian" head. Even the cows are slightly unsettling; one, oddly truncated, seems to be herding the milkmaids with its pointing head. The animal gives an extra directional push to the women,

who are already arranged to create a sequence of motion—walking to the water, bending down to dip. Thus, the scene, ostensibly so peaceful, reveals itself as fraught with tensions that are made all the more palpable by the closed space and dense, opaque, yet curiously animate shapes.

Superficially, the *Pond* is the most conventional of Rubens' landscapes. Yet by virtue of the idiosyncratic, strangely suggestive forms in an otherwise idyllic setting, the painting becomes one of the most difficult to deal with in conventional art-historical terms. Milkmaids along grassy banks constitute a landscape theme recommended by van Mander, for whom it had simple pastoral associations. Van Mander imagined the milkmaids resting, with Tityrus playing to Amaryllis nearby (*Grondt*, 8:42; cf. Virgil, *Eclogues* 1). Rubens on the other hand, depicts robust peasant women doing their chores; the only man about is a minute fisherman seen from the back on the far bank, marking space.

To H.G. Evers, the central land mass in the *Pond* looked so possessed of life that he claimed to see in it a fishlike creature, with vegetable fins and feelers, swimming around the pond. "The plump head hangs sleepily in the water," he wrote, "and nevertheless seems to be leering at the precious booty as it pushes toward them. Yet the maidens come striding along free of care; indeed one of them bends down over the surface of the water without even looking. The willow calls out a warning, the twigs on its old head stand on end; nevertheless it remains quiet, they don't hear it; a life in another language, in other sounds, broods around the humans."[31]

31. "Der ungefüge Kopf hängt schläfrig ins Wasser und scheint sich doch lauernd an die kostbare Beute heranzuschieben. Und wirklich schreiten die Mägde so unvorsichtig aus, wirklich beugt sich die eine zur Wasserfläche nieder und schaut nicht

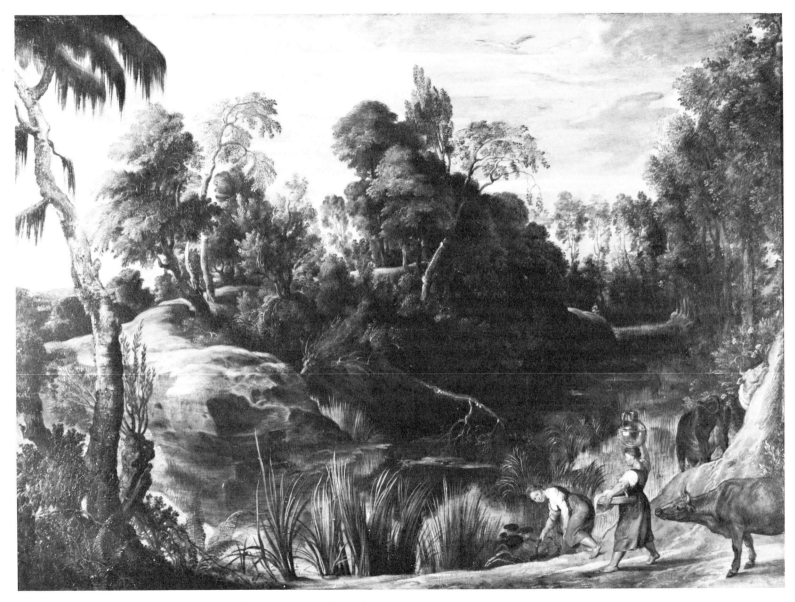

9. *Pond*, Schloss Vaduz, Sammlungen des Regierenden Fürsten von Liechtenstein

The situation depicted in the *Pond*, with its hints of past and imminent metamorphoses and of innocence threatened by some menacing force hidden in nature, goes beyond the pastoral. The painting more readily recalls Ovid than Theocritus or Virgil. Perhaps it is only a combination of hesitant artistic rumination and painterly energy that mark this early landscape by Rubens. But another kind of interpretation is also possible: I would like to suggest that the artist's reading of Ovid exerted a strong influence on his imagination, in effect shaping the conception of nature that he expresses in the landscape. In the stories Ovid tells of Alpheus and Arethusa (*Metamorphoses* 5:572 ff.), for example, and Salmacis and Hermaphroditus (4:285 ff.) personified elements of nature such as a river god and a pond nymph amorously pursue a victim who, unsuspecting, had been enjoying the pleasures of a lush, peaceful setting. That is, landscape in Ovid sometimes serves as a lure and a trap.[32] The very sounds of the words in such stories are sensuously evocative, and even though the poet employs a fairly limited number of landscape motifs, these are woven into the narrative in such a way that their associations become amplified. A mere wood, pond, shade, breeze, and bed of soft grass are artfully arranged to establish both setting and mood. Rubens, who read with a painter's eye, might easily translate the poet's lightly sketched images into a con-

cretely visualized, complete picture. Even the rich arboreal decor of the *Pond* may be a re-creation of the "ideal mixed grove"—a catalogue of different kinds of trees and a rhetorical *topos* frequently found in the poetry of Ovid and late antique writers.[33] This is not to say that the *Pond* is literally Ovidian; rather, it seems historically justifiable to say that in this case Ovid's poetry provided one lens through which Rubens envisioned a landscape.[34]

The *Pond* is not the first landscape that appears to incorporate both a closed, isolated "Ovidian" setting and the tenor of the poet's "inner world of free desires."[35] The *Nymph Bathing* (fig. 10), traditionally attributed to Adam Elsheimer, embodies some of the same qualities that are submerged in Ruben's painting—although unlike Rubens, he does not similarly enliven the nonhuman elements. Elsheimer paints a secluded setting of woods, hills, pond or river, and sky of yellow and blue. A tender young woman emerging from the water is pursued by a satyr on the opposite bank. The particular vulnerability that her nudity conveys is emphasized by the garment, a red cloak with a white lining, left hanging on a branch. Not surprisingly, Ovidian themes have been suggested for this work, namely *Pan Chasing Syrinx* (*Metamorphoses*

einmal hin. Da geckert die Weide und warnt, ihr sträuben sich die Zweige auf ihrem alten Kopf, doch bleibt es lautlos, sie hören es nicht; ein Leben in anderer Sprache, in anderen Lauten webt um die Menschen herum" (Evers [1942], p. 239).

 The comparison of landscape elements to human and animal forms has a long history. In a passage quoted below, for example, Virgil likens some treacherous rocks to a "monstrous spine, stretched along the surface of the sea."

32. See Charles Paul Segal, "Landscape in Ovid's *Metamorphoses*: A Study in the Transformation of a Literary Symbol," *Hermes, Zeitschrift für Klassische Philologie, Einzelschriften* 23 (1969), especially pp. 8, 15, 18.

33. See Ernst Robert Curtius, *European Literature in the Latin Middle Ages*, trans. Willard Trask (New York, 1953), pp. 194–95. Curtius's reference to Ovid bears citing: "Ovid presents the motif of the 'ideal and mixed forest' in elegant variation: the grove is not there from the beginning, it comes into existence before our eyes. First we see a hill entirely without shade. Orpheus appears and begins to play his lyre. Now the trees come hurrying—no less than twenty-six species!—and give shade (*Metamorphoses* 10:90–106)." Another "mixed forest" appears in Rubens' *Boar Hunt* (fig. 59; ckl. no. 6).

34. Rubens' extraordinarily perceptive reading of Ovid is evident from many paintings, among them the designs he made for the Torre de la Parada (cf. Svetlana Alpers, *The Decoration of the Torre de la Parada* [London, 1971].

35. The phrase is Segal's (p. 15).

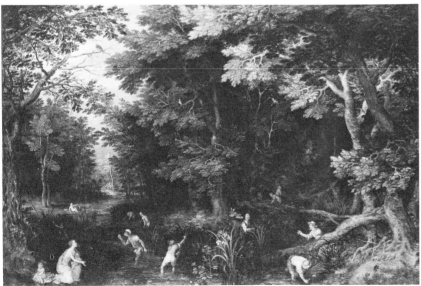

1:689 ff.) and *Alpheus and Arethusa* (5:572 ff.).[36] Although neither title is completely convincing, the Ovidian quality of the little painting cannot be denied. Rubens' landscape was perhaps not the less shaped by Ovid's poetry, even though the picture lacks the traditional gods, satyrs, and nymphs. In his tales of unexpected transformation, Ovid had presented a poetically convincing view of nature, but one tantalizingly vague in its particulars, not easily amenable to illustration. Only an artist attentive to the printed word and of a mind willing to respond and be transformed could have envisioned the quietly animated world of the *Pond*.

It is worth noting that an explicitly Ovidian work, Jan Brueghel's *Latona and the Lycian Peasants* (c. 1603; fig. 11), is close to Rubens' in composition and may have provided the visual model.[37] Besides Brueghel's landscape, the *Pond* also recalls in several respects Titian's *Milkmaid* (fig. 12), a woodcut that Rubens studied and presumably owned.[38]

36. See Frankfurt, Städelsches Kunstinstitut, *Adam Elsheimer: Werke, kunstlerische Herkunft und Nachfolge* (Frankfurt, 1966–67), no. 34, with further references. In a recent catalogue of Elsheimer's works, Keith Andrews gives the *Nymph Bathing* to Cornelis Poelenburgh or one of his followers but offers no explanation for this attribution (*Adam Elsheimer: Paintings—Drawings—Prints* [New York, 1977], p. 166, no. A3). Although Rubens owned a landscape by Poelenburgh, there is no evidence of his knowing the Dutch painter's works before the 1620s.

37. The landscape in Brueghel's painting corresponds to the main features of Ovid's briefly sketched setting: a scorching hot day in a low valley containing a pond, the latter with an island in the middle and surrounded by reeds (*Metamorphoses* 6:339 ff.).

38. Van Dyck made drawings of some of the details of this woodcut in his Antwerp Sketchbook (c. 1615–20), which is thought to reproduce in part a lost sketchbook of Rubens (see Michael Jaffé, *Van Dyck's Antwerp Sketchbook*, vol. 1 [New York, 1966], p. 25).

Van Mander had recommended Titian's woodcuts as models in his chapter on landscape (*Grondt* 8:24). He must have been thinking of woodcuts after Titian (such as the *Milkmaid*) or Domenico Campagnola's woodcuts, which seem to have been

10. Adam Elsheimer, *Nymph Bathing*, Berlin (East), Staatliche Museen, Gemäldegalerie

11. Jan Brueghel, *Latona and the Lycian Peasants*, Amsterdam, Rijksmuseum

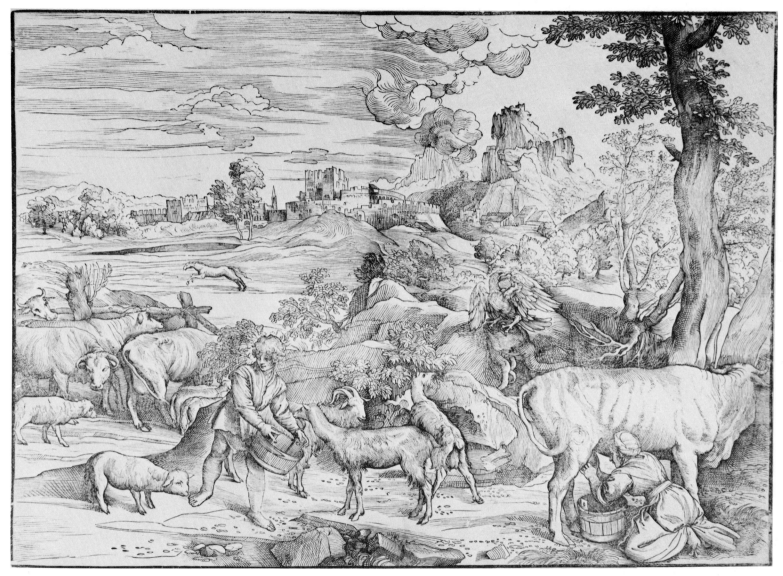

12. After Titian, *Milkmaid*, woodcut by Nicolo Boldrini, London, British Museum
(Reproduced by Permission of the Trustees of the British Museum)

Like Titian, Rubens depicts a scene of country life in terms of work rather than relaxation and arranges figures and cattle in front of an inclined landscape. Both artists, moreover, exhibit at every turn their realization of the pictorial possibilities of the subject, as when they play a witty game of hide-and-seek with the cows' anatomy. Rubens shows us only the inclined head of one animal, scratching its hide against rough bark; of another we get a dark backside and belly as it bends down to drink; and the lowest one is transformed into a heavy horizontal mass, supported at center on two short legs.[39] Even the tree at left, dripping with Spanish moss, is a Venetian motif seen in such works as Titian's *St. Francis Receiving the Stigmata* (fig. 13). More generally, in both Rubens' painting and Titian's woodcuts the earth, plants, people, animals, and sky are all conceived as large energetic masses; in the *Milkmaid*, clouds stream and puff through the sky, an old tree flexes its "muscles" in the continuous labor of growth, and new trees seem to wrench themselves from resistant rock. That these qualities are consciously achieved is underscored if one compares Titian's woodcut to a related work, Jacopo Bassano's *Sowing of Tares* (fig. 14), in which weighty forms remain discrete and placid.

Seen in relation to the rest of Rubens' landscape oeuvre, the material quality and surface texture of the motifs in the *Pond* are the least sharply defined and thus the least mimetically persuasive.

13. After Titian, *St. Francis Receiving the Stigmata*, woodcut by Nicolo Boldrini, Cambridge, Massachusetts, Fogg Art Museum (Courtesy of the Fogg Art Museum, Harvard University, Francis Calley Grey Bequest)

It is as if, with this early essay in landscape painting, Rubens resolved to unburden the native genre of its accumulated load of descriptive detail and the naturalistic embroidery that often resulted. All the more remarkable, then, that in combining a lucid, disciplined composition, a broad yet careful technique, and peaceful bucolic subject matter, the artist managed to convey some of that mystery and enchantment associated with Ovidian settings.

mistaken at an early date for works of Titian (cf. Carel van Mander, *Das Lehrgedicht des Karel van Mander*, ed. and German trans. R. Hoecker [The Hague, 1916], p. 342).

39. Rubens may have known manuscript illustrations of Virgil's *Eclogues* and *Georgics* in which cattle are similarly bisected by the frame (see Millard Meiss, with the assistance of S. Dunlap Smith and E. Beatson, *French Painting in the Time of Jean de Berry: The Limbourgs and their Contemporaries* [New York, 1974], p. 60).

14. Jacopo Bassano, *Sowing of Tares*, Lugano-Castagnola, Switzerland, Thyssen-Bornemisza Collection

Rubens' *Shipwreck* (c. 1620; fig. 15; ckl. no. 2), unlike the *Pond*, is a landscape whose connection with literature was suggested at an early date, in the lines from the third book of the *Aeneid* appearing on Schelte à Bolswert's engraving after the work (fig. 16).[40] The quotation on the print reads:

A blue-black cloud ran over head; it brought
The night and storm and breakers rough in darkness.
The winds roll up the sea, great waters heave.
And we are scattered, tossed upon the vast abyss[41]

[ll. 194-197]

In spite of this reference to the *Aeneid* on Bolswert's print, the relationship of the image to Virgil's text is not immediately apparent and hence presents certain problems. Gustav Glück, for example, doubted that the picture represented the shipwreck of Aeneas because the hero is not singled out among the figures and because,

40. Jan Kelch's catalogue entry on the *Shipwreck* became available only after this study was completed (see Jan Kelch, ed., *Peter Paul Rubens: Kritischer Katalog der Gemälde im Besitz der Gemäldegalerie Berlin* [Berlin, 1978], pp. 38–42. I agree with Kelch's reasons for tentatively dating the *Shipwreck* around 1620.
41. "Tum mihi caeruleus supra caput a stitit imber noctem hiememque ferens et inhorruit unda tenebris Continuo venti voluunt mare magnaque surgunt Aequora, dispersi iactamus gurgite vasto. Aeneid, Liber 3." The English translation is by Allen Mandelbaum (*The Aeneid*, [New York, 1972], p. 63).
The relationship between Rubens' landscapes and the engravings Schelte à Bolswert made after them has never been clarified. The evidence suggests, however, that the prints were made under Rubens' partial supervision during the 1630s.

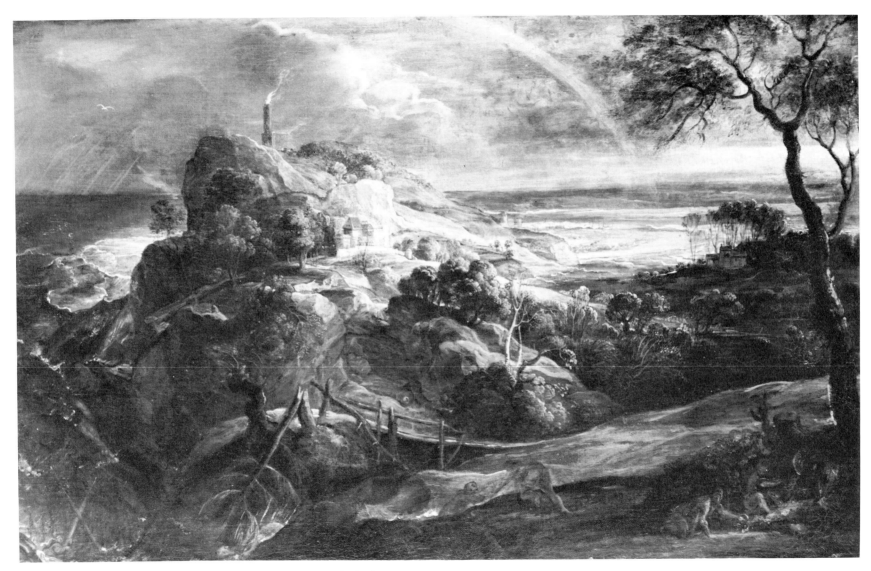

15. *Shipwreck*, Berlin-Dahlem, Staatliche Museen Preussischer Kulturbesitz,
Gemäldegalerie Berlin (West)

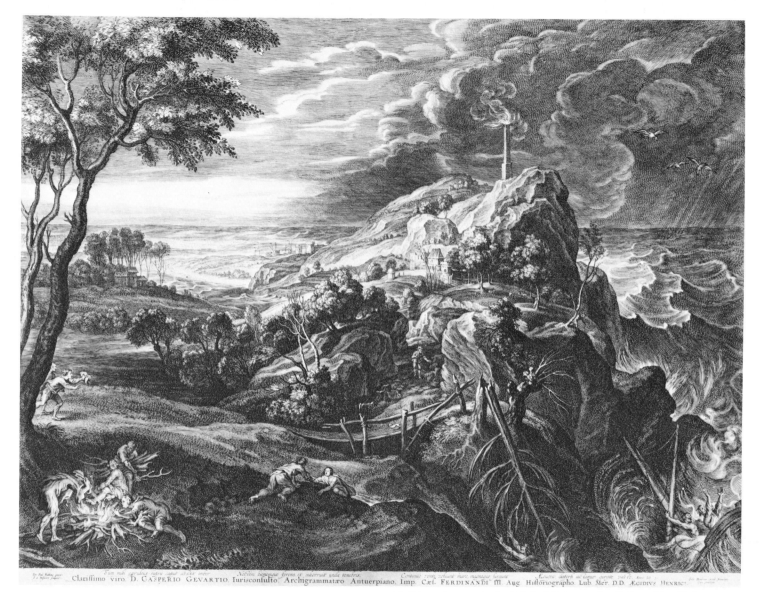

Clariſſimo viro D. CASPERIO GEVARTIO Iurisconſulto: Archigrammatæro Antuerpiano. Imp. Cæſ. FERDINANDI III. Aug Hiſtoriographo. Lub. Mer. D.D. ÆGIDIVS HENRICI

16. *Shipwreck*, engraving by Schelte à Bolswert after Rubens, New York, Metropolitan Museum of Art (The Elisha Whittelsey Collection, The Elisha Whittelsey Fund, 1951)

in his opinion, only a loose connection exists between the verses on the engraving and the image itself.[42]

Before addressing the interpretative issues, however, certain technical problems involving the physical condition of the picture must be faced. As Wilhelm von Bode had already remarked in 1904 (five years after the painting was acquired by the Berlin Museum), injury to the surface had obscured some of the fine details and clear colors.[43] In fact, the damage and repainting are fairly extensive.[44] For the figures, in particular, which have suffered the most, it is necessary to use Bolswert's engraving as a guide to their original poses and arrangement. Evers's suggestion that the scene might have been intended to represent the shipwreck of St. Paul, because one of the men around the fire appears to throw a snake into the flames, is contradicted by the group in the engraving.[45]

The questions raised by the inscription on the print compel us to take a closer look at the subject matter and organization of the landscape. To begin with, the composition is divided in two. The left side is dark and tempestuous: rain pours from the sky, seabirds wheel in the air, waves thrash wildly, and in the engraving, a tornadolike cloud twists through the air. In the left foreground a ship crashes against rocks, flinging the crew about. One man swimming toward land grasps at the fallen end of a tall pine that has been struck by lightning. The impression conveyed is that this tree's once upright beam will soon join the masts being swallowed by the sea.

The middle of the painting is dominated by a mountainous peninsula that begins to peak left of center, where a lighthouse demarcates the midpoint of its summit. On the stormy left side of the painting, the land mass is dark, steep, and barren, save for some trees that remain steadfast throughout the upheaval. Then, to the right of the lighthouse, everything changes. The land slopes down to a beach and harbor, and buildings nestle among the hills and along the shore. On this side of the painting, now peaceful, a rainbow has appeared, and in the foreground some of the survivors are seen making a fire (the rainbow does not occur in the engraving). A man helps one of the shipwrecked climb to higher ground, and in the engraving two others come running to help.

There is far more happening in this landscape, then, than the lines on the engraving suggest. The stormy seascape and jagged rocks on one side of the picture and the clearing weather and survivors on the other suggest different events making up a single narrative; that is, the painting may be read in sequential stages moving from left to right. This discursive mode of pictorial structure takes us back to the *Aeneid*.

The most famous description of a shipwreck in Latin literature does not occur in the third book of the *Aeneid* (the source of the lines engraved by Bolswert), but rather in the first. Rubens certainly knew this text well, for he had read it even as a pupil at Verdonk's, and in the course of his career he made several pictures based on incidents from Virgil's epic.[46]

42. Glück, no. 15.

43. Wilhelm von Bode, "Neue Gemälde von Rubens in der Berliner Galerie," *Jahrbuch der königlichen preuszischen Kunstsammlungen*, 25 (1904), p. 107.

44. See Kelch (p. 38) for a discussion of the condition of the painting.

45. Evers (1942), n. 420.

46. Bellori described Rubens' sketchbook (destroyed) as containing, among other observations, "battaglie, naufragi, giuochi, Amori ed altri passioni, ed avvenimenti, trascritti alcuni versi di Virgilio, e d'altri con rincontri principalmente de Rafaelle, e dell'antico" (*Le vite de' pittori, scultori, ed architetti moderni* [Rome, 1672], p. 254). Kelch (p. 42) observed independently that Rubens' painting seems to refer to the

Virgil's narration of the shipwreck in book 1 corresponds in many respects with the subject matter of Rubens' painting. For this reason, and because it provides a good example of how detailed and vivid landscapes in antique literature could be, it is worth quoting at some length:

> The winds
>
> .
>
> . . . blow across the earth in a tornado.
> Together, Eurus, Notus, and—with tempest
> on tempest—Africus attack the sea;
> they churn the very bottom of the deep
> and roll vast breakers toward the beaches; cries
> of men, the creaking of the cables rise.
> Then, suddenly, the cloud banks snatch away
> the sky and daylight from the Trojans' eyes.
> Black night hangs on the waters, heavens thunder,
> and frequent lightning glitters in the air;
> everything intends quick death to men.
>
> [1:82-91]
>
> The hurricane
> is howling from the north; it hammers full
> against his sails. The seas are heaved to heaven
> The oars are cracked; the prow shears off; the waves
> attack broadside; against his hull the swell
> now shatters in a heap, mountainous, steep.

> Some sailors hang upon a wave crest; others
> stare out at gaping waters, land that lies
> below the waters, surge that seethes with sand.
> And then the south wind snatches up three ships
> and spins their keels against the hidden rocks—
> those rocks that, rising in midsea, are called
> by the Italians "Altars"—like a monstrous
> spine stretched along the surface of the sea.
> Meanwhile the east wind wheels another three
> off from the deep and, terrible to see,
> against the shoals and shifting silt, against
> the shallows, girding them with mounds of sand.
>
> [1:102-12]

Then, after Neptune calms the sea, the story continues:

> And now Aeneas' weary crewmen hurry
> to find the nearest land along their way.
> They turn toward Libya's coast. There is a cove
> within a long, retiring bay; and there
> an island's jutting arms have formed a harbor
> where every breaker off the high sea shatters
> and parts into the shoreline's winding shelters.
> Along this side and that there towers, vast,
> a line of cliffs, each ending in the crags;
> beneath the ledges tranquil water lies
> silent and wide; the backdrop—glistening
> forests and, beetling from above, a black
> grove, thick with bristling shadows. Underneath
> the facing brow: a cave with hanging rocks,

shipwreck in book 1 of the *Aeneid*; he cites lines 170–76, which account for the motif of figures around a fire.

sweet waters, seats of living stone, the home
of nymphs. And here no cable holds tired ships,
no anchor grips them fast with curving bit.

Aeneas shelters here with seven ships—
all he can muster, all the storm has left.
The Trojans, longing so to touch the land,
now disembark to gain the wished-for sands.
They stretch their salt-soaked limbs along the beach.
Achates was the first to strike a spark
from flint and catch the fire up with leaves.
He spread dry fuel about, and then he waved
the tinder into flame. Tired of their trials,
the Trojan crewmen carry out the tools
of Ceres and the sea-drenched corn of Ceres.
And they prepare to parch the salvaged grain
by fire and, next, to crush it under stone.[47]

[1:157-79]

The stormy sea is used as a metaphor by Rubens in a letter of
1629 to his friend Jan Caspar Gevaerts (to whom, incidentally, the
engraving after the *Shipwreck* is dedicated). "We are living in a time
when life itself is possible only if one frees himself of every burden,"
he wrote, "like a swimmer in a stormy sea."[48] In this stoical pro-

nouncement the stormy sea is tantamount to Fortune, a concept
that seems to be implicit in Rubens' *Shipwreck*. In Italian and French
parlance "fortune" was actually a synonym for "tempest,"[49] and the
phrase *fortune di mare* was used in referring to shipwrecks.[50] In
Bartholomeaeus Sprangers's depiction of *Fortune* (1566-73; fig. 17),
furthermore, it has been pointed out that "the background illustrates
the duality of chance: on the viewer's right is a night scene of
general chaos, of battle, death, and fiery destruction; on his left,
which is Fortune's right-hand side, there is a peaceful harbor scene
in which the Colossus of Rhodes, identified with Helios, holds aloft
a torch to guide ships safely to port."[51] In this context, the two
opposed sides of Rubens' *Shipwreck* can be seen as expressing, if
not the duality, at least the vicissitudes of chance, and so categor-
ically that no depiction of Fortuna is neccessary.[52] But the left-right
progression in Rubens' painting implies less vicissitude per se than

47. Translated by Mandelbaum, pp. 4–7. The degree to which Rubens' painting
agrees with the details as well as the narrative structure of Virgil's shipwreck scene
sets it apart from other seventeenth-century works of this type, for example the
stormy seascapes by Lucas van Valckenborch of 1603 (Rotterdam, Museum Boy-
mans-van Beuningen) and Josse de Momper (Stockholm, Nationalmuseum), which
are cited by Kelch (p. 42) as showing a general dependence on Virgil.
48. Rubens to Gevaerts, September 15, 1629; not in *CDR*; Magurn, p. 337.

49. Cf. Edgar Wind, *Giorgione's Tempesta, with Comments on Giorgione's Poetic Al-
legories* (Oxford, 1969), p. 3 and n. 7, with further references, and Erwin Panofsky,
" 'Good Government' or Fortune?" *Gazette des beaux-arts* 68 (1966), p. 308.
50. Giovanni Paolo Lomazzo opens his chapter entitled "Composizioni di nau-
fragi di mare" with the words, "Nelle fortune di mare, o vogliamo dir nau-
fragi . . ." (*Trattato*, bk 6, ch. 29). Cristoforo Sorte's use of the term is quoted in
the text below.
51. Vassar College Art Gallery, *Dutch Mannerism: Apogee and Epilogue* (Pough-
keepsie, N.Y., 1970), no. 87.
The Flemish artist Kerstiaen de Keuninck (c. 1560–1635) reversed the scale re-
lationship between allegorical figure and landscape in his depiction of *Fortune* (Len-
ingrad, Hermitage): a snug harbor and a populous landscape represent Good Fortune
on the left, while at the right—in what to a seafaring people must have been one
of its most familiar forms—Misfortune is shown by ships dashed against cliffs in
a storm. De Keuninck's landscape is not dated and may have been painted after
Rubens' *Shipwreck*.
52. Rubens did represent Fortune as an allegorical figure elsewhere. In a painting
in Madrid (Prado) she is shown on her globe, propelled by a sail made from her
veil, atop an undulating sea. The figure bisects the field diagonally, and on the left

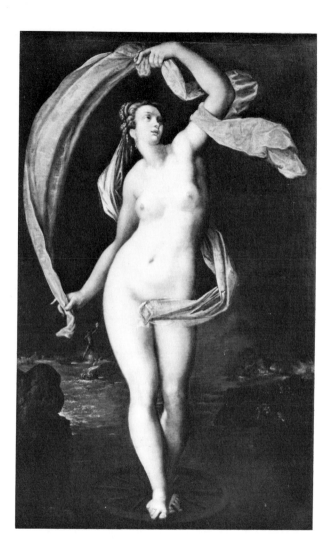

a positive resolution. The comparison between storm and fortune can thus be extended and modified. Martin Warnke has proposed that the ship symbolizes the state wrecked in the storm of war, the lighthouse hope, and the rainbow, together with the brightening sky on the right, the promise of peace.[53] This interpretation, which is plausible enough, given Rubens' political concerns and the constantly shifting fortunes of his native land, depends on the assumption that the traditional comparison between ship and state was intended.[54] The reference to the *Aeneid* on the print does not

the sky is neutral, while the right is given over to a raging storm. The painting is part of the Torre de la Parada series; a sketch showing a different design, without the storm, also exists (cf. Alpers, *Decoration*, nos. 23, 23a). See further the illuminating discussion by Panofsky ("Fortune?") of Rubens' oil sketch *Opportunity Seized with the Aid of Virtue, Fortune, and Time* (c. 1630; Marseille, Musée Grobet-Labadie); Panofsky's article contains a wealth of information concerning the depiction of "fortuna" as an allegorical figure.

53. Martin Warnke, *Flämische Malerei des 17. Jahrhunderts in der Gemäldegalerie Berlin* (Berlin, 1967), p. 15. In the sixteenth century the correspondence between disorder in the heavens (a storm, for example) and discord in the state was a commonplace (cf. E. M. W. Tillyard, *The Elizabethan World Picture* [London, 1943], p. 84).

54. "The ship of state" appears in Rubens' *Coming of Age of Louis XIII*, a painting in the Marie de Médicis series (Paris, Louvre).

Though considerably later in date than the *Shipwreck*, Rubens' *Voyage of Prince Ferdinand from Barcelona to Genoa* (Dresden, Gemäldegalerie) is relevant here. The painting is concerned with the voyage of a secular prince, contains references to the *Aeneid* (again the shipwreck, book 1), and employs the *concetto* of a storm modulating to calm within a single picture. On the Dresden painting, see John Rupert Martin, *The Decorations for the Pompa Introitus Ferdinandi* (New York, 1972), no. 3.

A beacon such as we see in Rubens' *Shipwreck* is used as an emblem of civic virtue in a landscape which appears as a painting within a painting, namely Rembrandt's *Staalmeesters* (Amsterdam, Rijksmuseum; cf. E. de Jongh, *Zinne- en minnebeelden in de schilderkunst van de zeventiende eeuw* [Utrecht, 1967], p. 63).

17. Bartholomeaeus Spranger, *Fortune*, Dayton Art Institute (Museum Purchase, 62.13) © 1962 The Dayton Art Institute

18. After Titian, *Submersion of Pharaoh's Army in the Red Sea*, woodcut, London, British Museum (Reproduced by Permission of the Trustees of the British Museum)

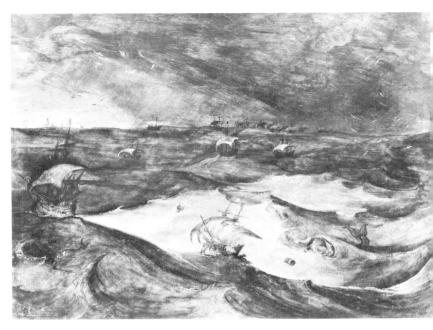

19. Pieter Bruegel, *Storm at Sea*, Vienna, Kunsthistorisches Museum

argue against Warnke's hypothesis. A humanist such as Gevaerts, with Schelte à Bolswert's engraving in hand, would have recognized that the depiction summed up one of the major themes of Virgil's epic: the search of Aeneas and his men for safe haven and a new home, where, after years of trial on land and sea they might finally enjoy the blessings of peace. But it seems unwise to propose an exclusively political significance for this work, a landscape that indeed gains more by expressing the universal themes of destruction and salvation, fortune and fate. In this respect Rubens' painting takes its place within a noble tradition of images involving the sea.

Many of the basic ingredients of the *Shipwreck* are prefigured in a woodcut after Titian, *Submersion of Pharaoh's Army in the Red Sea*

(fig. 18). In this work the doomed Egyptian army, tempestuous water, and a dark cloud are pictured on the left, and rescued Israelites, gently lapping waves, and clearing sky on the right. A great Northern precedent for Rubens' painting is provided by Pieter Bruegel's *Storm at Sea* (fig. 19), an allegorical picture given over almost entirely to ships, waves, and stormy sky, but including as well, in counterpoint, a church on a bit of sunswept land.[55] A

55. The various interpretations of Bruegel's *Storm at Sea* are summarized by Fritz Grossmann (*Pieter Bruegel: Complete Edition of the Paintings*, 3rd rev. edn. [New York,

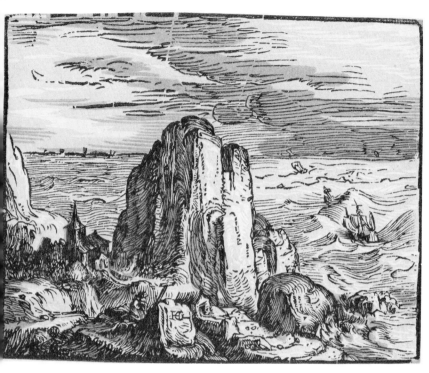

20. Hendrik Goltzius, *Cliff by the Shore*, woodcut, New York, Metropolitan Museum of Art (Rogers Fund, 1922)

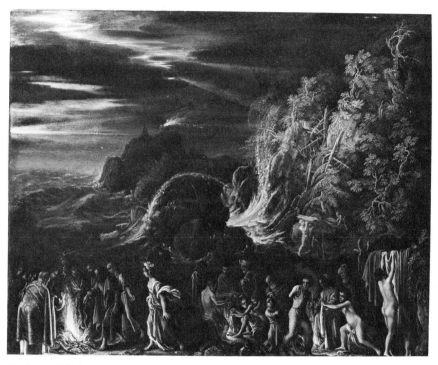

21. Adam Elsheimer, *Shipwreck of St. Paul*, London, National Gallery

woodcut by Goltzius (fig. 20) is like the *Shipwreck* in several respects: its compact composition with a giant seaside cliff massing in the middle, and its two opposing sides, the right with a dark heaven,

1973], no. 149). The general meaning of the subject rests on the comparison of a sea voyage to human life; throwing a barrel to the threatening whale, then, stands for the tactics of human survival, whether physical or spiritual.

ships tossed on the waves, and threatening rocks, the left with a praying monk, a church, and untroubled waters and sky. Yet another thematic and formal parallel to Rubens' landscape is Elsheimer's *Shipwreck of St. Paul* (fig. 21); this painting, too, employs a central rock surmounted by a beacon and contains fantastic light effects. Ruben's lighting system is equally dramatic, depending not

only on the play of light against dark but also of light against light: illuminated whitecaps, the beacon, rainbow, campfire, and sunlight shining on the hills. Finally, the men scrambling ashore in Rubens' painting may well derive from Perino del Vaga's *Shipwreck of Aeneas*, which was formerly in the Palazzo Doria in Genoa and was also engraved.[56]

It is significant that Rubens chose to express a conception of human life through a landscape, one that, for all its tightness of structure and careful selection of apparently emblematic motifs, maintains a look of naturalism. So astute a critic as Roger de Piles even believed that the *Shipwreck* was a topographical painting, representing Porto Venere near La Spezia.[57]

Rubens' decision to use a storm landscape as a vehicle of expression may well have been motivated, in part, by his knowledge of rhetorical topoi. The storm, as a spectacular natural phenomenon, seems to have generated an abundance of ekphrases in ancient and Renaissance literature. L. P. Wilkinson, in his study of Virgil's *Georgics*, reminds us: "Hellenistic taste for the picturesque, and also for realism, made descriptive passages a common feature of both poetry and history. . . . Orators had to be warned not to drag them into forensic speeches: verdicts would not depend on a description of a storm."[58]

The appeal of storm description continued to attract poets until well into the nineteenth century. Petrarch is the author of one of the most vivid accounts, which he wrote to Cardinal Giovanni Colonna from Naples in 1343. His introduction to his own display of rhetorical prowess is a conceit worth quoting:

> Juvenal, describing a great storm, puts much in little by concluding: "a poet's tempest arose." What could be briefer and more expressive? A sky and sea in anger can do nothing that may not be equaled or surpassed by a poet's words. Not to waste time on so familiar a matter, you know of the Homeric tempest, with the leader cast away on a rock, and the menace of Mount Caphareus. Our poets have imitated this, to the point of "raising mountains of water to the stars." But nothing can be depicted in words or even imagined that was not fulfilled or even surpassed yesterday by the fact. It was a disaster unique and unheard of in history. . . .[59]

In praising a poet's ability to create a vivid scene, it was traditional to adduce a list of natural phenomena which usually included the elements of a storm.[60] This was borrowed by painters engaged in

56. The engraving is attributed to Giulio Bonasone; John Rupert Martin suggests this source (p. 56).

57. Roger de Piles, *Recueil de divers ouvrages sur la peinture et le coloris*, "Description de quelques tableaux de Rubens, tirés du cabinet de M. le Duc de Richelieu" p. 343.

58. L. P. Wilkinson, *The Georgics of Virgil: A Critical Survey* (Cambridge, 1969), p. 7, and n. 6, citing Dionysius Halicarnassensis, *Rhetorica* 10:17. R. G. Austin gives a list of other famous antique descriptions of storms (Virgil, *Aeneidos liber primus*, with commentary by R. G. Austin [Oxford, 1971], p. 51).

Vivid scenes of seastorms and shipwrecks can have, of course, a very basic human appeal. As Lucretius wrote: "Pleasant it is, when over a great sea the winds trouble the waters, to gaze from shore upon another's great tribulation: not because any man's troubles are a delectable joy, but because to perceive what ills you are free from yourself is pleasant" (*De rerum natura* 2:1–4; trans. W. H. D. Rouse, rev. ed. Martin Ferguson Smith [Cambridge, Mass., 1975], p. 95).

59. Petrarch to Cardinal Colonna, November 26, 1343 (bk. 5:5; *Letters from Petrarch*, ed. Morris Bishop [Bloomington, Ind., 1966], p. 54).

60. For example, Hughes Salel on Homer: "Tonnerre, esclair, gresle, vent, pluyes, nues, / Pars ses beaux vers sont clairement cognues" (cited by Miedema [p. 545, n. 75] in his discussion of van Mander's chapter on landscape).

defense of their art; thus Vasari writing to Benedetto Varchi in 1548 claims:

> E per questo disegno et architettura nella idea [l'arte nostra] esprime il valor dello intelletto inelle carte che si fanno, et in i muri e tavole di colore e disegno ci fa vedere gli spiriti e sensi inelle figure e le vivezze di quelle, oltre contraffà perfettamente i fiati, i fiumi, i venti, le tempeste, le piogge, i nuvoli, le grandini, le neve, i ghiacci, i baleni, i lampi, l'oscura notte, i sereni, il lucer della luna, il lampeggiar delle stelle, il chiaro giorno, il sole e lo splendor di quello.[61]

Cristoforo Sorte goes further; in his *Osservazioni nella pittura* (Venice, 1580), he gives directions for painting a storm at sea and at the same time convincingly evokes a complete picture:

> Così farebbe quelli delle tempestose fortune di mare, quando le misere navi da subiti et oscurissimi nuvoli vedono loro in uno istesso istante essere tolto il sereno del cielo a la chiarezza della luce, eccetto da quella che con altissimo fragore fanno loro i spessi baleni, e da rabbiosi venti i flutti fino alle stelle levati, et il mare fino alla terra aperto, si vedono per viva forza tirate ora in profundissime valli, ora sopra altissimi monti, fino tanto ch'a'tristi nocchieri spezzate le antenne, il timone, le ancore e le sarte, stanno tutti intenti ad aspettar la vicina morte, minacciata loro dall' inimico nembo.[62]

Writing four years later, G.P. Lomazzo devotes an entire chapter of his treatise on art to the painting of shipwrecks.[63] Lomazzo employs all the traditional descriptive images, quotes appropriate passages from Aristo's *Orlando furioso*, lists subjects for which a knowledge of how to paint shipwrecks is necessary, and lavishly praises a painting by Palma Vecchio showing a storm striking a boat bound for Venice with the body of St. Mark. The painterly challenge implied by such theoretical writings as well as the illustrious models of Virgil, Titian, and Bruegel help to account for Rubens' interest in the rage and calm of sea, sky, and land.

As clearly as do his great history paintings, this storm landscape reveals the mind of Rubens. With the *Shipwreck* he explored the significance of an ancient topic and freshly formulated its expressive possibilities. Combining narrative, metaphor, and brilliant "rhetorical" description, the painting proves that Rubens had found in landscape a subject worthy of his best talents—a means to provoke thought, stir the emotions, and pronounce the power of art.[64]

BINARY COMPOSITION AND SEMANTIC STRUCTURE

The *Shipwreck*, as well as some of its more likely visual models, is divided compositionally into two opposing or complementary sides.

61. In Barocchi, p. 61; cited by Miedema, p. 545, n. 75. In discussing landscape as a challenge to the painter, van Mander recommends the depiction of a seastorm (*Grondt* 8:13).

62. In Barocchi, p. 292; cited by Miedema, p. 545, n. 75.

63. Lomazzo, bk. 6, ch. 38.

64. Judging from Gustav Glück's color reproduction (Glück, his fig. 17), a related storm landscape, this one with lightning and by or after Rubens (cf. ckl. no. 5), can be interpreted as a response to Pliny's story of several great ancient painters who used but four colors, white, yellow, red, and black (*Natural History* 35:50), and in particular of Apelles, who with these colors alone was able to paint unpaintable things, such as thunder and lightning. Van Mander refers to this story in his chapter on landscape (*Grondt* 8:12); see also Miedema, p. 545.

Evers has observed that most of Rubens' landscapes are constructed according to a two-part composition, a pictorial device found in many sixteenth-century landscapes.[65] The binary structure of such pictures controls our reading of the image and provides a crucial guide to its interpretation.

Few compositions are so decisively split as the example Evers adduces, a pair of altar wings by an anonymous German painter of the later fifteenth century (fig. 22). In this work the left side—a barren setting with a corpse, a ruin, and a broken tree—represents death, and the right side, with a young couple, two babies, and lush vegetation, categorically stands for life and procreation.[66] Other divided landscape settings or backgrounds have been found to convey more complex programs that can now be understood only through detailed scholarly research. Patricia Egan has shown, for example, that the setting of Giorgione's *Fête champêtre* functions within a dialogic structure, and that the painting as a whole is an allegory of the way poetry was understood by certain Venetian cognoscenti.[67] In the *Fête champêtre* the particular combination of figures suggests mythological or allegorical allusions, so that we are ready to accept a coherent solution to the "puzzle" of the picture.

65. Evers (1942), pp. 390–92.

66. Upper Rhein region, c. 1480. Cf. Nuremberg, Germanisches Nationalmuseum, *Die Gemälde des 13. bis 16. Jahrhunderts*, ed. E. Lutze and E. Wiegand, 2 vols. (Leipzig, 1937), no. 109, p. 143, and figs. 231–32. Evers illustrates the painting (1942, p. 309).

67. Patricia Egan, "Poesia and the Fête Champêtre," *Art Bulletin* 41 (1959), pp. 303 ff.

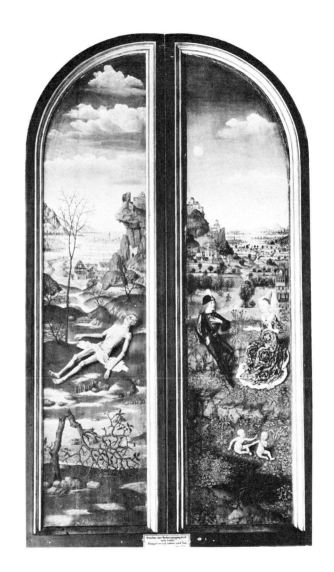

22. Anonymous German (Upper Rhein region), *Allegory of Life and Death* (altar wings), Nuremberg, Germanisches Nationalmuseum

But even a painting that would appear to be a straightforward depiction of a landscape view may reveal, if not an explicit program, at least a code that communicates a larger meaning. Jacob van Ruisdael's *Cornfield* (fig.23), recently interpreted by R.H. Fuchs, can serve as an example.[68] Fuchs begins with the admission that the painting, like many Dutch landscapes of the period, does not fit into any traditional category (for example, seasonal or Italianate) and that it depicts a place sufficiently recognizable as Netherlandish but is not specifically topographical. "That it is a landscape of such general character," he writes, "is . . . a key to its meaning." By closely analyzing the landscape's form and iconography, Fuchs has perceived that "the painting's semantic structure (which resides in the formal structure) seems to be built up of a series of visual contrasts between elements. . . . no specific sequence of reading the different oppositions is apparent; it is rather that they continually sound together simultaneously. . . ." He observes that the landscape is divided into a sunken side with a small meadow and beach, and a high, cultivated plateau; a middle ground (marked off by three groups of trees and a fence) that divides foreground from background; a tranquil side as well as one given movement by clouds and wind-blown trees; a blue sky on the left, and gathering rain clouds on the right; partially harvested grain (a sign of work), as well as figures at rest; crowns of trees divided into brown, decaying, autumnal leaves on one side, and green, summery foliage on the other; wild vegetation in the dark foreground, and cultivated, radiant yellow wheat in the middle ground. Fuchs concludes that the picture's theme is "nature in the world," a general category,

but one with philosophical and religious overtones. Often when landscape is introduced into Dutch poetry of the period, it is to make the point that nature is God's creation and thus the manifestation of the creator in the world; it is through studying his works that man ascends to a higher level.[69] The function of a landscape such as the *Cornfield*, then, might be to serve as a *speculum naturae*, a world in miniature as object of contemplation.[70] Perhaps the painting includes a more specific meditation on the theme of nature's wild forces constantly threatening the work of man.[71] In any case, although he observed nature carefully in its details, Ruisdael evidently assumed that a landscape had to satisfy a typical code, one that would communicate a commonly shared idea.[72]

One point that Fuchs does not make—but which is crucial for the present study—is that landscape, as an available genre, offered Renaissance and Baroque artists a new vehicle for expressing important traditional ideas. The notion of nature as revelation, frequently found in sixteenth- and seventeenth-century poetry, is a venerable one, going back to the Bible itself and expressed by theologians throughout the Middle Ages. Old Testament lines proclaiming at length the wonders of nature and calling for hymns of

68. R. H. Fuchs, "Over het landschap: Een verslag naar aanleiding van Jacob van Ruisdael, *Het Korenveld*," *Tijdschrift voor geschiedenis* 2 (1973), pp. 281 ff.

69. This point is made repeatedly by Th. J. Beening (*Het landschap in de Nederlandse letterkunde van de Renaissance* [Nijmegen, 1963]) and in P. A. F. van Veen's study of the hofdicht (*De soeticheydt des buyten-levens* . . . [The Hague, 1960]).
70. Fuchs, p. 291.
71. This idea was suggested to me in conversation by Egbert Haverkamp-Begemann.
72. Fuchs, p. 291. Fuchs (p. 288) also cites a seventeenth-century Dutch poem about a painter who goes outdoors to sketch nature, only to be caught by a storm; home the painter runs and sets down what he has seen. A feeling for such visually dramatic yet everyday experiences lies behind many masterpieces of seventeenth-century Dutch landscape.

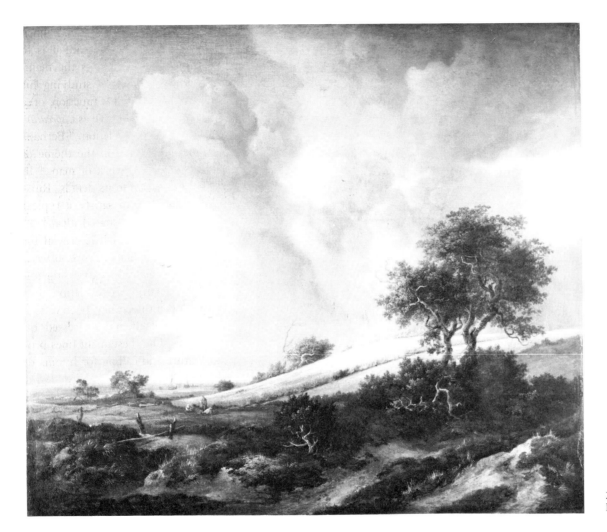

23. Jacob van Ruisdael, *Cornfield*, Rotterdam, Boymans-van Beuningen Museum

praise (for example, Sirach 43:1-27) must have readily evoked the image of landscape in the minds of seventeenth-century patrons and painters and may have generated, in turn, new works in this genre. Du Bartas, in his *Première sepmaine ou la création du monde*, actually compares God the Father admiring his work on the seventh day of creation to a painter admiring his freshly painted landscape. God's "landscape," as du Bartas describes it, is appropriately full; the poet expounds its contents throughout a full forty-four lines.[73] Du Bartas's extensive list of motifs corresponds to his God's all-seeing vision. A landscape structurally comparable to the passage in du Bartas is Lucas Gassel's *Judah and Tamar* (1548; fig. 24), an additive landscape with a panoramic viewpoint. Ruisdael's *Cornfield*, on the other hand, exhibits a "progressive" seventeenth-century style (that is, one we might normally call Baroque). As Fuchs notes, the picture's division into three planes that flow into each other and overlap in an unbroken, coherent space is a typical seventeenth-century Dutch formula. The *Cornfield's* change in style with respect to sixteenth-century "cosmic" or "world" landscapes of the Patinir-Bruegel type, its substitution of subtle contrasts for enthusiastic cataloguing, involves a change in meaning as well. The viewer is no longer given a high, privileged viewpoint of the kind that made Icarus "rejoice in bold flight" (*Metamorphoses* 8:223). Nor do we feel thunderstruck like the prophet Sirach at the wonders of God's creation (Sirach 43:25). The tone of Ruisdael's *Cornfield* is such that

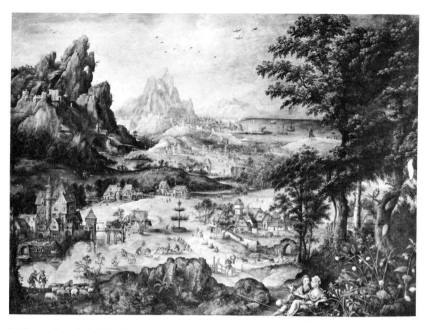

24. Lucas Gassel, *Judah and Tamar*, Vienna, Kunsthistorisches Museum

it evokes meditation, like his waterfall landscapes that veil the *vanitas* theme.[74]

Duality, dialogue, contrast, and the harmonious union of opposites, the *discordia concors* that permeates Renaissance and sev-

73. Du Bartas, *Première sepmaine*, "Le septiesme jour," ll. 1–40. Following the description are the lines: "Bref, l'art si vivement exprime la nature, / Que le peintre se perd en sa propre peinture, / n'en pouvant tirer l'oeil, d'autant qu'ou plus avant / Il contemple son oeuvre, il se void plus scavant" (ll. 41–44; *Works*, p. 416).

74. Wilfried Wiegand adduces many emblems to make this point. His discussion of Ruisdael's depictions of waterfalls constitutes one of the most convincing parts of his study (*Ruisdael-Studien: Ein Versuch zur Ikonologie der Landschaftsmalerei* [Hamburg, 1971], ch. 4).

enteenth-century thought—all are principles of composing a painting both formally and conceptually, But in fact, these structures per se can lead us only so far into any given landscape. The binary formula seems to be so basic an element of design and content, reflecting such universal and deeply rooted habits of thinking, that before it can serve as a useful critical category, its function must be analyzed anew for each work of art in which it occurs.

COSMOLOGICAL LANDSCAPE: THE *CARTERS*

One of the most powerful and profound landscapes ever created is surely Rubens' *Carters* (fig. 25; ckl. no. 9).[75] It has also remained one of the most mysterious. The painting is similar to the *Shipwreck* in that it has a two-part composition, the left side shrouded in nocturnal darkness and the right bathed in sunlight, the center of the painting being marked by the mouth of a quarry. Within this larger binary structure, the painting is bifurcated. A rocky outcrop topped by a mixed grove defines the middle of the picture. The left spatial alley comprises a low-lying pond reflecting the moon (pictured above it), a cloudy sky animated by swift-moving clouds and bats on the wing, and a man and woman sitting by a campfire while an animal grazes nearby. The avenue of space on the other side is conceived as a completely different sort of landscape, one with rolling hills and mountains.

A simple enumeration of motifs scarcely does justice to the power of this landscape. The *Carters* is the sort of evocative painting that encourages ekphrasis, and indeed Evers has provided us with a descriptive analysis that is well worth quoting.

75. Traditionally dated c. 1617–20.

Not only is one side of the painting in daylight, and the other in quiet, beautiful moonlight, but the bright side is also higher: not because the terrain actually rises steeply, but because the artist has assumed a high viewpoint. At the same time, the dark side lies sunken, with bats flapping above it. What could have been more ingenious than to have conceived of the descent of day into night in such a concrete way, to give it such presence, by making a heavily-laden wagon glide into the "sloping" evening, and to make the carter have to protect the wagon from toppling. With other landscape painters figures are used as staffage; with Rubens they convert the latent processes of nature into action.

The movements of the wagon are coördinated with those of the trees. The single dark tree, in front of the bright background, arches downward in such a way that the carter seems to have to support it as well as the wagon. On the other hand, a glimmer of light from the day reaches across to touch the night side, making a silky shine on the birch bark. And above all the willows—bushes like robbers, lurking behind the honest tree—lie in wait for the freight. . . .

But that is not all. The middle is piled up into a rocky creature. This is hardly an obvious idea, but rather one that presumes a special mind and the artist's singular solidarity with nature. The rock is at the same time doubled, so that it becomes a kind of sunken road, a cleft in the earth, and this makes the rock active and acting. It is as if the earth had broken up below it. Thus one can say that landscape is what rises out of the ground as well as what goes under it; landscape is not only what lies on the surface, but also the subterranean, what goes

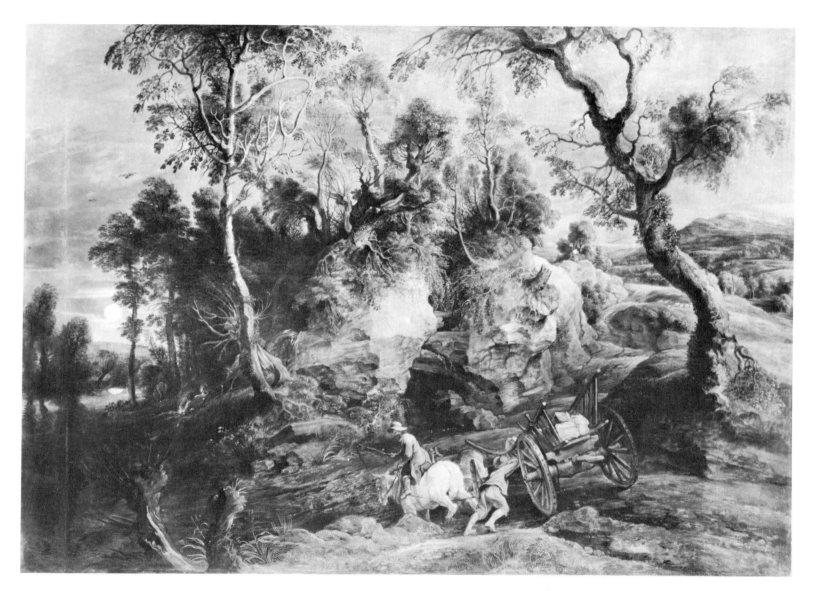

25. *Carters*, Leningrad, Hermitage

along under the soles of our feet; not only the trunk that grows in the air, but also the root that digs into the dark. Stones are fermentation and pressure and crystal. . . . Therefore this rock is no mere "middleground"; it is a being in itself, and the trees on its back are assembled into an extraordinary group. If one but observes the lovely and abundant luxury with which both the traditional and uncommon motifs are developed (as if the rank richness of nature itself were on the panel), then already such an "early work" can convey a sense of what a landscape by Rubens means.[76]

As Evers observes, the opposition between day and night in the painting corresponds to a division between high and low. Just as in the case of the *Shipwreck*, then, the two sides of this painting imply not only contrast, but also compression: of time and—considering the otherwise illogical dip in the horizon line—also space.

Another quality the painting embodies is sheer physical tension. The observer naturally responds to this aspect of the work, in part because he is compelled to read the painting from right to left, in reverse of the normal direction. In a synoptical sentence devoted to the *Carters*, Leo Steinberg has managed to convey a sense of the viewer's participation in the action depicted. Speaking of the landscape's "conflict of opposing directions," he observes, "The terrain declines sharply at left, but the trend of our vision propels the horizon upward, from sunken, nocturnal gloom to the high-rising skyline at right—a luminous clearing which, abstractly considered, is also the directional target of the young carter, whose vermilion coat gives the world its sole tinge of red, and whose strained effort

76. Evers (1942), p. 392; my translation.

to hold wagon and boulders in place tilts against gravity, against oncoming night, against the very scarp and dip of the land."[77] The peasant who strains to support the cart, and the conveyance itself, drawn by a dark and a light horse, thus act in a drama that is in one sense pictorial; in other words, this central motif epitomizes the larger design and tensions of the picture. Seeing these correspondences is one aspect of reading the work.

The question still remains as to what concept Rubens wished to express in a painting so obviously original and ingenious. Evers discerned that the descent of day into night is made into something concrete in this painting, and that the figures shifting their cart actually seem to effect the transition. But in fact there is no such transition. Day is day and night is night—each wing is a distinct landscape, each with its own staffage, and each in itself concrete. Yet the two wings are not separate, but rather joined in one landscape, bridged by the region between the two gigantic interacting trees. This middle region is also the painting's dramatic center. If the peasants are not effecting the transition between day and night, they nevertheless seem to be involved in something beyond the momentary maintenance of the cart's balance.

There is an element of heroic struggle in the action of the carter "whose vermilion coat gives the world its sole tinge of red." For Evers, he seemed to struggle not only with the cart but also with the great dark tree, and for Steinberg he was supporting the wagon against more than the usual odds, tilting in fact "against gravity, against oncoming night, against the very scarp and dip of the land."

77. Leo Steinberg, "Remarks on Certain Prints Relative to a Leningrad Rubens on the Occasion of the First Visit of the Original to the United States," *The Print Collectors Newsletter* 6 (1975), p. 100.

This carter, then, indeed stands out in the painting; he is in nature—and this nature is as animated and powerful as any artist ever conceived it—but he is "of a different color," and everything seems to hinge on his action.

We must now ask: what is the carter's function? If it is just to support the wagon, then this action is inexplicably insignificant to be given pride of place in a large landscape by Rubens. Perhaps, then, his effort stands for something larger. The one thing he clearly does embody is a physical principle: balance. We will naturally wonder why "balance" should figure at the center of a landscape. This, of course, is not just any landscape; rather, it is one that encompasses both day and night, high and low, rocks deep under the earth and rocks towering above the ground. It is a landscape clearly possessed of powerful vital forces, but it is also uncultivated and elemental. It is as though, in Evers's words, "the rank richness of nature itself were on the panel." All of this suggests a philosophical concern of ancient origin and, in Rubens' day, of continuing interest: namely, the very nature of the sublunary world.

The structure of the cosmos as generally understood in the Middle Ages and the Renaissance was divided into two spheres: the celestial, which was the fixed, perfect, immutable region of the stars, and the sublunary or terrestrial, subject to continual mutation and hence instability (there might also figure a third sphere, the supercelestial, but that need not concern us here). The region of the moon separated the pure celestial ether from the earth's troubled atmosphere and was the midpoint of the cosmos. In this scheme, man was seen as part animal and part divine; he was capable of spiritually transcending the earthly sphere or sinking ever deeper into its mire. According to another aspect of this theory, man was

a microcosm of the macrocosm, an analogy in which man and the universe were conceived as being constructed according to the same harmonic proportions, each sympathetically attuned to the other.[78]

The elements thought to constitute the terrestrial sphere were, of course, four: earth, air, fire, and water. In the *Carters*, Rubens included them all. As in any landscape of the period, earth and air appear, but these predominate on the right, where pastures roll back into space; the area at left, on the other hand, although more cramped and eroded, has been provided with fire and water.[79]

We may refer again to du Bartas's creation poem, *Première sepmaine*, in which he characterizes the elements as "quatre freres / Soustiennent l'univers pars leurs efforts contraires, / Et comme l'un par temps en l'autre se dissout / Tant que de leur debat naist la paix de ce Tout."[80]

Antithesis is typical of Renaissance theories of the equilibrium of the universe, and of course this notion has a classical pedigree. Ovid, for example, expressed the idea by saying, "Fire may fight with water, / but heat and moisture generate all things, / their discord being productive" (*Metamorphoses* 1:432–33). And in Juvenal's

78. The literature on this subject is vast, but an excellent introduction is provided by E. M. W. Tillyard (*The Elizabethan World Picture* [London, 1943]).

79. The theme of the four elements was popular in prints and paintings in Rubens' day. Some of the most carefully conceived images, combining allegorical figures and landscape, were produced by Rubens' friend Jan Brueghel (cf. fig. 26). Nonetheless, not a single painter envisioned the idea on such a monumental scale and in such naturalistic terms as did Rubens, so that his painting has continued to strike the modern viewer as a scene of "country life" (as implied, for example, by the context in which the painting is illustrated by Frans Baudouin; see *Pietro Pauolo Rubens*, trans. Elsie Callander [New York, 1977], p. 124). No painter since Leonardo, moreover, seems to have been quite so concerned with the physical mechanics and substantial nature of the world.

80. *Première sepmaine*, "Le septiesme jour," ll. 65–68 (*Works*, vol. 2, p. 417).

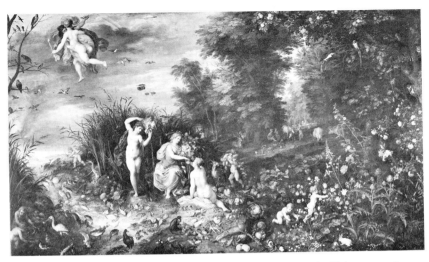

26. Jan Brueghel, *The Four Elements*, Madrid, Museo del Prado

words, "Mixed is the origin of this world, and its frame composed of contrarious powers"[81] The maintenance of balance among these four elements was crucial, a point made repeatedly in du Bartas's poem. In his words—as faithfully though quaintly translated by Joshua Sylvester in 1605—if even earth and sea were not mingled in just proportion, we should see that:

> All Climates then should not be served a-right
> With equal Counterpoise of day and night:
> The Horizon's ill-levell'd circle wide
> Would hang too much on th'one or th'other side.
>
> .
>
> [However,] this also serveth for probation sound,
> That th' Earths and Waters mingled Masse is Round,
> Round as a ball, seeing on every side
> The Day and Night successively to slide.[82]

In Rubens' landscape emphasis is given to the carter, then, because on one level he stands for the principle of balance and order that keeps *kosmos* from dissolving into chaos. The painting itself would seem to be a naturalized allegory of terrestrial nature: a

81. Cited by Wind, p. 82. Wind also lists ancient sources for the notion *harmonia est discordia concors* (p. 81, n. 2).

82. *Première sepmaine*, "Le troisieme jour," ll. 355–58, 365–68 (*Works*, vol. 2, pp. 279 f.); Du Bartas, *Devine Weekes*, p. 88.
The humors were to man what the elements were to the sublunary world. In his unpublished study of Rubens' *Garden of Love* (fig. 27), Leo Steinberg has argued that the men in the foreground of the painting represent, in one respect, the four humors. Both the *Carters* and the *Garden of Love*, then, would exemplify Rubens' tendency to imbed such ideas in an apparently naturalistic context, and would evidence his interest in the theory of correspondences. Immensely influential for sixteenth- and seventeenth-century poetry, this theory holds that all things in the universe are sympathetically attuned.

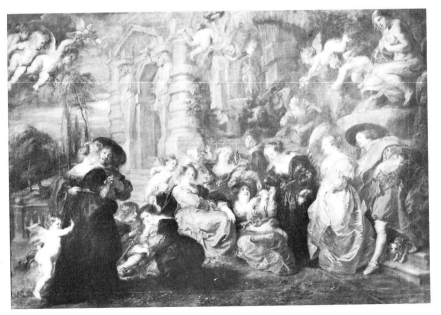

27. *Garden of Love*, Madrid, Museo del Prado

world in delicate balance, mutable, corruptible, but nevertheless awesome in its plenitude and vitality.[83]

The very notion of the harmonious coincidence of opposites (of night and day in the *Carters*) was apparently a central obsession with Rubens and is embodied in his art. The *Shipwreck*, with storm and calm, is one example. But that painting functioned on one level as a narrative, whereas the *Carters* does not. Still, it may have been narrative painting that inspired Rubens to create this icon of sublunary nature. Pieter Bruegel's *Way to Calvary* (fig. 28) provides an interesting parallel; in this painting the combination of bright sky on the left and dark sky on the right, above Golgotha, encourages narrative flow and provides a natural analogue for the impending tragedy; that is, the forces of nature participate in a great event and in fact seem more attuned to its significance than does the populous rabble for whom Christ is shown sacrificing himself. The precedent for combining day and night in a single image, albeit schematically, is found in religious painting; in countless examples of the Crucifixion, the sun and moon flank the cross.

All this would seem to take us far from the peasants who struggle to maintain a wagon full of stones. Yet we cannot help feeling that

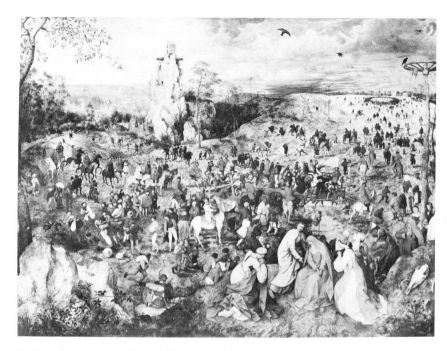

28. Pieter Bruegel, *Way to Calvary*, Vienna, Kunsthistorisches Museum

there is something heroic and profound about the effort of these carters caught in the midst of such an animated, powerful landscape. Arthur O. Lovejoy, in his classic study of the concept of the "great chain of being," presents the optimistic Christian view of man's place in terrestrial nature:

> If it [the sublunary world] was the only region of corruption it was also the only region of generation; here alone new souls were born, immortal destinies still hung in the balance, and, in some sense, the fulfillment of the design of the Creator

83. On the positive reevaluation of the meaning of terrestrial nature for man as expressed in religious tracts, philosophical treatises, and poetry of the Renaissance and seventeenth century, see Henry Ogden, "The Principles of Variety and Contrast in Seventeenth Century Aesthetics and Milton's Poetry," *Journal of the History of Ideas* 10 (1949), pp. 159 ff.

Time was, of course, a chief aspect of the earth's mutability. In connection with the *Carters* an iconographic detail in the engraving after Pieter Bruegel's *Triumph of Time* is interesting: Time's wagon is drawn by a light and a dark horse, the one with an image of the sun on its harness, the other with the moon (issued in 1574 by Philip Galle; cf. F. W. H. Hollstein, *Dutch and Flemish Etchings, Engravings, and Woodcuts*, vol. 3 [Amsterdam, 1949–], p. 298, no. 204).

himself was at stake. If, then, this dim and squalid cellar of the universe was (with one exception) the least respectable place in which any beings could have their abode, it was also the place in which all that was really dramatic and stirring was going on. Thus, with self-sufficiency and impassibility, the affairs of men were conceived to be objects of immeasurable solicitude on the part of the Deity itself; so that a single natural folly of an unsophisticated pair in Mesopotamia could, by its consequences, constrain one of the persons of the Godhead to take on human flesh and live and die upon this globe for man's salvation.[84]

It is precisely to this bright side of creation that du Bartas devotes his *Première sepmaine* after a hundred or so preliminary lines describing the chaos preceding God's creation of the world. The wedding of cosmological and religious subject matter was hardly unusual. An original aspect of the *Carters*, in fact, is that it dispenses with religion, mythology, and history, while retaining the grandeur and seriousness invested in these realms by art theory since Alberti.

With the *Carters* Rubens would seem to have painted a cosmological landscape that expresses his optimistic nature as well as his urge for order, principles expressed as well in his political philosophy, the practice of his profession, and his personal and religious life.

Admittedly, the painting's implications have only been glimpsed here; the picture still retains an element of enigma. One of the obvious questions remaining is why Rubens presented an allegory such as this in such a concrete way, why he insisted on giving it

such presence. The answer may be connected with the picture's "professional meaning," concerning the relationship between the artist and nature.

Two of the most common meanings of nature in antiquity and the Renaissance were *natura naturata* and *natura naturans*. The first phrase was used to refer to nature as a passive, complete product, that is, created things and latent forces. The second stood for nature in its active sense, as a lively, creative process controlling natura naturata. Jan Bialostocki has discussed the ideas of natura naturata and natura naturans with respect to theories of art from antiquity through the Renaissance, and his findings may illuminate further the sense of power that Rubens clearly felt with respect to the act of representation.[85]

That all representational artists imitate created nature is self-evident. But as Bialostocki points out, the human arts were also considered the imitation of "nature in action" by thinkers as early as Democritus, and Heraclitus compared active nature's method of creating harmony out of opposed elements to the methods of the artist who imitates nature. According to Bialostocki, the Renaissance stress on individual genius was important for the notion of the artist as imitator of active nature, natura naturans. "Painting compels the mind of the painter to transform itself into the very mind of nature, to become an interpreter between nature and art," he cites Leonardo as saying, and he points out that so far as *natura naturans* was often considered identical with God (*natura cioé Idio* occurs already in Alberti), imitation of active nature was equal to an imitation of God." Titian's personal *impresa* was a she-bear licking

84. *The Great Chain of Being* (Cambridge, Mass., 1936), p. 103.

85. "The Renaissance Concept of Nature and Antiquity," *Acts of the Twentieth International Congress of the History of Art*, vol. 2 (Princeton, 1963), pp. 19 ff.

her cub into shape, with a motto that read *Natura potentior ars* (art more powerful than nature).[86] Du Bartas also refers to the bear licking her cub into shape and uses the emblem as an analogy for God's creation of the world.[87] But already in the early biographies of Virgil the she-bear is compared to the poet carefully shaping the *Georgics*.[88]

Such ideas were repeated so often and in so many different contexts that Rubens was surely aware of them. One cannot help imagining that analogies made between the artist, nature, and even God fired his imagination and his conception of himself as a painter.[89] We feel Evers to be right when he says of the *Carters* that it is "as if the rank richness of nature itself were on the panel." But what we see in the painting is hardly nature growing wildly; rather, it is nature subordinated to Rubens' power of design. The effort of the carter to support the wagon (and also by imaginative extension, the composition) while at the same time appearing to "convert the latent processes of nature into action" is ultimately comparable to the creative, controlling, and balancing force of na-

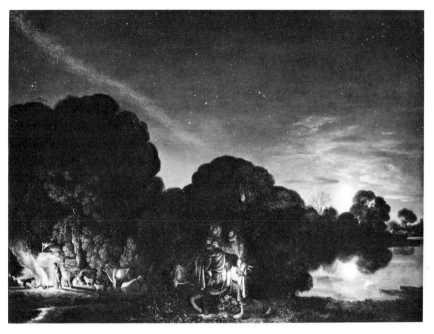

29. Adam Elsheimer, *Flight into Egypt*, Munich, Alte Pinakothek

tura naturans. From a humanistic point of view, one might say the painting not only treats sublunary nature but symbolizes as well the very activity—near divine—of the artist himself.[90]

86. Cited by Bialostocki, "Nature and Antiquity," p. 27, n. 42; the original study of the materials related to Titian's *impresa* is by Hans Tietze, "Unknown Venetian Renaissance Drawings in Swedish Collections," *Gazette des beaux-arts* 35 (1949), pp. 183 ff. The relative superiority of nature or art was one of the most commonplace topics in the Renaissance (cf. W. W. Tayler, *Nature and Art in Renaissance Literature* [New York, 1964], *passim.*).

87. *Première sepmaine*, "Le premier jour," ll. 407–14 (*Works*, vol. 2, p. 209).

88. Thus Suetonius, in his Vita Vergili: "When he was writing the 'Georgics,' it is said to have been his custom to dictate each day a large number of verses which he had composed in the morning, and then to spend the rest of the day in reducing them to a very small number, wittily remarking that he fashioned his poem after the manner of a she-bear, and gradually licked it into shape" (l. 22; *Works*, trans. John C. Rolfe, vol. 2 [London and New York, 1920], pp. 471 f.).

89. See, for example, Erwin Panofsky, *Idea: A Concept in Art Theory* (Columbia, S.C., 1968), p. 125.

90. A painting that inevitably comes to mind when viewing the *Carters* is Adam Elsheimer's *Flight into Egypt* (fig. 29). Obviously similar are the moon reflected in water, the figures around a fire, and the travelers at center, but the comparison throws into relief the dynamism as well as the apparently programmatic character of Rubens' landscape.

LANDSCAPE GENRES: PASTORAL

One way in which the assumption ut pictura poesis operated with respect to landscape painting was by allowing the two arts to share a common notion of genres, or kinds. In the Renaissance and seventeenth century, the theory of genres was a powerful force in literary production and criticism: genres, deemed essential to any imaginative life, served not only as categories for organizing literature but also, in a more dynamic sense, as instruments for interpreting reality, aiding invention, and transmitting culture. For the historian, the notion of kinds provides a means of making past culture into a "common place."[91]

Viewed within the context of ut pictura poesis the genre theory offers a tool for analyzing literature as well as the visual arts. An important question in the present study is whether Rubens' landscapes conform in any way to the generic conventions governing literary subject matter and whether there exist texts that, on one level, stand for the same type of experience, values, patterns of thought and strains of sentiment found in his works. If a logical extension of ut pictura poesis entitles the painter to the same freedom of imagination allowed the poet, then we should expect some of the same restrictions regarding the range of thematic references likewise to apply. In other words, the notion ut pictura poesis can help us to determine in some way the extent and boundaries of the "common places" of Renaissance and Baroque landscape.

A literary genre perhaps unequaled in pervasiveness during the Renaissance and the Baroque period and subject to the greatest debate, ancient and modern, is the pastoral. In spite of the seemingly infinite transmutations that the genre has undergone, however, scholars generally agree that the chief elements of its subject matter remain quite fixed.[92]

Conventional pastoral poetry takes as its subject matter the idealized leisurely life of shepherds, shepherdesses, and goatherds who make music and love in a peaceful spring or summer landscape. The recurring features of its setting are grassy meadows, murmuring brooks and fountains, caves, woods, flowers, and birds. Nature is shown as sympathetic, attuned to human mood and action; at the same time it possesses its own vitality, which may be embodied in mythological creatures such as nymphs, satyrs, and river gods. The way of life expressed in manners, food, clothing, and speech is simple and pure. There is no real moral quality to the purity of pastoral life, since the character's motives are spontaneous rather than premeditated, but the issues posed by the poetry itself may have philosophical and moral analogues. Pastoral life is also essentially erotic, concerned with feelings deemed fitting to the low social status of the characters and epitomized by such commonplace sexual symbols as bagpipes and flutes.[93] Characteristic of the genre is also the notion of disguise. Often it is the courtly

91. A useful introduction to the subject of Renaissance genre theory is provided by Rosalie Colie, *The Resources of Kind: Genre-Theory in the Renaissance* [Berkeley, 1973].

92. Thomas Rosenmeyer (*The Green Cabinet: Theocritus and the European Pastoral Lyric* [Berkeley, 1969]), who has set out fully the issues of the debate, argues persuasively for the coherence of pastoral lyric as a genre. In the present context, it is only the subject matter and tone, not the various literary forms of pastoral that are relevant. Gilbert Highet (*The Classical Tradition* [London, 1949], pp. 162–77) summarizes the genre's chief characteristics and the most important ancient and Renaissance examples.

93. On bagpipes and flutes as "orgiastic instruments," see Emanuel Winternitz, *Musical Instruments and Their Symbolism in Western Art* (New York, 1967), p. 153.

poet himself masquerading in shepherd's weeds, and once transported to a pastoral setting, remote in time or space, he begins to speak more freely of his life and loves.

Literary pastoral, unlike the folk songs of actual pastoral peoples, was always written for an urban or courtly audience. In Rubens' day, Netherlandish towns issued books of pastoral songs and courts delighted in pastoral masques. That the presentation of shepherd life in pastoral is artificial was recognized with the birth of the genre itself, and the tension between nature and art is just one of the conflicts on which such poetry depends.

Shepherds and Shepherdesses in a Rainbow Landscape

A painting by Rubens of the 1630s, the Leningrad *Shepherds and Shepherdesses in a Rainbow Landscape* (fig. 30; ckl. no. 10) approaches very closely the literary ideal of pastoral.[94] Here Rubens creates a visual equivalent of the literary pastoral pleasance: a river valley, the cool shade of a tree, green banks, the murmur of flowing water, and the shepherd with his herd are all stock motifs newly visualized.[95] These elements, along with the feeling of freshness created by a departing storm cloud, the clear colors, and the glory of a double rainbow arched over the central lovers, all bespeak nature's

benevolence. The conventional contrast between pastoral life and other modes of existence, moreover, is subtly hinted at in the walled estate with its garden, on the one hand, and the ships in the harbor, on the other.

Unlike Rubens' other landscapes, the *Shepherds* looks Italianate. This is partly because the artist fairly seized the main elements of the setting from a Venetian graphic source, evidently a design by Domenico Campagnola (fig. 31).[96] The pose of the flautist beneath the tree, furthermore, recalls the shepherd in Titian's Vienna *Pastoral* (*Paris and Oenone*), a work Rubens may have known in the original or from a copy.[97] The upright half of the flautist derives

94. The *Shepherds* is so generically typical and so naturally conceived in pictorial terms that to appeal to specific written sources would seem almost superfluous. On the other hand, Erwin Panofsky's suggested identification of Titian's "melancholy pastoral" in Vienna as a representation of Paris and Oenone (1969, p. 168–71) serves as a reminder that we may simply be unable to recognize a more specific subject here.

95. On the rhetorical topic of the *locus amoenus*, or pleasance, see Curtius, pp. 195–200.

96. Emil Kieser published the anonymous etching reproduced in fig. 31, which may date from the seventeenth century, and he connected it with Rubens' *Shepherds* ("Tizians und Spaniens Einwirkungen auf die späteren Landschaften des Rubens," *Münchener Jahrbuch der bildenden Kunst*, n.s. 8 [1931], pp. 282 f.). The etching clearly reflects a typical Campagnola landscape, although the original drawing has not been found. The same anonymous etcher produced a print, the design of which Rubens used for his Louvre *Farm at Sunset* (ckl. no. 22; cf. Kieser [1931], p. 284). Since Kieser's article appeared, the original Campagnola drawing for this etching has been published (cf. Hans Tietze and E. Tietze-Conrat, *The Drawings of the Venetian Painters* [New York, 1944], no. 717; and Konrad Oberhuber and Dean Walker, *Sixteenth-Century Italian Drawings from the Collection of Janos Scholz* [Washington, D.C., 1973], no. 94; neither the Tietzes nor Oberhuber and Walker note the connection between the drawing and Rubens' *Farm at Sunset*).

The scale and theatrical foreground disposition of the figures in Rubens' *Shepherds* may also reflect Venetian influence (cf. Kieser, "Einwirkungen," pp. 283 ff.; the original Campagnola model for the anonymous etching published this point by Kieser is a woodcut (fig. 32; see David Rosand and Michelangelo Muraro, *Titian and the Venetian Woodcut* [Washington, D.C., 1976], no. 29).

97. Titian's picture appears in David Teniers II's painting *The Archduke Leopold William in his Picture Gallery in Brussels*; the painting was in the Royal Palace in Madrid in 1653, having been sent as a gift by the Archduke to his cousin Philip IV (cf. Brussels, Musées Royaux des Beaux-Arts, *Maîtres flamands du XVIIe siècle du Prado et des collections privées espagnoles* [Brussels, 1975], no. 39, p. 140.)

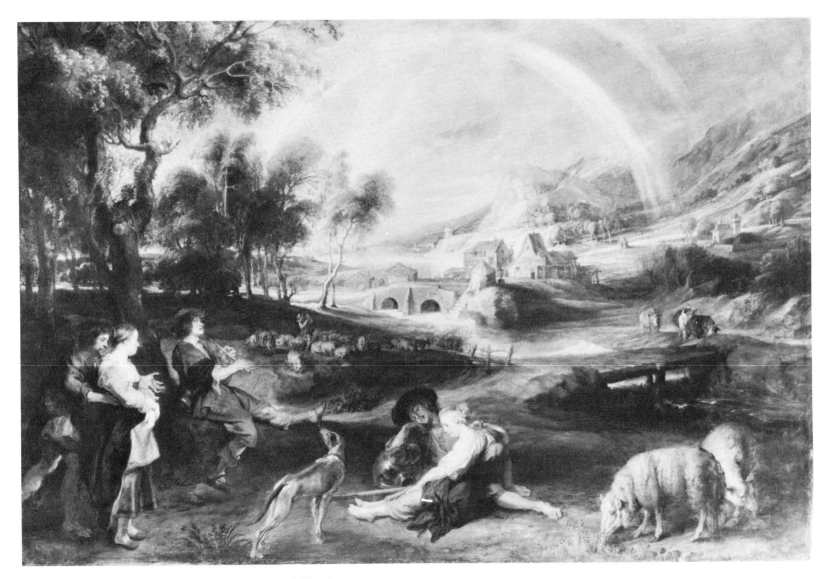

30. *Shepherds and Shepherdesses in a Rainbow Landscape*, Leningrad, Hermitage

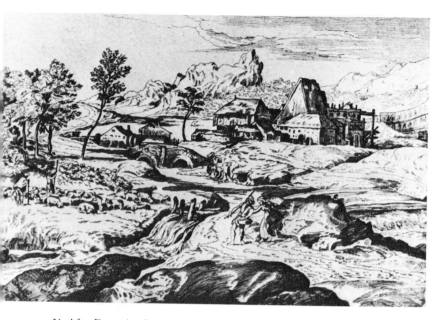

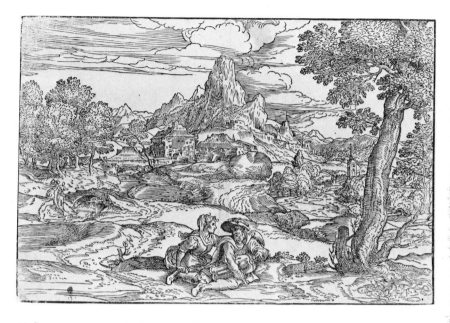

31. After Domenico Campagnola (?), *Landscape*, etching, location unknown (formerly Munich, Staatliche Graphische Sammlung)

32. Domenico Campagnola, *Landscape with Hurdy-Gurdy Player*, woodcut, London, British Museum (Reproduced by Permission of the Trustees of the British Museum)

from another Italian model, a beautiful chalk drawing by Annibale Carracci.[98]

Rubens might have chosen to "nationalize" his version of pastoral—as contemporary writers sometimes did—by placing rustic figures in the sort of rural Netherlandish setting he had developed by this time (cf. fig. 65). Instead, the pastoral subject matter is

joined to a landscape that is picturesque, evocative, and distinctly foreign.[99]

The governing concetto of the picture is the idea of the pair. So tightly composed is the central couple that the figures create a

98. Rupert Hodge, "A Carracci Drawing in the Studio of Rubens," *Master Drawings* 15 (1977), p. 268. Hodge also discusses a drawing by Rubens himself that is connected with the *Shepherds*.

99. Pastoral had already been "nationalized" in the Netherlands by certain neo-Latin writers of the sixteenth century. For example, Jacobus Sluperius of Herzele in Artois (1532–82), in his poem "Amyntas," sets the action in the countryside near Bruges and includes "Flemish" shepherds who, nonetheless, bear the names Alphesiboeus and Damoetas (cf. W. L. Grant, *Neo-Latin Literature and the Pastoral* [Chapel Hill, N.C., 1965], pp. 178 ff.).

veritable emblem of pastoral love. Even their shepherd's attributes suggest the nature of their involvement: she lets him lean on her open copper can, and his fork follows the line of her legs. In the right corner, two sheep are shown perpendicularly, head to tail; the arrangement is a traditional one for filling corners and articulating space, but the animals' proximity to each other makes them doubly fitting here. The theme of couples is also echoed throughout the landscape—in the double rainbow, "embracing" trees, twin huts, and paired openings under the bridges.[100]

Another theme of the picture is "the progress of love." A shepherd couple enters from the left, the swain coaxing his stock-still lady to come sit with him upon the ground, like the amorous pair at center. These two stages are anticipated by a third: beneath a tree on the left sits, forlornly, the fifth character, a single shepherd lifting his flute, his eyes, and his voice, as if in song or invocation. Only a compassionate hound attends the musician, who in a well-worn pastoral tradition seems to long for a girl of his own. This shepherd's implied complaint, the pose of the dreamy swain at center, and the downcast eyes of his shepherdess sound a faint note of melancholy, a mood not at all foreign to pastoral.[101]

Following Rubens' death, a moralizing message was inscribed on the engraving after this rainbow landscape (fig. 33). The lines, in Latin, warn against leisure and admonish the shepherd to put first his duty, the care and protection of his sheep. The sentiment expressed in the inscription shows that in seventeenth-century Antwerp the dangers of escapist, pastoral love were perceived. That the artist himself was of a different mind on the subject is revealed by the positive emotional force of his painting. Nevertheless, as we shall see, the most "natural" of Rubens' landscapes, those that speak most clearly his own language, belong to quite another genre, one superficially similar but in fact opposed to the pastoral.[102]

100. Ronsard's *Hercueil* comes to mind:

> Ici je voy la valée
> > Avalée,
> Entre deux tertres bossus,
> Et le double arc qui emmure
> > Le murmure
> De deux ruyseletz moussus.
>
> Tarde un peu noyre courriere
> > Ta lumiere . . .
> Donque, puis que la nuict sombre
> > Plein d'ombre,
> Vient les montaignes saisir,
> Retournon trouppe gentille
> > Dans la ville
> Demysoulez de plaisir.

Quoted by D. B. Wilson, *Ronsard, Poet of Nature* (Manchester, 1961), p. 36.

101. The idea of stages of love and paired trees also occurs in Rubens' *Garden of Love* (fig. 27). These aspects of the work are identified by Leo Steinberg in his unpublished study of the painting.
Raymond Klibansky, Erwin Panofsky, and Fritz Saxl (*Saturn and Melancholy* [London, 1964]) discuss the connotation acquired by the word "melancholy" in the early Renaissance, that is, melancholy as desriptive of a more or less temporary "mood," which they call "specifically 'poetic.'" They also remind us that Sannazaro used the word in a sentimental and emotional sense, making his shepherds "roam with melancholy brow and melancholy speech" (p. 220).

102. Herbert Herrmann cites the inscription on the engraving (*Untersuchungen über die Landschaftsmalerei des Rubens* [Berlin, 1936], n. 97). Occurring only on the state published by Gaspar Huberti, the inscription must have been added after Rubens' death. The content of a picture such as the *Shepherds*, however innocent, might have conflicted with the norms of publishers who conceived of prints as a means of moral or religious edification. A discrepancy in content between the moralizing inscriptions on some Dutch landscape prints and the images themselves has been observed by Alison McNeil Kettering (*The Batavian Arcadia: Pastoral Themes in Seventeenth-Century Dutch Art* [Ph.D. diss., University of California, Berkeley, 1974], p. 166).

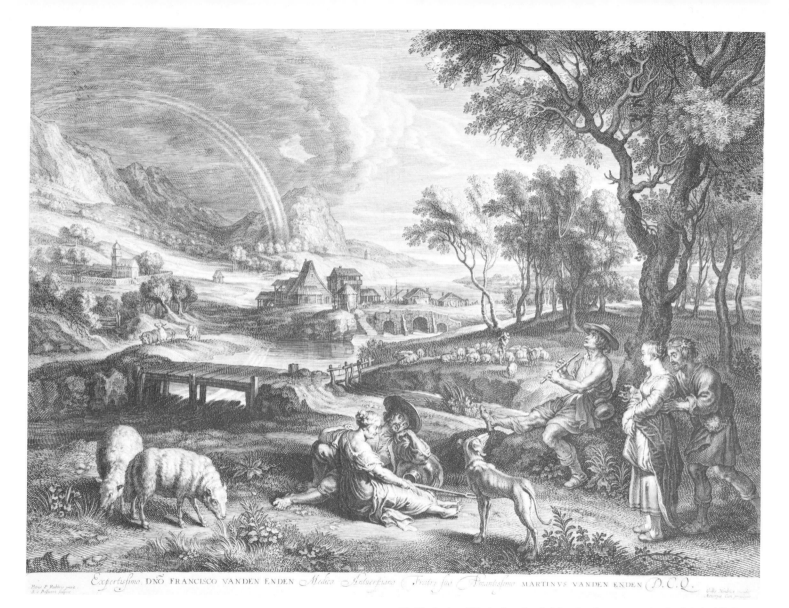

Petrus P. Rubens pinxit. S. à Bolswert sculpsit. Expertissimo. DÑO FRANCISCO VANDEN ENDEN Medico Antuerpiano Fratri suo Amantissimo MARTINVS VANDEN ENDEN D.C.Q. Gillis Hendricx excudit. Antverpiæ Cum privilegio.

33. *Shepherds and Shepherdesses in a Rainbow Landscape*, engraving by Schelte à Bolswert after Rubens, New York, Metropolitan Museum of Art (The Elisha Whittelsey Collection, The Elisha Whittelsey Fund, 1951) All rights reserved, The Metropolitan Museum of Art

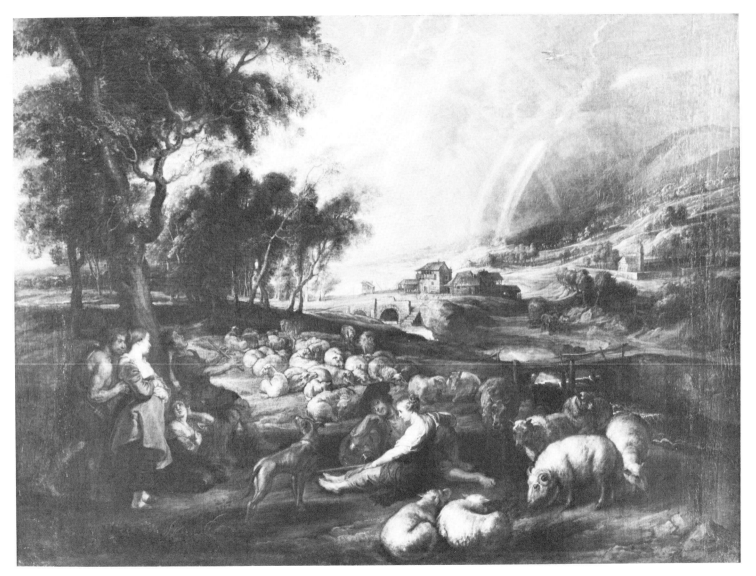

34. *Shepherds and Shepherdesses in a Rainbow Landscape*, Paris, Louvre; on loan to
Valenciennes, Musée des Beaux-Arts (Réunion des Musées Nationaux, Paris)

A version of the *Shepherds* belongs to the Louvre (fig. 34; ckl. no. 24). The Louvre landscape seems to be later than its counterpart in Leningrad and most likely a product of Rubens' shop. Although well executed, it shows some uncharacteristic stylistic features, such as the heavy outlining of the sheep and the smoother areas of color. More important in the present context is the way in which the tensions of the Leningrad work become dissipated. The shepherd watching his flock in the middle distance, for example, has disappeared, and the sheep—whose numbers have swollen—now belong to the main characters; the implication seems to be that the remaining figures have not abandoned their sheep. The shepherd under the tree, moreover, has been given a partner who is strangely squeezed in below him, like an afterthought, so that the implied pastoral complaint has vanished. A hay wain occupies the middle ground, the rainbow has been relegated to one side, and the pairing of landscape elements is no longer carried throughout the painting (the second opening of one of the bridges has been obscured, the two huts have been suppressed). The formerly coaxing shepherd also has changed: now his arm is bared, and his gesture has become aggressive, like that of the shepherd in Rubens' *Rustic Couple Embracing* (fig. 35), who is further advanced in the progress of love. All these alterations add up to a looser and coarser conception of the situation and reveal once again that Rubens' sensibility did not completely pervade the workshop.[103]

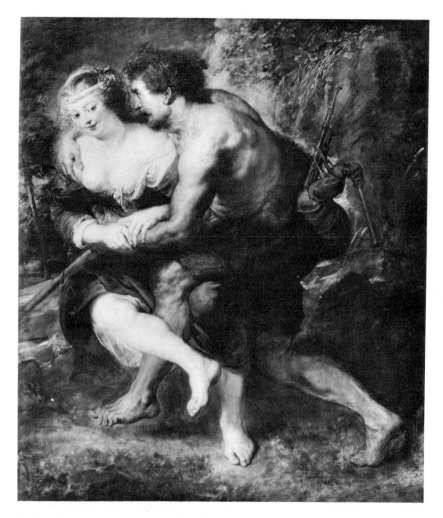

35. *Rustic Couple Embracing*, Munich, Alte Pinakothek

103. While not pastoral in kind, Rubens' *Landscape with a Birdnet* (fig. 36; ckl. no. 23) is concerned with the theme of love. (The painting is poorly preserved, but the details of the design can be seen clearly in Schelte à Bolswert's reproductive engraving; cf. Max Rooses, *L'oeuvre de P. P. Rubens*, vol. 5 [Antwerp, 1886–92], pl. 334). In this landscape two couples are depicted in the lower left corner, and one of the men is shown working a large raised birdnet. Fairly common as an emblem of love, the birdnet was used as a symbol of love's power to ensnare when darkness falls, in Jacob Cats's *Emblemata moralia et oeconomica*, no. 12: "Voor de nacht, dient

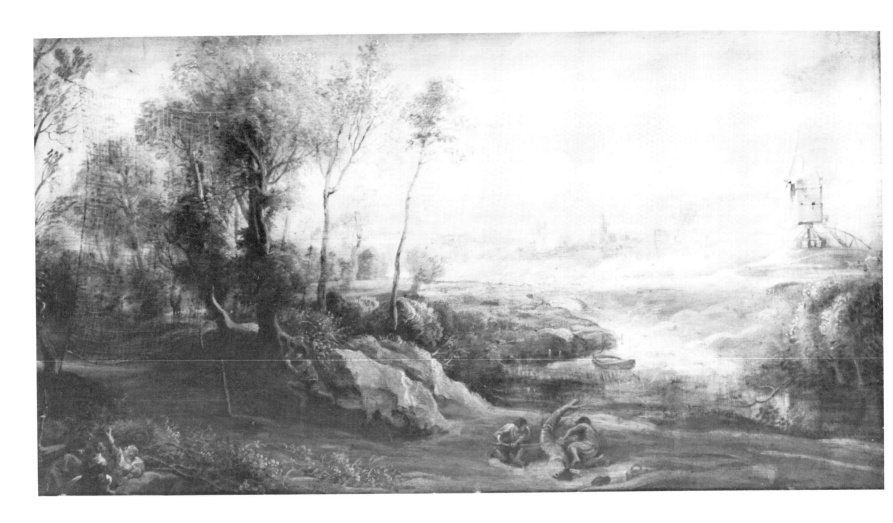

36. *Landscape with a Birdnet*, Paris, Louvre (Réunion des Musées Nationaux, Paris)

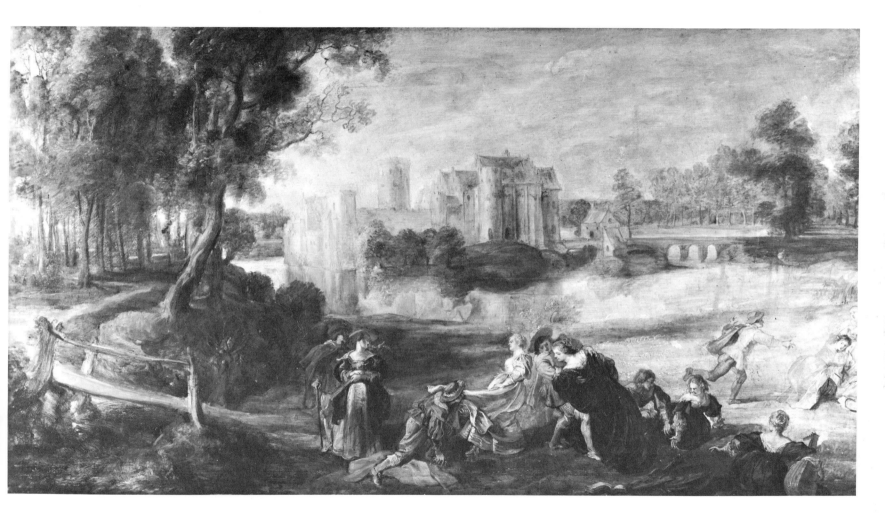

37. *Castle Park*, Vienna, Kunsthistorisches Museum

Shepherd before a Wood and *The Watering Place*

Two other pastoral landscapes appear in Rubens' *oeuvre*: *Shepherd before a Wood* (fig. 38; ckl. no. 12) and *The Watering Place* (fig. 39; ckl. no. 13).[104] These paintings are closely related; Rubens appropriated, almost unchanged, the entire design of the first, small picture for use in the second, large one.[105]

Rubens' claim to originality as a landscape painter could rest on these two works alone. Once again, he drew upon the rich family of forms found in Venetian graphic art, and perhaps on Northern compositional schemes as well, but he brings a new sensibility to

these traditions. In *Shepherd before a Wood*, the light of a sun low on the horizon articulates the land with warmth and grace, and Rubens paints with an unexpected delicacy; a faint, distant row of trees is viewed through the branches of a single tree in the foreground, and in the background appear such tiny details as swans, a hunter and hounds, and a cottage with a cart nearby. Nevertheless, a slight note of disharmony is sounded. A short, knotted willow clasps with its branches one of the trees on the left, seeming thereby to shake out two mischievous magpies, and within the woods a thin tree trunk has snapped.

A spot of light falls on the shepherd and flock. While the boy looks to the right, as if out of the painting, his seeking look is pointedly repeated in that of a single black ram. In this way Rubens hints at the shepherd's thoughts and establishes a situation of dynamic incompletion; once aware of the conventions of pastoral poetry, the viewer can easily supply the missing term—a partner for the shepherd.[106]

The Watering Place (fig. 39) presents, so to speak, act 2 of this pastoral drama. Here the viewpoint allows us to take in more of the landscape and to follow the direction indicated by the shepherd's glance—over the bridge and down the path. At the same time, the wedge of rocks and wood seen in the *Shepherd* has grown in size and wildness. One woody creature refuses to grow upright and instead seeks laterally with probing branches; a tree above, split open, falls down and meets the other. Now inhabiting the haunt

gewacht" (cf. Jacob Cats, *Alle de wercken*, vol. 1 [Amsterdam, 1700], p. 119). Rubens purchased an *Emblemata* by Cats in 1620 (cf. Max Rooses, "Rubens en Moretus," part 2, p. 180). In *Landscape with a Birdnet* the milky orb in the cloudy sky would seem to be the rising moon; J. R. Judson (*Dirk Barendsz.* [Amsterdam, 1970], p. 86), comparing this painting with an engraving after a design by Dirk Barendsz. representing Vespera (with an allegorical figure and a scene of bird-catching by lantern light), proposes that Rubens has depicted "Evening." In the emblematic tradition the windmill could stand for a variety of ideas, including the lover who without the "wind" of his beloved's love is immobilized; cf. *Emblemata amatoria*, Amsterdam (?), 1608 (emblem no. 9), attributed to Rubens' friend, the Dutch poet Daniel Heinsius. Such strained metaphors are hardly typical of Rubens' thought, however. I can offer no convincing interpretation of the woodcutters in the foreground of the painting.

Another of Rubens' landscapes on the theme of love is the pastel-hued *Castle Park* in Vienna (fig. 37; ckl. no. 28), which depicts gallants and their ladies sporting on the grounds of a château. The work is related to older illustrations of the month of May and to a whole class of poetry devoted to the delights of spring. As has often been observed, the couple on the left may well represent Rubens and his young wife Helena, whom he invites to join in the music and games, and thus the picture connects thematically with the Prado *Garden of Love* (fig. 27) as well as the Leningrad *Shepherds* (fig. 30).

104. Both in the National Gallery, London, and traditionally dated c. 1615–22.

105. Gregory Martin, "Two Closely Related Landscapes by Rubens," *Burlington Magazine* 108 (1966), pp. 180 ff.

106. Alexander Keirinx (1600–52), in his adaptation of *Shepherd before a Wood* (Brussels, Musées Royaux des Beaux-Arts), actually depicted a woman crossing the bridge and approaching the shepherd, though no amorous connection seems to be implied; the painting completely lacks the tensions of its model.

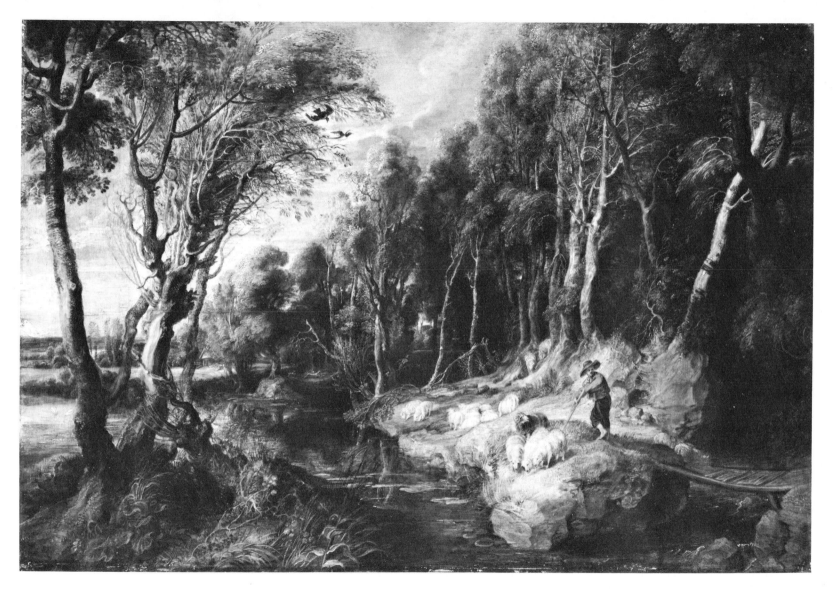

38. *Shepherd before a Wood*, London, National Gallery (Reproduced by Courtesy of the Trustees, The National Gallery, London)

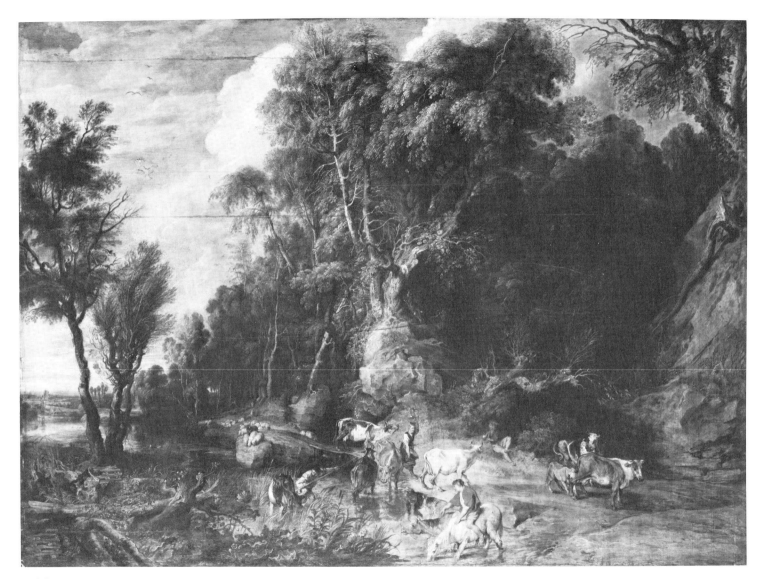

39. *The Watering Place*, London, National Gallery (Reproduced by Courtesy of the Trustees, The National Gallery, London)

of lascivious goats, and contrasting with the workaday attitudes of the herdsman and farmhand at center, the shepherd plays his pipes to a passing milkmaid, a Rubensian Amaryllis. A number of motifs create an underlying mood: two white birds in the air confront each other in a kind of foreplay, and a bull's eye strays toward an approaching white cow, she half-lured, it seems, by the invitation of the shepherd's tune. Rubens' sensuous conception of the world is shown as well in the nursing calf and the close clustering of sheep. *The Watering Place*, then, can be seen as a response to the idea generated by the *Shepherd*: wish fulfillment of a sort, but also an answering voice, as in a shepherd's poetry contest or singing match.

Ruben's perception of landscape as containing sexual tensions, so subtly expressed as to go almost unnoticed, nevertheless pervades these paintings. As we might expect, looking back from his works, the wood as a setting for lower forms of love is found in the Renaissance tradition. *The Watering Place*, in particular, seems to play upon the idea of a wooded landscape as a locus of licentiousness. A wood under this aspect, for example, appears in a painting in Berlin attributed to Paolo Fiammingo (fig. 40): here we see jagged rocks, caves, dark trees with broken branches, and a population of nymphs and drunken satyrs. The companion piece to this painting depicts a chaste subject, the hunt of Diana, in a wooded yet contrasting setting (fig. 41): now rounded hills replace rugged rocks and caves, and the foliage of healthy trees is bathed in sunlight.[107]

In 1955 E. Tietze-Conrat proposed that the larger program for

107. Cf. Berlin-Dahlem, Gemäldegalerie, *Katalog der ausgestellten Gemälde* (Berlin, 1975), p. 310, nos. 182A and 182B. The satyr landscape (no. 182A) also contains figures thought to represent Midas and Pan; significantly, Apollo is absent.

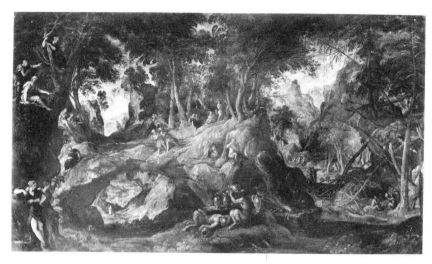

40. Paolo Fiammingo (?), *Nymphs and Satyrs*, Berlin-Dahlem, Staatliche Museen Preussischer Kulturbesitz, Gemäldegalerie Berlin (West)

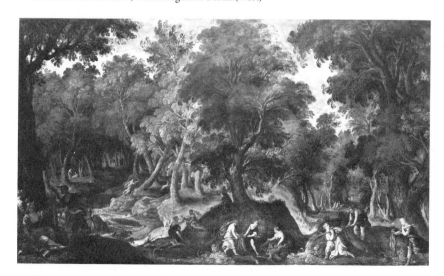

41. Paolo Fiammingo (?), *Hunt of Diana*, Berlin-Dahlem, Staatliche Museen Preussischer Kulturbesitz, Gemäldegalerie Berlin (West)

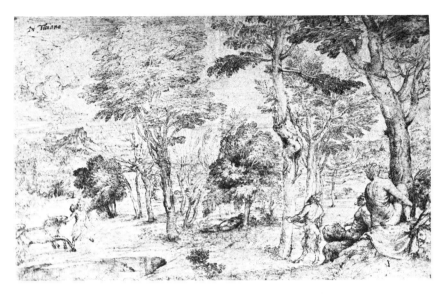

42. Titian, *Nymphs and Satyrs*, drawing, Bayonne, Musée Bonnat

this pair was "The Realm of Chastity and The Realm of Lasciviousness."[108] That the idea of a "Realm of Lasciviousness" existed, she deduced from the following passage in Lodovico Dolce's dialogue on colors:

Mario: Il satiro adunque dinoterà lascivia?
Cornelio: Così è. La qual cosa ha expresso mirabilmente Titiano in un sua paese; nel quale v'è una Ninfa, che si siede, insidiata

da due satiri; ne in quel paese vi si vede altro che satiri, mostrando di haverlo fatto per il paese della Lascivia; e forse imitando a un cotal modo, o più tosto alludendo alla pittura, che descrive Sannazaro nella sua Arcadia.[109]

Tietze-Conrat also relates this dialogue to Titian's drawing *Nymphs and Satyrs* (fig. 42), which she believed served for the (lost) landscape mentioned by Dolce's Cornelio. The drawing does seem to allude, rather loosely, to the *Arcadia*'s most famous ekphrasis.[110] Sannazaro's description begins with a simple pastoral scene. But what the poet says he finds most pleasing to examine attentively is the following incident depicted in the painting:

. . . certain naked Nymphs . . . were standing, half hidden as it were, behind the trunk of a chestnut tree, laughing at a ram who because of being intent on biting an oaken garland that was hanging before his eyes was forgetting to crop the grasses that grew about. Therewith four Satyrs with horns on their heads and goatish feet were stealing very softly through a thicket of mastic trees to seize them from behind. Becoming aware of this, they hurled themselves into flight through the thick forest, not even avoiding the brambles or other things that might do them injury. One of them who was quicker than the others had clambered up into a hornbeam tree, and from there was defending herself with a long branch held in her hand: the others in their fear had thrown themselves into a

108. E. Tietze-Conrat, "Titian as a Landscape Painter," *Gazette des beaux arts* 45–46 (1955), p. 18.

109. *Dialogo . . . nel quale si ragiona delle qualità, diversità, proprietà dei colori* [Venice, 1565], carta 51 verso; cf. Tietze-Conrat, p. 15.
110. Book 1: identified by Tietze-Conrat, p. 19. Rubens' own *Nymphs and Satyrs* (Madrid, Prado) is close in its conception to Titian's drawing.

river and were swimming it in their flight, and the crystal waves were hiding little or nothing of their white bodies. But when they saw themselves escaped from danger they remained seated on the other bank, vexed and short of breath, drying out their dripping hair; and from there with gestures and with words it seemed that they wanted to reprove those Satyrs, that had not been able to come up with them.[111] [Book 1]

To be sure, no nymphs or satyrs sport in the *Shepherd* or *The Watering Place*. But the spirit of free desire embodied by such creatures still lurks in these landscapes' darker parts.

The notion of thematic genres raises the question of mode, a critical subset that has to do with expression and decorum.[112] The three works just discussed are all pastoral. But such variables as the size of the picture, the lighting system, the handling of paint, and the motifs' arrangement and affective qualities (arising from artistic style as well as conventional poetic associations) differ considerably. Between *The Watering Place* and the *Shepherds*, for example, the modal variations reside in the earlier picture's near, dark, wooded cliff versus the other painting's far blue mountain, in boy versus man, and in peasants at work versus rustic lovers. The mode changes in every landscape by Rubens (save the pendants), something that cannot be said of the oeuvre of any landscape specialist. But variety was not seen by Rubens as a value in itself; rather, each landscape had to be unified and consistent throughout, its variety kept to a particular kind, in a particular mode; that is, the painting had to have an expressive unity of particular power with its own structure of meaning.

Ruben's figures, too, function in ways that we could not expect to find in the works of landscape specialists. As dramatis personae, his figures are made to perform crucial roles, explicitly articulating what is implicit in the larger landscape. Yet as we have seen, in some cases Rubens effects a reversal of the usual function of landscape as expressive background, which is to correspond to the *affetti* embodied in the human figures or to comment on the stories they enact. In the *Pond*, for example, the milkmaids are made to seem more silent, more unaware, than the animated landscape around them. Or the characters who inhabit Rubens' landscapes may appear only to echo nature's forces and processes, and what these things are made to signify. Thus, shipwrecked men nearly overwhelmed by nature's fury, others on the shore, saved, demonstrate the changeability of Fortune—a theme more fully embodied in the divided storm landscape. And the carters act out, in miniature, the drama of nature in its unceasing struggle for balance among the opposing elements that give it substance. Without these figures the landscapes would be reduced to scenery—of however magnificent a kind—and their power would be unintelligible. Instead, figures and setting truly unite in Rubens' landscapes, expressing themes as closely connected with man's feelings and fate as any that the visual arts ever were asked to convey.

111. Jacopo Sannazaro, pp. 42 f.
112. For an introduction to the concept of pictorial mode, see Jan Bialostocki, "Das Modusproblem in den bildenden Künsten," in his *Stil und Ikonographie* (Dresden, 1965).

3. RUBENS' RURAL LANDSCAPES

This chapter is devoted to three landscapes of the same type. Each painting includes cattle and so can be called "bucolic" in the most literal sense. But these works are not pastoral in the way in which we have here used that term, with its emphasis on shepherds in love and at leisure, nor do they contain compressed fantasy settings mirroring lusts and longings. The characteristic subject matter of this kind of landscape, which I call "rural," consists of crops, pastureland, copses, streams, cattle, and peasants at work; moreover, all of Rubens' rural landscapes contain details suggesting that the scene is Flemish.[1]

FARM AT LAEKEN AND SOME EARLY DRAWINGS

Farm at Laeken (fig. 43; ckl. no. 11)[2] dating from about 1617–18, is a large cheerful painting depicting a summer day in the country. Three farm women are shown at work, one carrying a basket of

fruit, another pouring milk, and a third milking. The women are joined by four cows, one of which, pregnant, is being eyed by a bull. In the right middle ground, a farmer waters two horses. In addition to these figures and animals, an array of details catches the eye: birds pecking on the ground and a flock beating their wings in the sky, a wooden milk bucket and a shiny copper pitcher; a wheelbarrow laden with vegetables, and a patch of grasses and thistle; tall, interlacing trees and diaphanous white clouds; a low-lying stream and an ascending road; and, framed by trees, a barn and church.

The composition has a light, open side as well as a dark, closed side, and it is further bisected—as well as supported—by the stately, graceful, canephorelike woman at center. To a certain extent Rubens organizes the picture to create an effect of depth. The chromatic structure corresponds to the traditional three-color scheme, graded through a warm foreground (typically accentuated with a brilliant area of red), a green middle ground, and a cool blue background. Dark and light strips alternate, and forms progressively diminish as they recede into the distance. But the painting is nonetheless the most planar of Rubens' rural landscapes, with motifs linked on the surface as if by an invisible net. Thus the upright

1. The three rural landscapes discussed in this chapter are all generally related to the flourishing in the sixteenth and seventeenth centuries of poetry written in praise of peaceful rural life, a subject taken up in chapter 6.
2. London, Royal Collection.

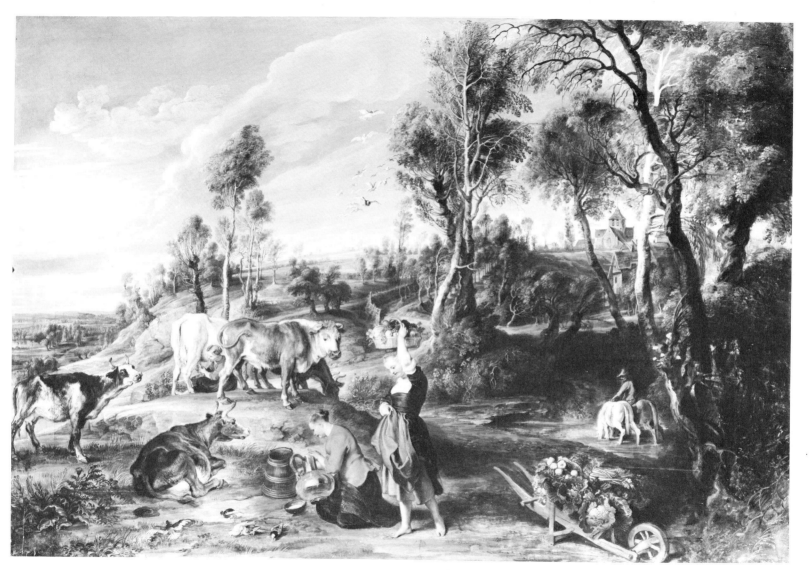

43. *Farm at Laeken*, London, Royal Collection, Her Majesty the Queen (Copyright Reserved)

form of the central figure is joined with the fence bordering the lane, which is as much above as beyond her; the horns of the cow lying down bracket a hoof of the bull, and the bull itself forms part of a tightly knit group abutting trees that bind middle ground, background, and sky. On the right, Rubens stacks the wheelbarrow, the small-scale farmer and horses, and the barn and church. In this respect, the picture is reminiscent of early Flemish still lifes, with their feasts spread out upon a tipped-up table.[3]

Thematically, some of the motifs in the *Farm* seem contrived in an emblematic spirit—the perfectly arranged still life of fruit, for example, atop a blonde head, and the careful selection of vegetables set in a wheelbarrow, although no orchard or field is in sight. The display Rubens arranges on this tilted plateau landscape can be read, indeed, as an artful eulogy to country life and abundance.

Unlike the landscapes discussed in chapter 2, the *Farm* has a recognizably Flemish character. Traditionally it has even been thought to depict the outskirts of Brussels; the identification is found in old descriptions of the work, and the church in the background is said to resemble the church of Notre Dame that once stood in the village of Laeken. The *Farm* looks Netherlandish, however, not only because of the style of the church depicted but also because of the way in which the entire painting echoes the greatest Flemish landscapes of the previous century, Pieter Bruegel's cycle of the months. Bruegel's *Harvest* (fig. 89), for example, offers the parallel of a plateau topped by a church viewed through an opening of trees, a distant valley, and the theme of peasants at

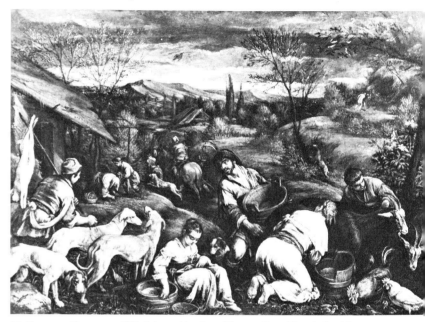

44. Francesco Bassano and Workshop, *May-June*, Vienna, Kunsthistorisches Museum

work. The *Farm* may also reflect Rubens' study of Titian's seminal design, the *Milkmaid* (fig. 12), as well as the works of the Bassani, with their robust peasants, piles of produce, and agricultural implements arranged in front of a landscape (cf. fig. 44).[4]

4. It is likely that Rubens knew Bruegel's *Months* firsthand. As a young man he might have seen them in Antwerp, as they were in the possession of the city from an unknown date until 1594. In 1594 they were given to the Archduke Ernst, who died the following year. Whether the paintings then remained in Brussels—where Rubens would have had easy access to them—or whether they were sent to Vienna at an early date, is not known. Apparently conflicting documents dating from after Rubens' death refer to a series of months being in Vienna as well as Brussels; cf. Fritz Grossmann, *Pieter Bruegel: Complete Edition of the Paintings*, 3rd rev. ed. (New York, 1973), p. 197.

3. Regarding the way in which Rubens composed this painting by adding on pieces in various stages, see Oliver Millar, "Landscapes in the Royal Collection: The Evidence of X-Rays," *Burlington Magazine* 119 (1977), p. 631.

Drawings: Peasants, Cattle, and Wagons

Particularly important in giving concrete shape to Rubens' vision of landscape was the artist's practice of executing drawings from life. For this urbane painter, who may have never plowed a furrow or milked a cow, drawing provided a way of knowing rural nature with a particular intimacy; and it gave him a means of controlling the plenitude of form, space and texture he found in the countryside, so that he could re-create it in his art.

The central figures in *Farm at Laeken* are based on drawings that Rubens sketched from life, apparently from the same female model. One study shows the woman carrying a pitcher (fig. 45),[5] and the other has her kneeling (fig. 46).[6] Both drawings were made for an *Adoration of the Shepherds* (Marseilles), that is, for a religious painting with rustic characters.[7] Rubens endows these figures with a combination of amplitude, solidity, and grace, and this is achieved through the surest of means—a harmonious weaving and echoing of firm, elegant curves, and a sensitive, sensuous modeling of fabric and flesh. Such drawings reveal that from the first Rubens envisioned rustic figures as noble personages. (At this stage of his development as a landscape painter he did not mind that the borrowed pose of the *Farm*'s central figure is curiously unsuited to her load-bearing task; clearly Rubens wished less to depict a farm woman performing her work than to create a personification of rural plenty.)

A careful, finished drawing of a bullock by Rubens (c. 1618; fig. 47)[8] is directly related to *Farm at Laeken*. The animal is shown in lengthy profile and stares out at the viewer, as such massive but often surprisingly alert creatures are wont to do. This bull was used to lend a large male presence to the painted landscape.

Also connected with *Farm at Laeken* is a design presenting in three quarter back view a cow being milked (c. 1615–18; fig. 48). We are shown the animal's bony protrusions, the swelling veins just beneath the hide, its folds of flesh, full udders, and the milkmaid sitting comfortably beside.[9]

Several drawings dating from the first period of Rubens' activity as a landscape painter have the quality of vignettes. One such study, made about 1618–20, portrays a peasant girl churning butter, a motif Rubens seems never to have incorporated into a painting (fig. 49).[10] But the girl and churn —each sturdy and straight on axis, and defined by soft curves bathed in sunlight—fill the page in such a way that the design itself has a look of self-sufficiency.

Another chalk study, of a farmer threshing near a ladder wagon, makes a picture that is even more compositionally complete (c.1615–17; fig. 50).[11] The drawing of the visually complicated,

5. B.-H., no. 98.

6. Vienna, Graphische Sammlung Albertina, *Die Rubenszeichnungen der Albertina zum 400. Geburtstag* (Vienna, 1977), no. 23: B.-H., under no. 98; Held, under no. 90. Another drawing of a farm woman, perhaps the same model, is in the Albertina (Vienna, Graphische Sammlung Albertina, no. 25); it served as a study for a figure in the *Adoration of the Magi* in Rouen.

7. The painting formed part of the predella of the *Adoration of the Magi* in the church of St. John, Malines, commissioned late in 1616; cf. B.-H., under no. 98.

8. Vienna, Graphische Sammlung Albertina, *Die Rubenszeichnungen*, no. 30; Held. no. 91.

Rubens' drawings of rural motifs are very difficult to date. I have relied here on Held's dating, which seems plausible in every case.

9. B.-H. no. 100; Held, no. 88. This drawing was also used for *The Polder*, discussed below.

10. B.-H., no. 177; Held, no. 95.

11. B.-H., no. 101; Held, no. 129.

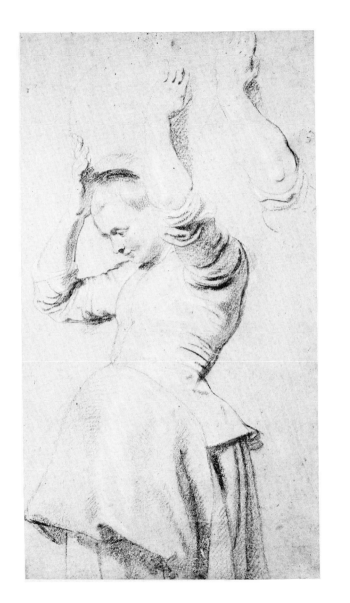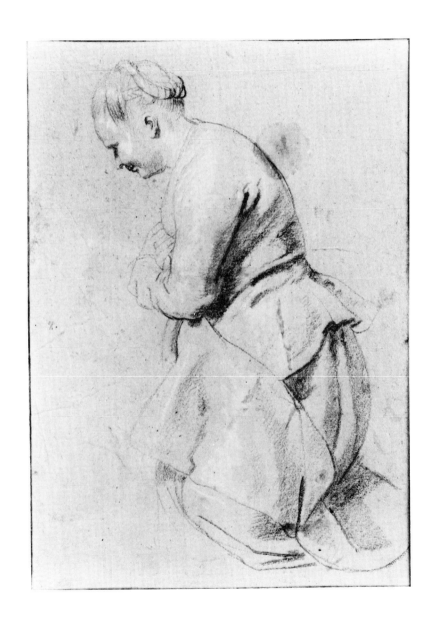

45. *Woman Carrying a Pitcher*, drawing, Berlin-Dahlem, Staatliche Museen Preussischer Kulturbesitz, Kupferstichkabinett

46. *Woman Kneeling*, drawing, Vienna, Graphische Sammlung Albertina

47. *Bullock*, drawing, Vienna, Graphische Sammlung Albertina

48. *Woman Milking*, drawing, Besançon, Musée des Beaux-Arts

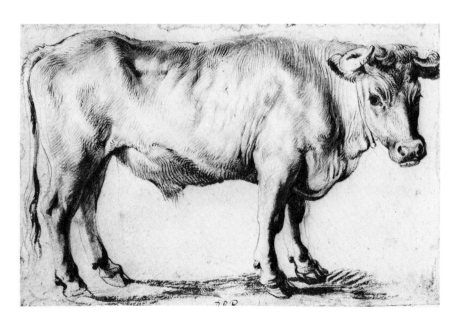

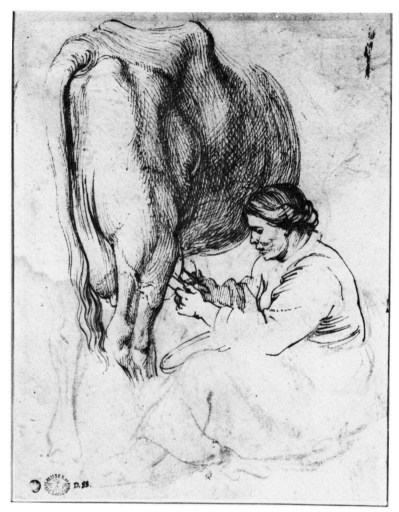

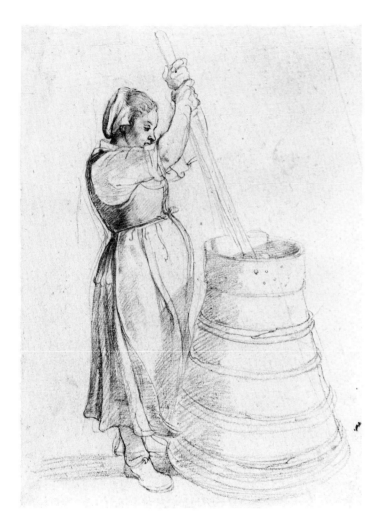

49. *Girl Churning*, drawing, Chatsworth, Devonshire Collection (Reproduced by Permission of the Trustees of the Chatsworth Settlement, and the Courtauld Institute of Art)

50. *Farmer Threshing near a Wagon*, drawing, Chatsworth, Devonshire Collection (Reproduced by Permission of the Trustees of the Chatsworth Settlement, and the Courtauld Institute of Art)

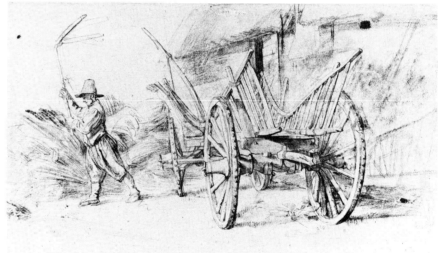

sharply foreshortened wagon with its wonderfully flaring spokes and rungs, is firm, confident, and precise. Rubens took over the motif unchanged for the farmyard scene in his *Prodigal Son* (c. 1615–17; fig. 95; ckl. no. 1).

Rubens must have made many sketches of agricultural implements and rustic conveyances. Only one other such study, however, has survived (c. 1618–20; fig. 51): two views of a streamlined, low-slung hay wagon, arranged elegantly on the page, and exact enough to serve as a wainwright's model.[12]

51. *Two Wagons*, drawing, Berlin-Dahlem, Staatliche Museen Preussischer Kulturbesitz, Kupferstichkabinett

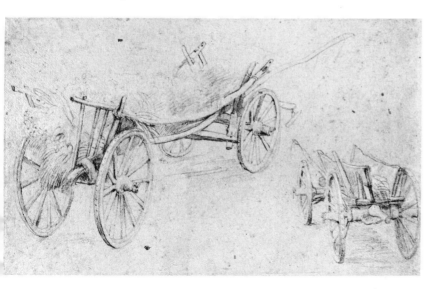

Drawings: Trees and Plants

Already in two drawings dating from before 1610, Rubens showed a preference for "grandly twisting trees."[13] In the first, a preparatory sketch for an equestrian portrait of the duke of Lerma (1603; fig. 52),[14] the palm tree enhances the physical stature of the figure, provides a natural baldachin, and serves as a symbol of victory. In the second drawing, depicting St. Ignatius in a landscape (1609; fig. 53),[15] Rubens begins to envision the kind of tense relationship among elements in nature that we saw in the *Carters*. The long upward thrust of the tree behind Ignatius contrasts dramatically with the compact form of the kneeling saint, yet has a pliancy and "passion" echoing that of the figure. This tree, lacking a firm core and tough sinews, seems fairly to wriggle away from the toothy grasp of a nearby bush.

Around 1615 Rubens' way of visualizing trees changed as he began to make studies from life. Presumably the earliest landscape drawing we have from his hand is *Country Lane* (c. 1615–18; fig. 54), showing a fence that has been made by attaching branches laterally to trees lining the road.[16] Perhaps it was the clear structure

12. B.-H., no. 102; Held, no. 133. Rubens' depictions of wagons are discussed by the agricultural historian J. Theuwissen, who praises their accuracy ("De kar en de wagen en het werk van Rubens," *Jaarboek van het Koninklijk Museum voor Schone Kunsten te Antwerpen* [1966], pp. 199 ff., and "Het werk van Bruegel en Rubens als beelddocument," *Volkskunde* 72 [1971], pp. 345 ff.).

13. Julius S. Held, "Rubens and the *Vita Beati P. Ignatii Loiolae* of 1609," in *Rubens before 1620*, ed. J. R. Martin (Princeton, 1972), p. 98.

14. Held, no. 71.

15. The drawing was published by Held, 1972.

16. New York, Morgan Library, *Drawings from the Fitzwilliam Museum, Cambridge* (New York, 1977), no. 88; B.-H., no. 206; Held, no. 130.

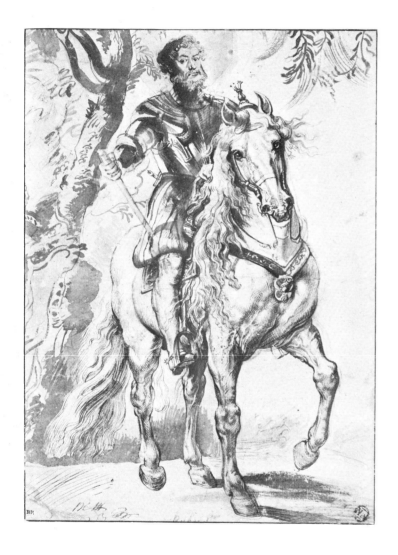

52. *Duke of Lerma*, drawing, Paris, Louvre (Réunion des Musées Nationaux, Paris)

53. *St. Ignatius in a Landscape*, drawing for the *Vita Beati P. Ignatii Loiolai* (Rome, 1609), Paris, Louvre (Réunion des Musées Nationaux, Paris)

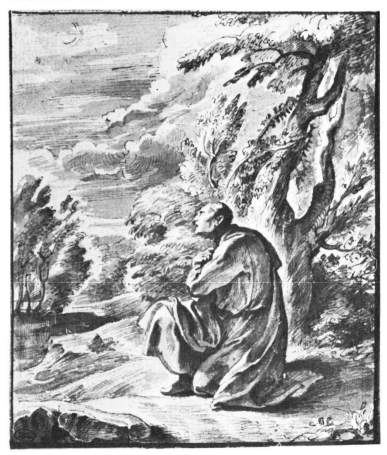

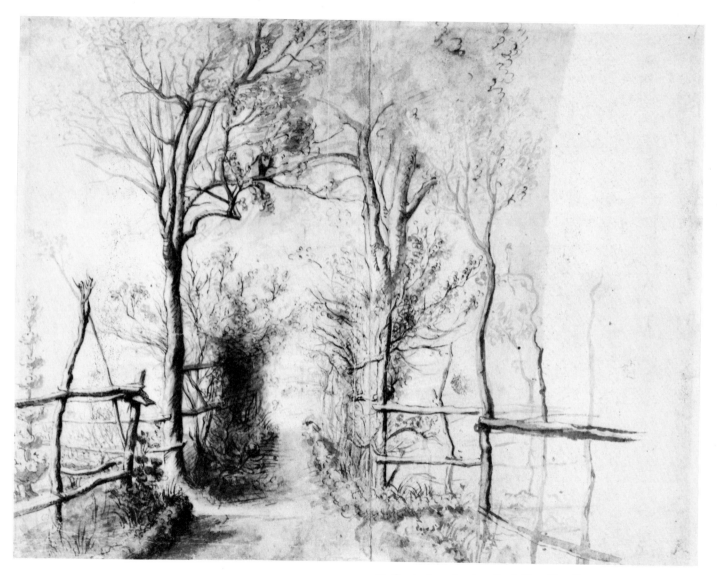

54. *Country Lane*, drawing, Cambridge, Fitzwilliam Museum

of the rural avenue that inspired Rubens to examine a familiar sight—one in which outdoor scenery already exhibits an order imposed by man and thus a fitting motif for an artist actively seeking his own grip on nature.[17]

Four of Rubens' sketches of trees and plants appear to date from before 1622 (figs. 55, 56, 57, 58). None of the first three can be connected with a particular painted landscape; they seem to have functioned, therefore, as did Rubens' sensitive chalk drawings of models in the studio, "academies" made without a specific figure painting in mind. Such sketches served as aids to invention by providing a means of simultaneously finding the truth of the form and liberating the imagination. Rubens' drawings of trees and plants, elements that were to be among the chief "figures" in his rural landscapes, document that sincerely naturalistic aspect of his art; with them the word "study" seems particularly apt.

Concerning the only drawing we have by Rubens of a single tree (fig. 55), Held notes that the artist "appeared to have liked old willow trees with their gnarled, pitted, and rough-surfaced trunks, and their thin and graceful branches."[18] Old willows, which are inherently picturesque, had appeared earlier in the works of Flemish painters, but never before had they been endowed with such simple monumentality.

A drawing of a very different sort of motif, a wild cherry tree with brambles and weeds, reveals the same sensibility (fig. 56).[19]

17. A series of landscape drawings that has often been attributed wholly or partially to Rubens and ascribed to his early years is discussed by Julius S. Held ("Rubens and the *Vita Beati*," pp. 130–32). Like Held, I cannot accept any of the drawings as being from the hand of Rubens.
18. Rowlands, no. 197; B.-H., no. 106; Held, no. 134. See also B.-H., no. 106.
19. Rowlands, no. 198; Held, under no. 131; Count Antoine Seilern, *Catalogue of the Collection at 56 Prince's Gate: Flemish Paintings and Drawings* (London, 1955), no. 63.

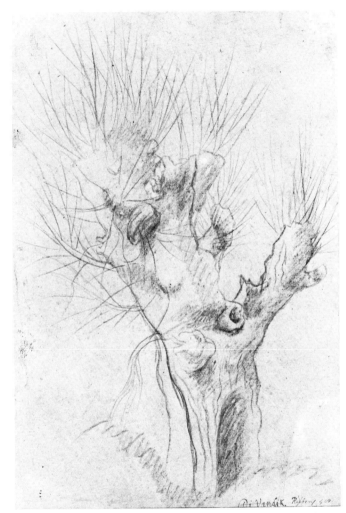

55. *Willow Tree*, drawing, London, British Museum (Reproduced by Courtesy of the Trustees of the British Museum)

56. *Wild Cherry Tree and Bramble*, drawing, London, Prince's Gate Collection (Reproduced by Permission of the Executors of the Will of the Late Count Antoine Seilern)

This sketch, large in size yet rendered with the utmost delicacy, is drawn on rough oatmeal-colored paper, with a variety of chalks: black for the contours of branches and leaves, which are heightened with white, and red and yellow for the berries, buds, and blossoms. Rubens' desire to render the motif accurately is shown not only by the gently searching path of the lines but also by his annotations concerning the species and colors of the plants. He wrote on the drawing such observations as: "blue berries like bedewed grapes"; "the leaves fine green shimmering but at the back a bit pale and dull"; "the stems reddish"; "light green stems"; "the leaves entirely green"; "yellow," "brown-green," "white bistre"; "the backs of the leaves lighter."[20] As Rubens studiously sketched, then, he seems already to have been thinking of the varieties and shades of color and the lighting he would use to make the plant reappear in a painting.

The third drawing, of a tree trunk winding up out of a patch of brambles, shows a somewhat different approach to a similar motif (fig. 57).[21] Instead of delineating each leaf, bud, and stem, so that three separate plants can be distinguished, as in the previous study, Rubens now seizes the wild, elusive motif as a whole and expresses it in a dynamic interplay between contours and shading, light and dark, chalk and ink, solid forms and empty shadows. An inscription on the sketch, which though written in seventeenth-

20. The annotations are cited and translated in Seilern, no. 63. Although Seilern dates the drawing of the cherry tree and brambles late (1630–40), Held (under no. 131) connects it with a drawing of two trees which he places c. 1617–19. The rubbed surface of the present drawing may in fact give it an atmospheric quality that it originally lacked. A motif similar to the bramble described in the drawing is already found in the left foreground of *The Watering Place* (fig. 39), which is unanimously placed in the early group of Rubens' landscapes.

21. Rowlands, no. 199; B.-H., no. 105; Held, under no. 131.

century Flemish is apparently not in Rubens' hand, has been translated: "Fallen leaves and in some places green grasses peep through."[22] Whether or not these words represent a record of Rubens' observations, they accurately convey the effect of layers of growth seen in the drawing.

Closely related to the *Tree Trunk and Bramble* is perhaps the finest landscape study by Rubens, the large and impressive *Two Trees* in the Louvre (c. 1617–19; fig. 58).[23] Rubens began with black chalk, but here used it only for the broadly visualized underdrawing. He then articulated this graphic substructure in brown ink applied with the kind of brilliant penwork that gives a distinctive character to every part. Once again, chalk and ink interact, so that the whole becomes a dynamic mixture of the linear and the pictorial, of precise hatching and suggestive scribbles, a work in which substance, atmosphere, and space are at once clearly felt.

The subject is treated in a completely new and complex way. One tree, having by some force been yanked from the ground, exposes fragments of root system, clods of earth, and stubs of wood. The foreshortened trunk issuing from this fantastic graphic mass is nevertheless muscular and firmly contoured, looking energetic still, with torsion in every limb. It forks out into two main branches, one resting on the ground, the other shooting upward to branch

22. Rowlands, no. 199; Held, under no. 131. Held is convinced that the inscription is not in Rubens' hand, but accepts the drawing itself as autograph.

23. Antwerp, Koninklijk Museum voor Schone Kunsten, *Peter Paul Rubens: Paintings—Oil Sketches—Drawings* (Antwerp, 1977), no. 143; B.-H., no. 104; Held, no. 131.

57. *Tree and Bramble*, Chatsworth, Devonshire Collection (Reproduced by Permission of the Trustees of the Chatsworth Settlement, and the Courtauld Institute of Art)

58. *Two Trees*, drawing, Paris, Louvre (Réunion des Musées
Nationaux, Paris)

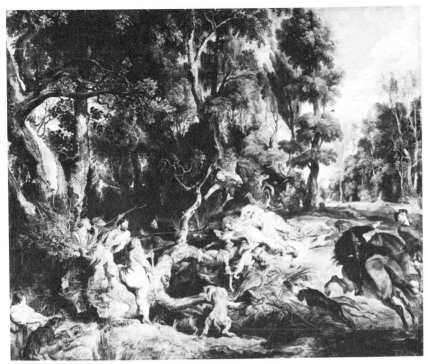

59. *Boar Hunt*, Dresden, Staatliche Kunstsammlungen, Gemäldegalerie Alte Meister

been too confusing a corner of nature for most artists to tackle yields an order to Rubens' eye and submits to his control as a draftsman. The natural disorder of the scene can quickly be grasped and yet sustains long looking. In this work, for all its magnificence only a study, Rubens reveals his experience as a history painter. He makes the drawing embody both setting and "characters," endowing the trees with gestures expressive of passion and even conceiving a drama between them.

Rubens' Louvre drawing is unusual with respect to his other tree studies, in that it is connected with a specific landscape, the Dresden *Boar Hunt* (fig. 59; ckl. no. 6). In the painting the transposed fallen tree is shown as a participant in the event, in fact as the central "actor," responsible for having caught the boar.[24] The tempestuous vision of natural forms and forces in the drawing thus seems to be explained, in part, by Rubens' conception of the violence of the hunt. But whether the motif gave Rubens the idea for the picture or whether meditations on the theme of the latter made him notice the two trees is not known; all we can say is that similar qualities of wildness and excitement bind both wood and chase.

THE POLDER

A few years after creating the large, bright, and ambitious *Farm at Laeken*, Rubens took up again the rural theme, stating its elements in different terms. *The Polder*, or *Landscape with Eleven Cows* (c. 1620; fig. 60; ckl. no. 19), is a small picture by Rubens' standards, and

again. On a small knoll, next to this sunlit hero of a fallen tree, its flabby companion leans back tensely and at the same time projects outward its long, thin, trembling branches—as if in frightened reaction to a thundering crash. The live and the felled tree, visually joined like two prongs by the knot of roots, frame a bit of scenery, part of a clearing and the surrounding shrubs. What might have

24. Evers discusses the active role of the tree in the scene (1942, pp. 232–33).

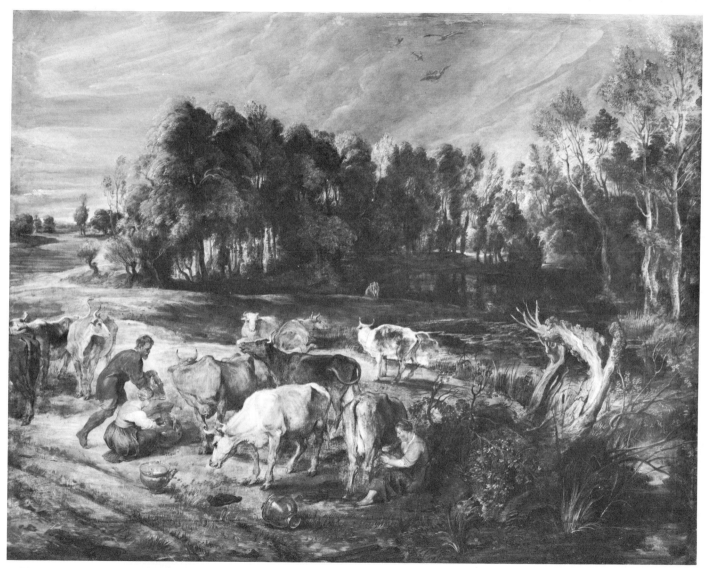

60. *The Polder*, Munich, Alte Pinakothek

it conveys a corresponding sense of intimacy. Unlike *Farm at Laeken*, with its boldly affirmed surface, the land here is depicted as both superficially and spatially absorbent: soft and wet, yielding to the wheels of a passing wagon, and drawing in the viewer with its wide, sweeping curves. Rubens still cherishes the glance of copper next to dull dung, the swelling of the earth and a slightly curving horizon (suggestive of space beyond the frame), the picturesque interaction of weather-worn trees, and a strong red garment in the foreground. But in *The Polder*, one might say, he rejects the rural opulence of the earlier painting for a quieter, more unified scene. The same colors, once pristine and glowing, are now muted; a blue sky has given way to gusting storm clouds; the land has flattened; magnificent bunches of trees have become a copse; and discrete specimens of well-bred cattle now read as a herd.[25] The unity is structural as well as thematic. Contours are shared; forms repeat, echo, enclose, and pinpoint each other; hues melt into tone. And the figures are now much less physically assertive; they perform their work patiently and in tacit fellowship. The male peasant, moreover, who is of unusually noble mien, almost chivalrously assists the milkmaid. And she herself has a graceful, even regal bearing: a drawing by Rubens of a woman crouching (c. 1617–18; fig. 61) served, in fact, both as a model for this milkmaid and also for the daughter of the Greek king Lykomedes.[26]

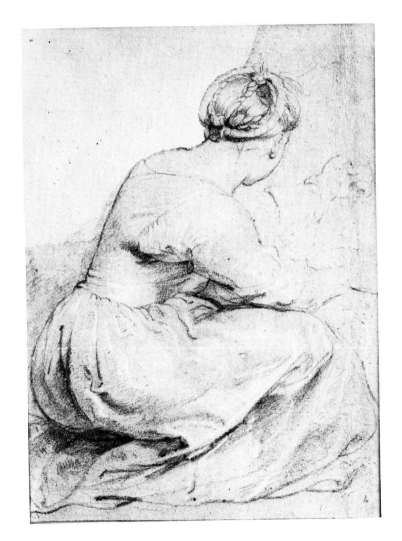

25. Kieser long ago observed this new kind of unity in *The Polder* (*Die Rubenslandschaften* [Munich, 1926], p. 18).

26. Vienna, Graphische Sammlung Albertina, *Die Rubenszeichnungen*, no. 26: B.-H., no. 99; Held, no. 90. The painting for which the drawing was originally made is *Achilles among the Daughters of Lykomedes* (Madrid, Prado; executed by April, 1618; cf. Held, no. 90).

61. *Peasant Woman Crouching*, drawing, Vienna, Graphische Sammlung Albertina

Realistic in form and varied in pose, Rubens' cows—so well represented in *The Polder*—were even deemed worthy of separate study by other artists. Paul Pontius engraved a sheet depicting six of these animals and three cow heads. Cows from three of Rubens' landscapes (the *Pond*, *The Watering Place*, and *The Polder*) are reproduced in the print, which derives from a drawing that was itself copied by several draftsmen (see, for example, fig. 62). It is not surprising that artists might wish to crib from the catalog of ready-made cows that Rubens' bucolic scenes provided. The most amusing echo of his invention is a painting attributed to Jan Brueghel (fig. 63) that repeats all the cows, peasants, and pots of *The Polder*.[27]

The Polder is one of the most convincing and appealing evocations of rural lowlands to have been produced in the seventeenth century, and it reflects a growing desire in the North for true-to-life views of the native land. If the painting is compared with contemporary landscapes being made in Holland, moreover, it appears surprisingly "advanced" in its subdued tonality, low viewpoint, and double diagonal structure—all characteristics associated with the vanguard "national" style of Dutch landscape.[28]

The extraordinary group of landscapes, scenes of country life, and drawings of rural motifs that Rubens had painted by the early 1620s should be evidence enough to dispel a popular notion: that the artist's interest in subject matter of this type appeared only during his later years. The pressing demands of such large commissions as the Marie de Médicis cycle (1622–25), as well as the diplomatic activities of the later 1620s, may have interrupted his activity as a landscape painter. But, his journeys completed in 1630, Rubens returned once again to his rural muse.

RETURN FROM THE FIELDS

The native Flemish tradition becomes more evident in Rubens' next rural landscape, the *Return from the Fields* (fig. 65; ckl. no. 7). Generally considered to date from the early 1630s, this large painting, of pronounced oblong format, presents a panoramic view of a flat

27. Emil Kieser (*Die Rubenslandschaften*, n. 1) observed that Jan Brueghel had copied motifs from *The Polder* in his painting *Country Life* (Madrid, Prado; fig. 63). Since Jan died in 1625, we have a *terminus ante quem* for *The Polder*. It should be noted that the size and proportions of Jan's painting (130 by 293 cm.) are unusual for him, and in the past the suggestion has been made that it is a work of Jan the Younger. Nevertheless, the most recent catalogue of the Flemish paintings in the Prado, like the previous one, maintains the attribution to Jan the Elder, affirming that the painting is completely autograph and typical of works he produced in the last period of his activity (Matias Díaz Padrón, *Museo del Prado: Catalogo de pinturas, 1, Escuela Flamenca: Siglo XVII*, 2 vols. [Madrid, 1975], no. 1444). Further evidence of Jan's interest in Rubens' rendering of cows is suggested by the attribution to him of the British Museum sheet of cows, one of the versions of the sketch that served as a model for Pontius's engraving. On the drawings related to Pontius's print, see Julius S. Held, *Rubens: Selected Drawings*, vol. 1 (London, 1959), pp. 12–23, and Rowlands, no. 200, with further references.

28. Wolfgang Stechow has traced the development of seventeenth-century Dutch landscape painting in great detail (*Dutch Landscape Painting in the Seventeenth Century* [London, 1966], especially ch. 1).

I have not included in this discussion of Rubens' bucolic works the famous *Landscape with Cows and Duckhunters* in Berlin (fig. 64; ckl. no. 3). In spite of the admiration accorded this landscape in the literature, and its undeniably brilliant passages, the painting still strikes me as having the quality of a pastiche. The figures and cows, for the most part taken from two other landscapes, are unimaginatively strung out along the foreground, and I find the proximity of the pissing end of a cow and a milkmaid's bucket both disturbing and un-Rubensian.

Jan Kelch's extensive catalogue entry devoted to *Landscape with Cows and Duckhunters* became available after the present study was completed (*Peter Paul Rubens:*

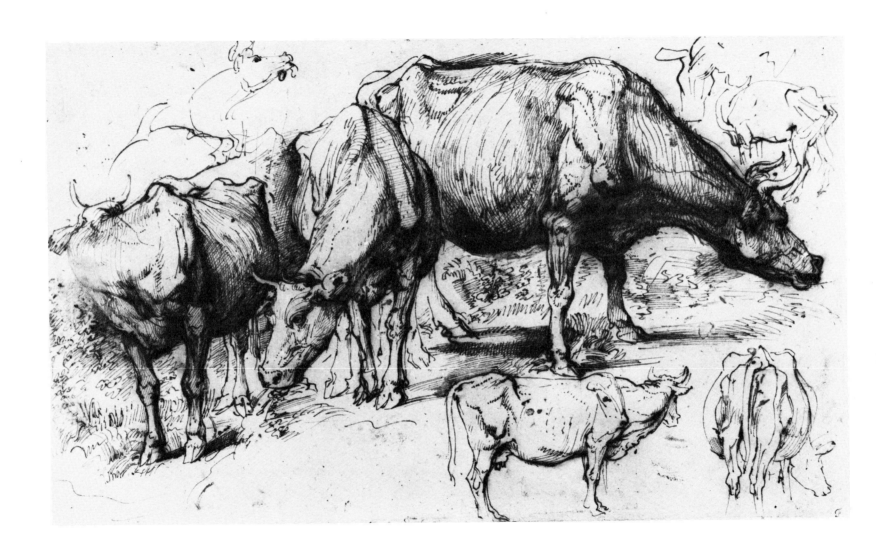

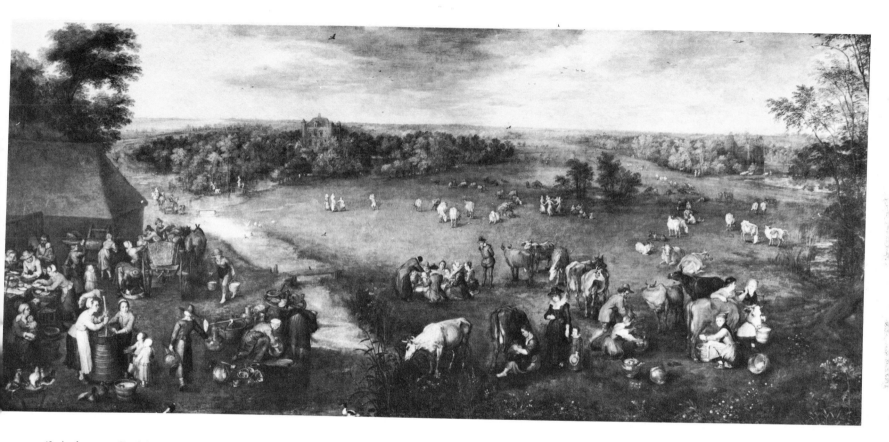

62. Anthony van Dyck (?), *Cows*, drawing, Chatsworth, Devonshire Collection
(Reproduced by Permission of the Trustees of the Chatsworth Settlement, and
the Courtauld Institute of Art)

63. Jan Brueghel, *Country Life*, Madrid, Museo del Prado (Rights reserved © Museo
del Prado, Madrid)

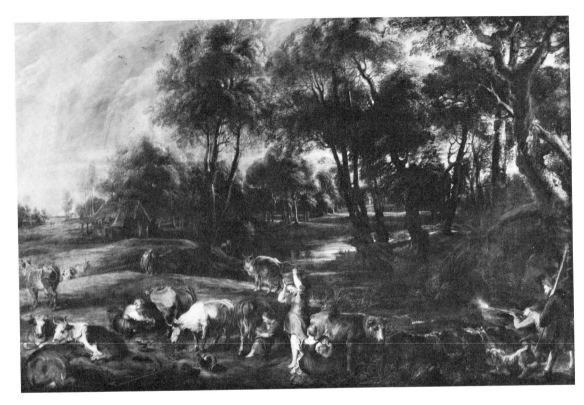

64. Rubens and Assistants (?), *Landscape with Cows and Duckhunters*, Berlin-Dahlem,
Staatliche Museen Preussischer Kulturbesitz, Gemäldegalerie Berlin (West)

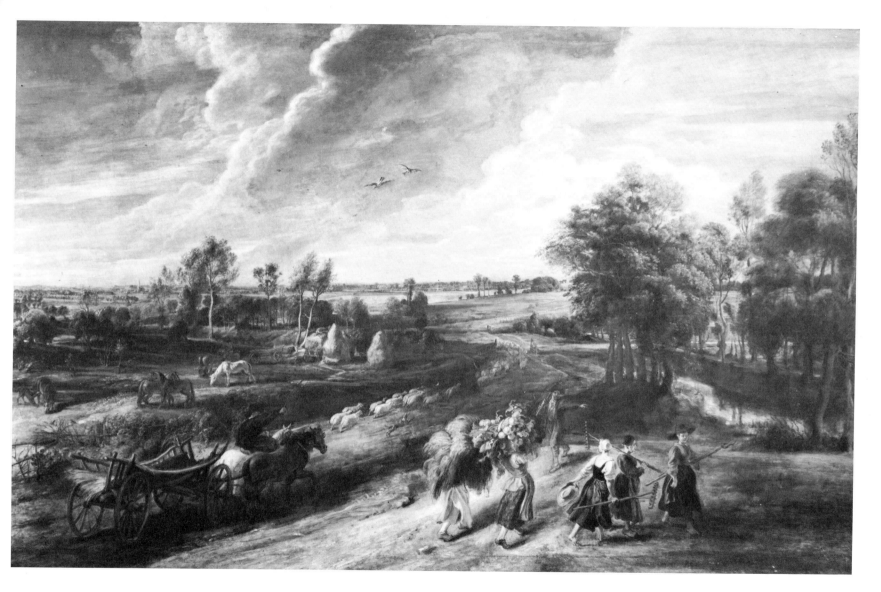

65. *Return from the Fields*, Florence, Galleria Pitti (Gabinetto Fotografico, Soprintendenza Beni Artistici e Storici di Firenze)

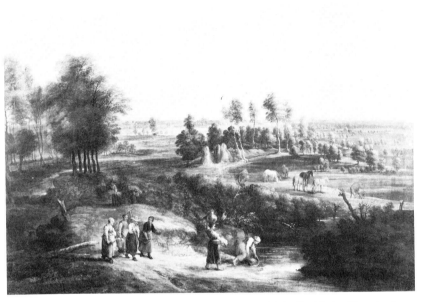

66. Lucas van Uden, *Rural Landscape*, Frankfurt am Main, Städelsches Kunstinstitut

landscape. Although the picture is in less than good condition, the grandeur of its conception remains undiminished.[29]

Kritischer Katalog der Gemälde im Besitz der Gamäldegalerie Berlin [Berlin, 1978], pp. 99–109). Since he deals with the development and sources of Rubens' earlier rural landscapes, some of our material overlaps; nevertheless, our approaches differ considerably.

29. Max Rooses believed that *Return from the Fields* was designed and retouched by Rubens, but executed by Lucas van Uden (*Rubens*, vol. 2, trans. Harold Child [Philadelphia and London, 1904], pp. 574 f.). There are indeed parallels between the handling of paint in this work and in van Uden's rural landscapes. The latter were also clearly influenced in their composition by *Return from the Fields* (cf. fig. 66), which also contains figures, in reverse, after those in the *Pond* (fig. 9).

The size of *Return from the Fields* and its broad compositional structure accommodate a large number of motifs: entering from the left, a farmer driving a hay wagon; five female peasants in the right foreground; a flock of sheep, with shepherd and dog, hurrying down a road that winds into the distance; a pasture with hedgerow, horses, and haystacks; a water ditch bordered by trees; birds in the sky; and, far off on the horizon, a church steeple.

Painted with a palette of ochres, russets, browns, muted green, cream, and gray, *Return from the Fields* suggests late summer or early autumn and the end of the day, when shadows begin to lengthen. More tonal than *The Polder*, it nevertheless features a pictorially dramatic contrast between the cool gray-and-white sky and the warm brown earth—a color duo epitomized in two pairs of horses and the costume of a peasant woman.

Already with *The Polder* Rubens had abandoned the complex, additive structure of his ambitious *Farm at Laeken* in what must have been a conscious effort to create a more naturalistic and "national" landscape—that is, one showing the relatively flat, open terrain of the Southern Netherlands. But *The Polder* does not quite prepare us for this painting's striking prospect over the Flemish *platteland*.

In *Return from the Fields*, the artist set himself a difficult compositional task: to create a flat landscape containing prominent figures in the foreground as well as a fully developed and continuous middle ground and background. Rubens seems to have been the first painter to attempt precisely this combination. In the few Dutch panoramas that had been painted by the early 1630s, the high viewpoint, low horizon, and resulting strip of land (seldom consistently flat) allowed only for diminutive figures functioning as staffage.

The important middle ground in *Return from the Fields* is worked up in great detail. To the left of the wagon is a hedgerow with birds, and then the pasture begins. Here the artist's sensuous vision of rural life is expressed by a mare suckling a colt and two brown horses nuzzling against each other; farther back, two scrawny old workhorses are content to graze; and a lone horse (a quotation from Titian's *Milkmaid*?) leaps in the distance. Toward the center of the picture stand two hay wains, one empty, one full; two haystacks; and a man and a woman piling hay. One of Rubens' favorite motifs, trees reflected in water, glows in the right middle distance.

Rubens' *Return from the Fields* proves to be "national" not only in the flatness of the depicted land but also in its relationship to tradition—that is, it recalls more deliberately than any of his previous works the series of months by Pieter Bruegel. The three women carrying rakes in *Return from the Fields*, for example, clearly echo those in Bruegel's *Haymaking* (cf. figs. 65, 88) and likewise represent three ages.[30] And the other women, whose heads are obscured by the abundant harvest, are related to Bruegel's basket-bearing peasants striding down the road. Yet another landscape from the season series, *Dark Day* (fig. 87), has a broad winding river that boldly penetrates the picture in much the same way as the road in *Return from the Fields*, where a flock of sheep further stresses the movement into space. Held has observed that originally

a hay wagon was shown traversing the road;[31] Rubens probably painted out the motif because it impeded the sweep of the road as a compositional element.

Like Bruegel, Rubens understood that a firm structure was necessary in such a large, full landscape. One difference is that Rubens "nationalized" the complex universalizing terrain of his predecessor. He accomplished this by deriving the pictorial armature from the actual division lines in the rural terrain of Brabant: hedgerows, water ditches, roads, rows of trees, and a barely interrupted horizon. For the first time in such a wide, open picture of the countryside, a Northern artist dispensed with mountains and valleys, maplike views and minuscule people, inventing instead a "natural" composition, unifying the tone of his palette, and orchestrating monumental motifs into surging movements.

Two figure drawings can be associated with *Return from the Fields*. One, a meticulous study of an old peasant woman in profile with annotations concerning her costume (fig. 67), corresponds closely to the middle figure of the trio bearing rakes (fig. 65).[32] The other drawing, *Peasant Woman Walking* (fig. 68)[33] is very different, a quick sketch suggesting vitality and motion through the figure's pose as well as the energetic quality of the lines themselves. A connection between *Peasant Woman Walking* and *Return from the Fields* is not immediately apparent, perhaps because the figure in the drawing is shown moving to the left rather than to the right, as in the

30. The similarity between the three women in Bruegel's *Haymaking* and those in Rubens' *Return from the Fields* has long been recognized. It should be pointed out that such figures occur in a painting in Madrid (Prado; Padrón, no. 1440) formerly attributed to Jan Brueghel but now given to Joos de Momper, another artist from Rubens' circle. In the Prado painting variations on figures found in another of Bruegel's *Months*, namely the *Harvest* (New York, Metropolitan Museum), also appear.

31. Held, under nos. 59–60.
32. Mentioned only as a costume study by Held (1959, p. 55).
33. B.-H., no. 152; Held, no. 117; Florence, Palazzo Pitti, *Rubens e la pittura fiamminga del seicento nella collezioni pubbliche fiorentine*, ed. Didier Bodart (Florence, 1977), no. 96. Held dates the drawing to the 1630s, which would tend to confirm its connection with *Return from the Fields*.

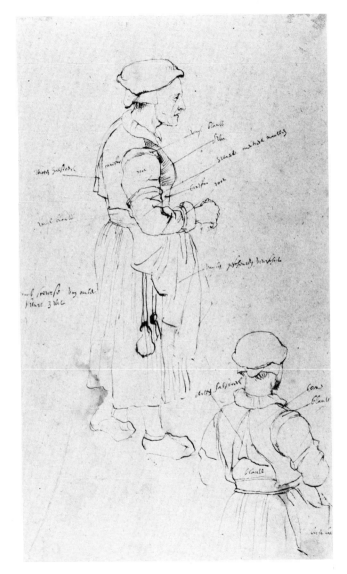

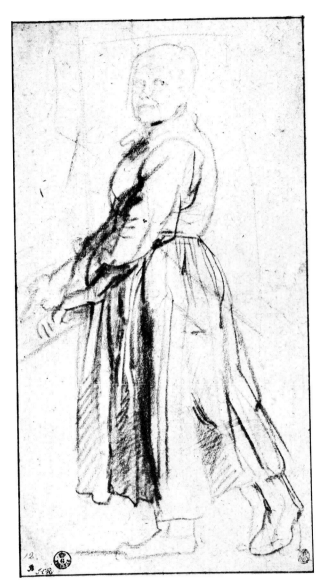

67. *Peasant Woman, Costume Study*, drawing, Berlin-Dahlem, Staatliche Museen Preussischer Kulturbesitz, Kupferstichkabinett

68. *Peasant Woman Walking*, drawing, Florence, Galleria degli Uffizi (Gabinetto Fotografico, Soprintendenza Beni Artistici e Storici di Firenze)

painting.[34] But by virtue of its theme—a peasant woman walking—
the drawing would seem to reflect some stage of preparation for
Return from the Fields. Rubens initially may even have made the
sketch in response to Bruegel's *Haymaking*, in which the group of
three peasant women does indeed move to the left (fig. 88).

The small figures making hay in the far middle ground of *Return
from the Fields* are generically related to the type of figure seen in
Rubens' drawings of women gathering sheaves.[35] Held has noted
the resemblance between a woman picking up wheat in one of these
drawings (fig. 69) and in Bruegel's *Harvest* (fig. 89).[36] The com-
parison is close, but a slight detail reveals one of the greatest dif-
ferences between the two artists' conceptions of the peasant. As
with this stooping figure and many similar ones—for example, the
man gathering branches in *Dark Day* (fig. 87)—Bruegel deliberately
obscures the faces of his peasants or unites them to the material
of their toil: hay may substitute for a face, or as in *Dark Day*, a
man pruning may become wedded to a tree. For Bruegel the peasant
is defined not only within nature—in landscapes almost miraculous
in their beauty and breadth—but also in a sense *as* nature. His
peasants are humble creatures in the world he envisions, but their
humility, invested as it is in such sturdy, substantial beings, is the
key to their dignity. Bruegel's peasants are pious in the face of
nature, are completely conditioned by it, and obey its laws in every
season. For this artist, who lived amid strife nearly overwhelming

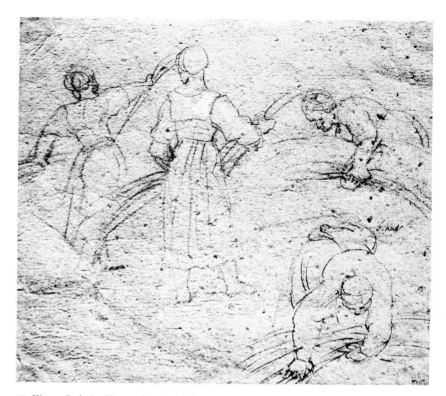

69. *Woman Gathering Sheaves*, drawing, Edinburgh, National Gallery of Scotland
(Reproduced by permission of the Board of Trustees of the National Gallery of
Scotland)

34. That the drawing is related to *Return from the Fields* is noted by B.-H., no.
152.

35. Edinburgh, National Gallery of Scotland. B.-H., nos. 153, 154; Held, nos.
59, 60.

36. Held, nos. 59, 60.

in its dimensions, nature's rules may have seemed infinitely superior to the legislations of governments and courts.[37]

Rubens' rural landscapes reveal an evolution in his conception of the peasant's place in nature. In *Farm at Laeken*, statuesque peasant women—personifications, really, of rural plenty— happily preside at the center of the painting. Then, in *The Polder*, the peasants are more integrated into the atmosphere of the landscape, and they mix among the cows (the backside of one of these beasts dominates the center foreground, and further on, one urinates): the picture and its motifs, as it were, have become more natural and organic. Finally, in *Return from the Fields*, the peasants are smaller in relation to the picture as a whole, but they move more freely and are sociable, as completely at home in the landscape as they are in the company of one another.

Rubens, like Bruegel, was not at all interested in the peasant as staffage. But unlike his predecessor he always retained a classicizing respect for the figure as a free form. Nature was not so vast for Rubens, his viewpoint not quite so godly, but by the same token his peasants are not so small; the proportion between figure and landscape in his works is more to the individual's own measure. In the next two rural landscapes we shall consider, that measure is the artist's very own.

37. In classical and Renaissance paeans to country life, an abiding topos is that in ordered rural nature one can find freedom from war and the courts of law; this idea is discussed below in chapters 5 and 6.

4. *HET STEEN* AND *THE RAINBOW*

By the time Rubens purchased the estate of Het Steen in 1635 he had produced more than fourteen landscapes, paintings as various in their subject matter as in their formal means. Thus far three works of the "rural" type have been discussed. The next two such landscapes by Rubens are the culminating examples: *Het Steen* (fig. 70; ckl. no. 14), in the National Gallery, London, and *The Rainbow* (fig. 71; ckl. no. 17), in the Wallace Collection, London.* Both have been dated to around 1636.

Het Steen and *The Rainbow* are wide oblong paintings of nearly equal dimensions. Each shows various rural activities set in a broad, deep plain, observed from a slightly elevated point of view. In both, the horizon is located approximately two-thirds up the picture. No other landscapes by Rubens exhibit the same composition or are of such great size; indeed, measuring approximately four and one-third by seven and one-half feet, these are the largest. The history of their ownership strongly suggests that from the beginning these pictures were paired (they almost certainly go back to Rubens' own collection and were together in a Genoese palace in the eighteenth century). *Het Steen* and *The Rainbow* therefore belong together in any critical discussion of the artist's rural scenes.[1]

* Figures 70 and 71 are reproduced in color between pages 128 and 129.

1. Gregory Martin presents the evidence for supposing that *Het Steen* and *The Rainbow* were nos. 135–36 in the inventory of Rubens' collection; that *Het Steen* presumably was inherited by Rubens' widow Helena and *The Rainbow* bought by the artist's eldest son, Albert; and he documents the presence of both paintings in the Balbi Collection, Genoa, by 1758 (G. Martin, pp. 140 and 142, nn. 34 and 35).

In the literature devoted to Rubens' landscapes, the statement that *Het Steen* and *The Rainbow* somehow form a pair is made repeatedly, but only recently has the landscapes' mutual relationship actually received any discussion. Gregory Martin raises but leaves open the question of whether the paintings are pendants, since "there is nothing to prove it beyond a doubt" (pp. 139–40). His brief arguments imply that the pictures do not relate to one another iconographically in any significant way.

John Constable was apparently the first critic to have observed publicly that *Het Steen* and *The Rainbow* were pendants. C. R. Leslie reported the following concerning a lecture the painter gave on June 9, 1833: "Constable described the large picture in the National Gallery, in which a fowler is seen watching a covey of partridges, as a fine specimen of Rubens' power in landscape, and lamented that it was separated from its companion, 'which had doubtless been painted to give more effect to it by contrast.' He said, 'When pictures painted as companions are separated, the purchaser of one, without being aware of it, is sometimes buying only half a picture. Companion pictures should never be parted, unless they are by different hands, and then, in general, the sooner they are divorced the better.' " C. R. Leslie, *Memories of the Life of John Constable*, ed. A. Shirley (London, 1937), p. 396.

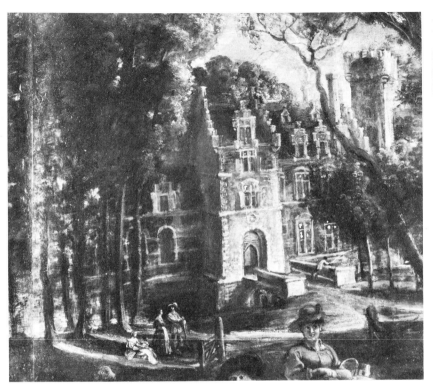

72. Detail of fig. 70

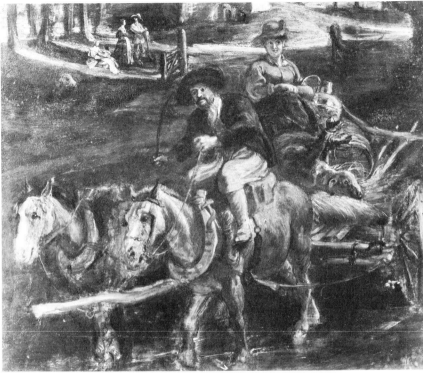

73. Detail of fig. 70

CONTENTS AND COMPOSITION

Het Steen, perhaps the most familiar of Rubens' landscapes, takes its traditional title from the motif of the artist's château, seen in the left middle distance (fig. 72). A wooden wagon, drawn by two horses (one carrying the driver) approaches from the direction of the house (fig. 73). The vehicle carries a trussed sheep, a barrel, and a passenger (a peasant woman with a pitcher looped over her arm). Turning into a shallow stream, the wagon is about to pass a hunter and dog stalking partridges. Before them, dominating the

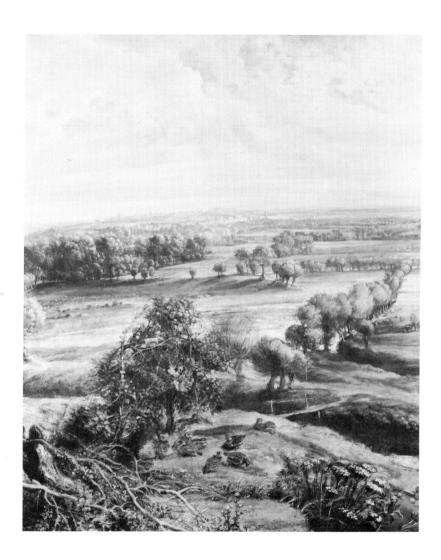

central foreground, is a split, knobby tree stump, laced and garlanded with brambles.

The right side of *Het Steen* is more open, showing acres of green pastureland worked up in great detail (fig. 74). In the foreground, birds busy themselves in a hedgerow, and then, moving back into space, there are a patch of wild flowers, a covey of partridges, a brook crossed by a footbridge, water ditches, a herd of cows being milked, another herd grazing, trees in rows and copses and, far in the distance, two towns. To the right, just above the horizon, floats a large golden sun, its top half concealed by cloud strata.

The spot occupied by the château in *Het Steen* is taken by a haymaking site in *The Rainbow* (fig. 71). Next to a wheat field, two pear-shaped stacks have been built, and three peasants are at work on a third. From atop a hay wagon, one of the laborers pitches up the half-dry grass, while a couple above lay it in place. Below them stands a second cart, still full and hitched with horses that nibble on hay while they wait.

The haystacks and wheat field are bounded on the right by a rutted road winding halfway into the picture. A wagon appears at the left, but now, instead of moving out of the picture, as in *Het Steen*, it heads into the landscape (fig. 75). Coming from the opposite direction are three peasants, two sturdy young women framing a farmer who has nudged in between them, his pitchfork pointing the way. Also ambling down the road and prodded by a herdsman are eleven dainty cows, scattering outward as they approach.

Earth meets water on the right. A stream, the visual counterpart of the road, refreshes cows and ducks in the foreground and then

74. Detail of fig. 70

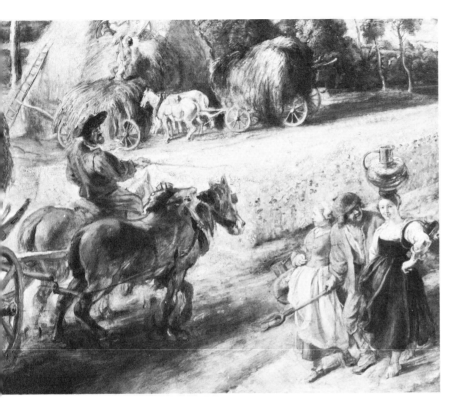

75. Detail of fig. 71

bends, disappearing into a wood. Above, a dense sheet of gray nimbus clouds dominates the sky, but the land itself is pervaded by golden light coming in low from the left. A rainbow arching over the countryside makes the air seem moist and warm.

The formal scaffolding of *Het Steen* and *The Rainbow* (figs. 76, 77) is sturdy and simple, consisting of two main horizontal elements: the horizon line itself and, below it, an implied horizontal that divides each work exactly in half; a concealed vertical axis at center, dividing the field in half again; and below the horizon, a curving **X** form. All these vectors, traceable on the surface, are completely embedded in the rural scenery; they structure the painting and act as hidden guides, at once beckoning and controlling the observer's wanderings.

The blue line of the horizon is so stressed in each painting that we do not notice at first the delineation of the picture's central horizontal axis. In *Het Steen*, if one reads from left to right, it begins at the illuminated château door as a path of light and slowly merges into a pasture's undulating upper contour. The corresponding line in *The Rainbow* is also a light-line. Although contrived, it is nevertheless unobtrusive—thin in some places, thick in others (notably at dead center, where it provides a foil for dark willows), disappearing at several points, and finally ending elegantly in a right angle as it moves up a tree.

Each painting is also bisected vertically. The prominent tree stump in *Het Steen* marks an imaginary center axis, further punctuated above by two flying magpies. The cowboy holds this crucial position in *The Rainbow*. Such axial members in Rubens' paintings defy rigidity: the tree stump's tentaclelike roots and surrounding tangle of growth reach out to the left and right, and the versatile herdsman, moving to our right while looking over his shoulder to the left, gives himself to both sides of the painting. The shout of his red sleeve, furthermore, is doubly echoed, on the left by a crimson bodice and on the right by scarlet berries. This herdsman

thus keeps his charges as well as the composition, so to speak, from straying, or in Evers's words, "[Er] scheucht sie [the cows] von der falschen Bildseite auf die ihre zurück."[2]

Besides marking the central axis, *Het Steen*'s tree stump and *The Rainbow*'s herdsman each act as a point of intersection for a sprawling **X** form, its vectors serving to anchor the terrain. In *Het Steen*, one arm of the crossing diagonals starts at the lower left and takes a straight path: from the shallow stream to the part of the hedgerow behind the stump, then running through a line of willows strung, as Evers put it, "like pearls," and measuring distance in one bold sweep. The other arm, which we tend to see receding as well as advancing, extends from the brambles at lower right on up to the château door. The matching **X** form in *The Rainbow*, on the other hand, is made by a meeting and parting of the curving road and stream.

Corresponding to the lower half of the **X** form in each painting is a triangular configuration defining the center foreground (figs. 78, 79). In *Het Steen* it is made of tree stump, brambles, and hunter and hound (themselves three-cornered) and acts as a *repoussoir*. The hunter, though flush against the front plane, also leads us into the fictive space, for if, following his lead, we seek his prey, our vision is guided beyond the hedgerow.

In *The Rainbow*, on the other hand, the center triangle is read in depth, with the herdsman's head as its distant apex. Yet the direction of the cows reverses the perspective impulse, causing this configuration as a whole to project forward.[3] Correspondingly, the background is now much more obstructed, on the right by the thick woods and on the left by trees overlapping the horizon. Even the distant rainbow is echoed by a "mirror rainbow" reflected in the foreground stream below.

Thus while the stable structure of the landscapes accommodates inward as well as outward movement, each painting also contains a dominant thrust. *Het Steen*, with its deep spatial penetration, conveys a feeling of "going forth," so to speak, and *The Rainbow*, with its peasants and cows coming toward us, a sense of "returning" (figs. 80, 81). An inverted subtheme, the counterdirectional coming and going of the ladder wagon, forms a further compositional parallel.

Another point of contrast in the landscapes lies in their color composition. The basic scheme of both paintings corresponds to the traditional Flemish formula of successive brown, green, and blue planes, a progression towards coolness of color that leads the eye into space. Each work exhibits the same rich, refined palette within this larger chromatic structure, but the hues are used in different measure, *Het Steen* being slightly greener and cooler in tone than *The Rainbow*, which has a subtle golden cast.

Het Steen and *The Rainbow*: A Pair

That two landscapes by Rubens exhibit such strikingly similar as well as complementary designs raises the issue of whether the pictures merely happen to match formally or were in fact con-

2. Evers (1942), p. 401.
3. This final artful arrangement of the herd was not arrived at immediately. X-rays show that a cow seen from behind was formerly to the right of the one drinking; Rubens' suppression of the animal tightened up the group. (I am grateful to Mr. R. A. Cecil of the Wallace Collection for making available to me x-rays of *The Rainbow*.)

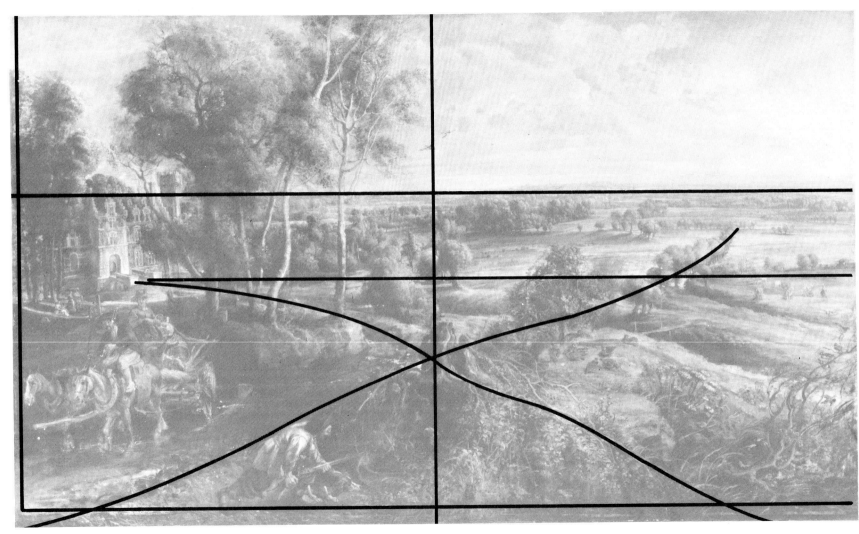

76. *Het Steen*, London, National Gallery, compositional diagram with additions at left
and bottom marked

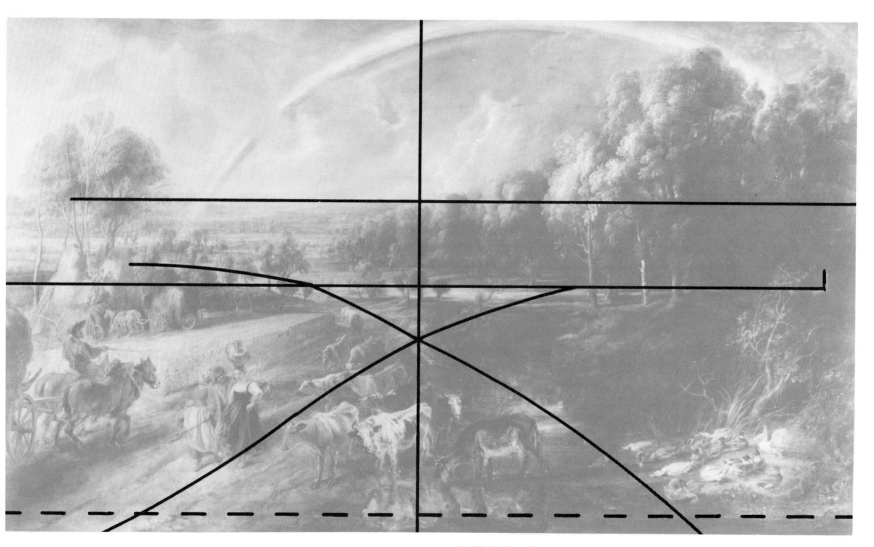

77. *The Rainbow*, London, The Wallace Collection, compositional diagram; strip at bottom original

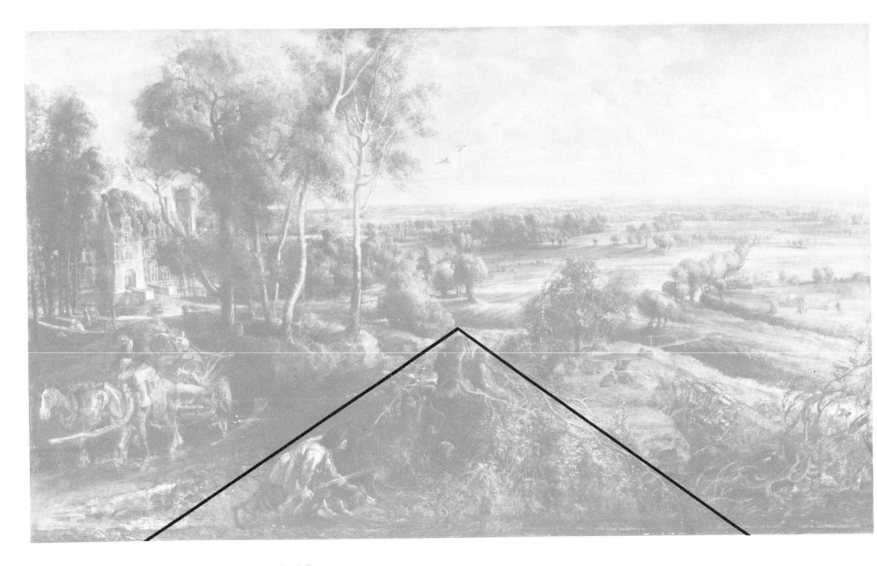

78. *Het Steen*, London, National Gallery, compositional diagram

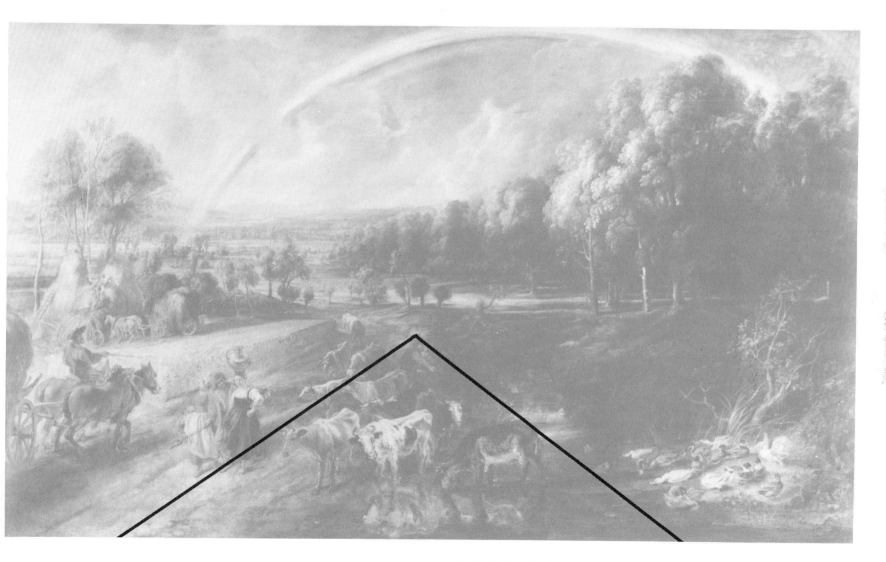

79. *The Rainbow*, London, The Wallace Collection, compositional diagram

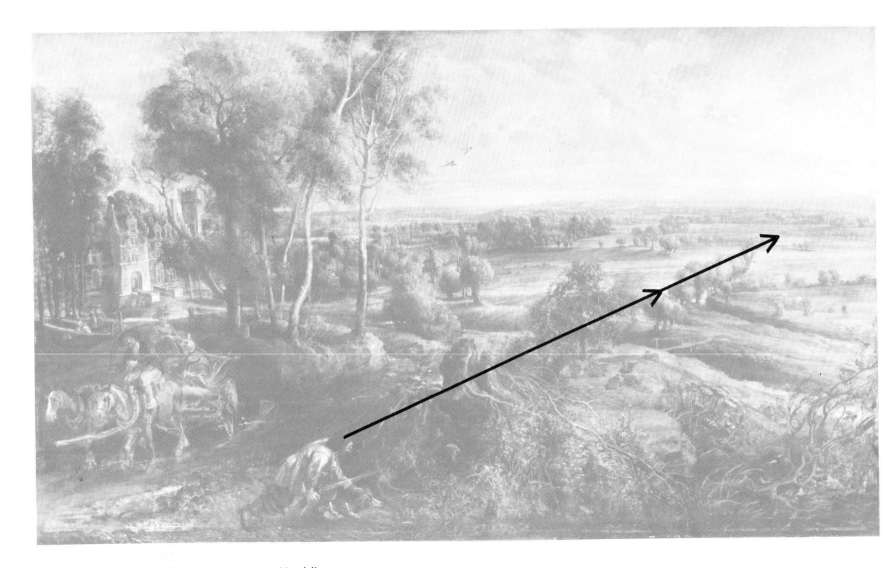

80. *Het Steen*, London, National Gallery, compositional diagram

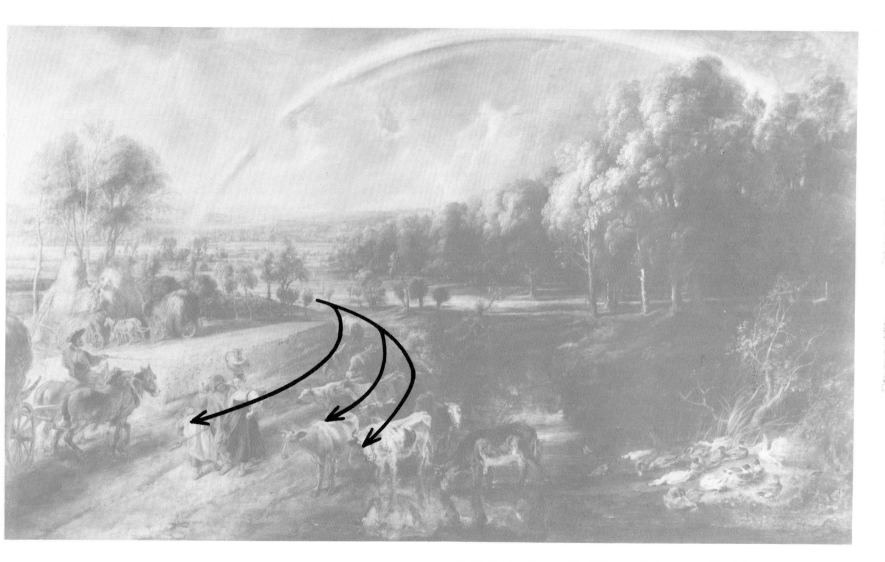

81. *The Rainbow*, London, The Wallace Collection, compositional diagram

sciously conceived as pendants. *Het Steen* and *The Rainbow* are actually continuous in some important ways. Placed together, *Het Steen* on the left, the "closed" halves of the compositions function as brackets for the combined panorama (figs. 82, 83). Once seen this way, three distinct sections emerge: the château, its background, and approaches, including the tongue of land bordering the stream on the left; a large central agricultural zone extending across the dividing frame to the brook in *The Rainbow*; and finally, the area of the woods and ducks. The whole is thus like a triptych, with a central open field flanked by two wooded wings. Yet another correspondence made visible by the pairing of the landscapes (figs. 84, 85) is that at the bottom center of their imaginary junction, lateral diagonals fan out towards one another, further binding the pictures in a dynamic relationship. Clearly, then, the landscapes make a formal pair.

The question remains as to how *Het Steen* and *The Rainbow* might be conjoined in terms of subject matter, that is, with respect to topography, season, and time of day.

Topography

Already in the three rural landscapes preceding *Het Steen* and *The Rainbow*, Rubens had moved toward depicting recognizably Netherlandish settings. *Het Steen* is the most topographically specific of all these paintings, since it features the château still standing at Elewijt (fig. 4). Architecturally, the character of the place is further articulated by a windmill, a village, and the skyline of a town with a steeple. Small though it is in the painting, this tower represents a very tall, lacy, openwork structure, much like the tower (400 feet high) that forms part of Antwerp's cathedral, the Onze Lieve

Vrouwekerk.[4] In reality, Antwerp could not have been visible from Het Steen, since the city lies some twenty-one miles northwest of Rubens' country house. And since the estate's crenellated tower (now destroyed) is known to have been situated to the north, Antwerp has not only been given a paradoxical proximity but has also been moved to the east. This sort of manipulation of landmarks seems to have been common enough in seventeenth-century landscapes.[5] Here Rubens' reference to his other residence and place of work would seem to suggest a personal meaning for the painting. It could hardly have been accidental that the artist arranged a line of birds in the sky so that they "point" to the city on the horizon.[6]

The Rainbow depicts the same type of rural terrain as *Het Steen*. No architecture explicitly identifying the locale has been included,

4. The identification of this town as Antwerp was made previously by G. Martin (p. 138). I cannot, however, accept his hypothesis that the little village in the background was intended as a "reminiscence of Malines." Malines was a former capital of Brabant, and an important city in Rubens' day; moreover, it boasted a church with a three-hundred-foot tower. The skylines of Antwerp and Malines are depicted on Pieter van den Keere's map of Brabant (*Germania inferior* [Amsterdam, 1617]). It is apparent from this and other maps of the period that the concentration of villages between Antwerp and Brussels was extraordinarily dense in Rubens' day.

On Rubens' depiction of real sites elsewhere in his art, see Evers (1944), pp. 321–23, 327.

5. Regarding Jan van Goyen's and Salomon van Ruysdael's juggling of a particular landmark in their paintings, see Wolfgang Stechow, "Die 'Pellekussenpoort' bei Utrecht auf Bildern von Jan van Goyen und Salomon van Ruysdael," *Oud Holland* 55 (1938), pp. 202 ff.

6. An analogous conceptualization of the relationship between two places, entailing a compression of distances, is found in John Denham's poem *Cooper's Hill* (London, 1642): from his country estate the poet claims to be able to see St. Paul's Cathedral, whose political associations form an important theme of the work.

Real or imaginary châteaux appear frequently in landscape paintings and prints of the period; sometimes such images incorporate depictions of seasonal activities, biblical stories, or classical motifs. R. H. Wilenski illustrates several Flemish landscapes with castles (*Flemish Painters, 1430–1830*, vol. 2 [London, 1960] figs. 444–47).

but in the area near the horizon are a few scattered buildings: windmills, a rural chapel or country house, and several churches, perhaps indicating villages. Although one does not want to assume too naturalistic a bias in analyzing seventeenth-century landscapes, the background hills in this painting may nevertheless be seen as representing the ascent of the Brabant plain which, due south of Rubens' château, rises some five times in height within the space of nine miles.[7]

Season

Rubens' earlier rural landscapes all contain seasonal indicators. *The Farm at Laeken* shows a sunny day—trees still green, fruits and vegetables ripened—and thus a summer landscape. In the works that followed, *The Polder* and *Return from the Fields*, the paintings themselves seem to have ripened: it is later in the day, colors have toned down, and the clouds, now heavy with rain, seem to be ushering in a new and darker season. The peasants' attire still suggests warm weather, however, and this, along with the hay-making and harvesting motifs in *Return from the Fields*, shows that in fact all three paintings were conceived as late summer landscapes.

Rubens' landscape pair affirms the artist's continuing interest in summer, the season of his country sojourn. In *Het Steen* the foliage is dull and dark green, and one branch already exhibits dry brown leaves, revealing its long exposure to the heat of the sun. Daisies, yarrow, and burdock, as well as the bramble bearing both blossoms and fruit, offer other seasonal signs; so too do the partridges, which begin to appear in the second half of the summer, after the young have become independent.[8] The small piles of freshly mown grass are yet another feature of summer in Brabant, where July was often called "hay month" (*hooi maand*).[9]

In *The Rainbow*, Rubens depicts a different stage of haymaking: after the mown and raked grass (such as we see in *Het Steen*) has sufficiently dried, it is carted away and made into stacks. Next to the haymaking site, with work in progress, stands a field of grain; it is almost high enough for harvest, and red poppies grow among the stalks. On the right side of the painting, near the ducks, are the same small purple flowers that occur in *Het Steen* and a species of mountain ash—here a wild-looking bush laden with red berries,

7. Cf. the *Grote Winkler Prins atlas* (Amsterdam, 1972).

Today it is impossible to get a good view of the countryside around Het Steen, since the land has been parceled into lots with suburban homes and the remaining fields are crisscrossed by highways. Given the fact that Brussels is so hilly, it is likely that the nearby rural lands were somewhat more rolling in former times—before the advent of the bulldozer.

In his *Pegasides pleyn* (1582–83) the Flemish poet Jan Baptist Houwaert refers to the "mountains" near his country house, situated outside Brussels (see Eugene de Bock, *Johan Baptist Houwaert* [Antwerp, 1960], p. 46): Philip Rubens also spoke of his uncle's depicting mountains near Het Steen (Charles Ruelens, "La vie de Rubens par Roger de Piles," *Rubens-bulletijn* 2 [1885], p. 167).

8. For a list of the proper Latin names of the flowers, see G. Martin, p. 138. Martin's argument for *Het Steen*'s being an autumn landscape rests solely on the supposition that the plants depicted flower in autumn. Consultation of Oleg Polunin's floral (*Flowers of Europe: A Field Guide* [London, 1969])—now the standard reference work—does not, however, confirm that the plants flower exclusively in autumn. In identifying flora in paintings we must remember that plants—and the number of species in northern Europe is extraordinarily large—have their own history, with species appearing and disappearing throughout time; the blossoming period of plants, moreover, varies according to yearly fluctuations in climate, quality of the soil, hardiness of the strain, and so on.

9. The seasonal occupations in Netherlandish illustrations of the months vary considerably. The cutting of hay occurs most frequently in the July print, but it may also figure in the depictions of May, June, and even August.

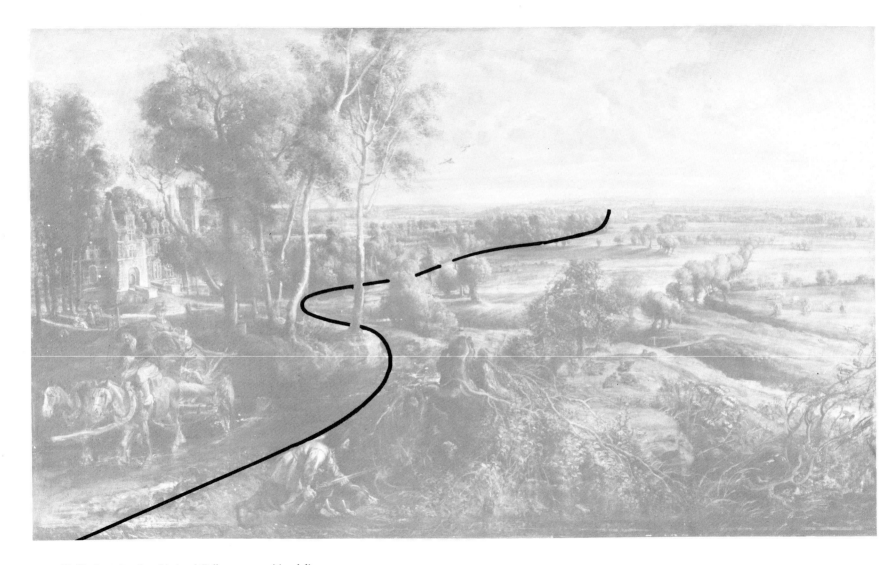

82. *Het Steen*, London, National Gallery, compositional diagram

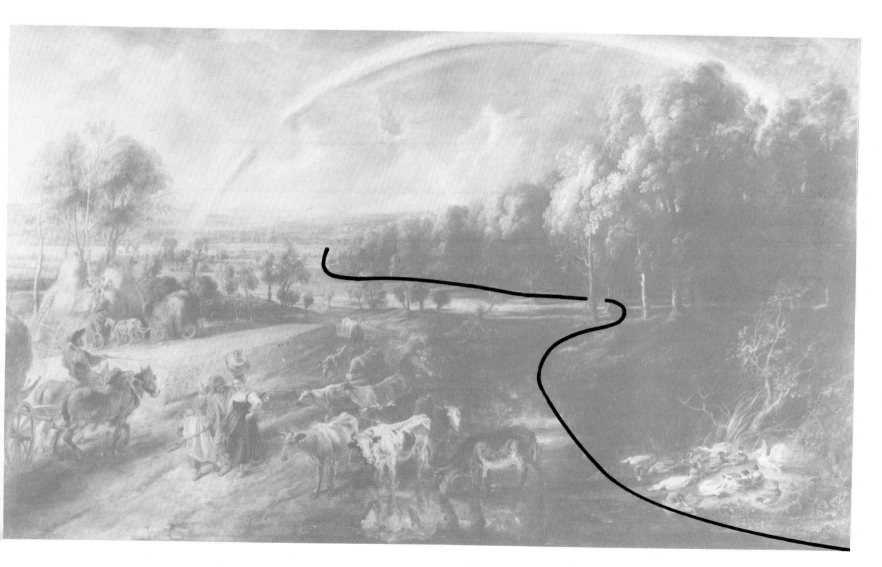

83. *The Rainbow*, London, The Wallace Collection, compositional diagram

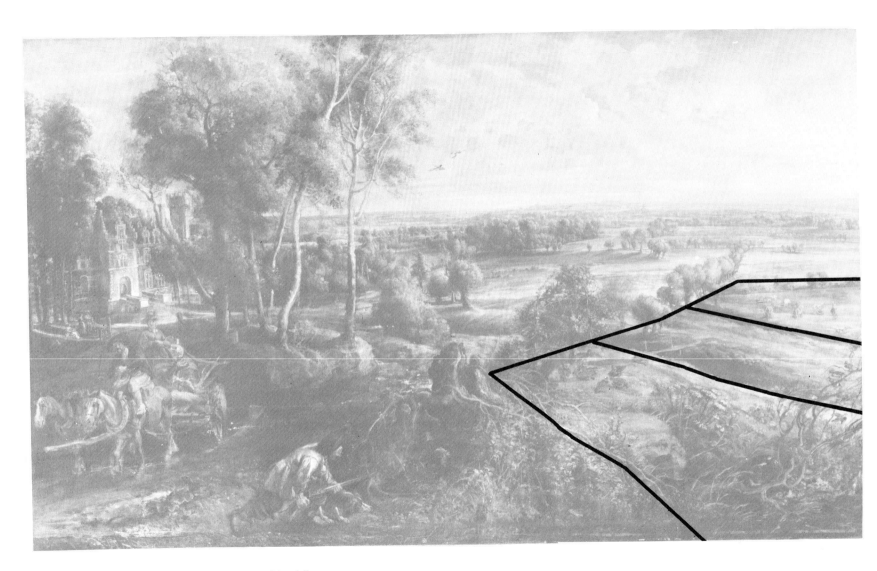

84. *Het Steen*, London, National Gallery, compositional diagram

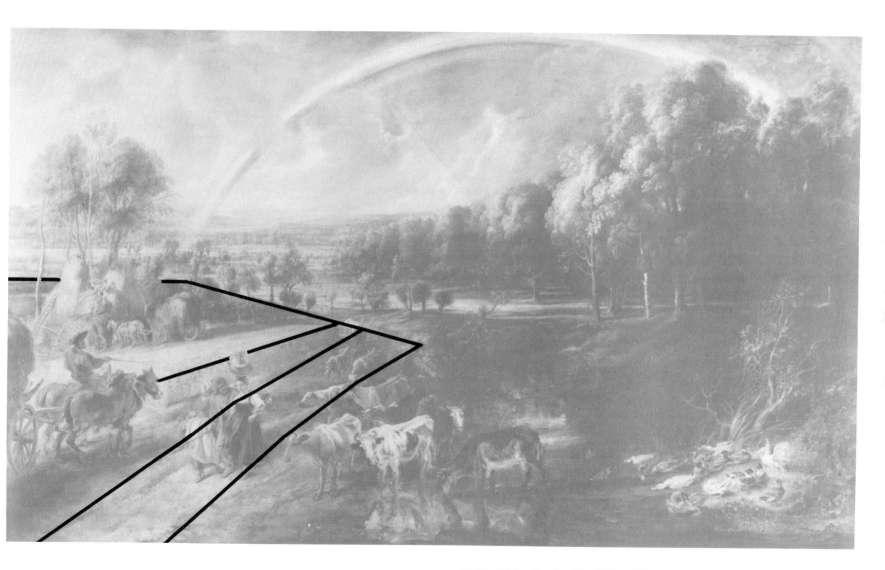

85. *The Rainbow*, London, The Wallace Collection, compositional diagram

yet another sign of summer's second half. *Het Steen* and *The Rainbow*, then, depict the same season.[10]

Certainly it is not necessary to attach the names of specific months to these works. Nonetheless, we should recognize that Rubens' concern to represent a generally identifiable time of year (other than winter) with this degree of coherence—and by employing all the elements of the painting rather than by the representation of traditional activities alone—shows an exceptional attitude toward the subject. Here, too, it is Bruegel's conception of rural landscape that is evoked in these pictures.[11]

Time of Day

The time of day represented in each painting is less easy to determine, especially if the works are seen separately. Since in *Het Steen* the sun is depicted as just over the horizon, the landscape must represent either early morning or the end of the day. The only secure directional signpost in the painting is the castle tower which, as previously mentioned, lay to the north. If one wants to argue from a naturalistic point of view, then, the sun is in the northeast and rising.[12] The couple in the wagon appear to be headed for market, and this also suggests sunrise, a choice not contradicted by the other activities, hunting and milking.[13] Rubens also included recognizable clouds of the altocumulus type ("sheep clouds"), which are best developed in early morning and at evening.

In *The Rainbow* the sun is also low, judging from the lighting system and the presence of the rainbow. The golden tone of the picture suggests late afternoon: at this time of day, in Northern climes, the sky clears and becomes radiant with sunlight; for a Netherlander, it is the time of *opklaring*. Finally, the time of day is hinted at by the amorous intentions of the farmer nudging in between the women; his share in the work apparently done, he seems eager for sunset and leisure.[14]

THE PROGRAM

Our reading of the subject matter of these landscapes would have to remain conjectural if each picture were viewed by itself. But when one places *Het Steen* and *The Rainbow* together, the system of mutual correspondences and contrasts becomes legible: two formally matched pictures, showing the pastures, fields, and woods of a lowland plain, during a single season, the one evoking cool morning, the other warm afternoon, a sense of going forth in the

10. As observed above, the fact that each painting has a dark, closed side suggests that if the works are seen as a formally matched pair, *Het Steen* would have to go on the left. If one were then to accept Martin's reading of the season of each work, however, the unlikely arrangement of summer following autumn would emerge. A. H. Cornette, the only scholar who to my knowledge has illustrated *Het Steen* and *The Rainbow* together—on facing pages—puts *The Rainbow* on the left; he does not discuss the relationship between the two pictures (in Stan Leurs, ed., *Geschiedenis van de Vlaamsche kunst*, vol. 2 [Antwerp, 1939], pp. 736–37).

11. Wolfgang Stechow has observed that the only distinguishable season in seventeenth-century Dutch landscapes is winter (*Dutch Landscape Painting in the Seventeenth Century* [London, 1966], p. 9). The depiction of specific seasons in Flemish painting after Pieter Bruegel is somewhat more common than in Dutch art.

12. G. Martin (p. 138) discusses in greater detail the issue of which time of day is represented in this painting; he is convinced that *Het Steen* is a morning landscape.

13. A landscape in Rubens' collection is listed as "A Wood with a Huntinge, with the Sun risinge, upon bord" (see ckl. no. 29).

14. X-rays of *The Rainbow* show that originally a man and woman (peasants) were shown seated next to each other in the area of the grainfield.

first and of returning in the second. The conclusion must be, then, that Rubens designed these works as pendants and that he conceived them according to a program: the cycle of a summer day in the surroundings of Het Steen.[15]

In these two panels, then, time and space are conflated to create a copious, complete world. The pair is complete, first of all, with regard to place. The tripartite structure of the paintings (when viewed side by side) shows gradations according to levels of culture: one begins with the extended structural domain of the left wing—the area of the gentleman's house, with its associations of high class and high culture and its links with the town; next comes the large, central agricultural zone, with pastures, crops, and cattle; and finally the dense woods, opposite the château's grove. Thus, one goes from high culture, to agriculture, to a wilder kind of nature.

Furthermore, *Het Steen* and *The Rainbow* appear to represent not only day—morning and afternoon—but also the passage of time from dawn to dusk; this is evoked by the dark, thinly painted areas of sky at the far left and far right of the pair (figs. 70, 71).[16]

Like the different kinds of places and times of day, weather as represented in the two paintings is also various and sequential. In the morning landscape, against blue sky, appear at least four kinds of clouds, all conveying a sense of movement in the atmosphere. The sun is equally active, as it gilds the edges of clouds, traces paths up tree trunks, and sparkles against windowpanes. Since it is half-shrouded in clouds, moreover, the sun may have also been meant as a portent of rain.[17]

And it does indeed rain in the next picture. The passing shower has left behind reflective foreground puddles, and continuing precipitation near the middle of the painting is implied by the rainbow itself. Thus the rainbow at once spans and helps bind the picture, while articulating the changing sky.[18]

TRADITION AND INNOVATION

There is no single precedent for Rubens' landscape pair, but the art of the past offered many models. The idea of pendant landscapes already existed, and Rubens himself may have designed such works

15. Some lines of van Mander's come to mind:

> Over my fertile green land I looked early and late in the day,
> And how the westerly winds delved into it with abandon
> And often caused the corn to move in waves like the sea.

From *Den Nederduytschen helicon*, 1610 (quoted and translated by Stechow, *Dutch Landscape Painting*, p. 9). That sunrise and sunset were considered the "poetic" times of day is revealed by a satirical comment of Seneca: "The poets are not content to describe sunrise and sunset, and now they even disturb the noonday siesta" (*Apocoloyntosis* 2; cited by L. P. Wilkinson, *The Georgics of Virgil: A Critical Survey* [Cambridge, 1969], p. 79).

16. A report made by the National Gallery in the late 1940s, when *Het Steen* was cleaned, notes: "The heavy blue across the sky, top left, may be *post* Rubens, but

is very hard: it was thought better not to try to remove it" (London, National Gallery, *An Exhibition of Cleaned Pictures 1936–1947* [London, 1947], no. 54).

Already in the *Carters* of about 1617–20, we may recall, Rubens had conjoined day and night in a single painting.

17. On the half-covered sun as a weather sign in Virgil's *Georgics*, see below, chapter 5.

18. The question naturally arises as to how *Het Steen* and *The Rainbow* were hung. Two possibilities make sense. They might have been placed directly opposite one another so that the viewer himself would turn as he followed the cyclical scheme, or side by side, probably separated by several feet, perhaps with a window intervening.

earlier; a *Sunrise* and a *Sunset* by him, for example, are listed consecutively in the 1628 inventory of the duke of Buckingham.[19]

In *Het Steen* and *The Rainbow*, the expected opposition between pendants is shown in the two times of day and, within the tripartite structure of the pair, in the different levels of culture implied by the two wooded "wings." In the work of Poussin—another outstanding example of a history painter who embraced landscape—one also finds a variety of pendant types: the narratively linked *Phocian* pair; the opposed *Temps Calme* and *Orage*; and the four *Seasons*, which are meant to be read sequentially on a variety of levels.[20]

The theme of two times of day does not seem to occur (or is not recognized) in earlier landscape pairs, but instances become more common in the seventeenth century.[21] The thesis that four times of day are evoked in the paintings relates in a general way to the numerous engraved and painted series devoted to this subject in the sixteenth and seventeenth centuries, although Rubens excludes the usual night and divides day into morning and afternoon. In other artists' series of the times of day, allegorical figures, whether alone or in the context of landscape, usually play a major role. It is typical of Rubens, however, that he chose to embody such concepts in the naturalistic context of landscape painting. The same process had occurred with respect to the seasons as early as the Limbourg brothers' calendar miniatures for the *Très Riches Heures* (c. 1410), images that represent a tradition culminating in Bruegel's series of *Months*. *Het Steen* and *The Rainbow* are not primarily, of course, depictions of the times of day, just as the progression from morning to night in Poussin's *Seasons* is only an aspect of that series's content.

The closest analogy to the pairing of *Het Steen* and *The Rainbow* is to be found, not unexpectedly, in Bruegel's *Months*, which originally seem to have been conceived as a set of six paintings, one of which was lost or never executed. Four of the five existing landscapes relate to each other as pendants within the group: *Hunters in the Snow* and *Dark Day* form a matched pair (figs. 86, 87), as do *Haymaking* and *Harvest* (figs. 88, 89); only *Return of the Herd* (Vienna, Kunsthistorisches Museum) is left without a companion piece, and the latter, quite plausibly, would have been the missing work.[22] Not only the pairs within the series, but all five *Months* as well, are united compositionally by marked linear continuities, figure groups echoing one another, repeated directional energies, and complementary wedges of high and low land. Rubens was inspired,

19. Randall Davies, "An Inventory of the Duke of Buckingham's Pictures," *Burlington Magazine* 10 (1906–07), p. 379.

20. On Poussin's *Temps calme* and *Orage*, now see the article by Clovis Whitfield, "Nicholas Poussin's 'Orage' and 'Temps calme,' " *Burlington Magazine* 119 (1977), pp. 4 ff.; on his *Seasons* see Anthony Blunt, *Nicolas Poussin*, vol. 1 (New York, 1967), pp. 332–36, with further references.

In sixteenth-century Italy, paired landscapes with saints were produced—for example, Polidoro da Caravaggio's magnificent frescoes in San Silvestro al Quirinale, Rome, and Tintoretto's *St. Mary of Egypt* and *Mary Magdalen* in the Scuola di San Rocco, Venice; Paolo Fiammingo's landscape pair is discussed above.

21. Many instances of paired landscapes representing morning and evening by Claude Lorrain are listed by Marcel Roethlisberger (*Claude Lorrain: The Paintings* [London, 1961]). Aert van der Neer's pendant landscapes in the Mauritshuis are listed in a recent museum catalogue as representing sunset and night, although in my opinion the rose color scheme of the one and the blue of the other (with moonlight) suggest daybreak and nightfall (see The Hague, Mauritshuis, *Kabinet van schilderijen: Vijfentwintig jaar aanwisten, 1945–70* [The Hague, 1970 (?)], nos. 30, 31).

22. Howard McP. Davis suggested to me that Bruegel's paintings function as pairs within the group.

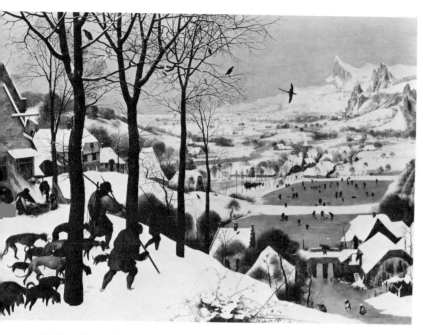

86. Pieter Bruegel, *Hunters in the Snow*, Vienna, Kunsthistorisches Museum

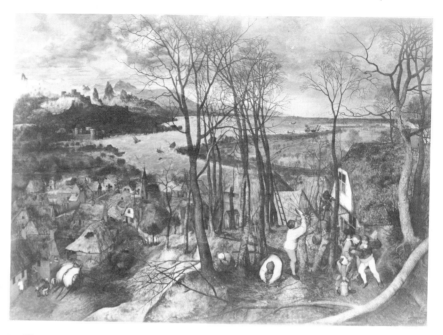

87. Pieter Bruegel, *Dark Day*, Vienna, Kunsthistorisches Museum

then, not only by the formal complexity and thematic richness of Bruegel's paintings—something that had interested him earlier—but now, apparently, also by the way in which the landscapes match up with one another within the series. One aspect of this pairing in the case of the *Months* is the different color scheme Bruegel devised for each picture according to the time of year. Rubens seems to have appreciated the way in which the greens of *Haymaking* (early summer) complemented the golds of *Harvest* (late

summer), for he appropriated the same color contrast to help define morning and afternoon in his landscape pendants.[23]

The tripartite scheme of *Het Steen* and *The Rainbow*, seen as one work, also has precedents. In *The Raising of the Cross* (Antwerp

23. Although *Het Steen* and *The Rainbow* represent summer, the transitional aspects of the time of year are indicated, just as in each of Bruegel's five paintings—one reason, in the case of the latter, why it is so difficult to attach names of specific months to each picture.

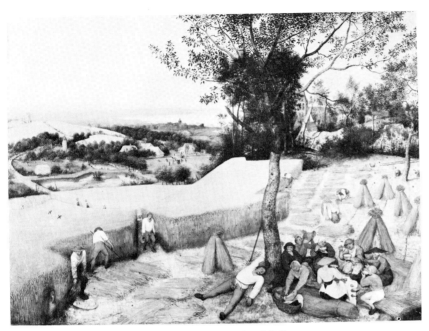

88. Pieter Bruegel, *Haymaking*, Prague, National Gallery

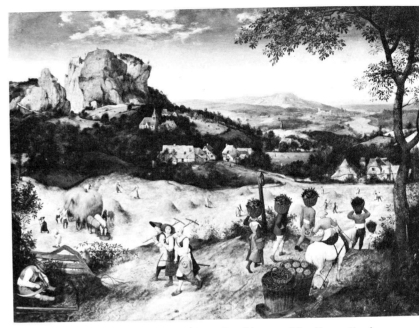

89. Pieter Bruegel, *Harvest*, New York, Metropolitan Museum of Art (Rogers Fund, 1919)

cathedral), a triptych by Rubens, the background landscape runs across all three panels, just as in many sixteenth-century Flemish examples. Sometimes, on the other hand, the wings of fifteenth- and sixteenth-century altarpieces show contrasting views. So many landscape arrangements were suggested by earlier art, in fact, that Rubens had only to choose according to his needs, and it is not surprising that his selection was so inventive.

NATURALISM AND ARTIFICE

Long before the 1630s, landscape had clearly come to be regarded by Rubens as a subject worthy of his best talents. We may recall that Philip Rubens even assumed that his uncle had purchased Het Steen in order to be able to paint more vividly the rising and setting of the sun.[24] This motive might seem more in keeping with nine-

teenth-century ideas: a blend of naturalism and romanticism à la Constable—the very painter who most eloquently expressed in both words and paint his admiration for Rubens' landscapes.

Rubens' vision of landscape encompassed many attitudes and categories of feeling. But each of his works, as we have maintained, has its own "peculiar language" that is consistent and legible on a number of levels. In one respect, the expressive language of any representational artist can be discussed with respect to forms that are imitative and at the same time pictorial, products of an alliance between a perception of created nature and a particular conception of design—"artifice" in the best sense. The question of nature and art in Rubens' landscapes is in fact an abiding topic in all discussions of the subject.[25]

Two remarkable letters that Rubens wrote in his later years relate to the issue of nature and art in landscape. The first, dating from 1636, contains a passage concerning an engraving after an ancient fresco Peiresc had sent him. "I have looked with pleasure at the engraving of the antique landscape," Rubens responds, but he con-

tinues by saying that the work seems to him "purely an artist's caprice, without representing any place in *rerum natura*." He then expands the critique, observing:

Those arches, one above another, are neither natural nor constructed, and could hardly subsist in that fashion. And those little temples scattered on top of the cliff haven't enough space for such buildings, nor is there any path for the priests and worshippers to go up and down. That round reservoir is of no use, since it does not hold the waters it receives from above, but discharges them again into the common basin through many very wide outlets, so that it pours out incomparably more water than it receives. The whole thing may be called, in my opinion, a *nymphaeum*, being like a confluence *multorum fontium undique scaturientium* [of many fountains flowing from all sides]. That little temple with three female statues could be dedicated to the nymphs of the place, and those on the summit of the hill to certain deities of the fields or mountains. The square building is perhaps the tomb of some hero, *nam habet arma suspensa prae foribus* [for it has arms hung at the entrance], the cornice is adorned with foliage and the columns with festoons and torches. At the corners are baskets in which to place fruits and other gifts *quibus inferias et justa solvebant defunctis et tanquam oblatis fruituris Heroibus parentabant* ["with which they paid due rites and ceremonies to the dead and made sacrifice to the Heroes on the supposition that they would enjoy the offerings"]. The goats are sacred to some deity, for they are grazing without a shepherd. The picture appears to have been painted by a good hand, but as far as optics are concerned, certain rules are not too accurately observed, for

24. Ruelens, "La vie," p. 167.

25. J. M. W. Turner, for example, said of Rubens' *Tournament before a Castle* that it was "one continual glare of color and absurdities when investigated by the scale of nature, but captivating; so much so that you are pleased superficially, but to be deceived in the abstract." As John Gage, who cites this comment, notes, "Turner seems to be using 'abstract' here to refer to an underlying rationale recognizable on closer examination" (*Color in Turner* [New York, 1969], p. 61). Another such response to a landscape by Rubens is Goethe's discussion of the artist's twofold relationship to nature, as exemplified by *Return from the Fields* (conversation with Eckermann, April 11, 1827; Johann Peter Eckermann, *Conversations of Goethe with Eckermann and Soret*, trans. John Oxenford [London, 1874], pp. 247 f.). Baudelaire, in chapter 15 ("Du paysage") of his review of the Salon of 1846, spoke of Rubens' landscapes as landscapes of imagination (*fantaisie*); Kenneth Clark classifies them under "Landscapes of Fantasy" (*Landscape into Art* [London, 1949], p. 49–51); but John Constable always emphasized their naturalism.

the lines of the buildings do not intersect at a point on a level with the horizon—or, to put it in a word, the entire perspective is faulty.[26]

The insistence on thematic and pictorial logic in this letter coincides in time with Rubens' execution of the pendants.[27]

The second letter, dating from 1640, concerns a painting of the Escorial by Pieter Verhulst based on a detailed drawing made "from life" by Rubens himself in Spain. Edward Norgate had seen the painting in Rubens' studio and mistook it for the master's own. When Norgate informed Charles I of the landscape, the king enlisted his agent Balthasar Gerbier to obtain it for him. Although Rubens explained to Gerbier that the painting was in fact by "un peintre des plus communs," the sale nevertheless took place, and the artist sent along a written description:

Here is the picture of St. Lawrence in Escorial, finished according to the capacity of the master but with my supervision. Please God, the extravagance of the subject may give some pleasure to His Majesty. The mountain, which is called La Sierra de S. Juan en Malagon, is very high and steep, and very difficult to climb and descend, so that we had the clouds far below us, while the sky above remained very clear and serene. There is, at the summit, a great wooden cross, which is easily seen from Madrid, and nearby a little church dedicated to St. John which could not be represented in the picture, for it was behind our backs; in it lives a hermit who is seen here with his mule. I need scarcely say that below is the superb building of St. Lawrence in Escorial, with the village and its avenues of trees, the Fresneda and its two ponds, and the road to Madrid appearing above, near the horizon. The mountain covered with clouds is called La Sierra Tocada, because it almost always has a kind of veil around its top. There is a tower and a house on one side; I do not remember their names particularly, but I know the King used to go hunting there occasionally. The mountain at the extreme left is La Sierra y Puerto de Buitrago. That is all I can tell you on this subject, remaining ever, Monsieur,

Your very humble servant,
Peter Paul Rubens

I forgot to say that at the summit we found *forze venayson*, as you see in the picture.[28]

26. *CDR* 6:164; Magurn, pp. 403 f. As Herbert Herrmann (1936, n. 104) observed, the engraved landscape is illustrated in Lucas Holstenius, *Vetus pictus nymphaeum exhibens* (Rome, 1676). Perhaps more accessible is Lucas Holstenius, "Commentarium in veterem picturam nymphaeum referentem," in *Thesaurus antiquitatum Romanarum*, vol. 4 (Venice, 1732), p. 1799. On Rubens' use of this engraving for his Vienna *Feast of Venus*, see K. M. Swoboda, *Neue Aufgaben der Kunstgeschichte* (Brünn, 1935), pp. 120 f.

27. Rubens' observation that the engraving is "purely an artist's caprice without representing any place in *rerum natura*" distantly echoes Vitruvius's condemnation of the fantastic wall decorations fashionable in his day (the remedy he prescribes is a return to naturalistic landscape views). Vitruvius says of the offending decorations (ancestors of Renaissance *grotteschi*) that such things as they represent "neither are, nor can be, nor have been," and he flatly declares that "pictures cannot be approved which do not resemble reality" (*On Architecture*, bk. 7, ch. 5, trans. F. Granger [Cambridge, Mass., 1956], p. 105). I am grateful to Paula Spilner for suggesting the analogy between Vitruvius's critique and Rubens' letter. E. H. Gombrich points out that Vitruvius's critique became the authoritative model for later descriptions of styles perceived as fantastic or depraved—for example, Vasari's condemnation of the Gothic. ("Stylistic Categories of Art History and their Origin in Renaissance Ideals," in *Norm and Form* [London, 1966], p. 83). Rubens, we may recall, owned two copies of Vitruvius.

28. *CDR* 6:303; Magurn, p. 414. The landscape to which Rubens refers is most likely the version in the collection of the Earl of Radnor, Longford Castle (illustrated in Christopher White, *Rubens and His World* [New York, 1968], p. 86).

In 1933 Herbert Herrmann noted the expression of a similarly naturalistic conception of landscape in these two letters. He then compared Verhulst's presumed work to the actual spot depicted by Rubens.[29] Herrmann found that the painted and real panoramas coincide, except for the diminution of the distances between ranges, the height of certain mountains, and the form of some precipitous rocks.

These letters do not insist, however, on the utter fidelity to nature. Although in the first Rubens criticizes the artist's "caprice," in the second he reveals a certain embarrassment about Verhulst's unimaginative translation of a mere topographical drawing into an independent painting. Rubens' introduction to Verhulst's landscape seems to indicate his feeling that any interest the work had to offer rested on the subject alone, the picture's component of "art" being minimal.

Although *Het Steen* and *The Rainbow* have a topographical aspect, they are not, strictly speaking, "views." We have already noted, for example, the discrepancy between Antwerp's actual location with respect to the estate and its position in the painting, a relationship expressing an abstract concept rather than an optical perception. Rubens' choice of the large size and oblong format of the paintings, on the other hand, seems to reflect his actual experience of expansive rural space and the gradual flow of time during a summer day spent in the country. This blend of naturalism and artifice is part of Rubens' language of landscape and thoroughly informs each painting. The following section examines the ways in which certain motifs work within the landscapes, how they serve for the display of Rubens' particular painterly talents, and the qualities and values they tend to convey.

Land and Horizon

In *Het Steen* and *The Rainbow* the artist's conception of a complete landscape meant the combination of close-up and panorama, the latter encompassing the middle ground as well as a fully worked-up, though atmospheric, distance. In envisioning all these aspects of landscape simultaneously, Rubens eschewed both a low, inevitably obstructed and limiting viewpoint and a high, remote one. With these pictures, the observer has a sense of nearness and immediate access—for he is only slightly above the large foreground elements—and at the same time he can visually traverse the paintings to a great depth, "up to their horizons."

Rubens used many devices to bind these separate views into a unified scene. Objects do not diminish in space at a consistent rate; in *Het Steen*, for example, the transition from outsized foreground elements, such as partridges and wild flowers, to a Lilliputian footbridge is abrupt, to say the least, yet barely noticeable within the larger context. And two abbreviated pastures, the far one scattered with minute milkmaids and a herd of tiny cows, visually increase the amount of acreage; but the artifice is betrayed—for those who require consistency—by nearby willows, which in comparison to the milking scene appear suddenly gigantic (cf. fig. 74).

The land in *Het Steen*, then, is irregular. No system of hills and dales, but sporadic "waves" of earth make the ground itself seem to surge with life. In *The Rainbow* the terrain also has its ups and downs, such as the haymaking site's deliberate elevation with re-

29. Herbert Herrmann, "Rubens y el Monasterio de San Lorenzo de El Escorial," *Archivo español de arte y arqueologia* 9 (1933), pp. 239–41.

spect to the grainfield. Yet the transitions from near to far seem plausible, and the landscapes bestow on us the privileged sense of being able to take in many things at once.

We have already referred to Rubens' practice of stretching or compressing a view he had observed so that it would fit within the complex structure of a large landscape. Two of his most beautiful drawings may reflect a type of study made for just such use: *Landscape with a Wattle Fence* (fig. 90) and *Woodland Scene* (fig. 91).[30] Both appear to date from the period of *Het Steen* and *The Rainbow*; Held has observed that the "prevailing flatness of the land, the lightness and softness of the forms diffused in light are characteristic of the master's late style in the rendering of landscapes,"[31] as are "the light touch and the transparency of the foliage."[32] Neither of the scenes sketched was incorporated into a known painting, but one can infer how the observations they embody are utilized in Rubens' landscapes. Both drawings are seen spatially in terms of wedges of land. The *Landscape with a Wattle Fence*, enlarged and with scale relationships juggled, could have served for the sort of left middle ground that occurs in *Return from the Fields* (fig. 65) or for the central middle ground of *The Rainbow* (fig. 71). In his discussion of *Woodland Scene*, Held noted that a "little bridge, not unlike the one in the drawing, surrounded by slender trees, is seen at the approaches of Castle Steen [in *Het Steen*]."[33] The other bridge in *Het Steen*, at the right, also occurs within a middle ground wedge. These "middle ground" drawings, then, must have served an important purpose as Rubens set out to construct the wide, deep spaces characteristic of his later rural landscapes.

Reading across the landscape pair reveals other aspects of Rubens' blend of naturalistic observation and artful contrivance. Beginning with the château, one sees that the building is relatively small and recessed but that the trees in this section are extraordinarily tall. The place is aggrandized, therefore, but in a modestly roundabout way. In the same section, the arrangement of trees on the knob of land washed around by the stream may at first seem quite unstudied, but there is nothing random about these trunks and branches pointing in every direction. The straight, thick-set one, fenced at its base and projecting several branches toward the viewer, acts as a fastening rod for the whole left wing of *Het Steen*. Its long lowest branch masks part of the house and frames the tower, thereby binding the diagonally set building with the frontal tree. Consequently, the direction in which the house faces becomes slightly ambiguous and flexible; its main portal fronts on the fields but at the same time welcomes the viewer.

Next to the dark tree that functions as the kingpin of the group, Rubens places a trembling birch, its trunk winding in a lively, effective, and by no means uncommon way. Placed between two straight trees, it lends movement to the group and contributes to the irregular framing of the background—a device exploited by Bruegel in *Dark Day* (fig. 87). The pronounced curving of this birch is more subtly echoed in some of the branches in the grove. This is characteristic of Rubens' trees, and especially when accentuated by a tracing of sunlight, makes them seem fairly to course with life. Another device, combining style with observation, is the fork-

30. Held, no. 136 and Held, no. 137; B.-H., no. 207.
31. Held, no. 136.
32. Held, no. 137.
33. Held, no. 137.

90. *Landscape with a Wattle Fence*, drawing, London, British Museum (Reproduced by Courtesy of the Trustees of the British Museum)

91. *Woodland Scene*, drawing, Oxford, Ashmolean Museum

ing of nearly every branch into curved prongs, imparting a sense of continual sprouting and growth.[34]

The next section of *Het Steen* is articulated by the dead tree and the bramble in the foreground. Rubens was interested not only in their compositional function but also in their concrete qualities as physically experienced and perceived in nature. The base of the trunk, lost in the undergrowth, is not visible, making the stump, with its odd roots, seem to rise like an octopus out of the deep. It conveys qualities we call picturesque and at the same time recalls the slight smell of rotting wood or the sense of a forbidding obstacle, to be avoided, lest one become entangled and stuck with thorns.

Brambles were the subject of two of Rubens' drawings (figs. 56, 57, discussed above), and they occur in several of his paintings. The motif must have appealed to Rubens' conception of form, and at the same time it was well suited to his particular artistic means— in the case of painting, extraordinarily vigorous, controlled brush-work and a colorful palette. Rubens depicts the bramble as both flowering and bearing fruit, giving him the opportunity to combine russets and browns, bright red, shade upon shade of green, and a sparkling white; to flourish flat, broad, tapering strokes for the leaves, to jab on thorns, stipple in blossoms, trail the brush for creeping vines, and dab on berries. This section of the picture provides a veritable catalogue of brush strokes, and its several layers of paint—from the brown *imprimatura* to the white highlights or

from shadowed depths to sunlit surfaces—create a sense of the vegetation's component openness and density.

A profusion of willows dots the countryside in *Het Steen* and *The Rainbow*. Even as these little trees sprout up, they seem to pin down the earth, keeping the land from rising and expanding as it seems to want to do. In many of the late landscapes, willows are used as structural modules, and to great effect; they are marshaled to fill in any spot, to create a line in any direction, and to catch or block the sun. Rubens also exploits to the fullest the visual contrast between this short, chubby tree and the tall, graceful poplar. And in another spirit, he observes that peasants, having pruned the poplar's foliage, use the tree's tall thin trunk as a core around which to construct haystacks and that they leave others unshorn to shade their work.

The large yellow flowers in the right foreground of *Het Steen* (fig. 74) enjoy a vast exaggeration in size because of Rubens' vision. It is as if the artist had set them up to display his painterly bravura and to create a living still life. The wheat field in the afternoon landscape is another motif naturalistically depicted in all details save size: it is exceedingly small, clearly a token crop, placed there to characterize the setting as productive agricultural land, to signal the season, and to allow for a long, low strip of shimmering gold.

A forest was in Rubens' day the subject most exploited by land-scape painters for its picturesque qualities. But though dark and deep, the wood in *The Rainbow* contains no writhing trunks, no grotesque or fantastic branches; only the foreground tree is gnarled and staccato-limbed. Otherwise, the trees—ancient survivors, one imagines, of a previous clearing of the land—grow straight. Some of their leaves are accented by sunlight, but mainly it is buoyant

34. Of Rubens' trees H. G. Evers writes: "Die Bäume wachsen bei Rubens nicht, wie bei anderen Künstlern, indem ein Hauptstamm sich fortsetzt und Nebentriebe entsendet, sondern an einen Stamm oder Ast schliesst eine zwei-zinkige Gabel an: Rubensbäume vermehren sich durch Zweiteilung" (1944, p. 354).

masses of foliage that create the particular character of Rubens' woods.

Sunlight and Shadow

Rubens' painting of sunlight is one of the most admired features of his landscape art. Like scale, it was a variable that he adapted to a host of compositional and iconographic functions. His deliberate use of sunlight also worked in the interest of description; thus the cows seem lustrous because of the streaks of light tracing their skeletal frames, just as here and there individual trees stand out because they have been touched on one side with light.

In *Het Steen* the sun strikes objects consistently on the right, although it does not always do so at the same angle, and the hunter is illuminated from several directions. In this picture the sun, fixed though it may be, is shown as a powerful force, sending out its light to touch, trace, enfold, and penetrate the elements of the landscape. At the same time, the sun seems magnetically to attract growing things; the large yellow flowers, for example, themselves like so many suns, turn toward their heavenly counterpart over the horizon.

The system of sunlight and shadow in *The Rainbow* is far more arbitrary from a scientific point of view. The main indication of the sun's position is the lighting of trees and haystacks from the left. But it is as if, after having established this—and therefore the time of day—Rubens abandoned all naturalistic consistency with regard to light. Sunlight is used to pick out the features of greatest dramatic importance or to set up contrasts: thus the faces of the men are browned by the sun and are also in shadow, whereas the fair skin of the ladies reflects the light (fig. 75).

In both paintings, Rubens took care to distribute sun and shadow on every object he rendered. No area is left flat and unaccented. The paintings themselves seem to move and alter, dramatically or subtly, according to the actual light they receive; the artist indeed may have taken pleasure in contemplating their brightening up and toning down with the passing hours of the day.

Clouds, Rainbow, and Reflections

The painter's ability to represent elusive atmospheric conditions was part of the *paragone* tradition, but it was van Mander who actually related this topos to landscape painting proper. In his biography of Gillis van Coninxloo, van Mander says that he has "read some dialogues and essays, written by two or three Italian authors, on the two arts, painting and sculpture, and which one of the two is superior." He then continues:

These writers favor the art of painting, because the artist can paint anything the human eye can see—the sky; various kinds of weather; the sun piercing clouds and sending its rays to the earth, the mountains, and into the valleys; sometimes dark rain clouds; hail; snow; all possible variations in green, of trees, and fields, when spring smiles and birds sing. The sculptor cannot possibly cut all this in stone. For various reasons, painting is a more pleasing and flexible art than sculpture. The clever work of the excellent landscape painter, Gillis van Coninxloo, from Antwerp, will confirm that statement.[35]

35. *Dutch and Flemish Painters*, trans. C. van der Wall (New York, 1936), p. 306.

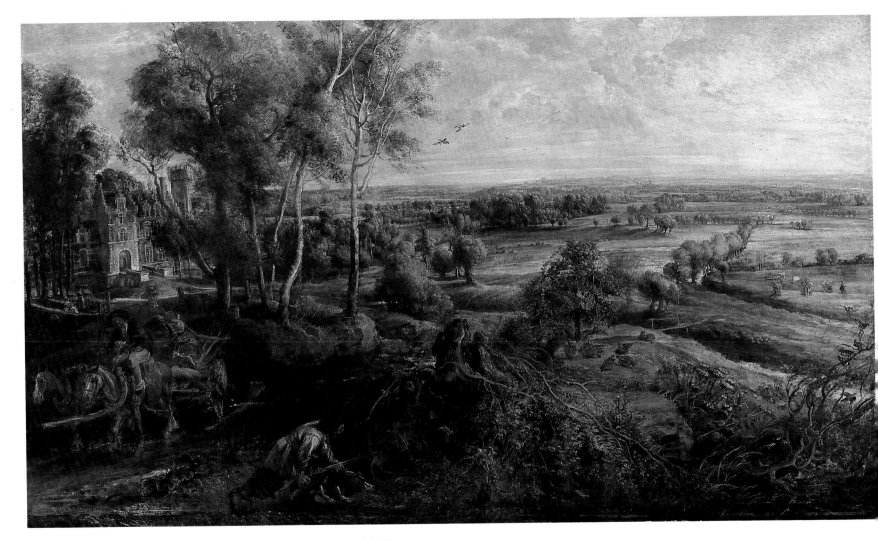

70. *Het Steen*, London, National Gallery (Reproduced by Courtesy of the Trustees,
The National Gallery, London)

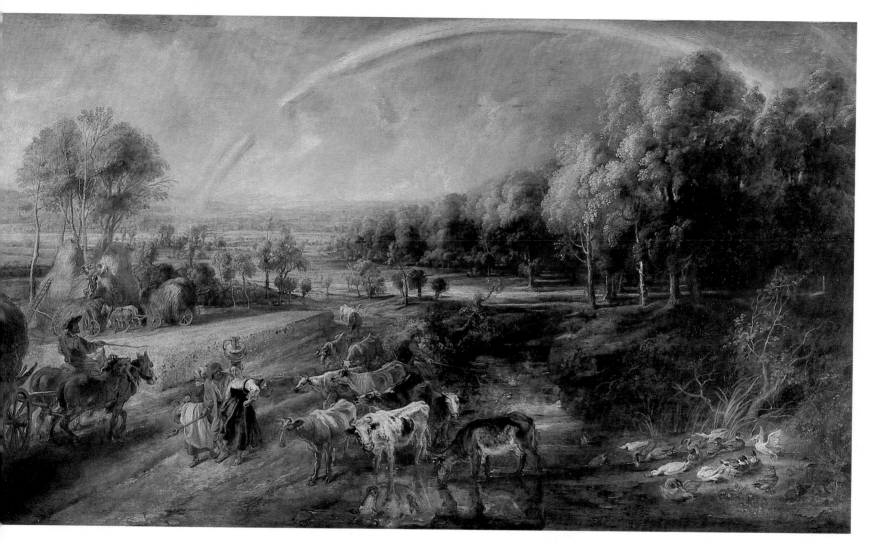

71. *The Rainbow*, London, Wallace Collection (Reproduced by Permission of the Trustees of the Wallace Collection)

"The sun piercing clouds and sending its rays to earth" is one theme of *Het Steen*. The clouds themselves, some with sunlit edges, form an interesting collection. Easily identifiable are the low-lying stratus clouds and the high altocumulus, the latter fanning out toward the companion piece. Some of the clouds expand and open up, forming holes through which blue sky can be seen, just as in Bruegel's *Flight into Egypt* (London, Prince's Gate Collection), a work that Rubens may have owned. Yet others roll and popple like those in sixteenth-century German and Venetian prints.[36] In the afternoon landscape the sky is heavy and moist but nonetheless active. Cloud masses rove the sky, one assuming the shape of a giant paw grabbing the rainbow. And on the right, above the woods, delicate pink striations ascend in response to an approaching blanket of nimbus clouds. Later in the century, the German painter Joachim Sandrart (Rubens' guide during the Fleming's visit to Holland in 1627) wrote in his treatise on art, "Landscape is more beautiful after rain, or when a storm breaks, for at that moment the clouds assume shapes so wonderful as to be difficult to imagine.[37]

The rainbow is one of the most versatile elements of composition in the afternoon landscape. At first glance it seems to arch across the picture plane, but it is actually disposed in depth, spanning the distance between far left and near right middle ground. It thus binds not only left and right, but near and far, and in conjunction with its reflection in the stream below, the upper and lower parts of the painting. Rubens surely knew that the direction of the sun and the position of the viewer must be perpendicular to the bow, not at an angle to it, as we see here. But he wanted side lighting for the sake of composition and iconography, as well as a magnificent arch spanning the abundance of things below.[38]

Rubens' rainbow almost reads as an emblem of his painterly powers. Since it had to appear both strong in form and light in substance, the motif presented a particular challenge. A contemporary Dutch poet indulging in the ancient comparison between nature and art found the rainbow a case in point for nature's supremacy. Within the context of a long, emblematic poem on country life, he wrote:

When curved Iris colorfully passes overhead,
She promises to drench with the fall of her tears the thirsty land
And to gently cleanse the world below.

36. Cf., for example, fig. 29 and Dürer's engraving *The Sea Monster*, B. 71. A *Flight into Egypt* by Bruegel is listed in Rubens' inventory (J. Denucé, *The Antwerp Galleries: Inventories of the Art Collections in Antwerp in the Sixteenth and Seventeenth Centuries* [Antwerp, 1932], no. 191, p. 64). Cf. Count Antoine Seilern, *Catalogue of the Collection at 56 Prince's Gate, Flemish Paintings and Drawings* (London, 1955), no. 5.

37. Joachim von Sandrart, *Teutsche Academie der Edlen Bau-, Bild-, und Mahlerey-Künste* (Nuremberg, 1675), ch. 6, p. 71.

38. By Rubens' time it was well known that the eye of the observer, the sun, and the center of the rainbow must be on the same straight line (cf. C. B. Boyer, *The Rainbow: From Myth to Mathematics* [New York], p. 151).

Ruskin was critical of Rubens' artifice in lighting the rainbow. In *The Eagle's Nest* he wrote: "Rubens' rainbow . . . was dull blue, darker than the sky, in a scene lighted from the side of the rainbow. Rubens is not to be blamed for ignorance of optics, but for never having so much as looked at a rainbow carefully" (cited in M. Minnaert, *Nature of Light and Color in the Open Air*, trans. H. Kremer-Priest, [New York, 1954], p. 170). Jacob Burckhardt was a trifle condescending: "Rubens always took liberties of many kinds. . . . We must make allowances for his frequent use of rainbows, while admitting at any rate that nobody solved the problem better than he" (*Recollections of Rubens*, trans. Mary Hottinger, ed. H. Gerson [New York, 1950], p. 155).

The splendor of her clothes surpasses by far your art,
O clever painter; your hand, worthy indeed of high praise,
Misses the mark here; no color, no brush,
Will in the least bit imitate Iris' bright shine.[39]

Van Mander, on the other hand, takes the side of the artist, but cautions that whoever attempts to paint a rainbow must show how the various bands of color subtly blend, flowing into one another so that each hue seems to give rise to the next. He indicates that where yellow and blue meet in the rainbow, green is formed, and that yellow and red blend to create orange (*Grondt* 7:22–23). The two outer bands of the rainbow, he says, are purple—the topmost flanked by blue and the lower one by red—but he does not go on to say that red and blue combined make purple. It is not clear, therefore, whether he really understood the relationship between primary and secondary colors; the point he makes is only that the rainbow teaches which colors go well together. This leads to a stanza on how to arrange colors on a palette, with the advice that white should be closest at hand so that out of every saturated color two or three lighter shades can be made.

Rubens' interest in the rainbow went back at least to the early years of the second decade. About 1611–13, he produced a title page for a treatise on optics (*Opticorum libri sex*) by Franciscus Aguilonius, a member of the Jesuit college in Antwerp. Besides the title page, some of the material concerning the properties of color may have been supplied to Aguilonius by Rubens. According to Charles Parkhurst, Rubens' *Juno and Argus* (fig. 92) functions on

92. *Juno and Argus*, Cologne, Wallraf-Richartz Museum

one level as a kind of demonstration piece of a theory presented in book 1 of the *Optics* (the painting dates from the same period as the title page).[40] The theory, well known today but perhaps first defined in print by Aguilonius, concerns the relationship between

39. Philibert Van Borsselen, *Den Binckhorst* (Amsterdam, 1613), ll. 222–28. This poem is discussed further below, in chapter 6.

40. Charles Parkhurst, "Aguilonius' Optics and Rubens' Color," *Nederlands kunst-historisch jaarboek* 12 (1961), pp. 35 ff.

primary and secondary colors and black and white, as well as three methods of color mixing.[41]

As Parkhurst points out, in *Juno and Argus* the main female figures make up a triangle of the primary colors; these appear again, interspersed with secondary colors, in the rainbow over Iris' head. Near-black, near-white, and the livid color (seen in the corpse of Argus) that results from the mixing of the three primaries, also have their place in the painting, as do the three kinds of color mixing described by Aguilonius. The *Juno and Argus*, more than depicting a mythological story about how the peacock got its eyes, is an allegory of vision itself (as Parkhurst points out, the eyes are given to Juno's "painted" bird—*pavonibus pictis* [*Metamorphoses* 2:532]). The presence of Iris, goddess of the rainbow and "chief sensate manifestation of color and light" confirms this; while she appears in Ovid as Juno's messenger, she is not part of the Argus story.[42]

Certainly the rainbow in Rubens' afternoon landscape is a tour de force of painting, especially the rendering of its terminus as a transparent veil of colored mist, executed in a manner that deceives the eye. For John Constable, the rainbow exemplified the basic qualities of all Rubens' art. "By the rainbow of Rubens," he wrote, "I do not allude to a particular picture, for Rubens often introduced it; I mean indeed, more than the rainbow itself, I mean dewy light and freshness, the departing shower, with the exhilaration of the returning sun, effects which Rubens, more than any other painter, has perfected on canvas."[43]

An elusive blend of colored light and water, the reflections in Rubens' landscapes seem to epitomize the painterly aesthetic of his mature years. As early as the *Shepherd before a Wood* of about 1617–20 (fig. 38), he had depicted reflections of trees and sky in water, and he included this motif in at least seven of his other landscapes. He also made a bare whisper of a drawing, difficult to date, showing trees, bushes, and a red sky mirrored in a stream or country canal (fig. 93). Rubens annotated the sketch, observing, "The reflection of the trees in the water is darker and clearer than the trees themselves.[44]

The reflections in *The Rainbow* are the most pronounced of any in Rubens' landscapes, whether earlier or later in date. Just as he had observed concerning the reflection of trees when the sun is low, the mirroring of the rainbow in the foreground of the afternoon landscape is far more saturated in color than the rainbow itself. The reflections of the cows, moreover, are substantial enough even to hold their own at the center foreground of a vast picture. (Rubens added a strip at the bottom to accommodate these reflections—cf. fig. 77). More than ten years earlier, he had painted the reflections of cows in *The Watering Place* (fig. 39); there, however, they are less palpable, blending in with the general tonality of the picture. In *The Rainbow* they read more as self-sufficient motifs,

43. Leslie, p. 315. Delacroix, too, connected the rainbow with Rubens' palette; of a nude child painted by the Flemish artist, he observed: "C'est de l'arc-en-ciel fondu sur la chair . . ." (G. Sand, *Impressions et Souvenirs* [1873], p. 90, cited by Gage, p. 239, n. 40).

44. Held (no. 135) offers a literal translation: "The reflection of the trees in the water is browner [darker?] and more perfect [clear?] in the water than the trees themselves"); Rowlands, no. 195. Recently Held has interpreted this sentence in relation to Rubens' interest in optics (Julius S. Held, "Rubens and Aguilonius: New Points of Contact," *Art Bulletin* 61 [1979], p. 261).

41. John Gage has recently summarized what is known about the history of Rubens' lost treatise on light and color (p. 222, n. 10, with complete bibliography). Evers speculates at some length on what this treatise might have contained (1942, pp. 438–42).

42. Parkhurst, p. 37.

93. *Trees at Sunset*, drawing, London, British Museum (Reproduced by Courtesy of the Trustees of the British Museum)

much like the strange watery echoes of the Andrians in Rubens' otherwise close variant of Titian's *Bacchanal of the Andrians* (fig. 94).

Animals

Rubens creates his own brand of realistic workhorse: a small animal, plodding along, its neck jutting out from the yoke, mane straggling, its head ending in a blunt muzzle, and the barrel of the beast appearing to have stretched from its constant forward pull.

Evers, with only slight exaggeration, claimed that cows were the only animals Rubens needed to depict the pastoral economy.[45] An artistic enthusiasm for cows is already heralded by van Mander. Emphasizing cattle in his chapter on animals (*Grondt* 9), he discusses the difference between the appearance of cows, bulls, and oxen; the color of hides; and the importance of imitating nature. Following Virgil's *Georgics*, he describes the features to look for in a breeding cow: a coarse, fearsome head more like that of a bull, threatening horns, a spirit that refuses the plow, white markings on the hide, a generous neck, big legs and hooves, a tail so long that it brushes the ground, large, full flanks, crooked horns above shaggy ears, and a dewlap that hangs from the jaw to the chin (*Grondt* 9:30–31; cf. *Georgics* 3:51–59). Van Mander, perhaps disturbed by Virgil's picture of so fierce a cow, twice cautions the reader that cows and heifers should not really be so horrible and shaggy (*gruwzaam en ruig*) as bulls and oxen (*Grondt* 9:31, 33), and he observes that the females of any species should be smoother and softer and nicer to look at than the males (9:32). He finds especially pleasing the sight of heifers with subtle musculature and full flanks as they stand

45. Evers (1942), p. 396.

94. *Bacchanal of the Andrians* (after Titian), Stockholm, Nationalmuseum (Copyright Nationalmuseum, Stockholm)

being fattened in the stall (9:33). In another vein, he commends the ancient painter Pausius for having dared to show a sacrifical ox foreshortened, with its head facing the viewer (9:37–38). The

cows in *The Rainbow*—small attractive animals presenting a fashion show of hides—not only face the viewer in some cases but have been boldly painted as they appear from above.[46]

Like the cows, the flock of ducks challenged Rubens to devise multiple views of a single motif. A patch of sun falls on the spot where they congregate, highlighting the diversity of their colors and movements. A pure white one, beating its wings energetically and rising in full display, is about to take flight, while a dark one dives under water so that only its tail feathers show. Some are compact as they sit in the sun; others turn back on themselves, fussing with their feathers; and several are seen stretching out sinuous necks as they dart after food. Thus a corner of the landscape other painters might ignore becomes an arena for one of Rubens' most delightful performances.

Naturalistically conceived though the ducks may be, and loath as we may be to burden such innocent creatures with the weight of classical tradition, it is possible they also reflect Rubens' reading of Philostratus's *Imagines*. In "A Marsh," discussed above, the Greek writer describes in the following terms the attitudes of some long-legged birds with huge beaks:

> One stands on a rock resting first one foot and then the other, one dries its feathers, one preens them, another has snatched some prey from the water, and yet another has bent its head to the land so as to feed on something there.[47]

Peasants

Het Steen and *The Rainbow* represent the two times of day when the sun is low but still flooding the land with light—neither dawn nor dusk nor strength-sapping noon, but the hours when there is most human activity in the countryside. In these pictures the only people who do not fish, transport food to market, hunt, milk, make hay, tend cows, or bring pitchers home are the small upper-class figures, a family group, near the château (fig. 73). Clearly it is the working peasants, regardless of their implied social status with respect to the lord and the lady, who are shown presiding over this land.

Although the landscape is as deep in the pendants as it is in *Return from the Fields*, the peasants are larger in relation to the frame, and they are less anonymous. In *Het Steen* the couple going to market give the air of being man and wife—like their horses, "yoked" and setting off down a familiar path. Leaning forward, urging his horses on through the water, the wagoner contrasts with the woman in back, who sits up straight and relaxed, hands folded, with a slight, satisfied smile on her face (fig. 73). As in all of Rubens' paintings, glances set up directional energies—the man gazes ahead, concentrating upon his task, while his consort's eyes shift to the right as she observes the hunter. And the hunter himself, naturally, fastens his eyes on the partridges. The posture of this figure—the fowler—is hardly classical, yet the inspiration may have come from those ancient relief figures that, without losing any naturalness of

46. According to Elizabeth McGrath, Rubens' sacrificial scene with a foreshortened ox, seen head on, which he designed for the façade of his Antwerp studio, "was certainly meant both to evoke and pay homage to the skill of the ancient painter [Pausias]" ("The Painted Decorations of Rubens's House," *Journal of the Warburg and Courtauld Institutes* 41 [1979], p. 261).

47. Philostratus, *Imagines*, trans. Arthur Fairbanks [Cambridge, Mass., 1960], 1:9, p. 137.

pose, are ingeniously accommodated to the corners of pediments.[48]

The wagoner in *The Rainbow* (fig. 75) is a craggy-faced man of middle age. Unlike his counterpart in *Het Steen*, he leans back slightly in the saddle, slowing the horses so that he can exchange a few words with the passing peasant woman. She, too, is individualized: short, a bit stocky, with small sharp features set into a full, round face, and hair tucked under a neat white cap. In contrast, her younger looking companion is tall, dark-haired, and prettier, as she gracefully walks along barefoot and with one arm crooked, balancing a large copper pot on her head and carrying another slung over her shoulder. Between this brightly clad pair of women thrusts a hulking farmer. He stoops a bit and turns to smile at the milkmaid, but she, not without a smile of her own, averts her gaze.

Separated from the others, near the middle of the painting, is the herdsman. With his short, scruffy beard, broad nose, and down-turned eyes and mouth, he too is individualized in appearance. In spite of the vigor implied by his suddenly reversed *contrapposto*, he looks somewhat forlorn and dreamy: among fellows who are alert, engaged, and coupled, he is the lonesome cowboy, stuck with a troublesome herd.

Even the trio making hay are distinguished, though in proportion to their small size: the peasant pitching hay, like the wagoners, wears a broad-brimmed hat, jacket, and breeches; the young fellow above, on the other hand, has stripped down to a chemise and exposes a head of yellow hair to the sun. We are made to feel that the artist knew these people, studied them from life, and then placed them in anecdotal situations.

Rubens' aristocratic notion of the peasants as strong, healthy, sociable, and possessing a certain autonomy within the rural social structure is most fully expressed in *Het Steen* and *The Rainbow*. Although his peasants are not so completely equated with nature as are their counterparts in Bruegel's *Months*, they are shown to be in harmony with the world around them. Their shapes are set into the larger configurations of the landscape, and in some cases they even seem to define the pictorial structure. They also breathe in as well as emanate the atmosphere of the land around them, especially in the afternoon picture. Rubens artfully limits the clothing of the women there to a simple color triad: rose, white, and aquamarine, with the strong gold accent of glinting copper pitchers. As carriers of such bright colors the peasants contribute to the cheerfulness of the landscape, and with their strongly saturated clothing echo emphatically the delicate spectrum of the rainbow.

48. On the many changes Rubens made in the course of executing this figure, see G. Martin, p. 137.

5. RURAL LANDSCAPE: THE CLASSICAL BACKGROUND

With *Het Steen* and *The Rainbow* Rubens moved beyond a single rural scene to create a larger and more organized world than is represented in *Farm at Laeken*, *The Polder*, and *Return from the Fields*. As compared with these earlier works, the pendants appear more realistic and at the same time suggest a wider range of ideas.

Rubens' initial decision to take up the rural theme and then to extend it in such a searching way seems to have arisen from his immediate experience of nature and his knowledge of pictorial traditions, as well as from the classical ideals that informed his entire life and art; surely this truly humanistic painter approached rural landscape with, and through, an intimate understanding of what the ancient authors had to say about country life.

Several obstacles, however, have prevented us from linking Rubens' landscapes to classical traditions: a habit of believing landscape to be an indigenously Northern—and therefore somehow naive—genre; the Flemish character of the rural landscapes; and, at the same time, the great difference between landscape as Rubens painted it and as it appears in antiquity—when "classic" ideas about country life were philosophically and poetically formulated. Julius Held is among the few art historians to have suggested that Rubens'

conception of country life has a classical, literary dimension. "Rubens' landscape and peasant scenes," he writes,

> may be another form of tribute to the culture of the ancients. Rubens knew the bucolic poems of Vergil and Horace. When he transformed a Bruegelian harvest festival into a peasant bacchanal, he was probably aided by the recollection of Horace's "*Nunc est bibendum, nunc pede libero / pulsanda tellus*" (*Odes* 1:37: "Now is the time for drinking, for stomping the ground with an unrestrained foot"). If anything, it was the civilizing influence of the classical tradition that made graceful athletes out of boors.[1]

Held's singling out of Virgil and Horace is certainly just, for in Rubens' day their works were chief among those considered by the learned as offering the most elevated, complete, and satisfying ways of viewing rural life. These and other antique sources allow us to

1. Julius S. Held and Donald Posner, *Seventeenth·and Eighteenth Century Art* (Englewood Cliffs, N.J., 1973], p. 210.
Herbert Herrmann seems to have been the only scholar to have suggested that one might study the possible relationship between Rubens' rural paintings and a classical work, namely Virgil's *Georgics* (*Untersuchungen über die Landschaftsmalerei des Rubens* [Berlin, 1936], n. 97).

form a clearer picture of what rural landscape must have meant to the passionately classical-minded Rubens.[2]

Antique literature, whether didactic or lyric, associates landscape mainly with two types of situation. These can be broadly distinguished according to the sense of place, time, and the kind of activity described. The first, essentially escapist in outlook, has as its setting a landscape designed or selected purely for pleasure, relaxation, and love, where the season is an endless spring or summer, and the time is usually morning or midday. This category includes not only the rustic, unspoiled land of pastoral, but also the blessed regions of the Golden Age and the refined, artificial world of the garden. Obviously, none of these features apply to the paintings of Rubens that we have called "rural." But the other situation, prevalent mostly in Roman literature and showing a practical, earthy vein, offers many points of comparison with Rubens' rural landscapes. We can limit our discussion, in fact, to those sources concerned with the farm or country estate and in which the author, fictional speaker, or main character actively participates in the shaping of the landscape—either objectively, through farming, or subjectively, through close observation of the appearance of the place and the workings of nature. The rural estate may be viewed as a world in itself or as an extension—albeit by contrast—of urban life, that is, as a reward for fulfilling onerous civic responsibilities. In this context, the theme of the Golden Age is not an example of self-indulgent nostalgia, but rather an aspect of the larger idea of work and commitment.[3]

The life of the farmer or of one who regularly sojourns in the country is a recurring topic in ancient literature. The following survey of specific texts is intended to convey a sense of the nuances given this subject by various authors and the relevance of such notions to Rubens' rural landscapes.[4]

Cicero

Cicero's *On Old Age* (*De Senectute*) epitomizes many of the main classical ideas relating to rural life. The essay is a fictionalized account of a conversation held in Rome in 150 B.C., the main speaker being Cato the Elder at age eighty-four. Later considered

2. P. A. F. van Veen, who in his study of the country house poem offers a convenient compendium of classical writings about rural life, emphasizes the special importance of Virgil and Horace (*De soeticheydt des buyten-levens, vergheselschapt met de boecken, het hofdicht als tak van een georgische literatuur* [The Hague, 1960]).

3. A. B. Giamatti, *The Earthly Paradise and the Renaissance Epic* (Princeton, 1966), pp. 20–23. Giamatti treats the theme of the Golden Age and its variants from classical times through the Renaissance. The *Earthly Paradise* by Rubens and Jan Brueghel (The Hague, Mauritshuis) reflects this tradition, one very much alive in Rubens' day (cf. Jan Bialostocki, "Les bêtes et les humains de Roelant Savery," *Bulletin des Musées Royaux des Beaux-Arts de Bruxelles* 7, [1958], pp. 69 ff.)

4. The material to be presented here is undoubtedly already very familiar to some readers, and thus the chapter as a whole will seem unnecessarily long; others may object that it strays too far from the landscapes or overloads them with the weight of literary tradition; but the majority, I believe, will gain a greater appreciation for the uniqueness of Rubens' vision as a landscape painter when seeing how committed he was to a convincing and positive view of rural life—a view accessible only, perhaps, through the Roman witnesses now called forth.

The selection of works to be discussed in this chapter was made on the basis of their importance in European thought in the late sixteenth and the first half of the seventeenth century, and the likelihood of Rubens' familiarity with them. All were available in many Latin editions and were translated into modern languages as well. The question of the originality of the ideas expressed was not taken into consideration; many of the concepts dealt with can be traced back to Greek authors, but these would have been less familiar to Rubens.

as the embodiment of Stoic wisdom, Cato was a farmer, soldier, statesman, orator, writer, and stern patriotic moralist. *On Old Age* shows him as a representative of an unspoilt Republican past, yet also as a polished speaker profoundly aware of Greek ideals, with which he became familiar, according to Cicero, through the studies of his last years.[5]

Part 5 of the essay, entitled "The Joys of Farming," is of interest here. Cato's first point is that farming provides great pleasures which, unlike so many others, are not impeded by old age. These enjoyments, he says, "come closest of all things to a life of true wisdom."

Cicero's capitalist Cato associates farming not only with the life of the mind but also with security: "The bank, you might say, in which these pleasures keep their account is the earth itself. It never fails to honor their [the farmers'] draft; and, when it returns the principal, interest invariably comes too—not always very much but often a great deal." The first product Cato dwells on is wheat, but not so much the actual crop as "the productivity and nature of the Earth herself," which the old man illustrates, as a host of later writers would do, by a description in human, sexual terms of the process of the corn's growth. Next comes the vine; Cato admits that his delight in its cultivation is "unsatiable." He speaks with awe of the fact "that in every product of the earth there is an inborn power . . . by which a minute fig seed, or a grape stone, or the tiniest seeds of any crop are transformed into vast trunks and branches." It is implied that wonder at the glorious spectacle of nature's creativity compensates for one's own diminishing potency in old age. But even the elderly farmer need not be a passive observer; Cato stresses man's active role in cutting, grafting, and training the vine so that it produces more than if left alone.

The satisfaction Cato derives from observing the process of growth is sensuous. Of the ripened grapes, "wrapped around by young foliage which tempers the heat and keeps away the too powerful rays of the sun," he asks, "What could be more delicious to the taste or more attractive to the eye?" And the very orderliness of the manner in which grapes are cultivated also gives him a sense of pleasure and rightness.

The more exhausting work of the farmer is only briefly mentioned by Cato, who refers the reader to his *De Agricultura* (most of which still survives) for a discussion of such subjects as irrigation, ditching, and hoeing. But this, too, is honorable work, and Cato even takes care to mention the lowlier task of manuring, which he dignifies by asserting that Homer "tells how Laertes consoled his longing for his absent son Ulysses by tilling his lands and manuring them well." That this opinion of country life is not Cato's alone is brought out by discussions of famous men who took up farming. One is a great military general, living in retirement. Others are the senators ("that is *senes*, 'elders' ") of earlier Roman history, who were thought

5. Cicero, *Selected Works*, trans. Michael Grant (Harmondsworth, Middx., 1967), commentary, p. 211. Among other scholars, Grant (p. 21) has discussed Cicero's great influence on the later sixteenth and seventeenth centuries.

Three of Cicero's works were taught at Verdonck's school, where Rubens had been a pupil, and the artist includes quotations from Cicero several times in his letters—though not from *On Old Age*. In 1624 Rubens acquired an edition of Cicero's works (Hamburg, 1618; with annotations by Heidelberg scholar Jan de Gruytere, or Gruterus; Rooses, "Petrus Paulus Rubens en Balthasar Moretus," part 4, *Rubensbulletijn* 2 [1885], p. 198). Jan Brant, Rubens' father-in-law, collected in book form the praises of Romans found in Cicero (Max Rooses, *Rubens*, trans. Harold Child, vol. 1 [Philadelphia and London, 1904], p. 117); although I have not seen this work, it should have included excerpts from *On Old Age*, where several Romans are lauded. Rubens owned a bust of Cicero (*CDR* 2:240).

actually to have lived on their farms; chief among these men, of course, was Cincinnatus, famed for having been found plowing when he received his appointment as dictator. Another story about a noble farmer is cited from Xenophon's *Oeconomicus*: the Persian prince Cyrus plans an elaborate park that amazes visitors. And the statesman Marcus Valerius Corvinus, says Cato, worked his farm at an advanced age, "indeed until he was a hundred."

On Old Age repeatedly stresses the usefulness and beauty of country life. The services of the farmer, which are "beneficial to the entire human race," result in the "abundant and plenteous production of all things needed for the worship of the gods and the sustenance of mankind." But even hedonists, Cato says, should love farming because it provides a full larder (its holdings enumerated), and the relish of eating when hunger has been "sharpened by labors for time of leisure, such as hawking and hunting." In short, a "well-kept farm is the most useful thing in the world, and also the best to look upon. And age, far from impeding enjoyment of your farm, actually increases its pleasures and fascinations. For nowhere else in the world can an old man better find sunshine or fireside for his warmth, or shade and running water to keep himself cool and well."

As Montaigne remarked of Cicero, "he gives one an appetite for growing old." Rubens at age fifty-nine might not have sympathized with this welcoming of old age, but he certainly would have appreciated Cato's zest for life, the immediacy of his tone, his spirit of optimism, his enthusiasm, and his delight in what is both practical and aesthetically pleasing, the learning he uses in support of arguments that derive essentially from his own experience, and his acceptance of hard, physical work as worthy of a noble man.

Virgil

In 1637 Rubens acquired a copy of Virgil's works edited by Juan Luis de la Cerda, and another with the famous commentary by Servius.[6] Rubens' earlier familiarity with the *Aeneid* and the *Bucolics* is documented, and it is reasonable to expect that he also knew the *Georgics* before 1637.[7] The many editions of this work available in his day included Carel van Mander's Flemish translation of 1597.[8]

Virgil's *Georgics* is the locus classicus of a recurring poetic and philosophical vision of the rural world. The poem is in the form of a treatise on agriculture, a literary type for which there were a number of important precedents, notably Hesiod's *Works and Days*. It is Virgil's poem, however, that synthesizes past traditions into a masterpiece of the greatest power and widest appeal.[9]

6. Rooses, "Petrus Paulus Rubens en Balthasar Moretus," part 1, *Rubens-bulletijn* 1 (1882), pp. 205–06.

7. Virgil is the most frequently quoted author in Rubens' surviving letters, although we find no lines from the *Georgics*.

8. *Virgil, Bucolica en georgica, dat is, ossen-stal en landtwerck* trans. Carel van Mander (Haarlem, 1597). E. K. J. Reznicek (*Die Zeichnungen von Hendrik Goltzius*, vol. 1 [Utrecht, 1961], p. 24) considers the appearance of this translation as further proof of a growing interest in nature in the Netherlands around the turn of the century.

9. Thomas G. Rosenmeyer, (*The Green Cabinet: Theocritus and the European Pastoral Lyric* [Berkeley and Los Angeles, 1969]) prefers to call the alternative tradition of rural poetry (alternative, that is, to pastoral) "Hesiodic," which means for him "the arena of sweat and labor and farmers' almanacs" (p. 3). "For 'Hesiodic,'" he explains, "I might have said 'rustic' or 'agrarian' or even 'Boeotian,' but every one of the alternatives has overtones which might prove misleading. It is better to settle for a word which recalls the ancestor of the tradition" (p. 20). Rosenmeyer himself, however, makes it clear that the world of the farmer was early on identified by poets with that of the *Georgics*. He also says of the *Georgics* that it is almost entirely "Hesiodic," using that term once again to denote a type (p. 24).

For a study of the georgic as a literary genre, see Marie Loretto Lilly, who writes: ". . . there is much of Hesiod in Vergil, but it is Vergil, not Hesiod, who created the literary form of the georgic" (*The Georgic* [Baltimore, 1919], p. 10).

Virgil's farmer, to whom most of the poem is addressed, is vaguely defined with respect to his social class and the extent of his wealth, but we picture either a freeholder or a tenant connected with a rather small holding that he works with his own hands.[10] Virgil exhorts the husbandman to perform various tasks in certain ways and at specified times, yet this cannot have been intended as a practical agricultural manual, for the advice is highly selective and sometimes of dubious utility. The *Georgics* is above all a literary work; Virgil chose to "sing a rural theme," knowing that this could be made artistically valid.[11] The very sophistication of the poem leads one to presume that its intended readers were highly cultured. They may have owned land, but they did not necessarily identify themselves with the farmers and peasants whose job it was to tend cattle and till the soil.[12]

Ostensibly didactic, the *Georgics* is nevertheless primarily a descriptive work. Although many of its "pictorial" passages would have greatly interested and stimulated an artist such as Rubens, more important for our understanding of his rural landscapes is the view of country life that the poet presents and the meanings that he assigns to agricultural activity.[13]

The central theme of the *Georgics* is the nobility of human endeavor, represented by the work of the husbandman. In book 1 this idea is stated in a passage that constitutes—to use L. P. Wilkinson's phrase—a "Theodicy of Labor." The poet discusses the annoyances that continually harass the farmer and explains their cause thus:

> For the Father of agriculture [Jove]
> Gave us a hard calling: he first decreed it an art
> To work the fields, sent worries to sharpen our mortal wits
> And would not allow his realm to grow listless from lethargy.
>
> [1:121–24]

10. In spite of the prevalence of slaves as argicultural workers in Italy during Virgil's day, the poet deliberately avoids any mention of bondage, and as a result, L. P. Wilkinson points out, his picture of country life has more universal a character than that of other classical *scriptores rei rusticae* (*The Georgics of Virgil: A Critical Survey* [Cambridge, 1969], pp. 54 f.).

11. Wilkinson (Georgics, p. 15) cites Seneca's observation (*Epistulae*, 86:15) that Virgil was not writing to teach farmers but to delight readers.
Even "the business of wool-bearing flocks and shaggy she-goats" gives Virgil a "hope of winning fame." He goes on: "I'm well aware it's hard to master this subject in words / And honour a theme so constricted: but over those steep and lonely / Places I'm winged by poetry's /Rapture: how grand to go on that ridge where no man before me / Has made his mark wheeling aside down the gentle slope! / Now, worshipful goddess of sheepfolds, grant me a fuller tone!" (3:289–94; Virgil, *Georgics*, trans. C. Day Lewis [London, 1940]; all quotations are from the verse translation by C. Day Lewis unless otherwise indicated). This pasage and Virgil's description of a shepherd's day (quoted below) gave classical sanction to later depictions of shepherds in situations that cannot strictly be called "pastoral" in the sense of the literary type emphasizing love and leisure.

12. Cf. Jacques Perret, "The *Georgics*," in *Virgil: A Collection of Critical Essays*, ed. Steele Commager (Englewood Cliffs, N.J., 1966), pp. 28 ff. Perret writes (p. 37): "Those who read the *Georgics* were members of the educated classes, large and small

landowners from the villages and towns of Italy, provincial leaders who were more or less permanently settled in Rome, but who still remained very much attached to their rural investments. To inspire their respect for the land and for those who lived by it was to save through them the thousands who would not read the poem."

13. Cf. Wilkinson, *Georgics*, p. 13: "The *Georgics*, which have so often been delightfully illustrated, are like a superb documentary of Italy painted by the hand of a Brueghel, peasants in a landscape busy with the tasks and religious rites of the four seasons."
Since the *Georgics* in fact contains no lengthy descriptions comparable to the shipwreck sequence in the *Aeneid* (book 1), the observation of Derek Pearsall and Elizabeth Salter is perhaps more to the point: "The blending of landscape reality into a comprehensive poetic vision seems . . . to be Virgil's peculiar achievement; for other poets landscape provides a series of motifs for poetic ornamentation and elaboration" (*Landscapes and Seasons of the Medieval World* [Toronto, 1973], p. 9). In the present study I am more concerned with Virgil's conception of agricultural life than with particular images.

The hardships attending the passage of the Golden Age, "before Jove's time," forced man to learn through experience, to forge various crafts, to invent new tools, and ultimately to transform the face of the earth.[14] The famous conclusion drawn is: "Yes, unremitting labor and harsh necessity's hand will master anything (1:145–46: "labor omnia vicit / improbus et duris urgens in rebus egestas"). Here toil is not a punishment, as it is in classical versions of the Golden Age story and in the biblical account of the fall, but rather the source of man's dignity and glory. Jacques Perret's concise comments on the meaning of work in the poem are worth quoting:

In Virgil . . . it is in struggling to nourish his body that man raises himself towards the light and responds to the ideal a fatherly god has set for him; from human effort exercised on the material world is born the light of the spirit. If the ancients always thought material work degrading, it was because they thought of matter as the negative pole of reality, the opposite of the spirit, or God. When man works with matter, he inevitably bears the marks of what he fashions: he becomes more corporeal and less spiritual; he sinks farther from light, deeper into darkness. In Virgilian perspective, on the contrary, the enhancement of work entails an enhancement of matter. To a new conception of work must correspond a new cosmology.[15]

"Matter," in Rubens as in Virgil, is clearly not the negative pole of reality, and the artist's positive view of what is natural shows up best, perhaps, in his scenes of rural life, where the context demands an earthy quality, and even dung becomes decorous.[16] Both painter and poet, moreover, continually show admiration for man working with matter, that is, for craftsmanship, and Virgil's list of the farmer's tools provides an apt parallel with Rubens' display of implements in the *Prodigal Son* (fig. 95; ckl. no. 1). Virgil's passage (1:160–75) runs as follows:

I'll tell you too the armoury of the tough countryman,
For without this the harvest would neither be sown nor successful:
The plowshare first and heavy timbers of the curving plough,
The ponderous-moving waggons that belong to the mother of harvest,
Threshers and harrows and the immoderate weight of the mattock;
Slight implements, too, of osier,
Arbutus hurdles, the Wine-god's mystical winnowing fan.
Be provident, lay by a stock of them long beforehand
If you wish to remain worthy of the land and its heaven-sent honor.
Early in woods the elm, by main force mastered, is bent
Into a share-beam and takes the shape of the curving plough:
Then to its stock are fitted a pole eight feet in length

14. Wilkinson observes (drawing from the dissertation of J. Lünenborg, *Das philosophische Weltbild in Vergil's Georgika* [Münster, 1935], p. 47): "His [Jove's] kingdom . . . is as much the minds of men as the fields that feed them" (*Georgics*, p. 136).
15. Perret, "Georgics," p. 33.

16. Cf. Joshua Reynolds's Eleventh Discourse (*Discourses on Art*, ed. Robert Wark [London, 1966], p. 174): "What was said of Virgil, that he threw even the dung about the ground with an air of dignity, may be applied to Titian: whatever he touched, however naturally mean, and habitually familiar, by a kind of magick he invested with grandeur and importance." The same could be said for Rubens, who on several occasions did paint dung, in the *Prodigal Son* (fig. 95), for example, and the Munich landscape *The Polder* (fig. 60).

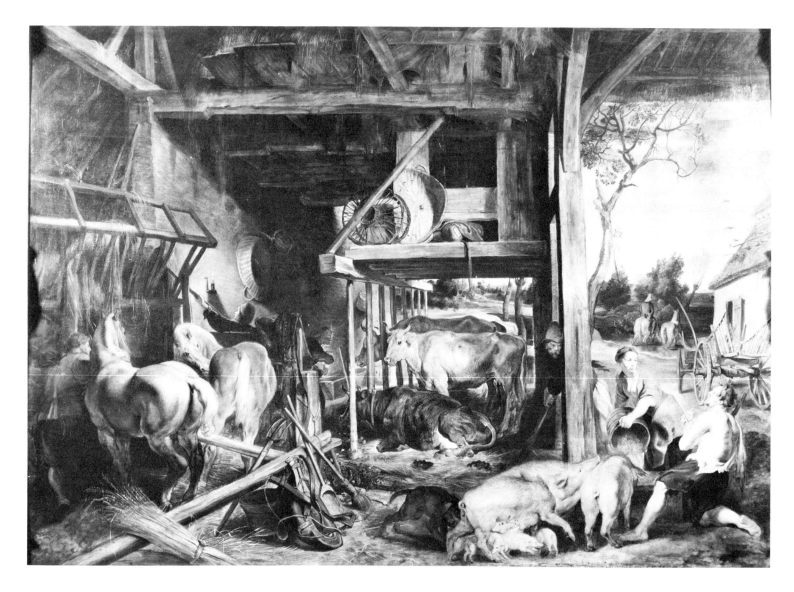

95. *Prodigal Son*, Antwerp, Koninklijk Museum voor Schone Kunsten (Copyright
A.C.L.-Brussels)

And two earth-boards, and the share-head is set in its double
 back:
Light lime has been cut already for a yoke, and lofty beech
To make the handle that guides the whole affair from behind,
And the wood is hung up in chimneys where smoke will
 season it.

Rubens' *Prodigal Son* is in striking contrast to other Northern works
of art featuring barns and farms; we may recall, for example, Cor-
nelis van Dalem's Munich painting, with its suggestion of the *vanitas*
theme; Jacques de Gheyn II's picturesque tumble-down farmyard
and idlers (1603; fig. 96), as well as similar scenes by Abraham
Bloemaert; and Roelant Savery's hexed barn with witches and liz-
ards (Amsterdam, Rijksmuseum). There seems to be no real prec-
edent for Rubens' neat, prosperous-looking, well-equipped barn,
and this only reinforces our sense that the artist's conception of
country life was shaped at least in part by the alternative suggested
in the *Georgics*.[17]

The importance Virgil assigns to cattle, moreover, may have
confirmed Rubens' own conviction when he painted cows and bulls.
As we have seen, van Mander specifically referred to Virgil's *Geor-
gics*—"the book in which the Mantuan teaches farmers"—when he

96. Jacques de Gheyn II, *Farmyard*, etching, 1603, New York, Metropolitan Museum
of Art (Gift of Georgina W. Sargent in Memory of John Osborne Sargent, 1924) All
rights reserved, The Metropolitan Museum of Art

described the features to look for in a breeding cow (*Grondt* 9:30).
Besides citing the *Georgics*, van Mander also devoted lines to classical
prototypes from the visual arts, namely the Farnese Bull and My-
ron's cow, the latter known then, as now, only through a literary
source.[18]

17. Rubens must have made careful studies of the tools and implements in this
picture, since they are all precisely rendered—as confirmed in conversation by Dr.
J. M. C. van der Poel, historian at the agricultural college in Wageningen, The
Netherlands.

In the *Prodigal Son* the stable structure of the barn, its tools of honest production,
the peasants within who go about their regular work, all stand in dramatic coun-
terpoint to the supplicant prodigal; typical of Rubens is the idea of representing the
young farm woman—frightened, perhaps, but sympathetic—listening to the pleas
of a wanderer finally come home (behind a post an old peasant listens suspiciously).

18. The original poem describing Myron's work is part of the *Greek Anthology*
(bk. 9, epigrams 713–42). As Miedema points out (pp. 568 f.), however, van Mander
based his verses (*Grondt* 9:42–46) on Ronsard's version.

A central tenet of the *Georgics* is that one must learn to read the signs in the heavens and on earth in order to live in harmony with nature and avoid disaster. This ancient concept, of such importance to the farmer, seems to be expressed in Rubens' work by the precisely distinguishable cloud formations in *Het Steen*, as well as the half-covered disk of the morning sun there. In Virgil, as already noted, the rising sun half-shrouded in clouds portends a rainstorm (1:441–43), although Rubens does not depict the destructive power of the storm Virgil describes.[19]

In the *Georgics*, the repeated theme of the cycle—whether that of germination, growth, maturity, decay, death and rebirth (2:319–35), or the procession of seasons and times of day—functions in relation to a broadly philosophical framework emphasizing universal order.[20] With regard to the poet's sense of the times of day, one need only recall his description of a herdsman's duties, from dawn to night:

At the first wink of the Morning Star let us wend away
To the frore fields, while the morning is young, the meadow
 pearly,
And dew so dear to cattle lies on the tender grass.
Then, when the fourth hour of the sun has created a thirst
And the plantations vibrate with the pizzicato of crickets
I'll bid them drink the water that runs in the troughs of ilex.
But now it's the noonday heat, make for a shady combe
Where some great ancient-hearted oak throws out its huge
Boughs, or the wood is black with
A wealth of holm-oak and broods in its own haunted shadow.
Then give them runnels of water again and let them browse
About sundown, when the cool star of evening assuages
The air, and moonlight falls now with dew to freshen the
 glades,
And the kingfisher's heard on the shore and the warbler in
 woody thickets.

[3:324–38]

This formal compression of a single day into a few sentences may have suggested the same possibility—in visual terms—to Rubens. The final lines of Virgil's passage, moreover, are reminiscent of Rubens' *Shepherd at Sunset* (fig. 97; ckl. no. 15), *Horse Grazing by Moonlight* (fig. 98; ckl. no. 17), and *Farm at Sunset* (fig. 99; ckl. no. 22). But the conception of nature moving in ordered revolutions is most grandly figured in *Het Steen* and *The Rainbow*: grass grows, is cut, and dries into hay; grain ripens; on a green tree the leaves of a branch become brown while another tree rots; the sky clouds and clears; summer moves into autumn; and dawn turns into dusk.

19. Another of the poet's weather signs, the heifer sniffing the air before a shower, may help to explain why in Rubens' afternoon landscape the white cow at the rear of the herd lifts its head. The passage in Virgil reads: "No, rain need never take us / Unawares: for . . . a calf [heifer] has looked up / At the sky and snuffed the wind with nostrils apprehensive, . . ." (1:375–76). According to Wilkinson, "this may be a true sign; at any rate it is widely believed to be so" (*Georgics*, p. 238).

Virgil's sense of weather changes is amply illustrated in book 1, for example in the passage about the reaction of rooks to clearing weather (ll. 413–23): "they love, when rain is over, / To visit again their baby brood, their darling nests. / It's not, to my belief, that God has given them / A special instinct, or Fate a wider foreknowledge of things; / But when the wet atmosphere / Shifts and a sky dripping from the south wind condenses / What was rare just now and rarefies what was condensed, / New images possess their mind, impulses move / Their heart other than moved them when the wind was herding the clouds. / Thus, the countryside over, begins that bird-chorale, / Beasts rejoice, and rooks caw in their exultation."

20. The connection between seasons and different rural tasks is implicit throughout the *Georgics*, especially in book 1, and also, for example, in book 2, lines 516–22, and 401–19, the latter passage beginning: "A farmer's work proceeds in cycles, as the shuttling year returns on its own track."

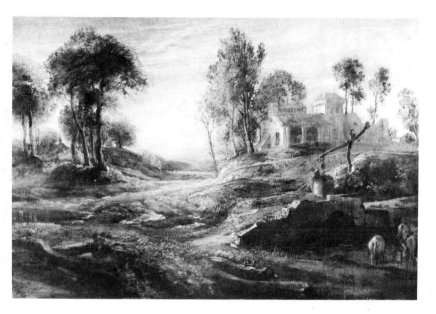

97. (top left) *Shepherd at Sunset*, London, National Gallery (Reproduced by Courtesy of the Trustees, The National Gallery, London)

98. (left) *Horse Grazing by Moonlight*, London, Prince's Gate Collection (Reproduced with the Permission of the Executors of the Will of the Late Count Antoine Seilern)

99. (top right) *Farm at Sunset*, Paris, Louvre (Réunion des Musées Nationaux)

Another theme of the *Georgics* is piety, the honoring of the gods and goddesses who care for the land. Although such deities as Ceres, Bacchus, Pan, and the nymphs and satyrs are named, Virgil gives the impression that these represent a universal divine spirit permeating all of nature. The poet implies, much more strongly than had Cicero, that all nature is in fact alive, even working toward definite ends, and that man in his role as cultivator helps fulfill these goals by clearing the land for plowing, coaxing the corn to grow, grafting new shoots onto trees, irrigating fields, and supervising the mating of cattle.[21]

Insofar as all things are made to share an essential vitality, equality rather than hierarchy exists in the rural nature of the *Georgics*. The organic unity of the poem itself arises in part from the expression of this feeling; Virgil consistently uses anthropomorphic language in speaking of nature, and he sympathetically adopts the "viewpoint" not only of the farmer but also of cattle, corn, trees, and soil. His conception of nature as sentient, moreover, is frequently conveyed by suggestive sexual wording, which reaches its height in a description of spring (2:323–35).[22]

Like the *Georgics*, Rubens' rural landscapes reveal the artist's "poetic" perception of the world as fully alive. Virgil's metaphor of the wind "herding the clouds" (1:421), for example, readily recalls the animated skies of Rubens' rural landscapes, and his image of the first cattle that "lapped up the light" (2:340) is echoed in the lovely sun-streaked cows of *The Rainbow*. The way in which motifs interact in Rubens' landscapes is one expression of this feeling toward the world and the work of art.[23]

Throughout the *Georgics* Virgil reiterates the theme of nature's utility; in book 2, for example, he describes the characteristics of different trees and their uses, delighting in the fact that even "fruitless forests" yield a great many products and have practical functions. Here the tree stump in *Het Steen* comes to mind. Such a centrally placed tree or stump occurs countless times in Mannerist landscapes, but there its thematic function is generally limited to setting the scene, defining it merely as "wooded." It is characteristic of Rubens' art that this motif assumes a more practical function, serving as part of a hedgerow, a natural fence; Rubens, like Virgil, has a sense of nature's economy, in which all things are useful and nothing is wasted.

21. On Virgil's religious ideas, see Wilkinson, *Georgics*, pp. 151 f., 122–24, and 219 f.

22. Oh, spring is good for leaves in the spinney, good to forests,
In spring the swelling earth aches for the seed of new life.
Then the omnipotent Father of air in fruitful showers
Comes down to his happy consort
And greatly breeds upon her great body manifold fruit.
Then are the trackless copses alive with the trilling of birds,
And the beasts look for love, their hour come round again:
Lovely the earth in labour, under a tremulous west wind
The fields unbosom, a mild moisture is everywhere.
Confident grows the grass, for the young sun will not harm it;
The shoots of the vine are not scared of a southerly gale arising

Or the sleety rain that slants from heaven beneath a north wind,
No, bravely now they bud and all their leaves display.

23. D. B. Wilson, who has written about Ronsard as a poet of "nature" in terms of the Renaissance meanings of the word, speaks of "the idea, running through the [sixteenth] century, of a world in continual but controlled flux, and in which room must be found for God and for Nature, for the authority of the Church and that of the perhaps more frequently consulted texts of the pagan philosophers [all of which] is bound to lead to a pantheism that is unacknowledged and largely involuntary. . . . in the philosophic and scientific writings of the century, the idea of *l'âme du monde* is a commonplace" (*Ronsard: Poet of Nature* [Manchester, 1961], p. 82).

In the *Georgics* Virgil takes care to distinguish different kinds of landscape, some more cultivated than others, just as we see in the tripartite division of Rubens' landscape pair. Thus the poet moves from the vineyard, requiring intensive cultivation, to the olive grove and the orchard, which need almost no care: "Fruit-trees, too, so soon as they feel their stems firm, and come to their strength, swiftly push forth skyward with inborn force, needing no help from us" (2:426–28). And in this same passage Virgil creates an image analogous to the wild mountain ash in the "uncultivated section" of *The Rainbow*: "and the birds' wild haunts blush with crimson berries" (2:430).[24]

Within the quadripartite structure of the *Georgics* there are changes in tone and in the difficulty of the labors described; the second book, for example, is distinguished by being the most optimistic and lyrical. Here we find a passage in praise of Italy: its agricultural abundance, excellent cities, the variety of its landscapes, wealth of minerals, and worthy men. The poet declaims:

Hail, great mother of harvests! O land of Saturn, hail!
Mother of men! For you I take my stand on our ancient
Glories and arts, I dare to unseal the hallowed sources
And sing a rural theme throughout the cities of Rome.

[*Georgics* 2:173–76]

Virgil's praise of his country has all the features of the traditional encomium of place, and one cannot help seeing similar elements in Rubens' necessarily limited yet glorious depiction of the Brabant

countryside in all its variety: open pastures, thickets, streams, a field of wheat, far-off hills, healthy herds, weather good for growing things, at least one "excellent city" and, most certainly, a hardy race of men. We are reminded, too, of Velius's commendation of van Mander's translation of the *Georgics*, that now one could sing in the barbarian Batavian tongue as sweetly as in Latin (see above, chapter 2).

Perhaps the most influential passage in book 2 of the *Georgics* (2:458–541) is a set piece telling of the joys of country life and often referred to by its opening words, "O fortunatos." The passage is of a tenor and spirit that cannot be abstracted, but we can at least summarize its themes. For Virgil, as for many before and after him who dwell on the subject, the truly lucky man is he who lives calmly and securely in the countryside, far from battle, especially the civil war that "sets brother at brother's throat." The country dweller is out of reach of the power of monarchs, of the "iron rigor of the law, the municipal racket, the public records," the royal courts, the senate, the cities with their pitiful poor, envy-awakening rich, and hysterical crowds. The country man leads a life free of worldly ambition and luxury:

. . . no mansion tall with a swanky gate throws up
In the morning a mob of callers to crowd him out and gape at
Doorposts inlaid with beautiful tortoise shell, attire
Of gold brocade, connoisseur's bronzes. . . .

[*Georgics* 2:461–64]

The earth itself provides for every need in every season, so that the self-sufficient farmer, laboring throughout the year, constantly enjoys the fruits of his own diligence and the generosity of nature.

24. The last two citations from Virgil are from H. Rushton Fairclough's translation (rev ed., [Cambridge, Mass., 1935], p. 147), Lewis in this instance being less exact.

It is the just country folk, moreover, who revere the gods, are friends with "Pan and old Silvanus and the sisterhood of nymphs," respect the family, and enjoy "dear children who dote on kisses" and "a house that preserves the tradition of chastity" (2:523–24). Finally, respite from the labors of the field and occasions for celebration are provided by holiday festivals with simple, wholesome entertainments.

It is the "Theodicy of Labor" passage near the beginning of the *Georgics*, however, rather than the "O fortunatos" section, that sets the philosophic tone of the work. Although plowing and "the annual labor" are mentioned in the latter, the emphasis—uncharacteristic of the poem as a whole—is on the leisure of pastoral life, in such images as "caves, living lakes, and combes that are cool even at midsummer / mooing of herds and slumber mild in the trees' shade" (2:468–70), or, "The fruit on the bough, the crops that the field is glad to bear / are his for the gathering" (2:500–01). The happiness of country life was in Virgil's time already a stock theme—a myth, even as today, the romantic "dream of the literary townsman."[25] And in fact, as the passage draws to a close, we realize that Virgil is not talking about the present at all, but about a golden age, the time of Romulus and Remus and the ancient Sabines: "Before the rise of the Cretan / Lord, before impious men slaughtered bullocks for the banquet, / Such was the life that golden Saturn lived upon earth: / Mankind had not yet heard the bugle bellow for war, / Not yet heard the clank of the sword on the hard anvil" (2:537–41).

In the context of the whole poem, however, this passage becomes

more than a nostalgic fiction. We must contrast it, as well as the preceding Praise of Italy ("land of Saturn") to the ending of book 1, where the present is called "a shipwrecked era," and the poet laments:

> Long enough now have we
> Paid in our blood for the promise Laomedon broke at Troy.
> Long now has the court of heaven grudged you to us, Caesar,
> Complaining because you care only for mortal triumphs.
> For Right and Wrong are confused here, there's so much war
> in the world.
> Evil has so many faces, the plough so little
> Honor, the labourers are taken, the fields untended,
> And the curving sickle is beaten into the sword that yields
> not.
> There the East is in arms, here Germany marches:
> Neighbor cities, breaking their treaties, attack each other:
> The wicked War-god runs amok through all the world.
> So, when racing chariots have rushed from the starting-gate,
> They gather speed on the course, and the driver tugs at the
> curb-rein—
> His horses runaway, car out of control, quite helpless.
>
> [1:501–14]

This passionate denunciation of the chaos and destruction of civil war, as well as the passages in a wholly different vein, depicting Italian life as peaceful and idealized, are set in the context of a poem generally stressing hard work, persistence, and productivity—all of this indicating that Virgil's perception of disturbing political events and the troubled condition of society had something to do

25. See Wilkinson's discussion of this issue (*Georgics*, p. 144). He observes that the first example Quintilian gives of a stock thesis is: "Is town or country life the better?" (2:4:24).

with his choice and treatment of the subject of the *Georgics*. The work can even be interpreted as a call for the war-torn country's renewal; "The subject of the *Georgics*," Perret has written, "is not 'what it is best to do when one wants to cultivate the land;' it is instead an 'exhortation to cultivate land.' "[26] And if "O fortunatos" appears somewhat out of keeping with the spirit of the poem as a whole, there is still the suggestion that the Golden Age will return if man makes a great enough effort, that in an ideal scheme the joys of rural life would be the rightful reward for the labor by which man is defined. As L. P. Wilkinson notes, the passage is thus "in a way the kernel, the poet's justification for writing his poem at all."[27]

The link between agriculture and peace already occurs repeatedly in the Old Testament, as in Isaiah's prophecy that "they shall beat their swords into plowshares." For the Christian humanists of Rubens' day, it was natural to associate this phrase with Virgil's condemnation of war in his agricultural poem.[28] One question to be considered in the following chapter is whether the emphasis on peace in works of a georgic type enables us to recognize an implicit political content in Rubens' landscape pendants.

Horace

Already in Virgil's lifetime, Horace, it appears, adopted the diction and themes of the "O fortunatos" passage for his *Second Epode* on the joys of country life, often called by its opening words, "Beatus ille."[29] In this poem the happy man is again the farmer, who escapes the "bugle call of war," the angry sea, the haughty gates of high-placed men, and the attendant cares of business, politics, and amorous passion; his chores follow the seasons; he is pious, and married to a modest, hard-working wife who has filled the home with children; he spreads a banquet "all unbought" of food he himself has grown; and his wealthy house is full of "home-bred slaves." Horace's picture of country life in this poem is compelling enough to sweep the reader along, convinced. But in the last four lines, the idyll is abruptly debunked with an ironic twist when we learn that the speaker is the usurer Alfius who, just on the point of becoming a farmer, decides instead to call in his loans, "and on Kalends [the next new moon] seeks to put them out again."

The *Second Epode*'s enormously appealing view of country life—not its satire of a conventional enthusiasm mouthed insincerely by a man such as Alfius—has made it one of Horace's perennially popular poems. The vogue enjoyed by "Beatus ille" in the sixteenth and seventeenth centuries was immense, and more often than not translators and imitators omitted the ironic ending.[30]

Also central to the humanistic conception of rural landscape were

26. Perret, *Georgics*, pp. 36–37. See also Wilkinson (*Georgics*, pp. 24–39, 49–55, and 159–83), who feels that the element of personal involvement in the *Georgics* came from Virgil's belief that "a return of Rome's ruling class to the old values symbolised by country life could cure a sick generation" (p. 183).

27. Wilkinson, *Georgics*, p. 91.

28. Cf. below, chapter 6.

29. Horace, *Opera omina*, ed. E. C. Wickham, vol. 1 [Oxford, 1896], p. 356. Horace is quoted eight times in Rubens' letters; there are lines from the *Sermones*, *Epistolae*, *Carmen seculares* (*Odes*), and the *Ars poetica*.

30. L. P. Wilkinson, *Horace and His Lyric Poetry* (Cambridge, 1946), p. 166.

certain themes Horace connected with his country home, the famous Sabine farm. Frequently mentioned in his writings (and described in *Epistles* 1:16), this rural retreat was of great and manifold importance in the poet's life and art. With his direct experience of country life, Horace could convincingly describe a landscape, but the lasting appeal of his images rested more on the fact that they tended to occur within metaphors, referring back to man and asserting a moral order.[31] In his lyrical works, along with masterly evocations of the Italian countryside and Bacchic celebrations, one finds such commonplaces—always beautifully expressed—as the view that periods of living in the city should alternate with sojourns in the country (*Odes* 3:29) and the notion that while the seasons revolve endlessly, human life, constant in its progress, is nevertheless brief and fragile (*Odes* 4:7)—one must, therefore, always seize the moment. Sometimes natural phenomena are presented as symbolic of human experience (in *Odes* 2:9, a winter storm is compared to sorrow) or as a challenge to the human spirit (epode 13 has Horace defying a storm by drinking and making merry), or nature's ways are seen as models for human behavior: in the frequent exhortations, for example, to act according to one's age, to adapt to inevitable change. Often, simplicity and contentment are contrasted with luxury and ambition, the opposition being treated in terms of country versus city.[32]

In his later works the sense of nature and time is different from that of the lyrical poetry, where alteration, change, and living for the present are major themes. The country in the *Epistles* now becomes an "ideal framework for a life devoted to wisdom," and Horace writes in a very personal way about his quest for truth in the Sabine hills.[33]

Epistles 1:10, "a rhapsody upon the simplicity and charm of country life addressed to a cultivated man of the town,"[34] raises the issue of the Stoic ideal of "living agreeably with nature."[35] Here the traditional advantages of rural life are contrasted with their artificial counterparts. Thus the poet asks:

> Is grass poorer in fragrance or beauty than Libyan mosaics? Is the water purer which in city-streets struggles to burst its leaden pipes than that which dances and purls adown the sloping brook? Why, amid your varied columns you are nursing trees, and you praise the mansion which looks out on distant fields. You may drive out nature with a pitchfork, yet she will

A landscape by David Vinckboons showing Diana and her nymphs hunting in woods near a Flemish country house (Brussels, Musées Royaux des Beaux-Arts) recalls Horace's feeling that the gods of the hills and woods—actually, the forces they signify—inhabited the Sabine hills.

31. Steele Commager, *The Odes of Horace* (New Haven, 1962), ch. 5, *passim*.

32. Already in his *Satires* (2:6) Horace told the tale of the city mouse and the country mouse. In *Odes* (2:5) we might add, Horace laments the invasion of huge private estates and gardens into the countryside, and the resulting disappearance of small farms and common lands; he always describes his own farm, moreover, as modest.

33. Jacques Perret, *Horace* (New York, 1964), p. 112. Rubens quotes from Horace's *Epistles* in the letters dated April 10, 1609 (*CDR* 6:324) and August 16, 1635 (*CDR* 6:126).

34. Horace, *Satires, Epistles, and Ars Poetica*, trans. H. Rushton Fairclough (London, 1924; with commentary by Fairclough), p. 313. All translations of the *Epistles* are from this edition.

35. H. Rushton Fairclough in his translation of Horace, p. 315.

Perret observed (*Horace*, p. 116) that the connection established in this letter between *rus* and *natura* "hardly appears in other authors of antiquity, but . . . has become customary in our modern languages, where the word 'nature,' without losing its philosophical connotations, also brings up before our eyes fields, foliage, and landscapes."

ever hurry back, and ere you know it, will burst through your foolish contempt in triumph.

[1:10:19–25]

The rest of the letter has to do with spiritual freedom and knowing oneself; the country, then, has not been presented for its own sake, but rather as an analogue to what is best and truest in human nature.[36]

In another letter, *Epistles* 1:14, Horace is concerned not only with the parallel between nature and human nature but also with the connection between his own land and his own identity; thus when the poet speaks of "the little farm which makes me myself again," he offers a key to how landscape can be interpreted in his works. Steele Commager writes:

The phrase confirms what so many of his Odes suggest, that the Italian countryside, particularly the Sabine farm, represents for Horace not only a physical environment but also a local habitation and a name for certain ideal values. The idyllic landscapes to which he invites his friends are calculated to 'give them back to themselves,' to call them from the arbitrary to the essential, from the search for political or financial advantage to an awareness of the limitations and possibilities of human life. And in some of the Odes still more private in their concern, the country, we might say, gives Horace to himself as an artist. With its gods Bacchus and Faunus it expresses the possibilities Horace found in poetry itself—possibilities of isolation and commitment, of freedom and security, of creativity and peace.[37]

The "myself" in the poet's phrase, we might add, refers specifically to the Horace who writes in the present, a middle-aged man who admits to having been "foolish" and ambitious when once a foppish young city dweller—the idea, found more than once in his works, that human decorum "is not categorical but chronological," and simplicity comes with maturity.[38]

In this context we may recall the letter (quoted in chapter 1), that Rubens wrote to Peiresc just five months before he purchased Het Steen. The painter happily reports his renunciation of every employment outside his "beloved profession"; in contrast, he uses metaphors of entrapment ("that labyrinth," "this golden knot of ambition") to characterize the final phase of his life at court, and declares that, throwing himself at the feet of the infanta, he had begged dispensation from service at court "as the sole reward for so many efforts." His claim here that he has "no pretension in the world other than to live in peace" signals a new attitude. As an aging classicist, yet a painter still at the height of his powers, Rubens surely must have been conscious of the propriety of retreating periodically to a country home—for freedom, artistic inspiration, wisdom, and pleasure.[39]

36. Perret, *Horace*, p. 116.

37. Commager, *Odes of Horace*, p. 343. The idea of artistic inspiration and the isolation of the country is a commonplace in the Renaissance.

38. Commager, *Odes of Horace*, p. 249.

39. *Het Steen* and *The Rainbow* can be seen as autobiographical in much the same way as are Horace's *Epistles* and *Odes* referring to his country estate, or many of the lyrical poems on nature by Ronsard, or even Marvell's "Upon Appleton House,"

Pliny the Younger

Unlike Horace and Virgil, Pliny the Younger was not a poet, although his lucid prose is esteemed. In his letters he reveals a practical, straightforward character and a skill at observation and description. Coming from a wealthy landowning family in northern Italy, and at heart always very much a member of the provincial gentry, he had considerable success in Rome as a senator, lawyer, and administrator.[40]

Three of Pliny's letters are of interest here because of the attitudes—later taken as authoritative—that they reveal toward country life. The first (1:6) begins with the news that he has caught three boars almost by accident while sitting by the hunting nets, making notes and thinking. The real subject, however, is the ancient Greek dictum for the good life: "a healthy mind in a healthy body" (the phrase Rubens had carved on the portico of his courtyard in Antwerp). To the old idea that the mental and the physical are in harmony is added the notion that the activities proper to each naturally fit in an outdoor setting, that "Minerva walks the hills just as much as Diana." What Horace might merely have suggested in a fairly subtle manner is here explicitly presented as a piece of practical wisdom; but like Horace, Pliny writes freshly from his own experience.

The other two letters (2:17 and 5:6), each dealing with a different country retreat of the writer, are the longest, most detailed descriptions of real buildings and grounds that have come down to us from antiquity. Pliny takes the reader on a tour of each place, discussing its precise location, climate, and the situation of the estate in a particular landscape (one being by the seaside, the other in the mountains); all the rooms are enumerated, and most are described with respect to size, function, the view or views from the windows, the way the sun hits them at various times of the day and in different seasons, and the auditory experience provided —from absolute silence to the roar of waves. Pliny also elaborates at length on the gardens, parks, drives, and surrounding countryside, sounding the familiar praise of both their beauty and usefulness.[41]

In comparison with Horace's sketch of his Sabine farm, a full-scale landscape is painted by Pliny in these letters, partly for the sake of literary display but also as a means of expressing pride in ownership, of conveying to the recipient of the invitation (and to future readers) the impression of actually visiting the place, and of imparting and deriving pleasure by his verbal tour. Pliny inserts

the literary culmination of the tradition (the autobiographical quality of European landscape lyric has been stressed by H. M. Richmond, *Renaissance Landscapes: English Lyrics in a European Tradition* [The Hague, 1973], *passim*). The narrator of "Upon Appleton House," incidentally, passes through three kinds of landscape: he begins at the country house, moves into a working landscape, then to the woods of the estate, where he has an intense psychic experience, and finally returns to the country house (cf. Raymond Williams, *The Country and the City* [New York, 1973], pp. 55–58). This pattern tends to affirm the common background of "country house poetry" (discussed in chapter 6) and Rubens' pendants, even though their content differs.

40. Pliny the Younger, *Letters and Panegyrics*, trans. Betty Radice, vol. 1 (Cambridge, Mass., 1969), p. 15. All translations into English are from this edition.

In a letter of June 25, 1627, to Pierre Dupuy, Rubens cites Pliny the Younger, among other authors, as having written on the theme of wifely devotion (*CDR* 4:278; Magurn, p. 190).

41. The nature/art issue is briefly raised here: "The whole garden is enclosed by a dry-stone wall which is hidden from sight by a box hedge planted in tiers; outside is a meadow, as well worth seeing for its natural beauty as the formal garden I have described. . . ." (5:6:18).

into an extraordinarily detailed description of the landscape around his Tuscan estate the observation, "It is a great pleasure to look down on the countryside from the mountain, for the view seems to be a painted scene of unusual beauty rather than a real landscape, and the harmony to be found in this variety refreshes the eye wherever it turns" (5:6:13). This early adumbration of the notion of the picturesque would not be lost on a painter such as Rubens, and in the pendants he indeed employed a composition offering variety "wherever the eye turns."[42]

Although each of the letters dealing with an estate conveys the impression of a large, elaborate, and luxurious villa, the noble, responsible Pliny feels bound by a certain modesty to remark, "The house is large enough for my needs but not expensive to keep up. It opens into a hall, unpretentious but not without dignity" (2:17:3).

42. An example of Pliny's way of describing landscape is worth quoting: "The countryside is very beautiful. Picture to yourself a vast amphitheatre such as could only be a work of nature; the great spreading plain is ringed round by mountains, their summits crowned by ancient woods of tall trees, where there is a good deal of mixed hunting to be had. Down the mountain slopes are timber woods interspersed with small hills of soil so rich that there is scarcely a rocky outcrop to be found; these hills are fully as fertile as the level plain and yield quite as rich a harvest, though it ripens rather later in the season. Below them the vineyards spreading down every slope weave their uniform pattern far and wide, their lower limit bordered by a plantation of trees. Then come the meadows and cornfields, where the land can be broken up only by heavy oxen and the strongest ploughs, for the soil is so stiff that it is thrown up in great clods at the first ploughing and is not thoroughly broken until it has been gone over nine times. The meadows are bright with flowers, covered with trefoil and other delicate plants which always seem soft and fresh, for everything is fed by streams which never run dry; though the ground is not marshy where the water collects, because of its downward slope, so that any surplus water it cannot absorb is drained off into the river Tiber flowing through the fields. The river is navigable, so that all produce is conveyed to Rome by boat, but only in winter and spring—in summer its level falls and its dry bed has to give up its claim to the title of a great river until the following autumn" (5:6:7–12).

Swimming pools, ball courts, and heated baths are all provided for the pleasure of family and guests, but intellectual endeavors can also flourish in these retreats; Pliny writes, for example, "One of the rooms is built round in an apse to let in the sun as it moves round and shines in each window in turn, and with one wall fitted with shelves like a library to hold the books which I read and read again" (2:17:8). The "Horatian" values of simplicity and peace are stressed when Pliny explains why he prefers a Tuscan country seat over one in the fashionable places around Rome:

[Here] I can enjoy a profounder peace . . . , more comfort, and fewer cares; I need never wear a formal toga and there are no neighbours to disturb me; everywhere there is peace and quiet, which adds as much to the healthiness of the place as the clear sky and pure air. . . . I enjoy the best of health, both mental and physical, for I keep my mind in training with work and my body with hunting. My servants [slaves] too are healthier here than anywhere else; up to the present I have not lost a single one of those I brought here with me—may I be forgiven for saying so, and may the gods continue to make this the pride of the place and a joy to me.

[5:6:45–46]

The interest shown in the last line about the welfare of the slaves had probably become a familiar topic in evocations of ideal country life, as in the roughly contemporary "Baiana nostri villa" by Martial (*Epigrams* 3:58), a work very similar in its themes to Horace's "Beatus ille" but centering on a specific villa. The afterlife of these ideas in relation to Rubens' art is taken up in the following chapter.

6. THE HUMANIST CONCEPTION OF IDEAL COUNTRY LIFE

INTRODUCTION

The Medieval Interval

As we saw in the preceding chapter, a major strain in classical literature was based on the principle that man's relationship to landscape, often a particular place, can be direct, practical, and aesthetically pleasing. This attitude was also embodied in the Roman villa, where the distinction between outdoors and indoors, the natural and the artificial, was deliberately harmonized. In such rural, though hardly rustic, houses, windows were calculated to frame the pleasing and varied views offered by the setting, certain walls could be removed, while others were painted with illusionistic landscapes, and even the gardens served as atria to the surrounding countryside. All of this seems to have changed in the Middle Ages, when *contemptus mundi* became a characteristic sentiment, and landscape painting disappeared. In general, the world outside the walls of the castle and monastery, which replaced the villa, now tended to become hostile and threatening.[1] In literature,

agriculture was no longer spoken of as dignified work that even the noblest of men might pursue, or even as the occupation of a class of slaves, but rather as symbolic of the punishment meted out to the whole of fallen mankind: "Cursed be the ground because of you [Adam], in toil shall you eat of it all the days of your life" (Genesis 3:17–18). There are many biblical passages expressing a positive attitude toward farming, but these were rarely elaborated in the Middle Ages, and the *Georgics* was not seized upon—although it might have been—as a gospel of work.[2]

Repeatedly in medieval writings, earthly change and mutability are seen as cause for sadness. Winter may be felt as exile from grace, and even summer can inspire a melancholy contemplation of death.[3] In all of nature only spring offers joyful respite, and the enclosed garden a certain refuge; these are thus reserved as the season and locus most worthy of poetic and artistic expression. The wider panorama of nature, if appreciated at all, is allowed merely

(*Figur und Landschaft: Eine historische Interpretation der Landschaftsmalerei von der Antike bis zur Renaissance* [Berlin, 1973]) offer full accounts of landscape in the art and poetry of the Middle Ages.

2. L. P. Wilkinson, *The Georgics of Virgil: A Critical Survey* (Cambridge, 1969), p. 285.

3. Pearsall and Salter, p. 133.

1. Derek Pearsall and Elizabeth Salter, *Landscapes and Seasons of the Medieval World* (Toronto, 1973), p. 14. The studies by Pearsall and Salter and by Götz Pochat

to function allegorically, as a repository of moral examples and divine emblems. Even in passages of great beauty devoted to the garden or spring, one finds little of the sharp observation of nature and confident familiarity with country life exhibited in many classical writings.[4]

While the mutability of the sublunary world might be considered by medieval man as a cross to be borne, the constancy of the seasonal round provided some consolation. This was acknowledged in the representations of the months, which offered the possibility of a much wider experience of nature than is found in the enclosed garden or the stereotyped *pleasance*. At first the months were conceived solely in terms of human activity, and their potential for landscape description long remained unexplored. But as interest in man and his earthly surroundings grew in the later Middle Ages and mutability was again seen positively—as one basis of the world's pleasing variety—artists began to produce vivid nature studies and the landscape backgrounds of calendar pictures began to expand. Even so, the most innovative and accomplished of these early illustrations, the *Très Riches Heures*, might never have seen the light, save for the crucial role played by Jean de Berry, who was indeed a very special patron. Both he and his chief artists, the Limbourgs, had a taste for naturalism in art (bred in part by their acquaintance with fourteenth-century developments in Italian painting), and they associated such qualities as verisimilitude, variety, movement, and change with landscape. It is quite understandable that the calendar, already a feature of the book of hours, was chosen as the vehicle for the exploration of this interest in nature. And it is not without significance for the duke's discovery of the calendar form's artistic potential that Nicolas de Clamange, who worked at the papal court, wrote a paraphrase of the *Georgics* and composed a true eclogue, Virgilian in style, subject, and mood.[5] Jean de Berry himself possessed a manuscript of Virgil's *Eclogues*, and one of his officers, Jacques Courau, commissioned a text of Virgil, complete with exegetical notes and containing an illuminated frontispiece to each work (*Eclogues*, *Georgics*, and *Aeneid*).[6] Two illuminated copies of Virgil's works, moreover, were produced in Paris around 1411.[7] In this atmosphere there arose in France a new acceptance of the classical idea that agriculture and rural life are suitable subjects for art, a concept that may have provided one stimulus for the Limbourg's more objective portrayal of landscape in the calendar. So, too, when the months are described with a certain fullness and accuracy in earlier medieval poetry, one suspects that classical literature played a role. This proves to be the case in one of the most extended treatments of the months dating from the early Middle Ages, the ninth-century monk Wandelbert's poem, *De mensium XII*

4. Cassiodorus (c. 490–583) and Hrabanus Maurus (c. 780–856) are the two medieval writers most often associated with the allegorization of nature (P. A. F. van Veen, *De soeticheydt des buyten-levens, vergheselschapt met de boecken, het hofdicht als tak van een georgische literatuur* [The Hague, 1960], p. 148). Cassiodorus recommended to his monks the study, in a Christian spirit, of the ancient *scriptores rei rusticae*, but he thought that farm work should be carried out only by monks who were not suited to copying manuscripts (Wilkinson, *Georgics*, p. 276).

5. Millard Meiss with the assistance of S. Dunlap Smith and E. Beatson, *French Painting in the Time of Jean de Berry: The Limbourgs and their Contemporaries* (New York, 1974), pp. 19, 435, n. 4.

6. Meiss, Smith, and Beatson, pp. 55 f. Cato, Varro, and Cicero were also avidly read by French humanists writing around the turn of the century, and the popularity of these authors may also have fostered a new positive evaluation of agriculture as an artistic subject (Meiss, Smith, and Beatson, pp. 20–21).

7. Meiss, Smith, and Beatson, pp. 303 f.

nominibus, signis, culturis, aerisque qualitatibus, a work that may have been of considerable importance for calendar illustrations.[8] *De mensium* deals with the origin of each month's name as well as with the constellations and rural activities associated with it. The accounts of the labors, set in the Rhineland, echo the *Georgics* "freely and unmistakably," but there are original features as well, apparently based on the poet's own observations of regional peasant life.[9] Wandelbert's is one of the earliest attempts to nationalize Virgil's poem.

The Early Renaissance

In giving form to aesthetic interest in nature and in affirming the influence of landscape on human feeling and thought, the Renaissance equaled classical antiquity in literature. Although the actual ideas associated with the countryside in the Renaissance hardly differ from those known in classical times, the particular, often consciously individual modes of expression employed by artists change considerably. Literary genres, topoi, and motifs are combined and expanded upon in new ways, and the range of allusions widens. This process also occurs in the visual arts: not only does modern landscape come into being, but it soon acquires all the thematic complexity of its literary counterparts and finds its own means and themes as well.

The naturalistic depiction of landscape, even careful topograph-ical description, was particularly suited to certain perennial themes. An example is Ambrogio Lorenzetti's panoramic fresco, *Good Government in the Countryside* (c. 1339), a work presumed to have influenced the Limbourgs. In Lorenzetti's painting the well-tended field is a sign of civic virtue: but if solely the propagandistic aspect of the theme had interested the artist and his patrons, traditional devices such as allegorical figures could have been used throughout the entire decorative scheme. A new interest in nature closely observed must have been an essential element in Lorenzetti's way of visualizing his subject; this interest had clearly assumed new importance and demanded an up-to-date mode of expression.[10]

One function of Lorenzetti's fresco is to provide a visual encomium to a place, thus naturalistically embodying on a large scale a rhetorical device used since antiquity.[11] We find something similar in the *Très Riches Heures* landscapes, "pictorial replicas of fields and castles owned by the Duke or related to him."[12] Surely on one level these illustrations pay tribute by the fidelity of their representation to the ideals connected with the places shown and are an expression of pride on the part of the patron. This tributory function of landscape in art and literature persists throughout the Renaissance

10. In a letter to Guido Sette of 1353, Petrarch gives a long description of the region in which he is sojourning (Lombardy) and comments, "I do not remember ever seeing from so slight an elevation such a noble spectacle of far-spreading lands" (Petrarch, *Letters from Petrarch*, ed. Morris Bishop [Bloomington, Ind., 1966], p. 152).

11. E. R. Curtius, *European Literature in the Latin Middle Ages*, trans. Willard Trask (New York, 1953), p. 194.

12. Millard Meiss, Jean Longnon, and Raymond Cazelles, *The Très Riches Heures of Jean, Duke of Berry* (New York, 1969), p. 8. The accuracy with which the Limbourgs represented the castles and their surroundings has even led scholars to consider the possibility that the painters used an optical device (Meiss, Longnon, and Cazelles, text accompanying plate 4).

8. Wilkinson, *Georgics*, p. 283. Wilkinson draws his information in part from Alois Riegel, "Die mittelalterliche Kalenderillustration," *Mitteilungen des Instituts für oesterreichische Geschichtsforschung* (Vienna, 1889), especially pp. 35–51.

9. Wilkinson, *Georgics*, pp. 280, 282, and further references, p. 341, n. 36.

and can ultimately be connected with *Het Steen* and *The Rainbow*.

Realistic topographical depictions of the local countryside in so public a place as a town hall, such as we see in Siena, seem to have remained an isolated phenomenon for a long time. But the custom of decorating castles and private residences with landscape frescoes is thought to have been quite common in Italy and southern France by the end of the Trecento. Few examples have survived, but one can see that their designs approximated tapestries in their decorative form and motifs: walls were covered from top to bottom with lush meadows, an array of animals and plants, and courtly figures engaged in leisurely pastimes out-of-doors.[13] Landscapes such as these fulfilled yet another time-honored function, the psychological one of which Alberti speaks in his *Ten Books on Architecture*: "Our minds are delighted in a particular manner with the pictures of pleasant landskips, of havens, of fishing, hunting, swimming, country sports, of flowery fields and thick groves" (book 9, chapter 4). In the same passage Alberti claims that the life of the peasants is the most pleasing of all subjects for paintings, and appropriate for the decoration of gardens (*hortis . . . conveniet*).[14] It

is not clear what he meant by the latter—possibly the loggia of a courtyard containing a garden, or a country house. He is arguing, then, that such paintings should be exhibited near a setting with features that they imitate.[15] Later, landscapes would also be found appropriate for urban dwellings where, like a garden, they could serve as substitutes for some of the aesthetic enjoyments of country life.

Since Burckhardt, we have come to think of the early Renaissance as a time when men opened their eyes to nature, when landscape was sought out and enjoyed for its inherent beauty and variety, and when the educated Italian became enamored of country life. Burckhardt singled out Petrarch and Pius II for their fresh descriptions of landscape and the circle of Lorenzo de' Medici and Battista Mantuanus for the attention that they gave rural folk in their poetry. Alberti himself, in his third-person autobiography, confessed that "at the sight of noble trees and waving fields of corn he shed tears . . . and more than once when he was ill, the sight of a beautiful landscape cured him."[16]

13. Cf. Kenneth Clark, *Landscape into Art* (London, 1949), p. 8, and Bruce Cole, "The Interior Decor of the Palazzo Datini in Prato," *Mitteilungen des Kunsthistorischen Instituts, Florenz* 30 (1967), pp. 67 ff.

14. Leone Battista Alberti, *Ten Books on Architecture*, trans. James Leoni from the Italian trans. of Cosimo Bartoli, ed. Joseph Rykwert (London, 1955), p. 192. (All subsequent translations are from this edition.) E. H. Gombrich ("The Renaissance Theory of Art and the Rise of Landscape," in *Norm and Form* [London, 1966], p. 111) cites these ideas of Alberti as having importance for the rise of landscape painting as an independent genre; he also quotes (p. 111) a passage from the same chapter in Alberti that justifies landscape for its "psychological effect" (more precisely, therapeutic, in this case). Cf. also the biography of Girolomo Muziano written by his confessor, who recounts the landscape visions the painter had during a fever—

visions he successfully translated into art (quoted and trans. by A. Richard Turner, *The Vision of Landscape in Renaissance Italy* [Princeton, 1966], pp. 116 f.).

15. Alberti may have been interpreting Vitruvius's recommendation that landscape subjects decorate long galleries (bk. 7, ch. 5). Alberti's advice in this matter continued to be echoed in the seventeenth century; Sir Henry Wotton, for example, in his treatise on architecture (London, 1624), says, "Landschips, and Boscage, and such wilde workes [should serve as decoration] in open Terraces, or in Summer Houses (as we call them) and the like" (cited by H. V. S. and Margaret Ogden, *English Taste in Landscape in the Seventeenth Century* [Ann Arbor, Mich., 1955], p. 19, n. 13).

16. Alberti's biography is translated in James B. Ross and Mary Martin McLaughlin, *The Portable Renaissance Reader* (New York, 1953), pp. 480–92.

During the late Middle Ages, landscape had been associated with the nobility and the world of the peasants who sustained it. In the fifteenth century, however, the intellectual interest in country life came increasingly to be shared by the educated classes in general. Alberti, for example, whom we associate with the flourishing of urban life, judges the country worthier than the city in book 3 of his *Della Famiglia* (1443).[17] Forty years after *Della Famiglia* was written, Politian delivered a poem entitled *Rusticus* as an introduction to his public lectures on Hesiod and the *Georgics*. Considered by scholars to be one of the finest Virgilian imitations that has come down to us, *Rusticus* includes a eulogy to country life and a description of its occupations, season by season. It is dedicated to Lorenzo de' Medici, acknowledged as the Maecenas who had enabled the poet to write it in peace at Fiesole.[18]

The Sixteenth and Seventeenth Centuries

Politian's *Rusticus* is credited with awakening an enthusiasm for the *Georgics* that resulted in a sixteenth-century vogue for didactic poetry on a wide variety of subjects. Among these is the first true georgic of the Renaissance: Luigi Alamanni's *La Coltivazione* (Paris, 1546), a verse treatise on agriculture directly inspired by Virgil's work, as the author proudly admits.[19] Alamanni was a Tuscan poet

in exile at the court of Francis I, and he dedicated this work to the French king, whom he idealized as the Happy Man in a passage on the Golden Age. There is no eulogy of Italy in the poem, and some critics have felt that it is the fields of France that he describes. But Alamanni, perhaps diplomatically, puts forth only the most general agricultural precepts; in the first four books these are organized according to season, in the fifth they concern gardening, and in the sixth, lucky and unlucky days are treated. *La Coltivazione*, though no longer very highly regarded, enjoyed a certain popularity in its day, being reprinted four times in the sixteenth century. It is not the only expression of admiration for the *Georgics* in Renaissance France; Montaigne, who lived on his own rural estate, called the *Georgics* "the most accomplished work in all poetry" (*Essays* 2:10), and nearly two hundred echoes of Virgil's poem have been found in Ronsard's work.[20]

Horace's attitudes toward country life, which were easier to assimilate and adapt than Virgil's, were also revived in the Renaissance. The vogue enjoyed by "Beatus ille" throughout the whole of Europe in the sixteenth and seventeenth centuries was immense. Its myriad imitators included du Bartas, Fray Luis de Leon (Spain's great lyricist), Lope de Vega, Ronsard, Johann Fischart, Ben Jonson, D. V. Coornhert (who christianized it), and nearly every seventeenth-century Dutch writer who extolled a country house. That the popularity of the poem is related in some way to the art of landscape in the North is suggested by a series of prints designed by Abraham Bloemaert and engraved by Boetius à Bolswert (1614).

17. *Della Famiglia* was not published until 1734, but it circulated in manuscript during the Renaissance.
18. Wilkinson, *Georgics*, p. 292; Marie Loretto Lilly, *The Georgic: A Contribution to the Study of the Vergilian Type of Didactic Poetry* (Baltimore, 1919), p. 51.
19. Luigi Alamanni, "La coltivazione," in *Didascalici del secolo XVI*, ed. Andrea Rubbi (Venice, 1786); Lilly, pp. 59–64; Wilkinson, *Georgics*, p. 293; van Veen, pp. 162 f.

20. Wilkinson, *Georgics*, pp. 293 f., 342, nn. 54, 55.

On the title page of this set is a reworking of the *Second Epode* by a Dutch poet called Ryckius (otherwise unknown) that reads:

Most happy is he and truly blessed is the one who may spend his years free of burger cares, content to live under the thatched roof of his hut; his spirit does not become entangled in complications, he does not wrestle with a vacillating heart, but remains happy. Content with the possessions of his fathers, he looks at the yellow corn or the ripe apples of the tree or he drives his gleaming cow towards the meadow which he may call his own. When his wife happily takes her part in the work, most happy is he and in the highest measure blessed.[21]

A rejection of the cares of city living is implicit in the scenes themselves, which show peasants in rural settings and farmyards. Another, undated series after Bloemaert, engraved by C. J. Visscher, depicts peasant cottages and bears the title: "Various Pleasant Country Houses Portrayed after Life" (*Verscheyden aerdige Landhuysen nae 't leven Gekonterfeyt*).[22]

Although the *Second Epode* paints a picture of a simple but nonetheless prosperous farmer, Bloemaert's prints and Ryckius's poem suggest the life of a peasant who lives in a humble cottage and works a small piece of land; at the same time, many engravings depicting the country homes of the wealthy were also produced in the Netherlands. Behind all these works, regardless of their various class implications, is a common high regard for rural nature. In this connection an engraved series of twelve small landscapes showing the surroundings of Haarlem (c. 1608) by C. J. Visscher carries the interesting title: "Here you may have a quick look at pleasant places, you art lovers who have no time to travel far" (*Plaisante plaetsen, hier, meught ghy aenschouwen radt, / Liefhebbers die geen tyt en hebt om veer te reyson*).[23] As J. G. van Gelder observed many years ago, the emphasis in the titles of such series of *regiunculae* is on the word "pleasant," which is attributed to the familiar features of the countryside captured by the artist *ad vivum*. In Visscher's engraved landscape dating from about 1608, figures are seen merely strolling—and like us, the viewers of the prints—admiring the scenery. Van Gelder relates these images to a late humanistic, prosperous, and "quietly optimistic" culture.[24] An aspect of that culture was a love of travel, and the views of pleasing landscapes it affords. One of the most striking motifs in Rubens' *Return from the Fields* (fig. 65), we may remember, is the road winding into the distance. Besides its primary association with the working landscape, it also beckons the viewer. The road in this picture recalls as well the image in "Beatus ille" of "sheep hurrying homeward" at the end of the day. And in the same poem, Horace's phrase "when Autumn in the fields has reared his head crowned with ripened fruits" is reminiscent of the peasant in *Return from the Fields* who is so laden

21. Quoted from the English translation by Alison McNeil Kettering ("The Batavian Arcadia: Pastoral Themes in Seventeenth Century Dutch Art," [Ph.D. diss., University of California, Berkeley, 1974], p. 164, n. 8. Egbert Haverkamp Begemann earlier cited Ryckius's poem in connection with these prints (*Willem Buytewech* [Amsterdam, 1959], p. 42).

22. F. W. H. Hollstein, *Dutch and Flemish Etchings, Engravings, and Woodcuts*, vol. 2 (Amsterdam, n.d.), p. 69, nos. 564–89; cited by Kettering, p. 163.

23. Cited by J. G. van Gelder, *Jan van de Velde* (The Hague, 1933), p. 26, n. 3; the translation is Wolfgang Stechow's (*Dutch Landscape Painting in the Seventeenth Century* [London, 1966], p. 18).

24. Van Gelder, p. 27; van Gelder lists some of these early seventeenth-century series (p. 28).

with bounty that her head is completely obscured.[25] Similarly, the basket and wheelbarrow filled with produce in the *Farm at Laeken* (fig. 43) suggest the meal to come, "all unbought," a topic often elaborated upon at great length by Horace's modern imitators. The humanist Johann Fischart, for example, in his *Lob desz Landlustes* (before 1590; an extension of "Beatus ille" to 300 verses) provides a long list of the foods that the land provides, painting a picture comparable to the overflowing still lifes of the Flemings.[26] In general, Rubens' rural landscapes, with their limited number of carefully chosen motifs, can be seen as parts clearly standing for a whole, that is, for the humanist vision of the country as a place where life is at once richly productive and pleasing.

THE VILLA IDEAL AND THE NORTHERN COUNTRY HOUSE POEM

The sixteenth-century villa, formulated both as an ideal and as a reality, kept alive the esteem in which the ancients held the rural estate. In practice, the purpose of different villas varied; some, especially in the Veneto, were of great economic importance, while others were suburban pleasure palaces, used only occasionally, and with no productive function at all.[27]

In his *Ten Books on Architecture* (book 9, chapter 2), Alberti, following Vitruvius, had distinguished between country homes that are part of a working farm, and villas, "pleasure houses just outside the town." The latter, he said, are for people desirous of clean air, a relaxed, informal atmosphere, and the pleasures offered by rural landscape, all within easy reach of the city where they live and conduct their daily business; Pliny the Younger, we may recall, had said exactly the same.

Alberti was the first Renaissance writer explicitly to revive the ancient notion of the villa, and it is worthwhile to read his words on the subject. In one instance (book 5, chapter 18) he writes, "The country house and the town house for the rich differ in this circumstance; that they use their country house chiefly for habitation in summer and their town house as a convenient place of shelter in winter."[28] And later on (book 9, chapter 2) he gives the matter fuller treatment, declaring:

> I do not think that of all the structures which are raised for the conveniency of mankind, there is any so commodious or so healthy as the villa; which at the same time as it lies in the

25. That this figure may have been inspired by calendar illustrations or by Bruegel's *Haymaking* does not rule out the possibility that Rubens remembered the Second Epode; the artist may indeed have been drawn to the work of these predecessors precisely because he recognized a classical allusion in even such "Flemish" images. In classical antiquity and the Renaissance, allegorical figures representing the seasons wear small crowns of grain, vine leaves, ivy, flowers, etc. In the recently discovered garden herms by Bernini the crowns of this sort have grown considerably, and the Flora carries a basket full of flowers, while Priapus holds an array of fruit and vegetables in his arms (cf. Catherine Sloane, "Two Statues by Bernini in Morristown, New Jersey," *Art Bulletin* 56 [1974], pp. 551 ff.).

26. Van Veen, p. 188.

27. The literature on the villa is vast; some useful sources with extensive bibliographies are James Ackerman, *Palladio's Villas* (Locust Valley, N.Y., 1967); R. Bentmann and M. Muller, *Die Villa als Herrschaftsarchitektur* (Frankfurt, 1970); Howard Burns, in collaboration with Lynda Fairbairn and Bruce Boucher, *Andrea Palladio, 1508–1580: The Portico and the Farmyard* (London, 1975); Claudia Lazzaro-Bruno, "The Villa Lante at Bagnaia: An Allegory of Art and Nature," *Art Bulletin* 59 (1977), pp. 553 ff.; and Turner, ch. 10.

28. Alberti, p. 108.

way for business is not wholly destitute of pure air. Cicero desired his friend Atticus to build him a villa in a place of eminent note: but I, for my part, am not for having it in a place of such resort, that I must never venture to appear at my door without being completely dressed. I would have it afford me the pleasure which the old gentlemen in Terence boasts he enjoyed, of being never tired either with the town or country. Martial too gives a very just description of his way of living in such a villa:

> You tell me friend, you much desire to know
> What in my villa I can find to do?
> I eat, sing, play, bathe, sleep, eat again,
> Or read, or wanton in the muses' train.

There is certainly a vast deal of satisfaction in a convenient retreat near the town, where a man is at liberty to do just what he pleases. The great beauties of such a retreat, are being near the city, upon an open airy road, and on a pleasant spot of ground. The greatest commendation of the house itself is its making a cheerful appearance to those that go a little way out of town to take the air, as if it seemed to invite every beholder; and for this reason I would have it stand pretty high, but upon so easy an ascent, that it should hardly be perceptible to those that go to it, till they find themselves at the top, and a large prospect opens itself to their view. Nor should there be any want of pleasant landskips, flowery meads, open champains, shady groves, or limpid brooks, or clear streams and lakes for swimming with all other delights of the same sort, which we before observed to be necessary in a country retreat, both for convenience and pleasure. Lastly, what I have already said conduces extremely to the pleasantness of all building, I would have the front and whole body of the house perfectly well lighted, and that it be open to receive a great deal of light and sun, and a sufficient quantity of wholesome air. Let nothing be within view that can offend the eye with a melancholy shade. Let all things smile and seem to welcome the arrival of your guests.[29]

Het Steen, essentially a Northern villa, was both a summer retreat for its owner and the center of several active farms worked by tenants. It was just the sort of place that an educated man of Rubens' station would feel he must own. And when the artist depicted the château, he stressed many of the same ideal features that Alberti had pointed out. As we have noted, its relationship to the city is shown, with Antwerp, Rubens' place of business, in the background; the house, approached by a lane, and its door, apparently open and accentuated by sunlight, "invite" the beholder, as Alberti recommends; nor is there any want of pleasant landscapes—not only the grove and meadows of *Het Steen* itself, but also the fields, hills, and woods of the companion piece.[30]

The villa ideal was manifested in one form by the fresco cycles that adorned the houses themselves. Here we need only make a few generalizations regarding the types and functions of the land-

29. Alberti, pp. 189–90.
30. The topos of the country house's door being open to the community originates with Martial (*Epigrams* 3:58), and is found in the country house poems of Jonson, Carew, and Marvell (cf. Joel George Magid, "Andrew Marvell's 'Upon Appleton House': The Tradition and the Poem" [Ph.D. diss., Columbia University, 1969]).

scape paintings they contained.[31] All such works, it appears, figure as part of a larger scheme in which concepts of nature and history, as well as the vaunted virtue and worldly status of the owner, played an important role. Traditional components such as planets, the four elements, the seasons, and the months were used to represent the order of nature. And since the villa itself signified a rebirth of classical ideals, the return of a historical cycle, the antique past was evoked through landscapes with Roman ruins; as an extension of this idea, the frescoes might even be painted in a sophisticated, consciously antique style. Another type of landscape included a portrait of the villa or a series of such pictures displaying the master's other estates—much as we see in the *Très Riches Heures*. Such images could be given further significance by juxtaposing them with other scenes; the latter might either portray events from the earlier history of the land—thus suggesting the noble lineage of the ground itself—or depict other important buildings—hence a claim to status or an affirmation of class through association. Besides these more overtly ideological functions of landscapes with ruins or with portraits of buildings, ingeniously painted vistas might be used to give the illusion of real prospects viewed through openings in the wall.

Peasants, flowers and verdure comprised the kind of subject matter that Alberti claimed to find the most pleasing, and such elements must have decorated many villas at one time. Sixteenth-century examples apparently have not survived, but the series that Guercino painted for the Casa Pannini in the village of Cento (c. 1617) attests to this tradition.[32]

Many of the functions typically fulfilled by the landscapes in villas are synthesized in *Het Steen* and *The Rainbow*. The portrait of the country house, however modestly rendered, is a tribute to the owner and to a way of life. As paintings conveying a sense of the seasonal and diurnal cycle, moreover, the pendants are naturalistically depicted microcosms of the order of nature. Historical time is also suggested: it is quite probable that Rubens' château, parts of which are thought to date from the Middle Ages, evoked for him the medieval past. This is hinted at by the Louvre *Landscape with Jousting* (fig. 100; ckl. no. 21) which depicts a tower much like Rubens' own, a large castle of a type indigenous to the region, and a scene of knights jousting at sunset. That this is no ceremonial tournament of the sort that still took place in Rubens' day is evident from the lack of spectators and the usual trappings of such a public event. The picture in fact recalls medieval romances, a type of literature still enormously popular in the seventeenth century. Such adventure stories usually included at least one jousting incident, often illustrated with a woodcut.[33]

31. There is no comprehensive study of landscape decorations in villas, but one may refer to such studies as those by David Coffin, "Some Aspects of the Villa Lante at Bagnaia," in *Scritti di storia dell'arte in onore di Edoardo Arslan* (Milan, 1966), pp. 569 ff.; Konrad Oberhuber, "Gli affreschi di Paolo Veronese nella Villa Barbaro," *Bollettino del Centro Internazionale di Studi di Architettura Andrea Palladio* 10 (1968), pp. 188 ff.; and Juergen Schulz, "Le fonti di Paolo Veronese come decoratore," *Bollettino del Centro Internazionale di Studi di Architettura Andrea Palladio* 10 (1968), pp. 241 ff.

32. See Renato Roli, *I fregi centesi del Guercino* (Bologna, 1968), pp. 57–76. "Georgic" images were also produced in the Veneto—for example, G. P. Salviati (?), *Landscape with Plowman* (cf. David Rosand and Michelangelo Muraro, *Titian and the Venetian Woodcut* [Washington, D.C., 1976], no. 33); Paolo Fiammingho, *Agriculture* (cf. Graf A. J. Raczynski, *Die flämische Landschaft vor Rubens* [Frankfurt, 1937], fig. 11); and Francesco Bassano and workshop, *May–June* (fig. 44).

33. A woodcut illustration of jousting occurs, for example, in *La plaisante histoire*

The connection between the château in *Jousting* and Rubens' own country house can be seen in a preparatory oil sketch for the Louvre painting (fig. 101; ckl. no. 4). Rubens began with the motif of Het Steen's crenellated tower, placed in a landscape that, with its deep blue sky and yellow orb shrouded in clouds, can only be called "romantic." For the full-scale painting, Rubens proceeded to add to this tower an entire castle complex situated on a plain now lit by a large red sun, then enlarged the panel, and finally inserted knights, heralds, and pages to complement the mood of the architecture and landscape.[34]

It is known that especially in his later years, Rubens purchased many books of history; these may have stimulated new interest in his country's past and a taste for buildings, such as Castle Steen, in the national style. Similarly, *Het Steen* and *The Rainbow* attest to his great interest in a "national style" of painting—that of the elder Bruegel and perhaps the illuminators who preceded him. One can justly compare such a phenomenon with Italian artists' pictorial references to the antique style of landscape painting that was part of their national heritage, or with the plethora of "ideal landscapes" based on observation of the hallowed Italian countryside. Although it is tempting to imagine that *Het Steen* and *The Rainbow* once hung in Rubens' château, thus echoing the real landscape outdoors, we have no real proof that this was the case.[35]

An early landscape with antique ruins by Rubens, for which we now have only an engraving (fig. 102; ckl. no. 30), also conveys a sense of successive layers of history and the continuity of tradition. Apart from the ruins of the temple itself, a subtle link is established between the herding scene on the frieze, and the herdsmen and peasant women in the foreground. The fire burning inside the ruin suggests that the building is still in use, and the implication is that although the monuments that men erect may crumble, the same

du noble et vaillant Chevalier Pierre de Provence et de la belle Maguelonne, fille du roi de Naples, nouvellement mise en Flamen et Francoys ensemble (Antwerp, 1587), p. 141. Rubens owned a copy of the most famous ancestor of these romances, Heliodorus's *Histoire d'Ethiopie* (Max Rooses, "Petrus Paulus Rubens en Balthasar Moretus," part 1, *Rubens-bulletijn* 1 [1882], p. 201; acquired in 1625), a Hellenistic work, probably belonging to the third century A.D.; after its initial European publication in Basel (1534), the book attained great popularity.

34. The romantic quality of this painting is often commented upon. Kenneth Clark, for example, writes: "Rubens himself recognized the character of his romanticism, and expressed it in the picture of a *Tournament before a Castle*. . . . Like Altdorfer, he saw the connection between the landscape of fantasy and the Gothic past, and filled the foreground of his picture with knights in armour. As before one of Wren's Gothic churches we may think of it either as the end of the chivalrous tradition—the poetic spirit of Ariosto—or as the first example of the Gothic Revival; its remarkable similarity to Bonington and Delacroix suggests that the second reading is correct" (Clark, p. 51). And Yvonne Thiéry writes: "Dans *Le Tournoi*, du Louvre, des vieux murs de Steen surgissent les spectres des chevaliers morts, les ombres reprennent vie et, lance au poing, continuent les joutes d'antan" (*Le paysage flamand au XVII siècle* [Paris, 1952], p. 99). Jacob Burckhardt observed that the figures in *Landscape with Jousting* were painted in last, after the setting had been conceived (*Recollections of Rubens*, trans. Mary Hottinger, ed. H. Gerson [New York, 1950], p. 153).

35. Although it seems likely that nos. 135–36 of Rubens' inventory refer to the pendants, and though the inventory was made at the Antwerp house, it is not impossible that the landscapes hung at Het Steen before 1640. In the sale of Rubens' collection that took place in 1642 one item that went to the artist's eldest son Albert was described as "een groote landschappe, de wedergaey van dat tot Steen is," which could be translated as "a large landscape, the pendant of that which is at Steen." See J. Denucé, *The Antwerp Galleries: Inventories of the Art Collections in Antwerp in the Sixteenth and Seventeenth Centuries* (Antwerp, 1932; *Staetmasse ende rekeninge . . .* , no. 74), p. 79, and G. Martin, p. 142, n. 34, where the translation of wedergaey as "pendant" is suggested.

S. Speth-Holterhoff assumes that some of the paintings listed in Rubens' inventory were pictures that hung at Het Steen (*Les peintres flamands des cabinets d'amateurs au XVIIe siècle* [Brussels, 1957], p. 11).

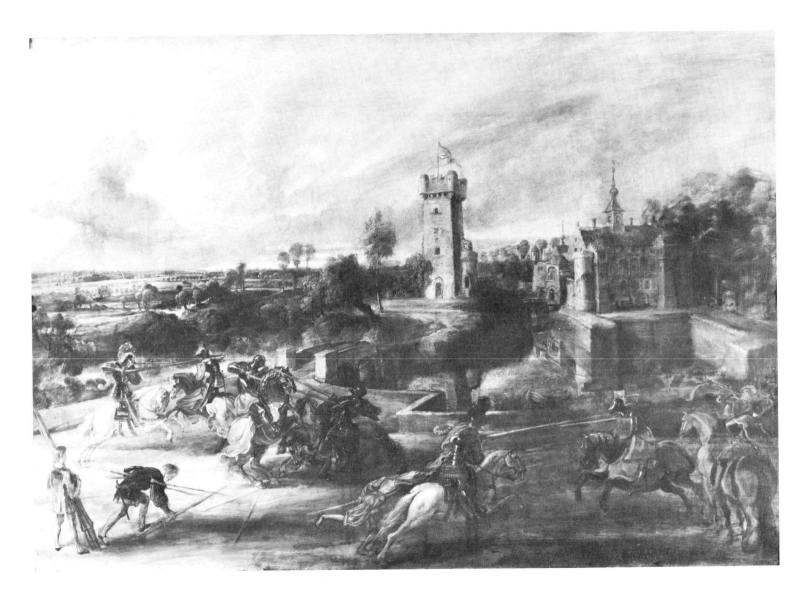

100. *Landscape with Jousting*, Paris, Louvre (Réunion des Musées Nationaux)

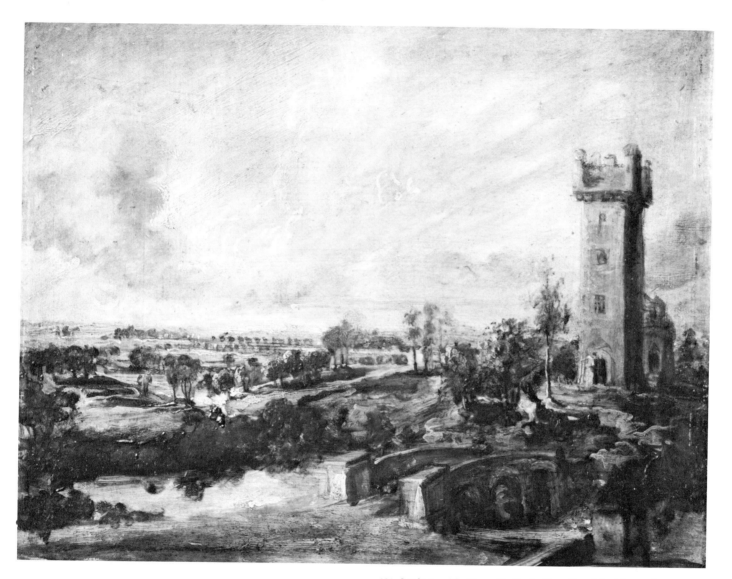

101. *Landscape with a Tower*, Berlin-Dahlem, Staatliche Museen Preussischer
Kulturbesitz, Gemäldegalerie Berlin (West)

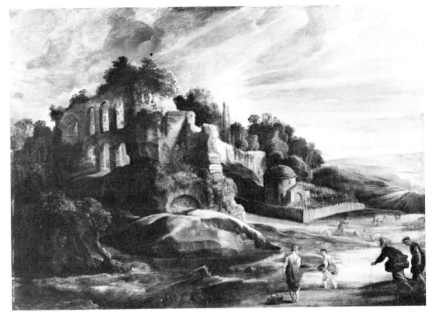

102. *Landscape with Ruins*, engraving by Schelte à Bolswert (after a lost painting by Rubens?), New York, Metropolitan Museum of Art (Harris Brisbane Dick Fund, 1933)

103. *Landscape with Roman Ruins*, Paris, Louvre (Réunion des Musées Nationaux)

occupations continue without interruption throughout history. And it is not as if history were forgotten, since the people shown standing on the porch and under the dark arch on the left seem to be paying tribute, by their visit, to the remains of a past culture that they continue to admire. The engraving probably reflects an early work by Rubens, made at a time when the artist was still enamored of Italy. It may indeed be that later on, back in his homeland, he

began to recognize that the peasants who worked the Northern countryside likewise carried on the customs of their ancient forebears, maintaining unceasingly the land and its people.[36]

36. That the engraving reflects an early design can be seen by comparing it with another ruin landscape by Rubens which is in the Louvre (fig. 103; ckl. no. 20). In both works the composition comes closest to that of the *Pond*, the handling of paint is smooth, and the colors are opaque, all of which point to an early date (before c. 1618).

As one last parallel to be drawn between Rubens' landscapes and the Renaissance doctrine of ideal country life, we can compare *Het Steen* and *The Rainbow* to a class of poetry known as the *hofdicht*, or country house poem, which flourished in the North in the seventeenth century. Like Rubens' landscapes, this genre adapted classical views in favor of country life to a Netherlandish situation, yet its outlook was also decidedly Christian. In Philibert van Borsselen's *Den Binckhorst ofte het Lof des Geluck-Salighen ende gerust-moedighen Land-levens* [*To Binckhorst, or in praise of blissful and secure country life*]; Amsterdam, 1613), which we shall take as a typical example, a Dutch reworking of Martial's thoroughly pagan epigram on the good life (with added references to the owner of Binckhorst, van Borsselen's patron Snouckaert) is appended to the poem, only to be followed by verses of van Borsselen's own making, entitled "Anders Christelicker" ("And now for the same thing, but in a more Christian vein"). The authority on this type of literature, the Dutch scholar P. A. F. van Veen, identifies the hofdicht as "a branch of georgic literature." Indeed, the influence of Virgil's poem is apparent, but so too, in somewhat lesser degree, are the works of a host of other biblical as well as classical writers. Van Veen provides an extensive catalogue of these sources, which range from the ancient Greeks to such sixteenth-century writers as Erasmus, whose "The Godly Feast" (1522) already combines most of the typical ingredients found in the hofdicht itself.[37]

As van Veen repeatedly asserts, the hofdicht is a genre distinct from the pastoral.[38] The four seasons, the tending of plants and animals, the local references, the high moral tone, the expression, often, of patriotic sentiments, and the conscious display of erudition, all set the country house poem apart from the pastoral. Concerned, moreover, with a specific country house, having a garden (*hof*), and with a particular owner of the house (usually the patron of the poem or the poet himself), the hofdicht has much in common with the villa ideal, something not actually found in the *Georgics*. One very important model for the hofdicht, in fact, was the Renaissance poem in praise of a villa. Usually written as a gesture of courtesy to the poet's host, this genre, too, has classical roots—for example, Martial's poem "Baiana nostri villa" (*Epigrams* 3:58), an elegant eulogy of a friend's Baian place.

The earliest recognized Northern example of such a poem hints at the Italian origin of the type; it is by the Dutch humanist Janus Secundus (d. 1536) and celebrates, in Latin, a Milanese estate.[39] Some of the topics receiving praise in this work are the virtuous wife of the villa's owner, the good hunting, the fragrance of the flowers, the view, and country life in general. The Plantin Press in Antwerp was the place of publication for another sixteenth-century estate poem, this by the Italian Laurentius Gambara, in

37. See P. A. F. van Veen, *De soeticheydt des buyten-levens, vergheselschapt met de boecken, het hofdicht als tak van een georgische literatuur* (The Hague, 1960).

In van Borsselen's *Den Binckhorst* (a poem of 1,228 lines) marginal quotations of Latin authors are found in the following numbers: Virgil, *Georgics* (23), *Aeneid* (11), *Bucolics* (21); Horace, *Epistles* (5), *Odes* (3); Catullus (1:31, the ode to the poet's retreat at Sirmio, a poem that enjoyed great popularity in the seventeenth century); Juvenal (5); Lucretius (2); Ovid (2); identified by P. E. Muller (Philibert van Borsselen, *De dichtwerken van Philibert van Borsselen, een bijdrage tot de studie van zijn taal en stijl*, ed. P. E. Muller [Groningen, 1937], pp. 248–251). Many more echoes of these and other classical writers are found in the Dutch text as well.

38. Sannazaro wrote a short hofdicht: *Ad villam Mergillinam* (*Opera omnia* [Venice, 1535]). According to van Veen, it "consists of merely eleven stanzas of four lines each, but it is nonetheless typically georgic, and definitely not pastoral" (p. 166).

39. Van Veen, p. 10.

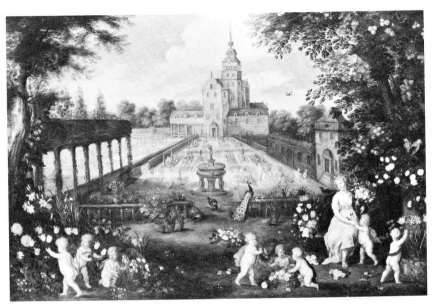

104. Jan Brueghel II and Peeter van Avont, *Flora before a Country House Garden*, Vienna, Kunsthistorisches Museum

Younger Pliny. But he may also tell of a visit to the beach, to nearby cities and villages, and often, to other country homes, the latter being an aspect of the strong sense of social class in these works.

Hofdichters do not, on the other hand, describe the house itself in any detail, even though Pliny the Younger had done so and in spite of the fact that prints of such homes were produced in the late sixteenth and throughout the seventeenth centuries. Paintings depicting country houses, moreover, had enjoyed a certain vogue in Flanders at the turn of the century and still occurred in the work of Jan Brueghel the Younger (fig. 104). In the hofdicht one does not actually get a look at the house, but rather a view out of it, into the garden. The library as well as the collections of art and natural curiosities, however, do claim attention. The connection between *het buitenleven* and intellectual life is always stressed,[41] not only by the enumeration of the owner's cultural treasures but also by didactic excursuses on horticultural matters and methods of hunting, for example, or by the recounting of events from the nation's history. Similarly, as we have noted, Rubens' actual library contained historical works as well as books of natural history, including one of the most beautifully illustrated florals of the seventeenth century, Beslerus's *Hortus Eystettensis* (Eichstatt, 1613; a

honor of the Villa Farnese at Caprarola (1569). Works such as these must have contributed to the extraordinary vogue for country house poems in the North.[40]

One of the conventions of the hofdicht is that the poet pretends to take the reader on a walking tour during which he describes the topography of the estate (or at least of the garden) and sometimes of the region in which the house lies, much in the style of the

40. Van Veen, p. 167.

41. The classical basis of this notion has already been pointed out above; the idea was conventional in sixteenth-century villa literature. To take but one example: Raffaele Borghini in his *Il Riposo* (Florence, 1584; a work named for the Vecchietti villa near Florence) lists the artistic treasures to be found within the house (including "very beautiful landscapes by some Flemings") and ends his account by saying, "In sum, all that can give pleasure to the body and nourish the mind is found in this villa" (Robert Klein and Henri Zerner, *Italian Art, 1500–1600: Sources and Documents* [Englewood Cliffs, N.J., 1966], pp. 153–55).

work divided into sections according to season).[42] In fact, Rubens' Antwerp home, designed on the plan of a suburban villa and containing a garden, already reflected the values expressed in the hofdicht, and his intellectual as well as class interests can be seen to coincide perfectly with those of the writers of such poems.[43]

A feature of the rural estate that is stressed in the seventeenth-century Dutch hofdicht is, as the term itself indicates, the garden. One practical reason is that in the Northern Netherlands country houses were not set on large tracts of land. But the primary explanation for such interest in the garden seems to have been the challenge offered by Virgil: unable to treat all aspects of farming and husbandry, the poet suggests that someone else take up the special theme of horticulture (Georgics 4:147–48). Since Virgil himself had rightly predicted the fame he would win by writing about rural occupations (4:6), later poets came to think that here indeed lay the road to lasting recognition.[44] A particular attraction of the garden, moreover, was that grafting and pruning were the occupations traditionally considered most honorable for a villa owner, whereas heavier labors such as plowing and sheepshearing were not. Besides gardening, a task highly esteemed in the hofdicht is the clearing and irrigation of uncultivated land. Like grafting, these tasks show a strong bias—already seen in Cicero—for nature controlled by reason and ingenuity and of practical use to man.

The theme of the self-sufficiency of the estate in supplying its own food always figures in the hofdicht, as it had in earlier literature, and the full table is frequently praised. Rubens illustrates this idea in a concise manner by depicting food being gathered from the land, air, and water: the cow—for van Mander a symbol of the earth—provides milk, and corn is on the way; a man fishes in the moat; and the fowler will soon bring fresh partridges to the larder. As the Caroline writer Thomas Carew formulated this topos in his house poem "To Saxham" (before 1640): "Water, Earth, Ayre, did all conspire, / To pay their tributes to thy [cooking] fire."

Dutch hofdichters do not exhibit any interest at all in wild nature. It is not the dense forest that they find lovely to behold, but rather a grove planted in neat rows. The preference, even in these poems celebrating the out-of-doors, is more for art than for nature. Since the Renaissance, however, there had been a strain of thinking about landscape—real as well as pictorial scenes—that one scholar has called "a doctrinal preference for untamed Nature."[45] This wild nature, preserved as well as "cultivated" to create or maintain the effect, was associated with psychic states very different from the rational, pragmatic, and moralistic attitude behind the hofdicht. Rubens, as always, follows his decorous instincts and omits from Het Steen and The Rainbow the two extremes of nature: the garden, on the one hand, and the dark, mysterious, "romantic" forest, on

42. Max Rooses, "Petrus Paulus Rubens en Balthasar Moretus," part 4, Rubens-bulletijn 2 (1885), p. 190; Rubens acquired the book in 1615.

43. The famous Walk in the Garden (Munich, Alte Pinakothek; Glück, no. 19), by Rubens or a follower, may be said truly to epitomize the tenor of a typical hofdicht (literally, a garden poem). The range of themes expressed in this kind of poetry can justifiably be compared in certain important respects to Het Steen and The Rainbow as well, however, since the specifically rural component is important in so many Netherlandish examples of the genre. (Evers [1944], pp. 336–41, citing circumstantial evidence as well as some of the uncharacteristic stylistic features of Walk in the Garden, doubts that the picture is by Rubens.)

44. Van Veen, p. 185.

45. W. W. Tayler, Nature and Art in Renaissance Literature (New York, 1964), p. 171.

the other. The pendants can be said to be more purely rural or "georgic," with the emphasis on agriculture. The beautiful woods of *The Rainbow* would seem to denote a characteristic and desirable feature of estate lands, a place for hunting small game and a source of herbs and firewood.[46]

PEASANTS

In the hofdicht the characters that receive attention are peasants and the aristocratic owners of country homes; urban and court life, needless to say, are disparaged. The actual relationship between gentlefolk and peasants is quite limited: the squire may be described as he takes a stroll to watch peasant festivities and to eavesdrop on rustic conversations in dialect, but he shows little interest of even an economic nature in the rural laborer's toil. As compared to the typical hofdichter, Rubens is much more interested in the peasants' work and play; he was able to project himself into their activities—or at least convincingly to portray their imagined way of life.[47]

46. On the taste for wild nature in the Renaissance, see Eugenio Battisti, "Natura Artificiosa to Natura Artificialis," and Elisabeth MacDougall, "Ars Hortulorum: Sixteenth Century Garden Iconography and Literary Theory in Italy," both in *Dumbarton Oaks Colloquium on the History of Landscape Architecture: The Italian Garden*, ed. David Coffin (Washington, D.C., 1972). Battisti (pp. 29–39) cites, for example, Lorenzo de' Medici's desire for "direct and intimate contact with wild and untouched nature," which he fulfilled by making pilgrimages with other humanists to the pine forests of Camaldoli (1468) or to the wilderness of the Franciscan monastery of La Verna. MacDougall discusses the woods as an essential element in the landscaping of the Italian villa.

47. Not only the rural landscapes bear out this assertion, but so too do Rubens' *Kermis* (fig. 105) and his *Peasant Dance* (fig. 106). In the latter work, which was in

One difference between pastoral and country house literature is that the latter celebrates lawful marriage rather than the free expression of love. The institution of marriage is embodied in *Het Steen* by the family group near the château, as well as by the couple going to market. The interest the peasant shows in the milkmaid in *The Rainbow* is entirely appropriate to the genre, however. The connection of the peasant with fertility and abundance was a time-honored and positive association. In Northern art the theme might be handled in a straightforward way, as in Joachim Beuckelaer's depiction of a young farm couple seated with harvest plenty (fig. 107). But a more pointedly amorous tradition also existed. In Lucas van Leyden's famous engraving *Milkmaid* (1510; fig. 108), for example, a loutish young rustic stares from beneath his hat at a milkmaid, she ostensibly demure but wearing a low-cut bodice and an apron with a suggestive central knot of drapery. The erotic interplay is underscored by paired elements: the man with his staff and the woman with her bucket are separated by a cow—its horns on his side, its udders on hers—and he rests a hand on the phallic protrusion of one tree, while the tree behind her has formed an opening. Lucas van Valckenborch devoted a painting to another bucolic-amorous encounter, this one, too, slightly comic: in a pasture under the trees, a milkmaid interrupted by a swain spills a

the artist's own collection, there is one dancing figure—the man with the broad-brimmed hat who has abruptly turned clockwise to steal a kiss—that Evers cautiously suggests represents Rubens himself ([1942], p. 322). Although this idea can hardly be proven, it is plausible in terms of the pastoral genre, a standard device of which is the poet's projection of himself into the imagined gaiety and freedom of rustic life. One need not identify any member of the swirling chain as Rubens himself, however, to see how involved he was in the spirit of the dance, a feeling conveyed in some of his drawings as well (cf. B.-H., no. 150; Held, no. 57).

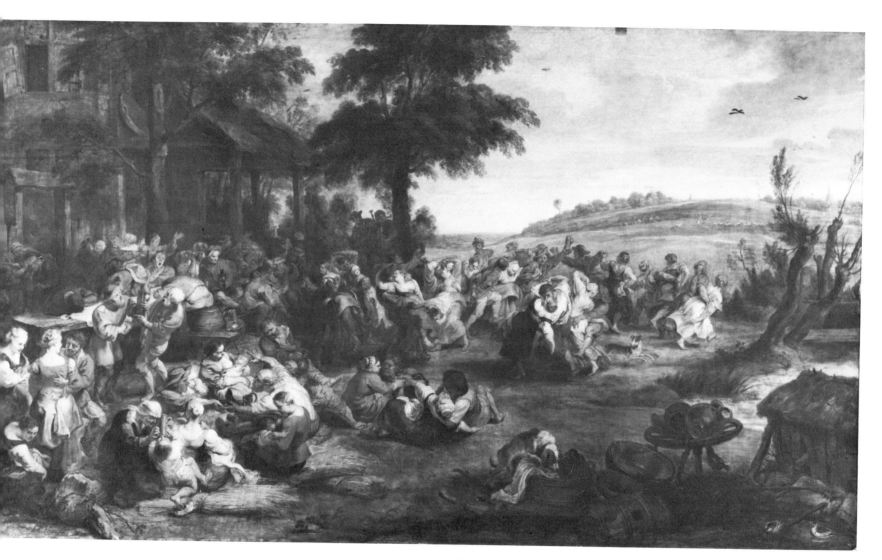

105. *Kermis*, Paris, Louvre (Réunion des Musées Nationaux)

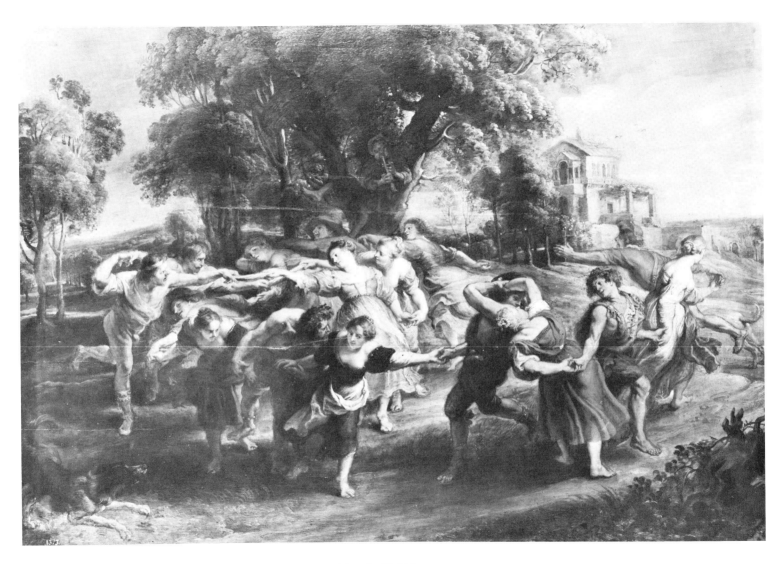

106. *Peasant Dance*, Madrid, Museo del Prado (Rights reserved © Museo del Prado, Madrid)

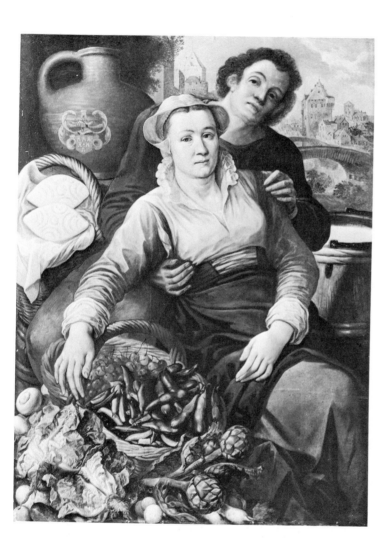

107. Joachim Beuckelaer, *The Market*, Budapest, Museum of Fine Arts

108. Lucas van Leyden, *Milkmaid*, engraving, New York, New York Public Library (Prints Division, Astor, Lenox and Tilden Foundations)

109. Lucas van Valckenborch, *Pasture under the Trees*, Frankfurt am Main, Städelsches Kunstinstitut

110. Rubens and Frans Snijders (circle), *The Market Stall*, Hartford, Wadsworth Atheneum (Courtesy Wadsworth Atheneum, Ella Gallup Sumner and Mary Catlin Sumner Collection)

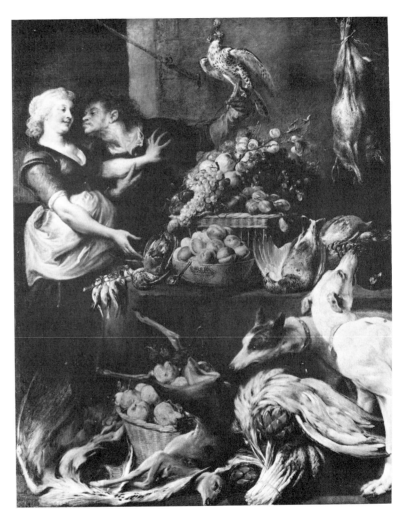

bucket of milk (1573; fig. 109). And a painting by Rubens' associate, Frans Snijders, depicts a young rustic back from the hunt, making advances to the feminine keeper of a market stall (fig. 110). The bird held high in this picture functioned also as a sexual pun (*vogelen:* "to copulate"), making the artist's intent even more obvious, and a comic note is provided by two hounds sniffing the untended game.[48]

Themes linking the peasant or a personification of agriculture with fertility and abundance enjoyed a special popularity in the Southern Netherlands precisely at the time when its cities were foundering and the economy was becoming agricultural. We may cite such works as Rubens' own *Statue of Ceres* (fig. 111); Jan Brueghel's *Allegory of Abundance*, showing peasants, fruit, vegetables, and farm implements (location unknown; illustrated in the Decimal Index of the Art of the Lowlands); Cornelis de Vos's *Wealth Crowning Agriculture* (fig. 112); and Jacob Jordaens's *Allegory of Fertility* (fig. 113). It is noteworthy, too, that whereas Martin de Vos used a wagon full of goods and a sailing ship to symbolize prosperity in a triumphal entry design of 1585 (fig. 114), when Antwerp was still identified with trade, Rubens depicts agricultural tools for the Temple of Janus in 1635 (fig. 115). Moreover, abun-

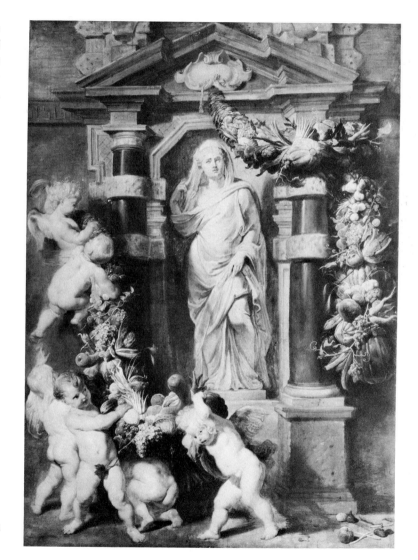

48. On the pun of a man offering a bird to a woman, see E. de Jongh, "Erotica in vogelsperspectief: de dubbelzinnigheid van een reeks 17de eeuwse genrevoorstellingen," *Simiolus* 3(1968–69), pp. 22–74.
Fishing also provided opportunity for erotic-rustic encounters, as we see in the frequent piscatory scenes by David Vinckboons. In a drawing by him of 1608, for example, a couple sits closely together under a tree and they both reach for worms in a box held between the man's legs. Several paintings of this type followed (cf. New York, Pierpont Morgan Library, *Drawings from the Fitzwilliam Museum, Cambridge* [New York, 1977], no. 119).

111. *Statue of Ceres*, Leningrad, Hermitage

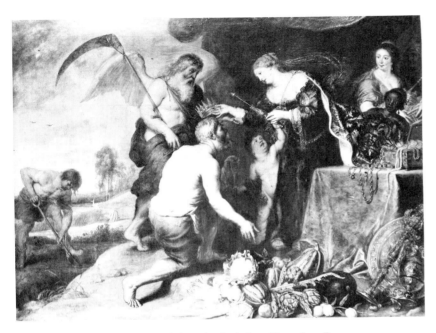

112. Cornelis de Vos, *Wealth Crowning Agriculture*, Rotterdam, Boymans-van Beuningen Museum

dance, fertility, and the gods who embody such concepts are among the most abiding—not to say obsessive—themes in Rubens' art.

The old praises of country life seem to have taken on new meaning for the Flemish in the seventeenth century and to have influenced their art. One form that this concern took was a way of thinking about the peasant as a human type endowed with piety, humility, dutifulness, trust, and industry. It should be noted that the majority

of Netherlanders, North and South, still made their living through agriculture in the seventeenth century. It was not the rural population in all its variety, however, but only the ideal good peasant who was seen in relation to a fixed moral order, in which his social position was low but his quotient of virtue high and his place in relation to men of nobler station ordained by God. This sort of idealization of the peasant was strongest in the works of Spanish

113. Jacob Jordaens, *Allegory of Fertility*, Brussels, Musées Royaux des Beaux-Arts (Copyright A.C.L.-Brussels)

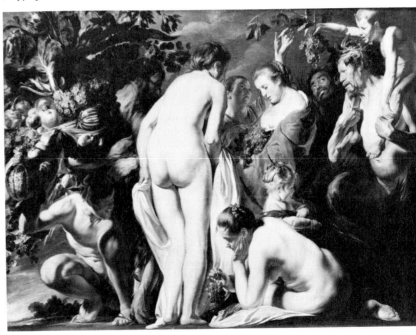

114. Martin de Vos, *Allegory on the Decay and Prosperity of the City of Antwerp*, drawing, 1585, Rotterdam, Boymans-van Beuningen Museum

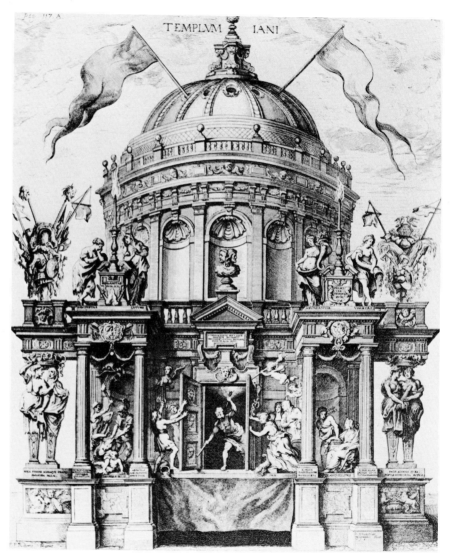

115. *Temple of Janus*, engraving by Theodore van Thulden after Rubens (from *Pompa Introitus Ferdinandi*, Antwerp, 1641), New York, Avery Library, Columbia University

writers and those who came under their influence, particularly writers of the Southern Netherlands. Although these authors indicate biblical and classical sources for their ideas, the latter must have been revived as a response to specific social conditions. In a recent study Faith Dreher has shown that the scenes of country life by Rubens' younger contemporary David Teniers II form a parallel to such moralistic literature concerning the peasant.[49] She suggests some of the reasons why these ideas had such currency in the Spanish Netherlands. One was the aspiration of many among the bourgeoisie to acquire membership in the class of the gentry, partly because they saw the countryside as an alternative to the depression in the towns. Intermittently since the late sixteenth century, moreover, large numbers of artisans and laborers had found themselves unemployed. Idleness and unrest, heresy or lack of religion were perceived in them, occasioning widespread fear among those who were better off. Given the dissolution of much of the economic life of Antwerp and other cities, peasants who had enduring roots in the land came to be regarded, at least in literary circles, as symbols of stability. This idealization of the peasant, in which the assumption that he is content with his lot obscures his real grievances, manifests a basically conservative and condescending attitude; Dreher aptly describes Teniers's peasants as neat, little, and well behaved. In comparison, Rubens' rural folk seem more akin to deities: the blond peasant woman in *The Rainbow* could be a rustic Ceres and her brunette companion a Venus, like the two goddesses of summer.[50]

If hypocrisy was rife in the idealization of the peasant, at least agriculture enjoyed great esteem. In a series of paintings in the Prado, Jan Brueghel the Younger (1601–78) documented the archduchess's interest in rural life; in one picture she is even shown with her court ladies in the surroundings of the palace of Mariemont, raking and stacking hay (fig. 116).[51]

Ultimately it was the rural population that suffered greatest and longest from the war. Naturally, they themselves were sometimes moved to violence, as when, in July 1635, they massacred allied soldiers retreating from an attack on Brussels (cf. Henri Pirenne, *Histoire de Belgique*, vol. 4 [Brussels, 1919], p. 277). Such "butchery" is mentioned by Rubens in a letter of August 16, 1635 (*CDR* 6:126).

It is impossible to determine the extent to which Rubens idealizes the peasant. That they are convincingly lifelike and convey a sense of physical well-being is in part a result of the artist's humanistic conception of man. But we have no reason to think that the peasants he encountered were particularly misshapen, lazy, impious, or poverty-stricken. It is likely enough that the tenants Rubens saw going about their work were faring better than the lower classes in the towns, and certainly better than members of the rural proletariat who were sometimes employed in small industries. Miseries in the countryside resulting from war and famine were sporadic, and so far scholars have only revealed trends covering long spans of time and large geographical areas. Sir Richard Weston's enthusiastic treatise entitled *A Discourse of Husbandrie Used in Brabant and Flanders, Shewing the Wonderful Improvement of Land There . . .* (London, 1650) is one indication of the profitability of agriculture in certain areas of the Southern Netherlands.

51. This painting (Madrid, Prado; Matias Díaz Padrón, *Museo del Prado: Catalogo de pinturas*, no. 1428) has as a companion piece a depiction of the Infanta Isabella and her court ladies in the Park of Mariemont (Prado; Padrón, no. 1429). The iconography of the pendants is connected with that of other paintings in the Prado attributed to Jan the Elder. Two sets of pendants by him pair a country dance attended by the archducal couple, Albert and Isabella, with a wedding banquet (Padrón, nos. 1438–1439 and 1441–1442). One (no. 1442) is signed "Brughel" and dated 1623. Another painting by Jan, *Country Life* (Madrid, Prado; Padrón, no. 1444; fig. 63), also confirms the Hapsburg interest in scenes of Flemish rural life.

49. See Faith Dreher, "The Vision of Country Life in the Paintings of David Teniers II" (Ph.D. diss., Columbia University, 1975), especially ch. 4–6.

50. Flemish peasants were not always as meek as Teniers makes them out to be.

116. Jan Brueghel II, *The Infanta Isabella and Court Ladies Raking Hay in the Park of Mariemont*, Madrid, Museo del Prado (Rights reserved © Museo del Prado, Madrid)

THE DELUGE

If young peasants were especially associated with regeneration, the old ones were linked with piety. This is seen in a print by Jacques de Gheyn II entitled *The Peaceable Couple* (*Vreedsamich paer*; fig. 117): an old man and woman seated next to a pile of fruits and vegetables

in a rustic setting, say their prayers (of thanks for the plenty that surrounds them, one imagines), while the Holy Ghost hovers above in a glory.[52] Rubens takes up a related theme, but in a pagan context, with his *Flood Landscape with Philemon and Baucis* (fig. 118; ckl. no. 27).[53] The story concerns an aged man and wife who, because of their kindness and hospitality, are spared from a disastrous flood inflicted on the greedy and impious people of the region.[54]

In a huge and awesome landscape, Philemon and Baucis are depicted in the company of Jupiter and Mercury, the gods with whom they alone, of all the population, had shared their humble food and shelter. Behind Philemon and Baucis grow an oak and a linden, issuing from a single trunk and intertwined, portent and symbol of the couple's fate. As a reward for their goodness they had been granted a wish—that they be made priests and guard a temple, and that neither be made to outlive the other. The story is from Ovid (*Metamorphoses* 8:611–724), who concludes:

52. The inscription on de Gheyn's print translates: "See how union sweet two hearts binds together, / With joy, rest, peace, agreeable to God" (trans. by Dreher, p. 174).

53. Vienna, Kunsthistorisches Museum; in my opinion, the work dates from after 1625.

The recent catalogue of the Rubens exhibition held in Vienna (Vienna, Kunsthistorisches Museum, *Peter Paul Rubens, 1577–1640* [Vienna, 1977]) became available to me after this study was completed. I do not cite, therefore, any overlapping interpretative material contained in its entry (no. 41) on the *Flood*.

54. Rubens' treatment of the story here is unusual, perhaps unique; most painters chose to depict the poor but cozy interior of the old couple's cottage, with Jupiter and Mercury seated at table. Rubens himself painted such a picture (now lost; school copy in Vienna). On the theme in seventeenth-century Northern paintings, see Wolfgang Stechow, "The Myth of Philemon and Baucis," *Journal of the Warburg and Courtauld Institutes* 4 (1940–41), pp. 103 ff.; Stechow does not mention Rubens' *Flood*.

And the prayer was granted.
As long as life was given, they watched the temple,
And one day, as they stood before the portals,
Both very old, talking the old days over,
Each saw the other put forth leaves, Philemon
Watched Baucis changing, Baucis watched Philemon,
And as the foliage spread, they still had time
To say 'Farewell, my dear!' and the bark closed over
Sealing their mouths. And even to this day
The peasants in that district show the stranger
The two trees close together, and the union
Of oak and linden in one.[55]

[8:711–20]

Ovid also tells of Deucalion and Pyrrha, yet another pious old couple saved by their virtue from a punitive flood (*Metamorphoses* 1:313 ff.). In a painting for the Torre de la Parada (c. 1638), Rubens pictured the elderly pair, sole survivors of the deluge, casting behind them the stones from which a new race of men would grow.[56]

When Rubens created his flood landscape, he may once again have been influenced by literature. If Virgil was not to be surpassed

55. Translated by Rolfe Humphries (Bloomington, 1972), pp. 203 ff. All subsequent translations are from this edition.
56. Svetlana Alpers, *The Decoration of the Torre de la Parada*, (London, 1971), nos. 17 and 17a, figs. 95 and 96.

117. Jacques de Gheyn II, *The Peaceable Couple*, etching, New York, Metropolitan Museum of Art (Elisha Whittelsey Collection, Elisha Whittelsey Fund, 1955) All rights reserved, The Metropolitan Museum of Art

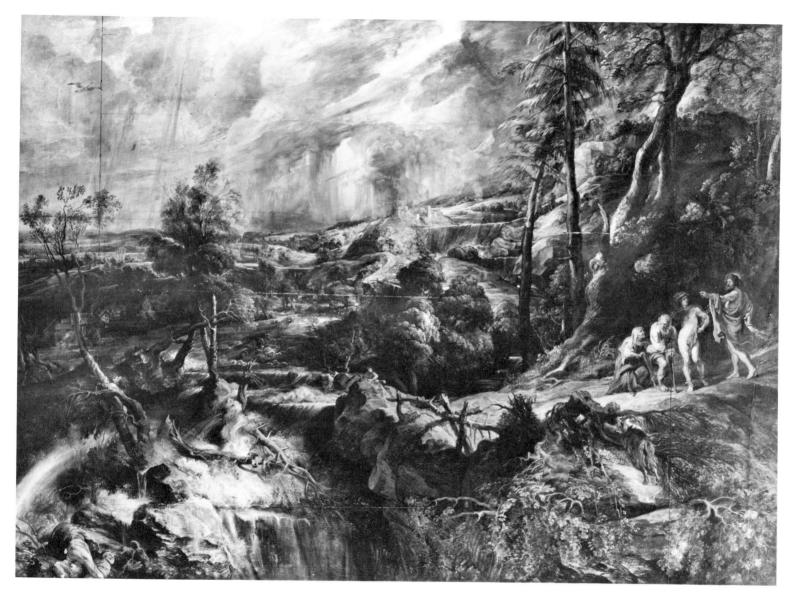

118. *Flood Landscape with Philemon and Baucis*, Vienna, Kunsthistorisches Museum

for his shipwreck, Ovid might make equal claim for his deluge, the description of which precedes and introduces the tale of Deucalion and Pyrrha. As the story goes, Jove, intent on punishing mankind for its unsurpassed evil, sends a flood to drown the world. Ovid describes Jove's work vividly—and not without something of a mock-epic quality—in the following words:

> His broad hands squeeze together
> Low-hanging clouds, and crash and rumble follow
> Before the cloudburst, and the rainbow, Iris,
> Draws water from the teeming earth, and feeds it
> Into the clouds again. The crops are ruined,
> The farmers' prayers all wasted, all the labor
> Of a long year, comes to nothing.
> And Jove's anger
> Unbounded by his own domain, was given
> Help by his dark-blue brother. Neptune called
> His rivers all, and told them, very briefly,
> To loose their violence, open their houses,
> Pour over embankments, let the river horses
> Run wild as ever they would. And they obeyed him.
> His trident struck the shuddering earth; it opened
> Way for the rush of waters. The leaping rivers
> Flood over the great plains. Not only orchards
> Are swept away, not only grain and cattle,
> Not only men and houses, but altars, temples,
> And shrines with holy fires. If any building
> Stands firm, the waves keep rising over its roof-top,
> Its towers are under water, and land and ocean
> Are all alike, and everything is ocean,
> An ocean with no shore-line.
> Some poor fellow
> Seizes a hill-top; another, in a dinghy,
> Rows where he used to plough, and one goes sailing
> Over his fields of grain or over the chimney
> Of what was once his cottage. Someone catches
> Fish in the top of an elm-tree, or an anchor
> Drags in green meadow-land, or the curved keel brushes
> Grape-arbors under water. Ugly sea-cows
> Float where the slender she-goats used to nibble
> The tender grass, and the Nereids come swimming
> With curious wonder, looking, under water,
> At houses, cities, parks, and groves. The dolphins
> Invade the woods and brush against the oak-trees;
> The wolf swims with the lamb; lion and tiger
> Are borne along together; the wild boar
> Finds all his strength is useless, and the deer
> Cannot outspeed that torrent; wandering birds
> Look long, in vain, for landing-place, and tumble,
> Exhausted, into the sea. The deep's great license
> Has buried all the hills, and new waves thunder
> Against the mountain-tops. The flood has taken
> All things, or nearly all, and those whom water,
> By chance, has spared, starvation slowly conquers.[57]
> [*Metamorposes* 1:268–313]

57. Translated by Humphries, pp. 11 f. The inscription on the engraving published by G. Hendricx after the *Flood* reads: "Occidit Una domus: Sed non domus Una perire / Digna fuit qua terra patet fera regna Erijnnis: / In facinus Iurasse putes

In Schelte à Bolswert's engraving after Rubens' flood landscape (fig. 119) it is easier to distinguish the people clinging to rocks, men and animals caught in branches as the torrent sweeps them along, others fleeing in panic, and a goat racing towards higher ground. This landscape is actually far more awe-inspiring than Ovid's text; in the painting no one fishes in trees. It is indeed more serious, more lofty, more "Virgilian" than Ovidian in tone, and the engraving made after it might justly be paired with Bolswert's reproduction of the *Shipwreck* (fig. 15; both are among the five landscapes engraved in a large format). The paintings themselves exhibit somewhat different styles, however. The larger work is the *Flood*, which is executed in such a way that the landscape looks truly drenched and the moisture of mist can almost be felt. It is, however, like the *Shipwreck*, a tour de force of painting, complete with Rubens' "signature"—a rainbow—in the lower left corner.

The *Flood*, like the *Shipwreck*, has a divided composition in which the two halves are distinguished by a difference in weather as well as by ascending versus descending ground. The rising right side of Rubens' *Flood* carries an obvious moral significance: it is the side of piety. More than a refuge, the ground is also characterized as a sanctuary, a flat piece of earth bordered by a rough fence of trees, wattle, and a ridge of earth, and blessed by the presence of gods, priest, and priestess. One is reminded here of Bruegel's *Dark Day* (fig. 87), in which peasants tend trees on a wedge of high ground, while below, in the background, ships are buffeted by waves under a terrible brooding sky. In Bruegel's vision of worldly order, however, the piety of the peasants is expressed in their collective work, whereas Rubens typically stresses the individual will of a particular peasant couple. And great power is attributed to this will, this individual moral force, for the artist pits it against dreaded chaos, an upheaval of cosmic proportions.[58]

THE RAINBOW

Rubens' *Flood* landscape gains in significance when viewed in relation to the artist's peaceful scenes of rural life. In certain kinds of essentially moralizing literature, the notion often occurs that agriculture provides the life most in harmony with divine order, and Rubens may have wished to make this point in his landscape pendants.[59] The rainbow in the Wallace Collection landscape (fig.

dent ocius omne: / Quas meruere pati sic stat sententia poenas." The faulty Latin should probably have read: "Occidit una domus, sed non domus una perire / Digna fuit; qua terra patet, fera regnat Erinys. / In facinus iurasse putes; dent ocius omnes / Quas meruere pati (sic stat sententia) poenas!" ("One house has fallen, / But more than one deserves to. Fury reins over all the fields of Earth. They are sworn to evil, / Believe it. Let them pay for it, and quickly. / So stands my purpose" [*Metamorphoses* 1:240–43; p. 10]). These lines, spoken by Jove, precede his ordering of the flood which introduces the story of Deucalion and Pyrrha; thus the connection between Rubens' painting and Ovid's tale of another pious old couple—as well as, perhaps, his description of a flood in book 1—was made as early as the seventeenth century.

58. Evers ([1942], p. 401) was the first to speak of the *Flood* as being divided into an "evil" side and a "good" side.

Another impressive storm landscape, known in several versions and engraved by Schelte à Bolswert, appears to reflect an original design by Rubens; the Rotterdam version (fig. 120; ckl. no. 25) may, in fact, be autograph. Like the *Flood*, this sketchlike work also features a wedge of high land on the right. But the only figures are a small, anonymous couple who hurry down a road, and a shepherd who gazes out at the rain falling over a wide valley running down to the sea.

59. In the *Georgics* Virgil had suggested the sacred associations of rural life with the phrase *divini gloria ruris* (1:168)—actually a concept far more ancient than his poem.

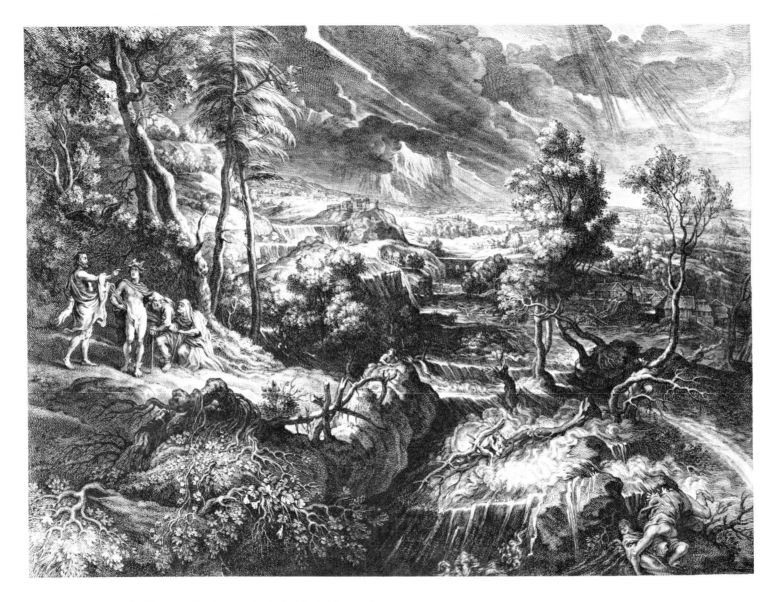

119. *Flood Landscape with Philemon and Baucis*, engraving by Schelte à Bolswert after
Rubens, New York, Metropolitan Museum of Art (Elisha Whittelsey Collection,
Elisha Whittelsey Fund, 1951)

120. *Storm Landscape*, Rotterdam, Boymans-van Beuningen Museum

71) would have reminded the viewer of the motif's most common meaning: the token of God's promise to mankind after the flood:

"Never again shall all flesh be cut off by the waters of a flood. . . . " And God said, "This is the sign of the covenant which I make between me and you and every living creature that is with you, for all future generations: I set my bow in the cloud, and it shall be a sign of the covenant between me and the earth. When I bring clouds over the earth and the bow is seen in the clouds, I will remember my covenant which is between me and you and every living creature of all flesh; and the waters shall never again become a flood to destroy all flesh." [Genesis 9:11–15]

The rainbow also appears with this meaning in van Mander's section on light (*Grondt* 7) where, echoing Genesis, the poet refers to the rainbow as "that eternal sign the Lord put between Himself and Noah and all human beings and animals on earth" (stanza 11). Reflections were of great interest to van Mander, but little of what he says constitutes specific directions on how to paint such phenomena.

In the same stanza in which van Mander cites the covenant between God and Noah, there is an abrupt change in topic, as he considers the second arc of a double rainbow. Van Mander states that in his opinion it is only a reflection of the first bow. In stanza 12 he refutes the idea that there can be more than one sun, even though several may sometimes be observed, he says, at sunrise and sunset when the sky is overcast. What is actually seen in such cases, according to the poet, is the sun and its reflection. In stanza 13 he argues against Pliny the Elder (who attributed the round form of the rainbow to imperfect clouds) by describing the rainbow's round-ness as a reflection of the perfectly round shape of the sun. And the following five stanzas (14–18) are given over to empirical evidence showing that this in fact is so. Miedema believes that van Mander's interest in the rainbow concerned its round form, which points to its divine origin, as well as the fact that it always stands opposite the sun, another symbol of God.[60] This would explain the poet's objection to the independent existence of the second arc: the "eternal sign" must be a single bow echoing a single sun. Yet two more stanzas on the rainbow cite several of its occurrences in the Bible (Ezekiel, Revelation, and Sirach); another, Ovid's description of Iris; and finally, the advice, which we mentioned earlier, that whoever attempts to paint a rainbow must be careful to show how the various bands of color blend with one another.

It is evident that van Mander saw the rainbow on several levels: as a phenomenon universally considered beautiful (7:9); as a sign with religious and mythical associations; as a pictorial motif posing a challenge to the artist's skill and subtlety; and as a painter's guide to color. His dogged insistence, moreover, that the rainbow can only consist of one true arc of perfectly round shape echoing the sun shows that for the poet-painter the rainbow was an unmistakable emblem of the divine. The biblical passages he cites confirm this.[61]

60. Miedema, pp. 515 ff.
61. Ezekiel 1:28 ("Like the appearance of the bow that is in the cloud on the day of rain, so was the appearance of the brightness round about. Such was the appearance of the likeness of the glory of the Lord"); Revelation 4:3 ("And he who sat there appeared like jasper and carnelian, and round the throne was a rainbow that looked like an emerald"); Sirach 43:10–12 ("A weapon against the flood waters stored on high, lighting up the firmament by its brilliance, behold the rainbow! Then bless its Maker, for majestic indeed is its splendor; it vaults the heavens with its glory, this bow bent by the hands of God"). The rainbow seen in this way might even be thought of as a naturalistic substitute for the heavenly court that appears

The relationship of the rainbow's meaning in Genesis to the motif in Rubens' landscape may become clearer if one remembers the passage immediately preceding the account of God's covenant with Noah. After descending from the ark onto dry ground, Noah offered a sacrifice to the Lord, and God, pleased, said to Himself:

"I will never again curse the ground because of man, for the imagination of man's heart is evil from his youth; neither will I ever again destroy every living creature as I have done. While the earth remains, seedtime and harvest, cold and heat, summer and winter, day and night, shall not cease."

And God blessed Noah and his sons, and said to them, "Be fruitful and multiply, and fill the earth. The fear of you and the dread of you shall be upon every beast of the earth, and upon every bird of the air, upon everything that creeps on the ground and all the fish of the sea; into your hand they are delivered. Every moving thing that lives shall be food for you; and as I gave you the green plants, I give you everything. Only you shall not eat flesh with its life, that is, its blood. For your lifeblood I will surely require a reckoning; of every beast I will require it and of man; of every man's brother I will require the life of man. Whoever sheds the blood of man, by man shall his blood be shed; for God made man in his own image. And you, be fruitful and multiply, bring forth abundantly on the earth and multiply in it."[62]

in a work such as the *View of Antwerp* by Hendrik van Balen and Abel Grimmer (1600; Antwerp, Koninklijk Museum voor Schone Kunsten). The Trinity is described as surmounting a rainbow in Herman Hugo's *Pia desideria* (Antwerp, 1624), p. 207 (cited by Wilfried Wiegand, *Ruisdael-Studien: Ein Versuch zur Ikonologie der Landschaftsmalerei* [Hamburg, 1971], n. 299).

Du Bartas's description of the rainbow in his *La seconde sepmaine* ("Deuxieme jour, L'Arche") of 1584 is worth quoting in this connection:

Noah lookes up, and in the Ayre he viewes
A semi-Circle of a hundred hewes:
Which, bright ascending toward th'aetheriall thrones,
Hath a lyne drawne betweene two *Orizons*
For iust *Diameter*: an even-bent bowe
Contriv'd of three; whereof the one doth show
To be all painted of a golden hew,
The second greene, the third an orient blew;
Yet so, that in this pure blew-golden-greene
Still (Opal-like) some changeable is seene.
A bow bright-shining in th' Arch-Archers hand,
Whose subtill string seemes levell with the Land,
Halfe-parting Heav'n; and over us it bends,
Within two Seas wetting his horned ends.
A temporall beauty of the lampfull skies,
Where powerfull Nature showes her freshest dies.

Trans. Josuah Sylvester, *Bartas: His Devine Weekes and Works* (London, 1605), pp. 403–04; cf. Guillaume de Salluste, Sieur du Bartas, *Works*, ed. Urban Tigner Holmes, Jr., John Coriden Lyons, and Robert White Linker, vol. 3 (Chapel Hill, N.C., 1940), p. 114, ll. 451–66.

62. Cf. the account by Du Bartas (*Première sepmaine*) of Noah's response:

Then [Noah] having call'd on God, our second Father
Suffers not sloth his arms together gather,
But fals to work, and wisely now renew'th
The Trade he learn'd to practise in his youth.
For, the proud issue of that Tyrant rude
That first his hand in brother's bloud imbru'd,
As scorning Ploughs, and hating harmlesse tillage,
And (wantons) prising lesse the homely village,
With fields and woods, then th' idle Cities' shades;
Imbraced Laws, Scepters, and Arts, and Trades.
But Seth's Sons, knowing Nature soberly Content
With little, fell to Husbandry,
Thereto reducing, with industrious care,
The Flocks and Droves cover'd with wool & hair;

Besides the theme of man's domination of the earth and its creatures for his sustenance, the line "Whoever sheds the blood of man, by man shall his blood be shed; for in the image of God man was made" would have struck a responsive chord in Rubens, who in later life became so weary of war. A letter he wrote to Peiresc on August 16, 1635 reveals his thought at the time. "I am a peace-loving man," he wrote, "and I abhor chicanery like the plague, as well as every sort of dissension. I believe that it ought to be the first wish of every honest man to live in tranquillity of mind, *publice et privatim, et prodesse multis, nocere nemini* [both publicly and privately, to render service to the many, and to injure no one]." He continues:

I am sorry that all the kings and princes are not of this humor; *nam quidquid illi delirant plectuntur Achivi* [whatever errors the kings commit, the people must suffer for]. Here public affairs have changed their aspect; from a defensive war we have passed with great advantage to the offensive, so that instead of having 60,000 of the enemy in the heart of Brabant, as we did a few weeks ago, we are now, with an equal number of men, in control of the country. By the capture of Schenkenschans we have the keys to the Betuwe and Veluwe in our hands, imparting terror and dread to our adversaries, yet at the same time leaving Artois and Hainault well prepared against any outside assault. It is incredible that two such powerful armies, led by renowned captains, have not accomplished anything worth while, but quite the contrary. It is as if fate had upset their judgment so that through tardiness, poor management, lack of resolution, and without order, prudence, or counsel, they have let slip from their hands all the many opportunities which presented themselves to make great progress. As a result, they were finally forced to retreat in disgrace and with great losses, reduced to small numbers through desertion, and by the butchery which the peasants have inflicted everywhere upon isolated detachments, and also by the dysentery and plague which have taken the majority of them, as one hears from Holland. Please believe that I speak without the slightest passion and say only the truth. I hope that His Holiness and the King of England, but above all the Lord God, will intervene to quench a blaze which (not put out in the beginning) is now capable of spreading throughout Europe and devastating it.[63]

In this letter, although Rubens recounts the recent success of the Spanish side against the Dutch, his tone is hardly triumphant.

WAR AND PEACE

In van Borsselen's country house poem *Den Binckhorst* the little estate outside the town is used, on one level, as an extended emblem of peace and security. Within this context, the subject of war also

As praise-full gain, and profit void of strife,
Art nurse of Arts, and very life of life.
So the bright honour of the Heav'nly Tapers
Had scarcely boxed all th' Earth's dropsie vapours,
When he that sav'd the store-seed-World from Wrack,
Began to delve his fruitfull Mother's back.

Trans. Josuah Sylvester, *Devine Weekes*, p. 404.

63. *CDR* 6:126; Magurn, pp. 400 f.

occurs, in some hundred lines recalling Virgil's passage on civil war in the *Georgics* (van Borsselen quotes *in margine* appropriate phrases from the *Bucolics*, *Georgics*, and *Aeneid*). The Dutch poet refers to a war that has gone on for forty years, and he must have had in mind as its starting point the attack of the Spaniards in 1572.[64] Not only the Spanish, French, English, and Germans have become involved in the conflict, according to van Borsselen, but fighting goes on even among "dear brothers" (1:951). Although the poet's sympathies lie with the Dutch, it is clear that he does not yet regard the split between the Northern and Southern provinces as irreversible. His passage on war mixes bitter lament with a harsh accusation of the Netherlands (North and South seen as one country) for the insanity of the conflict. "Go: see here and there the fields sown white / With human bones," he says, "and harvest those fruits." The poem continues:

> See if your barren rural lands
> Need yet more of that fertilizer—fat human flesh (it's cheap).
> Alas! What greater sadness, and with what misfortunes
> This civil war burdens you, day in, day out.
> Yet God's anger has been righteously roused.
> Indeed even harder, and harder rods must be needed
> To make you wise, and evil cease.
> Oh, foolish Netherlands: take counsel with yourself
> And benefit from these, God's three worst plagues—
> The pestilence, war, and inflation with which you've been
> beaten.
> Your blood is your refreshment, your own flesh your food;

> You love your destruction and hate your profit;
> You think that by killing yourself your life is attained.
> Thus you're propelled, as by a flood, to a conclusion
> That militates against you. You make war your peace,
> Peace your war; your joy makes you sad,
> And your sickly body—like a leper's—
> No longer has feeling. The more God visits upon you
> The hard hand of his ire, the more you harden,
> And like a mule, go slower with the beating.
> Oh wake from your sleep, and realize for once
> That to injure yourself this way is perversity.
> Let a firm Peace make all foreign war rabble
> Retreat home over the mountains, and cause
> The sharp steel to be forged once more into sickles,
> So that the farmer yet can plow his wild land in peace.
> And let everyone come together in concord. . . . [65]

[989–1,016]

The poet confesses that he cannot go on with such sad poetry, the tears moisten the very paper on which he writes; instead, he now calls upon his muse and turns to the happy praises of country life.

The link between peace and agriculture is inherent in poetry of a georgic type, including the countryhouse poem.[66] The connection

64. Van Borsselen, l. 962, and p. 241, n. 962.

65. I am grateful to Prof. J. W. Smit for his help with this translation.

66. In Thomas Carew's house poem, "To my friend G. N. from Wrest," Carew "frames the poem with his memories of the oppressiveness of war. . . . Wrest is seen as entirely natural, and the landscape described is an internal as well as external landscape of peace. . . . Wrest is an island paradise, a heaven on earth surrounded by a moat whose reflections create an upside-down world" (Rosemarie Wilcox, " 'Of Passion's Finest Thread:' Studies in the Life and Poetry of Thomas Carew" [Ph.D. diss., Columbia University, 1971], p. 156).

is also made explicit in a painting by Jan Brueghel (II?) and Hendrik van Balen: on the left is an allegorical figure of peace surrounded by personifications of virtues, as well as fruit, flowers, and finely wrought objects; on the right a soldier, a beggar, and a woman (a whore?) are being chased away; and in the background is pictured a rural landscape with a church, cottages, and a scene of harvest (location unknown; in Decimal Index of the Art of the Lowlands).

Rubens' desire for peace is well documented in his letters and the records of his diplomatic activities. He celebrates peace, moreover, in such late paintings as the *Allegory of War and Peace* (Munich, Alte Pinakothek), *Minerva Protecting Pax from Mars* (London, National Gallery; fig. 121), and the ceiling of the Whitehall Banqueting House in London.[67] In these works the theme of peace is explicitly embodied in allegories, while *Het Steen* and *The Rainbow* may satisfy the viewer as vivid scenes of country life. Yet in attempting to articulate the deeper meaning of these works, we must bear in mind that in seventeenth-century literature the rural estate becomes a microcosm, an enclosed ideal world, its every part subject to emblematic interpretation. Although such a work as van Borsselen's *Den Binckhorst* offers an important interpretive model for viewing Rubens' pendant landscapes, the emblematic habit of thinking behind it requires a degree of abstraction from nature that was ultimately foreign to the artist's perception of the world. As a painter, Rubens always maintained a passionate interest in the concrete reality of things themselves, regardless of the degree to which his attitudes, assumptions, and principles of order were shaped by literature and other works of art. Nevertheless, *Het Steen* and *The Rainbow* have a definite structure of meaning, and together their motifs form a "typical code" that can be read. We have already seen that the choice of motifs in the pendants corresponds to the humanist conception of ideal country life in almost a metaphorical sense. Although completely embedded in a naturalistic context, the light-struck door of the château, for example, registers as a sign of hospitality, the tiny cornfield as an emblem of fruitfulness, the color and articulation of the skies as a diagram of temporal and meteorological cycles. The town on the horizon, moreover, implies the connection between the gentleman's city and country abodes, with the woods providing the necessary counterpart to cultivated nature. And in view of the artist's Christian faith, as well as the

67. Cf. Per Palme, *Triumph of Peace: A Study of the Whitehall Banqueting House* (Stockholm, 1956), passim. Rubens' design for the *Temple of Janus*, one of the sets for the entry of the Infante Ferdinand, is divided in half thematically, with everything on the left side representing war and misery, and everything on the right peace and prosperity (J. R. Martin, *The Decorations for the Pompa Introitus Ferdinandi* [New York, 1972], no. 44a, fig. 83). The figures above the entablature on the right (fig. 115) are Abundance, holding a cornucopia upright, and Fertility, with an inverted cornucopia, its contents spilling out. Below them are two golden cornucopias from which issue children's heads, and the legend *Felicitas*. In van Thulden's etching of this scene (Martin, fig. 82), the temple is shown enlarged on both sides, and now, on the entablature to the right of Abundance and Fertility are the trophies of peace, including agricultural implements (a rake, hoe, bucket, winnow, and hay fork, as well as hay and vegetables); below this, among other motifs, recur children and fruit. Accompanying the portrait of the Infante on the Arch of Philip is a paraphrase from the *Georgics* (1:500–01) referring to Octavian after his victory at Actium—a parallel to Ferdinand's recent success at the Battle of Nordlingen (Martin, catalogue no. 20, fig. 30). Martin quotes Gevaerts's explanation: "As under Augustus Caesar, when peace was established on land and sea and the Temple of Janus was closed, the world enjoyed a long period of happiness and security, so also under the auspicious leadership and incomparable virtue of the Serene Prince Ferdinand do the Netherlands rightly look forward to the peace that they have long hoped for after the disturbances of civil war" (p. 100).

Earlier, Rubens had included the temple of Janus (door open) in his *Horrors of War* (Florence, Pitti), a work whose iconography he explained in a famous letter of 1638 to the painter Justus Sustermans (*CDR* 6:207–11; Magurn, p. 408).

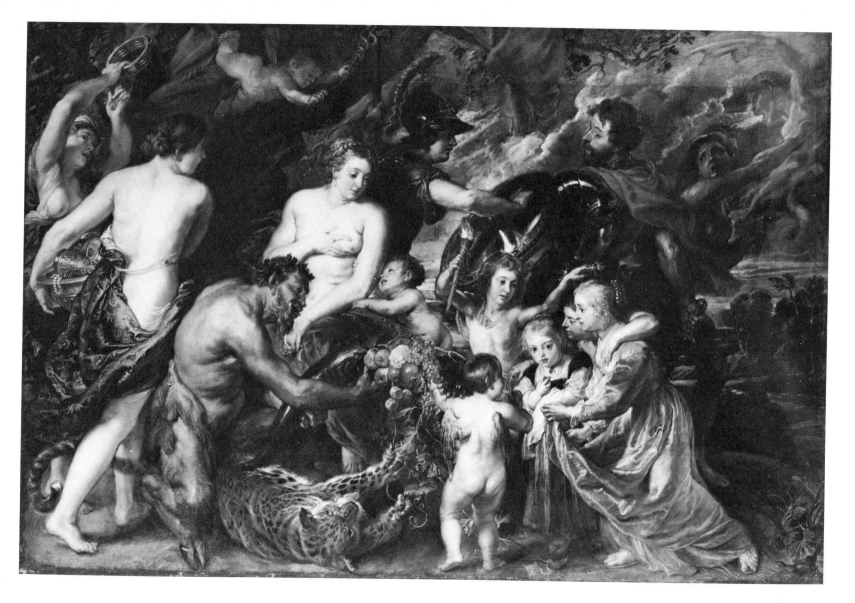

121. *Minerva Protecting Pax from Mars*, London, National Gallery (Reproduced by
Courtesy of the Trustees, The National Gallery, London)

optimistic way in which he presents the country and peasants, the rainbow becomes charged with biblical significance. Thus we can think of the pendants not only as views painted from nature but also, together, as an image of peace, piety, social order, productive work, and the continuity of life on the land.[68]

CONCLUSION

Reviewing Rubens' landscape oeuvre, we are struck by both its diversity and its consistency. From the first, landscape was for Rubens a way of interpreting experience, of weaving its threads together into a coherent pattern. Whether they mirror deep longings or propose moral imperatives, these paintings are unified by the artist's view of nature and human nature; they are humanistic landscapes in the fullest sense.

Rubens, as we have seen, not only observed nature, but also mastered conventions; he used the landscape topics and modes, the "common places" his culture offered, as frameworks around which to build pictures of what mattered most to him in the world. In

68. In the humanist tradition, agriculture was to peace as hunting was to war. Hunting was seen as the ideal preparation, during peacetime, for the duties of the battlefield that were sure to follow, cycles of war and peace being taken for granted. Since war was always deemed a necessary activity of the state, the skills of the hunter were highly valued and were considered an art. David Rosand ("Rubens's Munich *Lion Hunt*: Its Sources and Significance," *Art Bulletin* 51 [1969], especially pp. 38–40) has fully explored this meaning of the hunt in relation to Rubens' heroic hunting scenes of the second decade. It is noteworthy that in his later years Rubens did not produce hunting scenes of the heroic type; in the *Hunt of Atalanta* (1630s; ckl. no. 18) the mythological figures almost blend with the setting of woods and marsh.

his later years the Castle Steen may have seemed world enough, providing security, honor, and earthly beauty. From beneath the earth came coins, like messages from his beloved ancients, urging SPES and VICTORIA, and on high, like a sign from the Creator, appeared a rainbow.

Het Steen and *The Rainbow* go beyond Rubens' earlier rural landscapes in many ways. Dividing a single composition, as he had often done, was no longer sufficient to accommodate the georgic genre as the artist now conceived it: as a figure for order and regeneration in the world, as in Virgil's poem, and as a vehicle for the statement of personal concerns as well. Like Horace, Rubens understood the effect of a particular place upon personality and in turn imposed upon the landscape his own energetic nature.

We can say that the quality of Rubens' landscape vision was worthy of the care and intelligence with which he expressed it. At the same time, the nature of Rubens' painterly talents and power of design encouraged such works; they become symbols, in a way, of the artist's freedom to paint for himself. Not only cultural types—literary and pictorial modes—are embodied in Rubens' landscapes, then, but also, in his imitation of the world, his very self-conception; not only nature, but also the artist's individual nature shines through the paintings. That he preferred a late summer, working landscape seems to show an acceptance of his own season and his own ethic of unceasing creation; for the artist, who defined himself through his work, the stability of the georgic universe was ultimately preferable to the charms of arcadia. But although he may have rejected the epicureanism inherent in the pastoral—laxness and leisure and delight as an end—he did not for a moment reject the world.

The old heroes of virtue, philosophy's goal, were those who

ascended the jagged mountain. For Montaigne, on the other hand, who sought out his own true nature and found it good, virtue was not on the mountaintop, but rather, as he said, on a "belle plaine fertile et fleurissante" (*Essays* 1:26). With Montaigne, as we have seen, Rubens would agree.[69]

69. The fuller passage in Montaigne reads: "The most manifest sign of wisdom is a constant happiness; its state is like that of things above the moon: always serene . . . philosophy's object is to calm the tempests of the soul, to teach hunger and fever how to laugh . . . by natural and palpable arguments! Its aim is virtue, which does not, as the schoolmen allege, stand on the top of a sheer mountain, rugged and inaccessible. Those who have approached it have found it, on the contrary, dwelling on a fair, fertile plateau, from which it can clearly see all things below it. But anyone who knows the way can get there by shady, grassy, and sweetly flowering paths, pleasantly and up an easy and smooth incline, like that of the vault of heaven" (translated by J. M. Cohen [Harmondsworth, Middx., 1958], pp. 67 f.).

CHECKLIST OF RUBENS' PAINTINGS MENTIONED IN THE TEXT

Note: Entries in French from Rubens' inventory have been taken from J. Denucé, *The Antwerp Art Galleries: Inventories of the Art Collections in Antwerp in the Sixteenth and Seventeenth Centuries* (Antwerp, 1932), pp. 56–71; entries in English are from W. N. Sainsbury, *Original Unpublished Papers Illustrative of the Life of Peter Paul Rubens* (London, 1859), pp. 236–45. The inventory of Rubens' collection was made almost immediately after his death, and although it was issued in Flemish, English, and French, only a single printed copy (in French) survives. Only the engravings made by Schelte à Bolswert are listed here.

ANTWERP

Koninklijk Museum voor Schone Kunsten

1. *Prodigal Son* (fig. 95)
Panel 108 × 156 cm.
Coll. Rubens (no. 169): L'Enfant prodigue dans une estable; A Piece of the Prodigall Sonne, with a Stable.
Wijngaert, no. 113.
Glück, no. 3.

BERLIN-DAHLEM

Staatliche Museen Preussischer Kulturbesitz, Gemäldegalerie Berlin (West)

2. *Shipwreck* (fig. 15)
Canvas. 61 × 99 cm.
Wijngaert, no. 110; Rooses, *L'oeuvre de Rubens*, pl. 330 (fig. 16).
Glück, no. 15; Kelch, pp. 38–42.

3. *Landscape with Cows and Duckhunters* (fig. 64)
Panel. 113 × 176 cm.
Wijngaert, no. 107; Rooses, *L'oeuvre de Rubens*, pl. 343.
Glück, no. 13; Kelch, pp. 99–109.

4. *Landscape with a Tower* (fig. 101)
Panel. 23 × 30 cm.
Kelch, pp. 36–38.

COLOGNE

Collection Gottfried Neuerburg

5. *Storm Landscape with Lightning*
Panel. 39 × 69.3 cm.
Glück, no. 17.

DRESDEN

Staatliche Kunstsammlungen

6. *Boar Hunt* (fig. 59)
Panel. 137 × 168.5 cm.
Glück, no. 8.

FLORENCE

Galleria Pitti

7. *Return from the Fields* (fig. 65)
Panel. 122 × 195 cm.
Wijngaert, no. 112; Rooses, *L'oeuvre de Rubens*, pl. 332.
Glück, no. 15; Florence, no. 96.

8. *Odysseus on the Island of the Phaiakians* (fig. 6)
Panel. 128 × 207 cm.
Glück, no. 18; Florence, no. 95.

LENINGRAD

Hermitage

9. *Carters* (fig. 25)
Panel transferred to canvas. 87 × 129 cm.

Wijngaert, no. 93; Rooses, *L'oeuvre de Rubens*, pl. 332.

Glück, no. 7; Knoedler, no. 16.

10. *Shepherds and Shepherdesses in a Rainbow Landscape* (fig. 30)
Panel transferred to canvas. 81 × 129 cm.
Wijngaert, no. 98; Rooses, *L'oeuvre de Rubens*, pl. 338 (fig. 33).
Glück, no. 34.

LONDON

Royal Collection (Buckingham Palace)

11. *Farm at Laeken* (fig. 43)
Panel. 84.5 × 127.5 cm.
Glück, no. 2; Millar.

National Gallery

12. *Shepherd before a Wood* (fig. 38)
Panel. 63.9/64.4 × 94.3 cm.
Coll. Rubens (? no. 112): Un paysage avec des brebis, sur fond de bois; A Landschap, with sheepe, uppon bord.
Wijngaert, no. 106; Rooses, *L'oeuvre de Rubens*, pl. 335.
Glück, no. 4; G. Martin, no. 2924.

13. *The Watering Place* (fig. 39)
Panel. 98.7/99.4 × 135 cm.
Glück, no. 5; G. Martin, no. 4815.

14. *Het Steen* (fig. 70)
Panel. 131.2/131.8 × 229.2/222.9 cm.

Coll. Rubens (? no. 135): Un grand paysage au naturel avec des petites figures, sur fond de bois; A great Landschap after the life with little figures in't uppon a bord.
Glück, no. 30; G. Martin, no. 66.

15. *Shepherd at Sunset* (fig. 97)
Panel. 49.4/49.7 × 83.5 cm.
Coll. Rubens (? no. 112): See no. 12.
Wijngaert, no. 106.
Glück, no. 31; G. Martin, no. 157.

Prince's Gate Collection

16. *Horse Grazing by Moonlight* (fig. 98)
Panel. 63 × 89 cm.
Coll. Rubens (? no. 173): Une nuict sur fond de bois; A Night uppon bord.
Wijngaert, no. 102; Rooses, *L'oeuvre de Rubens*, p. 340.
Glück, no. 38; Seilern, no. 41.

Wallace Collection

17. *The Rainbow* (fig. 71)
Panel. 137 × 237 cm.
Coll. Rubens (? no. 136): Un grand paysage avec une pluye; A great Landschap where it raines, with little Cowes in it.
Glück, under no. 29; London, Wallace Collection, no. P63, pp. 287 ff.

A smaller version of this painting is in Munich (94 × 123 cm.; Glück, no. 29). Although to my knowledge the authenticity of the Munich painting has never been publicly called into doubt, I believe it to be a reduced copy, possibly by Lucas van Uden. The handling in this work is alternately crude and niggling (as in the foliage); it lacks the *pentimenti* of the London version; ample space remains at the lower edge, whereas in the London version Rubens clearly—and typically—ran out of room as he reached the bottom; and the additional space around the edges of the composition is left "dead." A version of *Het Steen* (the presumed companion piece to *The Rainbow*) by van Uden was mentioned as being in the Porgés Collection in Paris by Kieser (*Die Rubenslandschaften*, n. 18). If the Munich *Rainbow* is also by van Uden, then he would appear to have been the only Flemish painter who showed interest in—or perhaps knowledge of—*Het Steen* and *The Rainbow*.

MADRID

Museo del Prado

18. *Hunt of Atalanta*
Canvas. 160 × 260 cm.
Coll. Rubens (no. 131): Un grand bois au naturel, avec la chasse d'Atlante, en petites figures sur toile; A great peice, beinge a Wood made after the naturall, wherein is the huntinge of Atalanta in small figures.
Wijngaert, no. 111; Rooses, *L'oeuvre de Rubens*, pl. 331.
Glück, no. 37; Padrón, no. 1662, pp. 264 f.

MUNICH

Alte Pinakothek

19. *The Polder* (fig. 60)
Panel. 81 × 106 cm.
Glück, no. 6.

PARIS

Louvre

20. *Landscape with Roman Ruins* (fig. 103)
Panel. 75 × 101 cm.
Wijngaert, no. 90.
Glück, no. 11.

21. *Landscape with Jousting* (fig. 100)
Panel. 73 × 108 cm.
Coll. Rubens (no. 104): Une piece d'une
 Jouste dans un paysage; A Tiltinge, in
 Landschap.
Glück, no. 36.

22. *Farm at Sunset* (fig. 99)
Panel. 29 × 43 cm.
Wijngaert, no. 100 (dated 1638).
Glück, no. 33.

23. *Landscape with a Birdnet* (fig. 36)
Panel. 45 × 84 cm.
Wijngaert, no. 91; Rooses, *L'oeuvre de Rubens*,
pl. 334.

24. *Shepherds and Shepherdesses in a Rainbow
Landscape* (fig. 34)
Canvas. 122 × 172 cm.
Glück, under no. 34; Antwerp, no. 9.

The painting is on extended loan to the Musée
 des Beaux-Arts, Valenciennes. It appears
 to be a work of Rubens' shop.

ROTTERDAM

Museum Boymans-van Beuningen

25. *Storm Landscape* (fig. 120): copy (?) after
a presumed original.
Panel. 30.5 × 42 cm.
Wijngaert, no. 95.
Glück, no. 14.

VADUZ

Sammlungen des Regierenden Fürsten
von Liechtenstein

26. *Pond* (fig. 9)
Panel. 76 × 107 cm.
Wijngaert, no. 96; Rooses, *L'oeuvre de Rubens*,
 pl. 337.
Glück, no. 1; Liechtenstein, no. 16.

VIENNA

Kunsthistorisches Museum

27. *Flood Landscape with Philemon and Baucis*
(fig. 118)
Panel. 146 × 208.5 cm.
Coll. Rubens (no. 137): Un grand deluge avec
 l'histoire de *Philemon et Baucis;* A great
 Landschap with a Tempest, being the
 Historie of Baucis and Philemon.

Wijngaert, no. 109; Rooses, *L'oeuvre de Ru-
bens,* pl. 329 (fig. 119).
Glück, no. 12; Vienna, Kunsthistorisches
 Museum, no. 41.

28. *Castle Park* (fig. 37)
Panel. 52.5 × 97 cm.
Wijngaert, no. 103; Rooses, *L'oeuvre de Ru-
bens,* pl. 341.
Glück, no. 21; Vienna, Kunsthistorisches
 Museum, no. 56.

WYNNSTAY (NORTH WALES)

Collection Lt.-Col. W. O. Williams-Wynn

29. *Hunter at Sunrise*
Panel. 60 × 88 cm.
Coll. Rubens (no. 108): Un bois avec une
 chasse à l'aube du jour, sur fond de bois;
 A Wood with a Huntinge, with the Sun
 riseinge, uppon bord.
Wijngaert, no. 105; Rooses, *L'oeuvre de Ru-
bens,* pl. 342.
Glück, no. 28.

PRESUMED LOST

30. *Landscape with Ruins*
Collection Rubens (? no. 105): Une piece
 collée sur du bois d'un paysage d'Italie avec
 la ruine d'un Temple; A Peice, an Italian
 Landschap, w^{th} the ruines of a Church,
 which is cloth pasted upon a bord.
Wijngaert, no. 89 (fig. 102).
Glück, no. 40.

SELECTED BIBLIOGRAPHY

Exhibition catalogues not listed by editor appear under the cities in which the exhibitions were held.

Ackerman, James S., *Palladio's Villas.* Locust Valley, N.Y., 1967.

Alamanni, Luigi. "La coltivazione." In *Didascalici del secolo XVI*, ed. Andrea Rubbi. Venice, 1786.

Alberti, Leone Battista. *Ten Books on Architecture.* Trans. James Leoni from the Italian trans. of Cosimo Bartoli (1775), ed. Joseph Rykwert. London, 1955.

Alpers, Svetlana. "Ekphrasis and Aesthetic Attitudes in Vasari's *Lives.*" *Journal of the Warburg and Courtauld Institutes* 23 (1960), pp. 190 ff.

———. *"The Decoration of the Torre de la Parada.* Corpus Rubenianum Ludwig Burchard, Part X, London, 1971.

Andrews, Keith. *Adam Eisheimer: Paintings—Drawings—Prints.* London and New York, 1977.

Antwerp, Koninklijk Museum voor Schone Kunsten. *Peter Paul Rubens: Paintings—Oil Sketches—Drawings.* Antwerp, 1977.

Ariosto, Ludovico. *Orlando furioso.* Part 1. Trans. and intro. Barbara Reynolds. Harmondsworth, Middx., 1975.

Barocchi, Paola, ed. *Trattati d'arte del cinquecento, fra manierismo e controriforma.* Vol. 1. Bari, 1960.

Battisti, Eugenio. "Natura Artificiosa to Natura Artificialis." In *Dumbarton Oaks Colloquium on the History of Landscape Architecture: The Italian Garden.* Ed. David Coffin. Washington, D.C., 1972.

Baudouin, Frans. "Rubens' Social and Cultural Background." In *Stil und Ueberlieferung in der Kunst des Abendlandes. Akten des 21. Internationalen Kongresses für Kunstgeschichte in Bonn, 1964.* Vol. 3. Berlin, 1967.

———. *Rubens' House: A Summary Guide.* Antwerp, 1971.

———. *Pietro Pauolo Rubens.* Trans. Elsie Callander. New York, 1977.

Beekman, A. *Influence de Du Bartas sur la littérature néerlandaise.* Poitiers, 1912.

Beening, Th. J. *Het landschap in de nederlandse letterkunde van de Renaissance.* Nijmegen, 1963.

Bellori, Giovanni Pietro. *Le vite de' pittori, scultori, ed architetti moderni. . . .* Rome, 1672.

Bentmann, R. and M. Muller. *Die Villa als Herrschaftsarchitektur, Versuch einer kunst- und sozialgeschichtlichen Analyse.* Frankfurt, 1970.

Berlin-Dahlem, Gemäldegalerie. *Katalog der ausgestellten Gemälde.* Berlin, 1975.

Beslerus, Basil. *Hortus Eystettensis.* Eichstatt, 1613.

Bialostocki, Jan. "Les bêtes et les humains de Roelant Savery." *Bulletin des Musées Royaux des Beaux-Arts de Bruxelles* 7 (1958), pp. 69 ff.

———. "The Renaissance Concept of Nature and Antiquity." In *Acts of the Twentieth International Congress of the History of Art.* Vol. 2. Princeton, 1963. Pp. 19 ff.

———. *Stil und Ikonographie.* Dresden, 1965.

Bie, Jacques de. *Het gulden cabinet.* Lier, 1661.

Blunt, Anthony. *Nicolas Poussin.* 2 vols. New York, 1967.

Bock, Eugene de. *Johan Baptist Houwaert.* Antwerp, 1960.

Bode, Wilhelm von. "Neue Gemälde von Rubens in der Berliner Galerie." *Jahrbuch*

der königlichen Preuszischen Kunstsammlungen 25 (1904), pp. 102 ff.

Borsselen, Philibert van. *De dichtwerken van Philibert van Borsselen: een bijdrage tot de studie van zijn taal en stijl.* Ed. P. E. Muller. Groningen, 1937.

Boyer, C. B. *The Rainbow: from Myth to Mathematics.* New York, 1959.

Branden, L. van den. *Het streven naar verheerlijking, zuivering en opbouw van het Nederlands in de 16de eeuw.* Ghent, 1956.

Brussels, Musées Royaux des Beaux-Arts. *Maîtres flamands du XVIIe siècle du Prado et des collections privées espagnoles.* Brussels, 1975. (exhibition catalogue)

Burchard, Ludwig, and R. A. d'Hulst. *Rubens Drawings.* 2 vols. Brussels, 1963.

Burckhardt, Jacob. *Recollections of Rubens.* Trans. Mary Hottinger, ed. H. Gerson. New York, 1950.

Burns, Howard, in collaboration with Lynda Fairbairn and Bruce Boucher. *Andrea Palladio, 1508–1580: The Portico and the Farmyard.* London, 1975.

Cats, Jacob. *Alle de wercken.* 2 vols. Amsterdam, 1700.

Cicero. *Selected Works.* Trans. Michael Grant. Rev. ed. Harmondsworth, Middx., 1967.

Clark, Kenneth. *Landscape into Art.* London, 1949.

Coffin, David. "Some Aspects of the Villa Lante at Bagnaia." In *Scritti di storia dell'arte in onore di Edoardo Arslan.* Milan, 1966. Pp. 569 ff.

Cole, Bruce. "The Interior Decor of the Palazzo Datini in Prato." *Mitteilungen des Kunsthistorischen Instituts in Florenz* 30 (1967) pp. 67 ff.

Colie, Rosalie. *The Resources of Kind: Genre-Theory in the Renaissance.* Berkeley, 1973.

Commager, Steele. *The Odes of Horace.* New Haven, 1962.

———, ed. *Virgil: A Collection of Critical Essays.* Englewood Cliffs, N.J., 1966.

Curtius, Ernst Robert. *European Literature in the Latin Middle Ages.* Trans. Willard Trask. New York, 1953.

Davies, Randall. "An Inventory of the Duke of Buckingham's Pictures." *Burlington Magazine* 10 (1906–07), pp. 376 ff.

Denham, John. *Expans'd Hieroglyphicks: A Critical Edition of John Denham's Coopers Hill.* Ed. Brendan O'Hehir. Berkeley, 1969.

Denucé, J. *The Antwerp Galleries: Inventories of the Art Collections in Antwerp in the Sixteenth and Seventeenth Centuries.* Antwerp, 1932.

de Piles, Roger. *Recueil de divers ouvrages sur la peinture et le coloris.* Amsterdam-Leipzig, 1767.

———. *Dissertation sur les ouvrages de plus fameux peintres.* Farnborough, Hams., 1968. (a facsimile of the 1681 Paris edition)

Dreher, Faith. "The Vision of Country Life in the Paintings of David Teniers II." Ph.D. dissertation, Columbia University, 1975.

Dresden, Staatliche Kunstsammlungen, Gemäldegalerie. *Europäische Landschaftsmalerei, 1550–1650.* Dresden, 1972.

du Bartas, Guillaume de Salluste, Sieur. *Works.* 3 vols. Ed. Urban Tigner Holmes, Jr., John Coriden Lyons, and Robert White Linker. Chapel Hill, N.C., 1935–40. (critical edition)

———. *Bartas: His Devine Weekes and Works.* Trans. Josuah Sylvester. Intro. F. Haber. Gainesville, Fla., 1965. (a facsimile of the 1605 London edition)

Eckermann, Johann Peter. *Conversations of Goethe with Eckermann and Soret.* Trans. John Oxenford. London, 1874.

Egan, Patricia, "*Poesia* and the Fête Champêtre." *Art Bulletin* 41 (1959), pp. 303 ff.

Evers, H. G. *Peter Paul Rubens.* Munich, 1942.

———. *Rubens und sein Werk: Neue Forschungen.* Brussels, 1944.

Florence, Palazzo Pitti. *Rubens e la pittura fiamminga del seicento nella collezioni pubbliche fiorentine.* Ed. Didier Bodart. Florence, 1977.

Forster, Kurt, and Richard J. Tuttle. "The Casa Pippi, Giulio Romano's House in Mantua." *Architectura*, no. 2 (1973), pp. 104 ff.

Frankfurt, Städelsches Kunstinstitut. *Adam Elsheimer: Werke, kunstlerische Herkunft, und Nachfolge.* Frankfurt, 1966–67.

Franz, H. G. *Niederlandische Landschaftsmalerei im Zeitalter des Manierismus.* 2 vols. Graz, 1969.

Friedman, Donald. *Marvell's Pastoral Art.* Berkeley, 1970.

Fuchs, R. H. "Over het landschap: Een verslag naar aanleiding van Jacob van Ruisdael, *Het Korenveld.*" *Tijdschrift voor geschiedenis* 2 (1973), pp. 281 ff.

Gage, John. *Color in Turner.* New York, 1969.

Gelder, J. G. van. *Jan van de Velde.* The Hague, 1933.

Gerson, Horst, and E. H. ter Kuile. *Art and Architecture in Belgium, 1600–1800.* Harmondsworth, Middx., 1960.

Giamatti, A. B. *The Earthly Paradise and the Renaissance Epic.* Princeton, 1966.

Glück, Gustav. *De landschappen van P. P. Rubens.* Antwerp, 1940.

——. "Peter Bruegel the Elder and Classical Antiquity." *Art Quarterly* 6 (1943), pp. 167 ff.

Gombrich, E. H. *Norm and Form.* London, 1966.

Grant, W. L. *Neo-Latin Literature and the Pastoral.* Chapel Hill, N.C., 1965.

The Greek Anthology. Trans. W. R. Paton. Vol. 3. Cambridge, Mass., 1917.

Grossmann, Fritz. *Pieter Bruegel: Complete Edition of the Paintings.* 3rd rev. edn. New York, 1973.

Grote Winkler Prins atlas. Amsterdam, 1972.

The Hague, Mauritshuis. *Kabinet van schilderijen: Vijfentwintig jaar aanwisten, 1945–70.* The Hague, n.d. [1970?].

Haraszti-Takács, Marianne. "Einige Probleme der Landschaftsmalerei im Venedig des Cinquecento." In Dresden, Staatliche Kunstsammlungen, Gemäldegalerie, *Europäische Landschaftsmalerei, 1550–1650.* Dresden, 1972. Pp. 24 ff.

Haverkamp-Begemann, Egbert. *Willem Buytewech.* Amsterdam, 1959.

——, ed. *Wadsworth Atheneum Paintings: Catalogue 1. The Netherlands and the German-speaking Countries, Fifteenth–Nineteenth Centuries.* Hartford, Conn., 1978.

Held, Julius S. "Achelous' Banquet." *Art Quarterly* 4 (1941), pp. 122 ff.

——. *Rubens: Selected Drawings.* 2 vols. London, 1959.

——. "Rubens and the *Vita Beati P. Ignatii Loiolae* of 1609." In *Rubens before 1620,* ed. J. R. Martin. Princeton, 1972.

——. "Rubens and Aguilonius: New Points of Contact." *Art Bulletin* 61 (1979), pp. 257 ff.

Held, Julius S., and Donald Posner. *Seventeenth and Eighteenth Century Art.* Englewood Cliffs, N.J., 1973.

Hermann, Herbert. "Rubens y el Monasterio de San Lorenzo de El Escorial." *Archivo español de arte y arqueologia* 9 (1933), pp. 237 ff.

——. *Untersuchungen über die Landschaftsmalerei des Rubens.* Berlin, 1936.

Highet, Gilbert. *The Classical Tradition.* New York, 1949.

Hodge, Rupert. "A Carracci Drawing in the Studio of Rubens." *Master Drawings* 15 (1977), pp. 268 ff.

Hollstein, F. W. H. *Dutch and Flemish Etchings, Engravings, and Woodcuts.* 19 vols. Amsterdam, 1949– .

Holstenius, Lucas. "Commentarium in veterem picturam nymphaeum referentem." In *Thesaurus antiquitatum Romanarum.* Vol. 4. Venice, 1732.

Homer. *The Odyssey.* Trans. and intro. Richmond Lattimore. New York, 1965.

Horace. *Opera omnia.* Ed. E. C. Wickham. 2 vols. Oxford, 1896.

——. *Odes and Epodes.* Trans. C. E. Bennet. London, 1924.

——. *Satires, Epistles, and Ars Poetica.* Trans. H. Rushton Fairclough. London, 1924.

Houwaert, Jan Baptist. *Pegasides pleyn: Ende den lust-hof des maegden.* Antwerp, 1582–83.

Jaffé, Michael. *Van Dyck's Antwerp Sketchbook.* 2 vols. London, 1966.

Jongh, E. de. *Zinne- en minnebeelden in de schilderkunst van de zeventiende eeuw.* Utrecht, 1967.

——. "Erotica in vogelsperspectief: De dubbelzinningheid van een reeks 17de eeuwse genrevoorstellingen." *Simiolus* 3 (1968–69), pp. 22 ff.

Judson, J. Richard. *Dirk Barendsz.* Amsterdam, 1970.

Kelch, Jan, ed. *Peter Paul Rubens: Kritischer Katalog der Gemälde im Besitz der Gemäldegalerie Berlin.* Berlin, 1978.

Kettering, Alison McNeil. "The Batavian Arcadia: Pastoral Themes in Seventeenth-Century Dutch Art." Ph.D. dissertation,

University of California, Berkeley, 1974.

Kieser, Emil. *Die Rubenslandschaften*. Munich, 1926.

———. "Tizians und Spaniens Einwirkungen auf die späteren Landschaften des Rubens." *Münchener Jahrbuch der bildenden Kunst*, n.s. 8 (1931), pp. 281 ff.

Klein, Robert, and Henri Zerner. *Italian Art, 1500–1600*, Englewood Cliffs, N.J., 1966.

Klibansky, Raymond, Erwin Panofsky, and Fritz Saxl. *Saturn and Melancholy*. London, 1964.

Knoedler, M., and Co. *Paintings from the Hermitage and the State Russian Museum, Leningrad*. Ed. John Richardson and Eric Zafran. New York, 1975.

Kris, Ernst, and Otto Kurz. *Die Legende vom Künstler*. Vienna, 1934.

Lazzaro-Bruno, Claudia. "The Villa Lante at Bagnaia: An Allegory of Art and Nature." *Art Bulletin* 59 (1977), pp. 553 ff.

Lee, Rensselaer W. *Ut Pictura Poesis: The Humanistic Theory of Painting*. New York, 1967.

Leslie, C. R. *Memories of the Life of John Constable*. Ed. the Hon. Andrew Shirley. London, 1937.

Leurs, Stan, ed. *Geschiedenis van de Vlaamsche kunst*. 2 vols. Antwerp, 1939.

Lilly, Marie Loretto. *The Georgic: A Contribution to the Study of the Vergilian Type of Didactic Poetry*. Baltimore, 1919.

Lomazzo, G. P. *Trattato dell'arte della pittura, scultura ed architettura*. Milan, 1584.

London, National Gallery. *An Exhibition of Cleaned Pictures, 1936–1947*. London, 1947.

London, Wallace Collection. *Pictures and Drawings*. London, 1968.

Lovejoy, Arthur. *The Great Chain of Being*. Cambridge, Mass., 1936.

Lucretius. *De rerum natura*. Trans. W. H. D. Rouse, rev. Martin Fergusen Smith. Cambridge, Mass., 1975.

Macrae, Sigrid. "Rubens' Library." M.A. thesis, Columbia University, 1971.

MacDougall, Elisabeth. "Ars Hortulorum: Sixteenth Century Garden Iconography and Literary Theory in Italy." In *Dumbarton Oaks Colloquium on the History of Landscape Architecture, The Italian Garden*. Ed. David Coffin. Washington, D.C., 1972. Pp. 41 ff.

McGrath, Elizabeth. "The Painted Decorations of Rubens's House." *Journal of the Warburg and Courtauld Institutes* 41 (1978), pp. 245–77.

MacLaren, Neil. *Peter Paul Rubens: The Château de Steen*. London, 1946.

Magid, Joel George. "Andrew Marvell's 'Upon Appleton House': The Tradition and the Poem." Ph.D. dissertation, Columbia University, 1969.

Magurn, Ruth Saunders, trans. and ed. *The Letters of Peter Paul Rubens*. Cambridge, Mass., 1955.

Mander, Carel van. *Den grondt der edel vrij schilder-const*. In van Mander, *Het schilderboeck*. Haarlem, 1604.

———. *Den grondt der edel vrij schilder-const*. Trans. and ed. Hessel Miedema. 2 vols. Utrecht, 1973.

———. *Das Lehrgedicht des Karel van Mander*. Ed. and German trans. R. Hoecker. The Hague, 1916.

———. *Dutch and Flemish Painters*. Trans. C. van der Wall. New York, 1936.

Martial. *Epigrams*. Trans. W. C. A. Ker. 2 vols. rev. ed., Cambridge, Mass., 1968.

Martin, Gregory. "Two Closely Related Landscapes by Rubens." *Burlington Magazine* 108 (1966), pp. 180 ff.

———. *The National Gallery Catalogues: The Flemish School circa 1600–circa 1900*. London, 1970.

Martin, John Rupert. *The Decorations for the Pompa Introitus Ferdinandi*, Corpus Rubenianum Ludwig Burchard, Part XVI, New York, 1972.

Meiss, Millard, Jean Longnon, and Raymond Cazelles. *The Très Riches Heures of Jean, Duke of Berry*. New York, 1969.

Meiss, Millard, with the assistance of S. Dunlap Smith and E. Beatson. *French Painting in the Time of Jean de Berry: The Limbourgs and their Contemporaries*. New York, 1974.

Millar, Oliver. "Landscapes in the Royal Collection: The Evidence of X-Rays." *Burlington Magazine* 119 (1977), pp. 630 ff.

Minnaert, M. *Nature of Light and Color in the Open Air: The How and Why of Shadows, Reflections, Rainbows, Mirages and Over One*

Hundred Other Phenomena of Light and Color. Trans. H. M. Kremer-Priest. New York, 1954.

Mirollo, James V. *The Poet of the Marvellous: Giambattista Marino.* New York, 1963.

Montaigne, Michel de. *Essays.* Trans. J. M. Cohen. Harmondsworth, Middx., 1958.

New York, Pierpont Morgan Library. *Drawings from the Fitzwilliam Museum, Cambridge.* New York, 1977.

Norgate, Edward. *Miniatura, or the Art of Limning.* Ed. Martin Hardie. Oxford, 1919.

Nuremberg, Germanisches Nationalmuseum. *Die Gemälde des 13. bis 16. Jahrhunderts.* Ed. E. Lutze and E. Wiegand. 2 vols. Leipzig, 1937.

Oberhuber, Konrad. "Gli affreschi di Paolo Veronese nella Villa Barbaro." *Bollettino del Centro Internazionale di Studi di Architettura Andrea Palladio* 10 (1968), pp. 188 ff.

Oberhuber, Konrad, and Dean Walker. *Sixteenth-Century Italian Drawings from the Collection of Janos Scholz.* Washington, D.C., 1973.

Ogden, Henry. "The Principles of Variety and Contrast in Seventeenth-Century Aesthetics and Milton's Poetry." *Journal of the History of Ideas* 10 (1949), pp. 159 ff.

Ogden, Henry, and Margaret Ogden. *English Taste in Landscape in the Seventeenth Century.* Ann Arbor, Mich., 1955.

Ovid. *Metamorphoses.* Trans. Rolfe Humphries. Bloomington, Ind., 1972.

Padrón, Matias Díaz. *Museo del Prado-Catalogo de pinturas. 1. Escuela Flamenca, siglo XVII.* 2 vols. Madrid, 1975.

Palme, Per. *Triumph of Peacè: A Study of the Whitehall Banqueting House.* Stockholm, 1956.

Panofsky, Erwin. " 'Good Government' or Fortune?" *Gazette des beaux-arts* 68 (1966), pp. 305 ff.

———. *Idea: A Concept in Art Theory.* Columbia, S.C., 1968.

———. *Problems in Titian, Mostly Iconographic.* New York, 1969.

Parkhurst, Charles, "Aguilonius' Optics and Rubens' Color," *Nederlands kunsthistorisch jaarboek* 12 (1961), pp. 35 ff.

Pearsall, Derek, and Elizabeth Salter. *Landscapes and Seasons of the Medieval World.* Toronto, 1973.

Perret, Jacques. *Horace.* New York, 1964.

———. "The *Georgics.*" In *Virgil: A Collection of Critical Essays.* Ed. Steele Commager. Englewood Cliffs, N.J., 1966. Pp. 28 ff.

Petrarch, Francesco. *Letters from Petrarch.* Ed. Morris Bishop. Bloomington, Ind., 1966.

Pfeiffer, Rudolf. *History of Classical Scholarship, from 1300 to 1850.* Oxford, 1976.

Philostratus. *Imagines.* Trans. Arthur Fairbanks. Cambridge, Mass., 1960.

Pino, Paolo. *Dialogo di pittura.* Venice, 1548.

Pirenne, Henri. *Histoire de Belgique.* Vol. 4. Brussels, 1907–19.

Pliny the Younger. *Letters and Panegyrics.* Trans. Betty Radice. 2 vols. Cambridge, Mass., 1969.

Pochat, Götz. *Figur und Landschaft: Eine historische Interpretation der Landschaftsmalerei von der Antike bis zur Renaissance.* Berlin, 1973.

Polunin, Oleg. *Flowers of Europe: A Field Guide.* London, 1969.

Poumon, E. *Les châteaux du Brabant.* Brussels, 1949.

Prinz, Wolfram. "The *Four Philosophers* by Rubens and the Pseudo-Seneca in Seventeenth-Century Painting." *Art Bulletin* 55 (1973), pp. 410 ff.

Puyvelde, Leo van. "A Landscape by Rubens." *Burlington Magazine* 78 (1941), pp. 188 ff.

Raczynski, J. A. Graf. *Die flämische Landschaft vor Rubens.* Frankfurt, 1937.

Reynolds, Joshua. *Discourses on Art.* Ed. Robert Wark. London, 1966.

Reznicek, E. K. J. *Die Zeichnungen von Hendrik Goltzius.* 2 vols. Utrecht, 1961.

———. "Het leerdicht van Karel van Mander en de acribe van Hessel Miedema." *Oud Holland* 89 (1975), pp. 102 ff.

Richmond, H. M. *Renaissance Landscapes: English Lyrics in a European Tradition.* The Hague, 1973.

Riegl, Alois. "Die mittelalterliche Kalenderillustration." *Mitteilungen des Instituts für Oesterreichische Geschichtsforschung* (Vienna, 1889), pp. 1 ff.

Roli, Renato. *I fregi centesi del Guercino.* Bologna, 1968.

Rooses, Max. "Petrus Paulus Rubens en Bal-

thasar Moretus," part 1. *Rubens-bulletijn* 1 (1882), pp. 203 ff.

————. "Petrus Paulus Rubens en Balthasar Moretus," part 4. *Rubens-bulletijn* 2 (1885), pp. 176 ff.

————. *L'oeuvre de P. P. Rubens.* 5 vols. Antwerp, 1886–92.

————. "Staet van goederen in het Sterfhuis van Isabella Brant." *Rubens-bulletijn* 4 (1895), pp. 154 ff.

————. "Staet ende inventaris van den Sterffhuyse van Mynheer Albertus Rubens ende vrouwe Clara Del Monte." *Rubens-bulletijn* 5 (1897), pp. 11 ff.

————. "De plakbrief der heerlijkheid van Steen." *Rubens-bulletijn* 5 (1900), pp. 149 ff.

————. *Rubens.* 2 vols. Trans. Harold Child. Philadelphia and London, 1904.

————. "De vreemde reizigers Rubens of zijn huis bezoekende." *Rubens-bulletijn* 5 (1910), pp. 221 ff.

Rosand, David. "Rubens' Munich *Lion Hunt:* Its Sources and Significance." *Art Bulletin* 51 (1969), pp. 29 ff.

Rosand, David, and Michelangelo Muraro. *Titian and the Venetian Woodcut.* Washington, D.C., 1976.

Rosenmeyer, Thomas. *The Green Cabinet: Theocritus and the European Pastoral Lyric.* Berkeley, 1969.

Ross, James B., and Mary Martin McLaughlin. *The Portable Renaissance Reader.* New York, 1953.

Rothlisberger, Marcel. *Claude Lorraine: The Paintings.* London, 1961.

Rowlands, John. *Rubens: Drawings and Sketches.* British Museum. London, 1977. (exhibition catalogue)

Ruelens, Charles. "La vie de Rubens par Roger de Piles." *Rubens-bulletijn* 2 (1885), pp. 157 ff.

————. "Un témoignage rélatif à Peter Paul Rubens en Italie." *Rubens-bulletijn* 4 (1890), pp. 113 ff.

Ruelens, Charles, and Max Rooses, eds. *Codex diplomaticus Rubenianus: Correspondance et documents épistolaires.* 6 vols. Antwerp, 1887–1909.

Sainsbury, W. N. *Original Unpublished Papers Illustrative of the Life of Peter Paul Rubens.* London, 1859.

Sandrart, Joachim von. *Teutsche Academie der Edlen Bau-, Bild-, und Mahlerey-Künste.* Nuremberg, 1675.

Sannazaro, Jacopo. *Arcadia and Piscatorial Eclogues.* Trans. R. Nash. Detroit, 1966.

Schulz, Juergen. "Le fonti di Paolo Veronese come decoratore." *Bollettino del Centro Internazionale di Studi di Architettura Andrea Palladio* 10 (1968), pp. 241 ff.

Segal, Charles Paul. "Landscape in Ovid's *Metamorphoses:* A Study in the Transformation of a Literary Symbol." *Hermes, Zeitschrift für Klassische Philologie, Einzelschriften* 23 (1969).

Seilern, Count Antoine. *Catalogue of the Collection at 56 Prince's Gate: Flemish Paintings*

and Drawings. London, 1955.

Sloane, Catherine. "Two Statues by Bernini in Morristown, New Jersey." *Art Bulletin* 56 (1974), pp. 551 ff.

Speth-Holterhoff, S. *Les peintres flamands des cabinets d'amateurs au XVIIe siècle.* Brussels, 1957.

Stechow, Wolfgang. "Die 'Pellekussenpoort' bei Utrecht auf Bildern von Jan van Goyen und Salomon van Ruysdael." *Oud Holland* 55 (1938), pp. 202 ff.

————. "The Myth of Philemon and Baucis." *Journal of the Warburg and Courtauld Institutes* 4 (1940–41), pp. 103 ff.

————. *Dutch Landscape Painting in the Seventeenth Century.* London, 1966.

————. *Northern Renaissance Art, 1400–1600: Sources and Documents.* Englewood Cliffs, N.J., 1966.

————. *Rubens and the Classical Tradition.* Cambridge, Mass., 1968.

Steinberg, Leo. "Remarks on Certain Prints Relative to a Leningrad Rubens on the Occasion of the First Visit of the Original to the United States." *The Print Collectors Newsletter* 6 (1975), pp. 97 ff.

Suetonius. *Works.* Trans. J. C. Rolfe. 2 vols. London and New York, 1920.

Swoboda, K. M. *Neue Aufgaben der Kunstgeschichte.* Brünn, 1935.

Tayler, W. W. *Nature and Art in Renaissance Literature.* New York, 1964.

Theuwissen, J. "De kar en de wagen in het werk van Rubens." *Jaarboek van het Kon-*

inklijk *Museum voor Schone Kunsten te Ant-werpen* (1966), pp. 199 ff.

———. "Het werk van Bruegel en Rubens als beelddocument." *Volkskunde* 72 (1971), pp. 345 ff.

Thiéry, Yvonne. *Le paysage flamand au XVII siècle.* Paris, 1953.

Tietze, Hans. "Unknown Venetian Renaissance Drawings in Swedish Collections." *Gazette des beaux-arts* 35 (1949), pp. 183 ff.

Tietze, Hans, and E. Tietze-Conrat. *The Drawings of the Venetian Painters.* New York, 1944.

Tietze-Conrat, E. "Titian as a Landscape Painter." *Gazette des beaux-arts* 45–46 (1955), pp. 11 ff.

Tillyard, E. M. W. *The Elizabethan World Picture.* London, 1943.

Turner, A. Richard. *The Vision of Landscape in Renaissance Italy.* Princeton, 1966.

Vaduz, Sammlungen des Regierenden Fürsten von Liechtenstein. *Peter Paul Rubens aus den Sammlungen des Fürsten von Liechtenstein.* Vaduz, 1974–75.

Vassar College Art Gallery. *Dutch Mannerism: Apogee and Epilogue.* Poughkeepsie, N.Y., 1970.

Veen, P. A. F. van. *De soeticheydt des buyten-levens, vergheselschapt met de boecken, het hofdicht als tak van een georgische literatuur.* The Hague, 1960.

Vienna, Kunsthistorisches Museum. *Peter Paul Rubens, 1577–1640.* Vienna, 1977.

Vienna, Graphische Sammlung Albertina.

Die Rubenszeichnungen der Albertina zum 400. Geburtstag. Vienna, 1977.

Virgil. *Bucolica en Georgica, dat is, Ossen-stal en Landtwerck.* Trans. Carel van Mander. Haarlem, 1597.

———. *Georgics.* Trans. C. Day Lewis. London, 1940.

———. *Georgics.* Trans. H. Rushton Fairclough. Rev. ed. Cambridge, Mass., 1935.

———. *Aeneidos liber primus.* With commentary by R. G. Austin. Oxford, 1971.

———. *The Aeneid.* Trans. Allen Mandelbaum. New York, 1972.

Vitruvius. *On Architecture.* Ed. and trans. Frank Granger. 2 vols. Cambridge, Mass., 1956.

Vooys, C. G. N. de. *Geschiedenis van de nederlandse taal.* Antwerp, 1952.

Warnke, Martin. *Kommentare zu Rubens.* Berlin, 1965.

———. *Flämische Malerei des 17. Jahrhunderts in der Gemäldegalerie Berlin.* Berlin, 1967.

White, Christopher. *Rubens and his World.* New York, 1968.

Whitfield, Clovis. "Nicholas Poussin's 'Orage' and 'Temps Calme.'" *Burlington Magazine* 119 (1977), pp. 4 ff.

Wiegand, Wilfried. *Ruisdael-Studien: Ein Versuch zur Ikonologie der Landschaftsmalerei.* Hamburg, 1971.

Wijngaert, Frank van den. *Inventaris der Rubeniaansche prentkunst.* Antwerp, 1940.

Wilcox, Rosemarie. "'Of Passion's Finest Thread': Studies in the Life and Poetry of

Thomas Carew." Ph.D. dissertation, Columbia University, 1971.

Wilenski, R. H. *Flemish Painters, 1430–1830.* 2 vols. London, 1960.

Wilkinson, L. P. *Horace and His Lyric Poetry.* Cambridge, 1946.

———. *The Georgics of Virgil: A Critical Survey.* Cambridge, 1969.

Williams, Raymond. *The Country and the City.* New York, 1973.

Wilson, D. B. *Ronsard, Poet of Nature.* Manchester, 1961.

Wind, Edgar. *Giorgione's Tempesta, with Comments on Giorgione's Poetic Allegories.* Oxford, 1969.

Winkler Prins encyclopedie van Vlaanderen. 5 vols. Brussels, 1973.

Winternitz, Emanuel. *Musical Instruments and Their Symbolism in Western Art.* New York, 1967.

Worp, J. A. "Constantijn Huygens over de schilders van zijn tijd." *Oud Holland* 8 (1891), pp. 106 ff.

INDEX

Uden, Lucas van, 94*n*
ut pictura poesis, xiv; defined, 15; as expressed by
 Carel van Mander, 19–24; and genre theory,
 56

Valavez, Palamède de Fabri, Sieur de: Rubens'
 letter to, 3
Valckenborch, Lucas van, 38*n*, 170, 174, 175
Varchi, Benedetto, 43
Vasari, Giorgio, 43
Veen, Otto van, 2
Veen, P. A. F. van, 167
Vega, Lope de, 158
Velius, D. Theodorus, 23
Verhulst, Pieter, 122, 123
Vinckboons, David, 175*n*
Virgil, 2, 29*n*, 43, 55, 136, 139–48 passim, 180,
 192; *Eclogues*, 23, 27, 32*n*, 139–55; *Aeneid*,
 33–40, 43, 139, 155
—*Georgics*: 55, 154, 155, 183*n*, 190*n*; van
 Mander's translation of, 23, 147; illustrations
 of, 32*n*; description of a breeding cow, 133;
 view of rural life in, 139–49; influence on
 Carel van Mander, 143; influence in Middle
 Ages, 154, 155–56; influence in the
 Renaissance, 158; influence on the *hofdicht*,
 167, 169, 189
Visscher, Claes Jansz., 159
Vitruvius, 4*n*, 122*n*, 157*n*, 160
Vos, Cornelis de, 175, 176
Vos, Martin de, 175, 177

Wandelbert, 155–56
Warnke, Martin, 39
Watteau, Antoine, xiii
Wotton, Sir Henry, 157*n*
Woverius, Jan, 7, 8